ReVisioning

art for faith's sake series

SERIES EDITORS:

Clayton J. Schmit
J. Frederick Davison

This series of publications is designed to promote the creation of resources for the church at worship. It promotes the creation of two types of material, what we are calling primary and secondary liturgical art.

Like primary liturgical theology, classically understood as the actual prayer and practice of people at worship, primary liturgical art is that which is produced to give voice to God's people in public prayer or private devotion and art that is created as the expression of prayerful people. Secondary art, like secondary theology, is written reflection on material that is created for the sake of the prayer, praise, and meditation of God's people.

The series presents both worship art and theological and pedagogical reflection on the arts of worship. The series title, *Art for Faith's Sake*,* indicates that, while some art may be created for its own sake, a higher purpose exists for arts that are created for use in prayer and praise.

OTHER VOLUMES IN THIS SERIES:

FORTHCOMING VOLUMES IN THIS SERIES:

* *Art for Faith's Sake* is a phrase coined by art collector and church musician, Jerry Evenrud, to whom we are indebted.

ReVisioning

*Critical Methods of Seeing Christianity
in the History of Art*

EDITED BY

James Romaine *and* Linda Stratford

CASCADE *Books* · Eugene, Oregon

REVISIONING
Critical Methods of Seeing Christianity in the History of Art

Art for Faith's Sake 10

Cascade Books
An Imprint of Wipf and Stock Publishers
199 W. 8th Ave., Suite 3
Eugene, OR 97401

www.wipfandstock.com

ISBN 13: 978-1-62032-084-6

Cataloging-in-Publication data:

ReVisioning : critical methods of seeing Christianity in the history of art / edited by James Romaine and Linda Stratford.

xx + 356 p.; 23 cm—Includes bibliographical references and index.

Art for Faith's Sake 10

ISBN 13: 978-1-62032-084-6

1. Christian art and symbolism—History. 2. Art—History—Methodology. I. Title. II. Series.

N380 R45 2013

Manufactured in the USA.

Table of Contents

Color Plates

Color Plate 1 | *page 167*
Jean le Noir, *Psalter of Bonne of Luxembourg*, fol. 330v, 331r, before 1349, illuminated manuscript, 4 x 3 in. (12 x 9 cm), the Metropolitan Museum of Art, New York. With permission of the Metropolitan Museum of Art/ IAP.

Color Plate 2 | *page 168*
Jonah sarcophagus (Vatican 31448), third quarter of the 3rd century, marble, 27 3/16 x 87 13/16 x 7 7/16 in. (69 x 223 x 19 cm). Museo Pio Cristiano of the Vatican Museums, Vatican City. Photo courtesy of the Vatican Museums.

Color Plate 3 | *page 169*
Jonah sarcophagus (Vatican 31448), upper two central scenes, third quarter of the 3rd century, marble, 27 3/16 x 87 13/16 x 7 7/16 in. (69 x 223 x 19 cm). Museo Pio Cristiano, Vatican City. Photo by Linda Fuchs, courtesy of the Vatican Museums.

Color Plate 4 | *page 170*
Andrea Rico di Candia (?), *Virgin of the Passion*, mid-late 15th century, tempera on wood panel, 35 13/16 x 30 5/16 in. (91 x 77 cm), Princeton University Art Museum. With permission of Princeton University Art Museum. Photo by Bruce M. White.

Color Plate 5 | *page 171*
Theodore Apsevdis (?), Virgin Arakiotissa at the Panagia tou Arakos Church (south wall of nave), 1192, Fresco, c. 4 x 7 in. (10.16 x 17.8 cm), Lagoudera, Cyprus. Photo permission of Slobodan Ćurčić.

Color Plate 6 | *page 172*
Luca Signorelli, *Resurrection of the Dead*, 1499–1504, fresco, Chapel of the Madonna di San Brizio, Orvieto Cathedral, Orvieto, Italy. Photo permission of Gianni Dagli Orti/Art Resource, New York.

Color Plate 7 | *page 173*
Ara Pacis Augustae, relief detail, 13–9 B.C., marble, Rome. Photo permission of Rachel Hostetter Smith.

Color Plate 8 | *page 174*
Messe de Saint Grégoire, 1539, feathers on wood panel, 26.8 x 22 in. (68 x 56 cm), Musée des Jacobins, Auch, France. With permission from Musée des Jacobins.

Color Plate 9 | *page 175*
Imago Pietatis, Italo Byzantine Icon, c. 1300, mosaic (multicolored stones, gold, silver, wood), 10 x 11 in. (23 x 28 cm), Bascilica of Santa Croce en Gerusalemme, Rome. Permission of Fondi Edifici di Culto.

Color Plate 10 | *page 176*
(top) Masaccio, *The Tribute Money*, 1420s, fresco, left wall, upper register, Brancacci Chapel, Santa Maria del Carmine, Florence; (bottom) Masaccio, *The Raising of the Son of Theophilus*; *The Chairing of Antioch*, 1420s, completed 1480s, fresco, left wall, lower register. Photo permission of Antonio Quattrone.

Color Plate 11 | *page 177*
(top) Masolino, *St. Peter Healing a Cripple*; *The Raising of Tabitha*, 1420s, fresco, right wall, upper register, Brancacci Chapel, Santa Maria del Carmine, Florence; (bottom) Filippino Lippi, *The Crucifixion of St. Peter*; *The Disputation with Simon Magus*, 1480s, fresco, right wall, lower register, Brancacci Chapel. Photo permission of Antonio Quattrone.

Color Plate 12 | *page 178*
Joachim Patinir, *Saint Jerome in the Desert*, c. 1515, oil on panel, 30.7 x 54 in. (78 x 137 cm), Louvre, Paris. Permission of Réunion des Musées Nationaux/Art Resource, New York.

Color Plate 20 | *page 186*
Henry Ossawa Tanner, *Christ and His Mother Studying the Scriptures*, c. 1909, oil on canvas, 48 x 40 in. (122 x 101.6 cm), Dallas Museum of Art. Permission of Dallas Museum of Art.

Color Plate 21 | *page 187*
Max Beckmann, *Resurrection*, 1908–1909, oil on canvas, 155 x 98 in. (395 x 250 cm), Staatsgalerie, Stuttgart. Permission of Staatsgalerie Stuttgart, Artists Rights Society (ARS), New York.

Color Plate 22 | *page 188*
Francis Bacon, *Study after Velázquez's Portrait of Pope Innocent X*, 1953, oil on canvas, 60 1/4 x 46 1/2 in. (153 x 118 cm), Des Moines Arts Center. Permission DACS. © The Estate of Francis Bacon. All rights reserved, DACS 2013. Photo by Prudence Cuming Associates Ltd.

Color Plate 23 | *page 189*
Diego Velázquez, *Portrait of Pope Innocent X*, 1650, oil on canvas, 44 7/8 x 46 7/8 in. (114 x 119 cm), Galleria Doria Pamphilj, Rome. Permission of Bridgeman Art Library.

Color Plate 24 | *page 190*
Paul Pfeiffer, *Fragment of a Crucifixion (After Francis Bacon)*, still detail from projected images 3 x 4 in. (7.6 x 10.2 cm), digital video loop, projector, metal armature, DVD player, 5-second video loop. Permission of Paula Cooper Gallery, New York.

Illustrations

Figure 6 | *page 60*
Jonah sarcophagus (Vatican 31448), detail, right prone figure in the upper right central scene third quarter of the 3rd century, marble, 27 3/16 x 87 13/16 x 7 7/16 in. (69 x 223 x 19 cm). Museo Pio Cristiano of the Vatican Museums, Vatican City. Photo by Linda Fuchs, courtesy of the Vatican Museums.

Figure 7 | *page 72*
Theodore Apsevdis (?), Hetoimasia at Panagia tou Arakos Church (east pendentives and drum) 1192, fresco, c. 6 x 9 in. (15.25 x 22.9 cm) cross-section, Lagoudera, Cyprus. Photo permission of Slobodan Ćurčić.

Figure 8 | *page 94*
Orvieto Cathedral, 13th–14th c., Orvieto, Italy. Photo permission of Rachel Hostetter Smith.

Figure 9 | *page 107*
Lorenzo Maitani, Genesis Relief, early 14th c., Orvieto Cathedral, Orvieto, Italy. Photo permission of Rachel Hostetter Smith.

Figure 10 | *page 109*
Lorenzo Maitani, New Testament Relief, early 14th c., Orvieto Cathedral, Orvieto, Italy. Photo permission of Rachel Hostetter Smith.

Figure 11 | *page 114*
Mass of St. Gregory, c. 1460, woodcut, 9 x 7 in. (25 x 18 cm). Germanisches National Museum, Nuremberg. Permission of Germanisches National Museum.

Figure 12 | *page 128*
Devotional Booklet, left side, 1330–50, ivory, 4 x 2 in. (10.7 x 6 cm), the Victoria and Albert Museum, London. Permission of the Victoria and Albert Museum.

Figure 13 | *page 129*
Devotional Booklet, right side, 1330–50, ivory, 4 x 2 in. (10.7 x 6 cm), the Victoria and Albert Museum, London. Permission of the Victoria and Albert Museum.

Figure 14 | *page 132*
Israhel van Meckenem, *Mass of St. Gregory*, c. 1490–5, engraving, 18 1/4 x 11 5/8 in. (46.3 x 29.5 cm), the British museum, London. Permission of the British Museum.

Figure 15 | *page 146*
Brancacci Chapel, Santa Maria del Carmine, Florence. Photo permission of Antonio Quattrone.

Figure 16 | *page 149*
Masaccio, *St. Peter Healing with his Shadow*, 1420s, fresco, altar wall, left side, lower register, Brancacci Chapel, Santa Maria del Carmine, Florence. Photo permission of Antonio Quattrone.

Figure 17 | *page 160*
Masaccio, *The Baptism of the Neophytes*, 1420s, fresco, altar wall, right side, upper register, Brancacci Chapel, Santa Maria del Carmine, Florence. Photo permission of Antonio Quattrone.

Figure 18 | *page 163*
Masaccio, *The Distribution of Alms/Death of Ananias*, 1420s, fresco, altar wall, right side, lower register, Brancacci Chapel, Santa Maria del Carmine, Florence. Photo permission of Antonio Quattrone.

Figure 19 | *page 192*
Joachim Patinir, *Saint Jerome in the Desert*, detail, c. 1515, oil on panel, 30.7 x 54 in. (78 x 137 cm), Louvre, Paris. Permission of Réunion des Musées Nationaux /Art Resource, New York.

Figure 20 | *page 195*
Gerard David, *The Rest on the Flight into Egypt*, c. 1512–15, oil on panel, 20 x 17 in. (50.8 x 43.2 cm), the Metropolitan Museum of Art, New York. Permission of the Metropolitan Museum of Art/IAP.

Figure 21 | *page 206*
Michelangelo, *Pietà*, 1500, marble, 68.5 in. (174 cm), St. Peter's Basilica, Rome. Permission of Photo Scala Group.

Figure 22 | *page 211*
Tiberio Alfarano da Gerace, Plan of the Old Basilica of St. Peter, 1590, in Martino Ferrabosco, Architettura della basilica di San Pietro in Vaticano. Opera di Bramante Lazzari, Michel'Angelo Bonarota, Carlo Maderni, e altri famosi Architetti, Roma 1684. Permission of the Vatican.

Figure 23 | *page 224*
Lucas Cranach the Elder, *Pope Leading Armies*, 1521, woodcut, 3.73 x 4.63 in. (9.5 x 11.8 cm), in Lucas Cranach the Elder, *Passional Christi und Antichristi*, Wittenberg: Johannes Grau. Permission of Pitts Theology Library, Emory University.

Figure 24 | *page 234*
Lucas Cranach the Elder, *Christ Crowned with Thorns*, 1521, woodcut, 3.73 x 4.63 in. (9.5 x 11.8 cm), in Lucas Cranach the Elder, *Passional Christi und Antichristi*, Wittenberg: Johannes Grau. Permission of Pitts Theology Library, Emory University.

Figure 25 | *page 235*
Lucas Cranach the Elder, *The Pope Crowned with the Triple Tiara*, 1521, woodcut, 3.73 x 4.63 in. (9.5 x 11.8 cm), in Lucas Cranach the Elder, *Passional Christi und Antichristi*, Wittenberg: Johannes Grau. Permission of Pitts Theology Library, Emory University.

Figure 26 | *page 242*
Gregorio Fernández, *Cristo yacente*, 1609, polychrome wood, lifesize, Convento de San Pablo, Valladolid, Spain. Author photo, permission of Convento of San Pablo.

Figure 27 | *page 246*
Juan de Juni, *Entombment*, 1544, Polychrome wood and gilding, lifesize, Museo Nacional de Escultura, Valladolid, Spain. Permission of Erich Lessing/Art Resource, New York.

Figure 28 | *page 260*
Eugène Delacroix, *Pietà*, detail, 1844, oil and wax on canvas 11.6 x 15.5 ft. (3.56 x 4.75 m), Church of Saint Denis du Saint-Sacrement, Paris. Photo permission of Christian Murtin.

Figure 29 | *page 266*
Christ in Majesty plaque, c. 1160–70, Champlevé enamel, 5 x 13/16 x
3 ⁹/₁₆ in. (14.7 x 9.03 cm), the Metropolitan Museum of Art, New York.
Permission of the Metropolitan Museum of Art.

Figure 30 | *page 276*
Furniture Department, John Wanamaker Department Store, the
Historical Society of Pennsylvania, John Wanamaker Papers. Permission
of the Historical Society of Pennsylvania.

Figure 31 | *page 286*
Thomas E. Askew, *African American girl*, half-length portrait, with right
hand to cheek, with illustrated book on table, c. 1899–1900, the Library
of Congress, Prints & Photographs Division, LC-USZ62-63574. Permission of the Library of Congress Prints and Photographs Division.

Figure 32 | *page 291*
Window Display, John Wanamaker Department Store, c. 1893–1904, the
Historical Society of Pennsylvania, John Wanamaker Papers. Permission
of the Historical Society of Pennsylvania.

Figure 33 | *page 294*
Max Beckmann, *Resurrection*, detail, 1916–1918 (unfinished), oil on canvas, 135 3/4 x 195 2/3 in. (345 x 197 cm), Staatsgalerie Stuttgart. Permission of Staatsgalerie Stuttgart. Artists Rights Society (ARS), New York.

Figure 34 | *page 302*
Max Beckmann, *Departure*, Frankfurt 1932, Berlin 1933–35, oil on canvas, side panels 7 ft. 3/4 in. x 39 1/4 in. (215.3 x 99.7 cm), center panel 7 ft.
3/4 in. x 45 3/8 in. (215.3 x 115.2 cm), the Museum of Modern Art, New
York. Permission of the Museum of Modern Art/Licensed by SCALA/
Art Resource, New York. Artist Rights Society (ARS), New York.

Figure 35 | *page 307*
Max Beckmann, *Resurrection*, 1916–1918 (unfinished), oil on canvas,
135 ¾ x 195 2/3 in. (345 x 197 cm), Staatsgalerie Stuttgart. Permission of
Staatsgalerie Stuttgart. Artists Rights Society (ARS), New York.

Figure 36 | *page 309*
Max Beckmann, *Night*, 1918–1919, oil on canvas, 52 3/4 x 50 5/8 in. (133 x 154 cm), Kunstsammlung Nordrhein-Westfalen, Düsseldorf. Permission of Kunstsammlung Nordrhein-Westfalen, Düsseldorf © 2012. Artists Rights Society (ARS), New York.

Figure 37 | *page 310*
Giovanni Cimabue, *Crucifix*, c. 1287–8, tempera on panel, 1763/8 x 1531/2 in. (448 x 390 cm), Santa Croce, Florence. Permission of Bridgeman Art Library.

Figure 38 | *page 314*
Francis Bacon, *Three Studies for Figures at the Base of a Crucifixion*, c. 1944, oil on board, 37 x 29 in. (94 x 73.7 cm) each, Tate, London. Permission of TATE Images.

Figure 39 | *page 324*
Paul Pfeiffer, *Fragment of a Crucifixion (After Francis Bacon)*, projected images 3 x 4 in. (7.6 x 10.2 cm), digital video loop, projector, metal armature, DVD player, 5-second video loop. Permission of Paula Cooper Gallery, New York.

Acknowledgments

ReVisioning is a project of the Association of Scholars of Christianity in the History of Art (ASCHA). ASCHA has been organized by James Romaine, Linda Stratford, Ronald Bernier, and Rachel Smith. Many of the essays in this volume are based on papers presented at ASCHA symposia. These symposia include "History, Continuity, and Rupture: A Symposium on Christianity and Art" (Paris, 2010), co-organized by Romaine and Stratford; "Why Have There Been No Great Modern Religious Artists?" (New York, 2011), co-organized by Romaine and Smith; and "Faith, Identity, and History: Representations of Christianity in Modern and Contemporary African American Art" (Philadelphia, 2012), co-organized by Nikki A. Greene, Emily Hage, and James Romaine. We are grateful to all of the institutions and scholars who participated in and contributed to these symposia. This book is a record and recognition of the importance of those symposia for the development of methodologies by which the history of Christianity and the visual arts is addressed.

The co-editors are especially grateful to all of the scholars who contributed essays to *ReVisioning*. Each scholar has contributed something unique to this project. Their scholarship has been made possible by personal and institutional support that cannot all be named here but should not go unrecognized.

We also wish to thank Cascade Books and especially D. Christopher Spinks, editor, for supporting this project. We are grateful to Art for Faith's Sake (AFFS) series editors Clay Schmit and J. Frederick Davison, who along with editors at Cascade reviewed our proposal and selected it for inclusion in AFFS. We are grateful to Heather Carraher for typesetting the manuscript. Susan Cottenden and Erika Graham provided valuable editorial assistance for the project. Mike Peterson offered valuable advice. *ReVisioning* has been greatly enhanced by the inclusion of color plates. We thank Asbury University for generously funding these color image

reproductions, facilitating critical examination of historical methods in tandem with works of art. We also thank Kayce Price and Kerry Geary for their work in photo editing.

We are especially grateful to our institutions, Nyack College and Asbury University, for their support of our scholarship. Finally, we wish to thank our spouses and families for their continual patience while we have faced the pressures of completing a challenging project.

James Romaine
Nyack College
New York, NY

Linda Stratford
Asbury University
Wilmore, KY

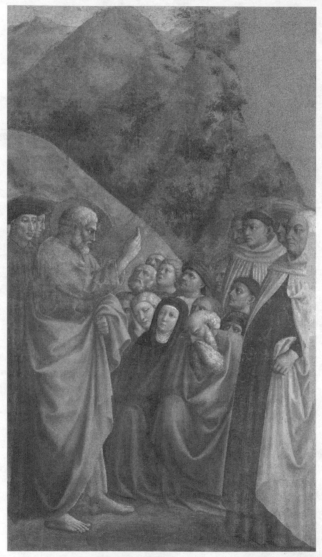

Figure 1. Masolino, *St. Peter Preaching*, 1420s, fresco, altar wall, left side, upper register, Brancacci Chapel, Santa Maria del Carmine, Florence. Photo permission of Antonio Quattrone.

Expanding the Discourse on Christianity in the History of Art

JAMES ROMAINE

The substance, terms, and tone of the art historical discourse are established by the methodologies that scholars employ. These methods shape how and what art history is written and taught. This is true both broadly across the academic field as well as when specifically addressing the history of Christianity and the visual arts. *ReVisioning: Critical Methods of Seeing Christianity in the History of Art* explores some of the underlying methodological assumptions in the field of art history by examining the suitability and success, as well as the incompatibility and failure, of varying art historical methodologies when applied to works of art that distinctly manifest Christian narratives, themes, motifs, and symbols.

In developing this project, the co-editors looked to several precedents in which the field of art history has engaged in a critical self-examination. One model for this book is *Feminism and Art History: Questioning the Litany*, edited by Norma Broude and Mary D. Garrard.[1] In their introduction to that collection of essays, Broude and Garrard rightly argued that certain methodological assumptions of art history, intentionally and unintentionally, excluded women from the canon. In addressing this problem, Broude and Garrard began by noting, "The history of art, like other scholarly disciplines, has matured over the centuries by expanding its boundaries

1. See Norma Broude and Mary D. Garrard, eds., *Feminism and Art History: Questioning the Litany* (New York: Harper & Row, 1982). Also, Norma Broude and Mary D. Garrard, eds., *The Expanding Discourse: Feminism And Art History* (New York: HarperCollins, 1992); and Norma Broude and Mary D. Garrard, eds., *Reclaiming Female Agency: Feminist Art History after Postmodernism* (Berkeley: University of California Press, 2005). The title of this introductory essay is an acknowledgment of this debt.

to include new ways of looking at its subject."² Following that model, this book and the Association of Scholars of Christianity in the History of Art (ASCHA), the organization that initiated this project, are here contributing to further expanding the dialog and the maturation of the discipline of art history by calling to its attention certain methodological attitudes and assumptions that limit the scholarly study of the history of Christianity and the visual arts.

Broude and Garrard's introduction articulated a two-part objective, both of which are applicable to *ReVisioning*. They wrote,

> On the most basic and, to date, most visible level, [feminism] has prompted the rediscovery and reevaluation of the achieve ments of women artists, both past and present. Thanks to the efforts of a growing number of scholars who are devoting their research skills to this area, we know a great deal today about the work of women artists who were almost lost to us little more than a decade ago, as the result of their exclusion from the standard histories.³

ASCHA and this book aim to cultivate a community of scholars committed to the recovery of the richness and diversity of the history of Christianity and the visual arts that has been in danger of becoming neglected and invisible.

However, as Broude and Garrard observed, there was/is a larger goal to be accomplished. They wrote, "Feminism has raised other even more fundamental questions for art history as a humanistic discipline, questions that are now affecting its functioning at all levels and that may ultimately lead to its redefinition."⁴ For Broude and Garrard, feminism was a reevaluation of the patriarchal "attitudes and assumptions" that defined both the concept of "art" and its history.⁵ Broude and Garrard's self-consciousness of the theoretical basis of their own practice as well as their act of shining a light onto the methodological assumptions evident in the field at large were both a great contribution to art history and have served as a model for this book's attempt to question how art history has addressed, and failed to address, the history of Christianity and the visual arts.

The prevailing narrative of art history is one that charts a movement from the sacred to the secular, progressing out of past historical periods in which works of art were produced to reveal, embrace, and glorify the

2. Broude and Garrard, *Feminism and Art History*, 1.

3. Ibid., 1.

4. Ibid., 2.

5. Ibid., 2.

divine and toward a modern conception of art as materialist and a more recent emphasis on social context.[6] In fact, for many art historians this secularization of art is not only a narrative *within* the history of art; it has been the narrative *of* art history as an academic field.[7] Some interpretations of twentieth- and twenty-first-century art not only insist on equating modernism with secularism but also describe the erasure of all mention of spiritual presence from the scholarly discourse as a triumph for the field of art history.[8] The rise of the academic art historian in the nineteenth century and the development of critical methods of art history, such as connoisseurship, formalism, iconography, psychoanalysis, and semiotics, have been regarded, and even designed, as part of a movement away from matters of personal (and therefore presumed to be subjective) faith toward a critical and rational (and therefore presumed to be objective)

6. This is the narrative of the history of art as advanced in many of the most popular survey textbooks. See Marilyn Stokstad and Michael W. Cothren, *Art History*, 5th ed. (Upper Saddle River: Pearson Education, 2013); and Fred S. Kleiner, *Gardner's Art Through the Ages*, 14th ed. (Boston: Wadsworth, 2013). In these textbooks, the religious content and contexts of art from historical periods before the nineteenth century are addressed; however, art with religious content and contexts in the nineteenth century or after are largely ignored. *Great Themes in Art*, 1st ed. (Upper Saddle River: Pearson Education, 2001), a thematic survey textbook by John Walford, treats issues of spirituality roughly equally in all periods of art history.

7. In her essay "The 'Return' of Religion in the Scholarship of American Art," Sally M. Promey describes the "secularization theory of modernity" (*The Art Bulletin* 85:3 [2003] 581–603). She notes that, as the field of art history took form in the late-nineteenth century, it was founded on positivist theories of secularization. Promey writes, "Most succinctly, secularization theory contends that modernism necessarily leads to religion's decline, that the secular and the religious will not coexist in the modern world." She adds, "secularization theory became a powerful shaper of disciplines and intellectual inquiry" (ibid., 584). She also adds, later in the essay, "It is no accident that American art history has recovered the study of religion at just the time when the array of 'post-modernisms' calls into question aspects of the Enlightenment agenda, with its attendant secularization trajectories" (ibid., 593).

8. For example, Rosalind Krauss uses the art of Piet Mondrian to make a larger point ("Grids," *October* 9 [1979] 50–64). She writes, "Given the absolute rift that had opened between the sacred and the secular [in the nineteenth century], the modern artist was obviously faced with the necessity to choose between one mode of expression and the other. The curious testimony offered by the grid is that at this juncture he tried to decide for both. In the increasingly de-sacralized space of the nineteenth century, art had become the refuge for religious emotion; it became, as it has remained, a secular form of belief. Although this condition could be discussed openly in the late nineteenth century, it is something that is inadmissible in the twentieth, so that by now we find it indescribably embarrassing to mention *art* and *spirit* in the same sentence" (ibid., 54; emphasis original). For a de-sacralized treatment of twentieth-century art, see Hal Foster, Rosalind Krauss, Yve-Alain Bois, and Benjamin H. D. Buchloh, *Art Since 1900: Modernism, Antimodernism, Postmodernism* (New York: Thames & Hudson, 2004).

discipline. Some recent methods of art history have maintained what has been regarded as a necessary skepticism toward matters of religious faith, presuming that art history and religion, especially Christianity, do not belong together.

In *Art History after Modernism*, Hans Belting notes that modernism was not only an artistic practice; it was also a paradigm of art history.[9] As the dominance of that paradigm has waned, the discipline of art history has been freed to explore other directions and methods of scholarship. In *Has Modernism Failed* and *The Reenchantment of Art*, Suzi Gablik voiced a disenchantment with modernism, not only with its manifestation but also with its assumptions and mechanisms.[10] Gablik, in turn, urged a sacralization of art as antidote. Building on Gablik's proposition, James Elkins and David Morgan have suggested that "enchantment" as a human way of knowing, accounts for the large numbers of the public appreciation of art that involves spiritual meaning.[11]

In critiquing the secularist assumptions of those methods of art history persisting from the last century, it is advisable, however, not to go too far. In many cases, the development of these art historical methods has contributed positively to the establishment of professional practices. At the same time, these methods have created problems for the field of art history. The history of art, that is, the production of art by artists, has been, is, and is likely to continue to be, largely committed to the creative visualization of faith, spirituality, and religion. Over the last two centuries, artists, not only in Europe and the Americas but throughout the world, have continued to produce works of art with distinctly Christian subjects, forms, and purposes. At the same time, images and objects reflective of Christian content and contexts have too often been met by a field that lacks the methodological framework by which to meaningfully inform their engagement. In some cases, the very structures imposed by these methods' secularist assumptions minimize, misconstrue, or marginalize the work of

9. Hans Belting, *Art History after Modernism* (Chicago: University of Chicago Press, 2003) vii.

10. See Suzi Gablik, *Has Modernism Failed* (New York: Thames & Hudson, 1985); and Suzi Gablik, *The Reenchantment of Art* (New York: Thames & Hudson, 1992). While there are many definitions of modernism, Gablik's description of it as a paradigm characterized by "mechanism, positivism, empiricism, rationalism, materialism, secularism, and scientism—the whole objectifying consciousness of the Enlightenment" will suffice here. Gablik, *The Reenchantment of Art*, 11. Our objective is not to discard these values and embrace their opposites but rather to open them to critique as assumptions for art historical methodologies.

11. See James Elkins and David Morgan, eds., *Re-Enchantment* (New York: Routledge, 2008).

art's Christian content. The effect is a contracting rather than expanding of the experience of looking at art. *ReVisioning: Critical Methods of Seeing Christianity in the History of Art* contends that scholars ignore the pervasive and influential presence of Christianity in the history of art at the risk of distorting that history. There is today an urgency to develop an open and rigorous discussion of methods by which scholars can constructively engage the history of Christianity and the visual arts, as a benefit not only to that history, but to the very integrity of the field of art history itself.

The dichotomy between the history of art and the methods of art history had earlier aroused Elkins's curiosity as demonstrated in *On the Strange Place of Religion in Contemporary Art*, where he noted, "It is impossible to talk sensibly about religion and at the same time address art in an informed and intelligent manner; but it is also irresponsible not to keep trying."[12] Elkins, together with Morgan, gives his own try in *Re-Enchantment*, which addresses the most "challenging subjects" in current writing on topics which "bear articulation yet are not sufficiently addressed," including the flourishing of religion in art.[13]

In his introduction to *Re-Enchantmen*t Morgan cites this trend, finding it noteworthy, the number of art critics, art school professors, and art historians who in the face of artwork evoking religious experience express "contempt for art that intends to do so and viewers that welcome it."[14] Morgan proposes:

> When art takes on spiritual meanings, it requires of the professional interpreter an expertise that far exceeds the narrower and more defensible boundaries of formalist criticism, art-world journalism, knowledge of artists and their works, and skill at making art and cultivating one's career at it.[15]

Morgan's observation suggests that despite the breadth of art historical methodologies in use today, the field continues to struggle to find the interdisciplinary tools by which to practice a more robust analysis of the ways in which religious faith has informed works of art. While the discrediting of antireligious rationalism appears to have spurred renewed

12. See James Elkins, *On the Strange Place of Religion in Contemporary Art* (New York: Routledge, 2004). At the same time, Elkins claims, "art that sets out to convey spiritual values goes against the grain of the history of modernism," explaining that most religious art today makes itself out to be too sentimental and thus becomes simply "bad" art by failing to exercise boundaries between art and religion (ibid., 20).

13. Elkins and Morgan, *Re-Enchantment*.

14. Ibid., 17.

15. Ibid.

interest within the academy in things spiritual, if not religious, interpretive strategies have not yet been consciously and critically developed.

The questions remain, has the discipline of art history developed sufficient methodologies by which to critically see the history of Christianity in the visual arts? Do art historians possess the methodological tools to recognize and discuss the meaningful interface with works of art bearing Christian content or reference? How will art historians responsibly write about works of art with Christian content? The field of art history stands in need of its own methodological reflection. Some, perhaps including Elkins, hold that the professional standards and methods of art history are necessarily at odds with religion. Others, the editors of this book included, wish to make the case that the field of art history, in fact, must find professional standards and methods by which to addresses the history of Christianity and the visual arts.

Thankfully, this project has already been underway, with increasing momentum, for many decades. The scholarly literature addressing the history of Christianity and the visual arts has developed to such an extent that it can no longer be justly overlooked. While this literature, reflecting the complexity and diversity of its subject is far too rich and manifold to be surveyed in any single essay, it is possible to note some of its characteristics.[16] One of the most interesting phenomena of the evolution of this literature is how it has developed along two distinct tracks: visual theology and religious culture.

Developing out of a recognition of the strengths and limitations of formalist and iconographic methods of art history, but, at the same time, wanting to keep the work of art, as a content-permeated image or object, at the center of the scholarly focus, a content-oriented method of art history began to emerge.[17] While this method was not exclusively concerned

16. Any list of this literature will be far from a complete accounting of the depth, diversity, and richness of the scholarly discourse concerning the history of Christianity and the visual arts. This essay is principally concerned with scholarship that fits within a category of art history. Therefore, scholarship that is mainly theological—see Jeremy S. Begbie, *Voicing Creation's Praise: Toward a Theology of the Arts* (Edinburgh: T. & T. Clark, 2000); or Gesa Elsbeth Thiessen, ed., *Theological Aesthetics: A Reader* (Grand Rapids: Eerdmans, 2004)—as well as books aimed at the encouragement of contemporary artists of faith—see James Romaine, ed., *Objects of Grace: Conversations on Creativity and Faith* (Baltimore: Square Halo, 2002); or Ned Bustard, ed., *It Was Good: Making Art to the Glory of God* (Baltimore: Square Halo, 2007)—are not a part of this discussion. This essay only cites books and catalogs, in English, that are largely concerned with the history of Christianity and art. To avoid redundancy, books cited in footnotes to the text of this essay are not repeated in lists of literature.

17. Erwin Panofsky and Sir Ernst Gombrich are scholars who established some of this foundation.

with spiritual or Christian content, many scholars, such as Doug Adams,[18] Diane Apostolos-Cappadona,[19] John Dillenberger,[20] Jane Dillenberger,[21] William Dyrness,[22] and Hans Rookmaaker,[23] have evidenced in their work a distinct concern for the sacred.

This method of art as visual theology recognizes the work of art as a personal medium, for the artist or the viewer, of a vertically-oriented imagination. Specifically applied to the history of Christianity and the visual arts, this method regards both Christianity as well as the visual arts as establishing a vertical relationship between God and humanity. This method tends to regard the work of art as biblical exegesis. This impact is not just that the work of art, or artist, is regarded as an interpreter of the Bible but that the scholar is an interpreter of the work's meaning as it is read from the work's iconographic and formal construction.

In the more recent literature, there has developed a rich diversity of methodological directions,[24] addressing works for the Early Christian

18. See Doug Adams, *Transcendence With the Human Body in Art: George Segal, Stephen De Staebler, Jasper Johns, and Christo* (New York: Crossroad, 1991). Doug Adams and Diane Apostolos-Cappadona, eds., *Art As Religious Studies* (New York: Crossroad, 1987).

19. See Diane Apostolos-Cappadona, ed., *Art, Creativity and the Sacred* (New York: Crossroad, 1992); and *The Spirit and the Vision: The Influence of Christian Romanticism on the Development of 19th-Century American Art* (Atlanta: Scholars, 1995).

20. See John Dillenberger, *The Visual Arts and Christianity in America* (New York: Crossroad, 1989); and *Images and Relics: Theological Perceptions and Visual Images in Sixteenth-Century Europe* (New York: Oxford University Press, 1999).

21. See Jane Dillenberger, *Style and Content in Christian Art* (Nashville: Abingdon, 1965); *Secular Art with Sacred Themes* (Nashville: Abingdon, 1969); *Image and Spirit in Sacred and Secular Art* (New York: Crossroad, 1990); and *The Religious Art of Andy Warhol* (New York: Continuum, 1998).

22. See William Dyrness, *Visual Faith: Art, Theology, and Worship in Dialogue* (Ada, MI: Baker Academic, 2001); *Reformed Theology and Visual Culture: The Protestant Imagination from Calvin to Edwards* (Cambridge: Cambridge University Press, 2004); and *Senses of the Soul: Art and the Visual in Christian Worship* (Eugene, OR: Cascade, 2008).

23. See H. R. Rookmaaker, *Modern Art and The Death of Culture* (New York: Crossway, 1994); and Marleen Hengelaar-Rookmaaker, ed., *The Complete Works of Hans R Rookmaaker* (Carlisle: Piquant, 2002).

24. For texts that survey histories of Christianity and the visual arts, see Michelle P. Brown, ed., *The Lion Companion to Christian Art* (Oxford: Lion Hudson, 2008); John Drury, *Painting the Word: Christian Pictures and their Meanings* (New Haven: Yale University Press, 1999); Neil MacGregor with Erika Langmuir, *Seeing Salvation: Images of Christ in Art* (New Haven: Yale University Press, 2000); Rowena Loverance, *Christian Art* (Cambridge: Harvard University Press, 2007); Martin O'Kane, *Imaging the Bible: An Introduction to Biblical Art* (London: SPCK, 2008); and *Painting the Text* (Sheffield: Sheffield Phoenix, 2007); and Jaroslav Pelikan, *The Illustrated Jesus Through*

and Byzantine,[25] Medieval,[26] Renaissance and Reformation,[27] Baroque and

the Centuries (New Haven: Yale University Press, 1997).

25. See Andreas Andreopoulos, *Metamorphosis: The Transfiguration in Byzantine Theology And Iconography* (Yonkers, NY: St Vladimir's Seminary Press, 2005); Clemena Antonova, *Space, Time, and Presence in the Icon: Seeing the World With the Eyes of God* (Burlington, VT: Ashgate, 2010); Charles Barber, *Figure and Likeness: On the Limits of Representation in Byzantine Iconoclasm* (Princeton: Princeton University Press, 2002); John Beckwith, *Early Christian and Byzantine Art* (Harmondsworth, UK: Penguin, 1970); Hans Belting, *Likeness and Presence: A History of the Image before the Era of Art*, trans. Edmund Jepphcott (Chicago: University of Chicago Press, 1994); Robin Cormack, *Icons* (Cambridge, MA: Harvard University Press, 2007); Paul Corby Finney, *The Invisible God: The Earliest Christians on Art* (New York: Oxford University Press, 1997); Pavel Florensky, *Beyond Vision: Essays on the Perception of Art*, ed. Nicoletta Misler, trans. Wendy Salmond (London: Reaktion, 2002); Michael Gough, *The Origins of Christian Art* (New York: Praeger, 1973); André Grabar, *Christian Iconography: A Study of Its Origins* (Princeton: Princeton University Press, 1968); Robin Margaret Jensen, *Understanding Early Christian Art* (New York: Routledge, 2000); and *Face to Face: Portraits of the Divine in Early Christianity* (Minneapolis: Fortress, 2004); Anastasia Lazaridou, ed., *Transition to Christianity: Art of Late Antiquity, 3rd–7th Century AD* (New York: Alexander S. Onassis Public Benefit Foundation, 2012); Robert S. Nelson, *Hagia Sophia, 1850–1950: Holy Wisdom, Modern Monument* (Chicago: University of Chicago Press, 2004); and ed., *Holy Image, Hallowed Ground: Icons from Sinai* (Los Angeles: J. Paul Getty Museum, 2007); Jeffrey Spier, ed., *Picturing the Bible: The Earliest Christian Art* (New Haven: Yale University Press, 2009); and Jaroslav Pelikan, *Imago Dei: The Byzantine Apologia for Icons* (Princeton: Princeton University Press, 1990).

26. See Martina Bagnoli, ed., *Treasures of Heaven: Saints, Relics, and Devotion in Medieval Europe* (Baltimore: Walters Art Museum, 2010); Anne Derbes, *Picturing the Passion in Late Medieval Italy: Narrative Painting, Franciscan Ideologies, and the Levant* (Cambridge: Cambridge University Press, 1998); Jeffrey F. Hamburger and Anne-Marie Bouché, *The Mind's Eye: Art and Theological Argument in the Middle Ages* (Princeton: Princeton University Press, 2005); Herbert L. Kessler, *Spiritual Seeing: Picturing God's Invisibility in Medieval Art* (Philadelphia: University of Pennsylvania Press, 2000); Aden Kumler, *Translating Truth: Ambitious Images and Religious Knowledge in Late Medieval France and England* (New Haven: Yale University Press, 2011); Henk van Os, *The Art of Devotion in the Late Middle Ages in Europe 1300–1500* (Princeton: Princeton University Press, 1995); Amy Knight Powell, *Depositions: Scenes from the Late Medieval Church and the Modern Museum* (Brooklyn: Zone, 2012); Sixten Ringbom, *Icon to Narrative: The Rise of the Dramatic Close up in Fifteenth Century Devotional Painting* (Doornaspijk, NL: Davaco, 1984); and Richard Viladesau, *The Beauty of the Cross: The Passion of Christ in Theology and the Arts—From the Catacombs to the Eve of the Renaissance* (Oxford: Oxford University Press, 2006).

27. See Paolo Berdini, *The Religious Art of Jacopo Bassano: Painting as Visual Exegesis* (Cambridge: Cambridge University Press, 1997); Carl C. Christensen, *Art and the Reformation in Germany* (Athens: Ohio University Press, 1979); John W. Dixon Jr., *Art and the Theological Imagination* (New York: Seabury, 1978); and *The Christ of Michelangelo* (Atlanta: Scholars, 1994); and *Images of Truth: Religion and the Art of Seeing* (Atlanta: Scholars, 1996); Creighton E. Gilbert, *How Fra Angelico and Signorelli Saw the End of the World* (University Park: Pennsylvania State University Press, 2003); Sara Nair James, *Signorelli and Fra Angelico at Orvieto: Liturgy, Poetry and a Vision of the*

End-time (Burlington, VT: Ashgate, 2003); Rhonda Kasl, ed., *Giovanni Bellini and the Art of Devotion* (Indianapolis: Indianapolis Museum of Art, 2005); Christian K. Kleinbub, *Vision and the Visionary in Raphael* (University Park: Pennsylvania State University Press, 2011); Joseph Leo Koerner, *The Moment of Self-Portraiture in German Renaissance Art* (Chicago: University of Chicago Press, 1997); and *The Reformation of the Image* (Chicago: University of Chicago Press, 2008); Andrew Ladis, *Visions of Holiness: Art and Devotion in Renaissance Italy* (Atlanta: University of Georgia Museum, 2001); Barbara G. Lane, *The Altar and the Altarpiece: Sacramental Themes in Early Netherlandish Painting* (New York: Harper & Row, 1984); Jules Lubbock, *Storytelling in Christian Art from Giotto to Donatello* (New Haven: Yale University Press, 2006); Sergiusz Michalski, *Reformation and the Visual Arts: The Protestant Image Question in Western and Eastern Europe* (New York: Routledge, 1993); Alexander Nagel, *The Controversy of Renaissance Art* (Chicago: University of Chicago Press, 2011); Scott Nethersole, *Devotion by Design: Italian Altarpieces before 1500* (London: National Gallery London, 2011); Bonnie Noble, *Lucas Cranach the Elder: Art and Devotion of the German Reformation* (Lanham, MD: University Press of America, 2009); Christine Sciacca, ed., *Florence at the Dawn of the Renaissance: Painting and Illumination, 1300-1350* (Los Angeles: J. Paul Getty Museum, 2012); R. W. Scribner, *For the Sake of Simple Folk: Popular Propaganda for the German Reformation* (Oxford: Clarendon, 1994); Steven Ozment, *The Serpent and the Lamb: Cranach, Luther, and the Making of the Reformation* (New Haven: Yale University Press, 2012); Timothy Verdon and John Henderson, eds., *Christianity and the Renaissance: Image and Religious Imagination in the Quattrocento* (Syracuse: Syracuse University Press, 1990); Timothy Verdon, *Mary in Western Art* (Manchester, VT: Hudson Hills, 2005); and Richard Viladesau, *The Triumph of the Cross: The Passion of Christ in Theology and the Arts. From the Renaissance to the Counter Reformation* (Oxford: Oxford University Press, 2008).

Rococo,[28] nineteenth-century,[29] twentieth-century,[30] and contemporary[31]

28. See Xavier Bray et al., *The Sacred Made Real: Spanish Painting and Sculpture 1600–1700* (London: National Gallery London, 2009); James Clifton, *The Body of Christ: In the Art of Europe and New Spain 1150–1800* (New York: Prestel, 1997); Lloyd DeWitt, *Rembrandt and the Face of Jesus* (New Haven: Yale University Press, 2011); Adelheid M. Gealt and George Knox, *Domenico Tiepolo: A New Testament* (Bloomington: Indiana University Press, 2006); Ronda Kasl, ed., *Sacred Spain: Art and Belief in the Spanish World* (New Haven: Yale University Press, 2010); John Rupert Martin and Gail Feigenbaum, *Van Dyck as Religious Artist* (Princeton: Art Museum, Princeton University, 1979); Mia M. Mochizuki, *The Netherlandish Image after Iconoclasm, 1566–1672: Material Religion in the Dutch Golden Age* (Burlington, VT: Ashgate, 2008); Shelley Perlove and Larry Silver, *Rembrandt's Faith: Church and Temple in the Dutch Golden Age* (University Park: Pennsylvania State University Press, 2009); Alain Saint Saëns, *Art and Faith in Tridentine Spain (1545–1690)* (New York: Lang, 1995); E. John Walford, *Jacob van Ruisdael and the Perception of Landscape* (New Haven: Yale University Press, 1991); and Arthur K. Wheelock Jr., ed., *Rembrandt's Late Religious Portraits* (Chicago: University of Chicago Press, 2005).

29. See Ronald Bernier, *Monument, Moment, and Memory: Monet's Cathedral in Fin De Siecle France* (Lewisburg, PA: Bucknell University Press, 2007); Marcus C. Bruce, *Henry Ossawa Tanner: A Spiritual Biography* (New York: Crossroad 8th Avenue, 2002); Michael Paul Driskel, *Representing Belief: Religion, Art, and Society in Nineteenth-Century France* (University Park: Pennsylvania State University Press, 1992); Kathleen Powers Erickson, *At Eternity's Gate: The Spiritual Vision of Vincent van Gogh* (Grand Rapids: Eerdmans, 1998); Michaela Giebelhausen, *Painting the Bible: Representation And Belief in Mid-Victorian Britain* (Burlington, VT: Ashgate, 2006); Cordula Grewe, *Painting the Sacred in the Age of Romanticism* (Burlington, VT: Ashgate, 2009); Joseph Leo Koerner, *Caspar David Friedrich and the Subject of Landscape* (London: Reaktion, 2009); Anna O. Marley, ed., *Henry Ossawa Tanner: Modern Spirit* (Berkeley: University of California Press, 2012); Joyce Carol Polistena, *The Religious Paintings of Eugène Delacroix, (1798–1863): The Initiator of the Style of Modern Religious Art* (Lewiston, NY: Mellen, 2008); Robert Rosenblum, *Modern Painting and the Northern Romantic Tradition: Friedrich to Rothko* (New York: Harper & Row, 1975); Debora Silverman, *Van Gogh and Gauguin: The Search for Sacred Art* (New York: Farrar, Straus and Giroux, 2000); and Timothy Wilcox, *Constable and Salisbury: The Soul of Landscape* (London: Scala, 2011).

30. See M. A. Couturier, *Henri Matisse: The Vence Chapel: The Archive of a Creation* (New York: Skira, 1999); Horton Davies and Hugh Davies, *Sacred Art In A Secular Century* (Collegeville, MN: Liturgical, 1978); William Dyrness, *Rouault: A Vision of Suffering and Salvation* (Grand Rapids: Eerdmans, 1971); Jefferson J. A. Gatrall and Douglas Greenfield, eds., *Alter Icons: The Russian Icon and Modernity* (University Park: Pennsylvania State University Press, 2011); John Golding, *Paths to the Absolute* (Princeton: Princeton University Press, 2000); Richard Lipsey, *An Art of Our Own: The Spiritual in Twentieth Century Art* (Boston: Shambhala, 1988); Sheldon Nodelman, *The Rothko Chapel Paintings: Origins, Structure, Meaning* (Austin: University of Texas Press, 1997); Marie-Therese Pulvenis de Seligny, *Matisse: The Chapel at Vence* (London: Royal Academy of Arts, 2013); Andrew Spira, *The Avant- Garde Icon* (London: Humphries, 2008); and Maurice Tuchman, ed., *The Spiritual in Art: Abstract Painting 1890–1985* (New York: Abbeville, 1986).

31. See Ronald Bernier, ed., *Beyond Belief: Theoaesthetics or Just Old-Time Religion?*

periods as well as non-Western cultures.[32]

A context-oriented method of art as religious culture has developed out of methods that placed issues of class, gender, race, and/or sexual orientation as formative to the work of art's interpretation. Keeping issues of theory and history at the center of the scholarly focus, scholars have adaptively applied these strategies to develop methods of art as religious culture that address the power and presence of the visual in religious culture and practice.[33] This method acknowledges the work of

(Eugene, OR: Pickwick, 2010); Richard Francis, *Negotiating Rapture: The Power of Art to Transform Lives* (Chicago: Museum of Contemporary Art, 1996); and Eleanor Heartney, *Postmodern Heretics: Catholic Imagination in Contemporary Art* (New York: Midmarch Arts, 2004).

32. See Sandra Bowden et al., *Beauty Given by Grace: The Biblical Prints of Sadao Watanabe* (Baltimore: Square Halo, 2012); Nicholas James Bridger, *Africanizing Christian Art: Kevin Carroll and Yoruba Christian Art in Nigeria* (Tenafly, NJ: Society of African Missions, 2012); Carol Damian, *The Virgin of the Andes: Art and Ritual in Colonial Cuzco* (Miami Beach: Grassfield, 1995); William Dyrness, *Christian Art in Asia* (Amsterdam: Rodopi, 1979); Deborah E. Horowitz, ed., *Ethiopian Art: The Walters Art Museum* (Surrey, UK: Third Millennium, 2006); C. Griffith Mann, *Art of Ethiopia* (London: Holberton, 2006); Ilona Katzew, *Contested Visions in the Spanish Colonial World* (Los Angeles: Los Angeles County Museum of Art, 2011); Suzanne L. Stratton-Pruitt, ed., *The Virgin, Saints and Angels: South American Paintings 1600–1825 from the Thoma Collection* (Geneva: Skira, 2006); and Elizabeth Netto Calil Zarur and Charles Muir Lovell, eds., *Art and Faith in Mexico: The Nineteenth-Century Retablo Tradition* (Albuquerque: University of New Mexico Press, 2001).

33. Inevitably, this methodological direction depends on scholars in fields of religion, history, sociology, and others. As Nigel Aston notes in his *Art and Religion in Eighteenth-Century Europe* (London: Reaktion, 2009), the field of art history has often lagged behind some of these fields in recognizing the significance of religion, and Christianity, in private and public life. The area in which the study of religious culture has especially flourished is American art. See David Bjelajac, *Millennial Desire and the Apocalyptic Vision of Washington Allston* (Washington: Smithsonian Books, 1988) and *Washington Allston, Secret Societies, and the Alchemy of Anglo-American Painting* (Cambridge: Cambridge University Press, 1997); John Davis, *The Landscape of Belief: Encountering the Holy Land in Nineteenth-Century American Art and Culture* (Princeton: Princeton University Press, 1996); David Morgan, *Icons of American Protestantism: The Art of Warner Sallman* (New Haven: Yale University Press, 1996); *Protestants and Pictures: Religion, Visual Culture, and the Age of American Mass Production* (Oxford: Oxford University Press, 1999); *Visual Piety: A History and Theory of Popular Religious Images* (Berkeley: University of California Press, 1999); *The Sacred Gaze: Religious Visual Culture in Theory and Practice* (Berkeley: University of California Press, 2005); and *The Embodied Eye: Religious Visual Culture and the Social Life of Feeling* (Berkeley: University of California Press, 2012); David Morgan and Sally M. Promey, *The Visual Culture of American Religions* (Berkeley: University of California Press, 2001); James Elkins and David Morgan, eds., *Re-Enchantment* (New York: Routledge, 2008); Sally M. Promey, *Spiritual Spectacles: Vision and Image in Mid-Nineteenth-Century Shakerism* (Bloomington: Indiana University Press, 1993), and *Painting Religion in Public: John Singer Sargent's*

art as operating in a public sphere of life along a horizontally-oriented axis and developing a greater consciousness of both social/personal difference and connectedness. Scholars following this methodological direction are also concerned with the question of "meaning." However, in this case, the meaning of the work of art is not read from the object itself but rather constructed from its social and cultural function.

The discipline of *art history* itself benefits from a balance of *art-* and *history*-oriented methods. The scholarly study of the history of Christianity and the visual arts benefits from the further development of both art-as-visual-theology and art-as-religious-culture methods. While individual scholars may be inclined in one direction or the other, it is unusual for a scholar of Christianity and the visual arts to pursue their work exclusively along either the vertical or horizontal axis. The field of scholarship needs to pursue both visual theology and religious culture.[34]

As the field of scholarly study of Christianity and the visual arts has grown, it has become necessary for scholars to initiate forums not only to further promote this direction of scholarship but to do so in an intentionally self-critical manner. In May 2010 a gathering of scholars convened in Paris, France for a symposium entitled "History, Continuity, and Rupture: A Symposium on Christianity and Art."[35] At this symposium, participants came to the consensus that the field of art history lacked scholarly forums in which issues of the history of Christianity in the visual arts could be openly, charitably, and critically addressed. This symposium became the inaugural event of the Association of Scholars of Christianity in the History of Art.

ASCHA is dedicated to the facilitation and promotion of scholarship that examines the complex and contradictory history of Christianity and the visual arts, as it is diversely manifested in all historical periods

Triumph of Religion at the Boston Public Library (Princeton: Princeton University Press, 1999); David Morgan and Sally M. Promey, *The Visual Culture of American Religions* (Berkeley: University of California Press, 2001); Kristin Schwain, *Signs of Grace: Religion and American Art in the Gilded Age* (Ithaca: Cornell University Press, 2008); and Gene Edward Veith, *Painters of Faith* (Washington, DC: Regnery, 2001).

34. In the interest of self-disclosure, it should be noted that the co-editors of this book favor differing methodological orientations. Romaine favors an emphasis on the content of the art object. Stratford favors an emphasis on theory and historical context. While every essay in this book addresses some part of the work of art's content and context, readers can judge for themselves where each contributor's essay fits along the vertical and horizontal axis.

35. This symposium was sponsored in part by Asbury University and its Lilly *Transformations* Project.

and world cultures. Second, at the conclusion of the Paris symposium, it was proposed that selected papers be gathered and published in order to continue the dialog. In February 2011, ASCHA held a symposium in New York at the Museum of Biblical Art. In 2012, ASCHA held symposia in Los Angeles at the Cathedral of Angels and in Philadelphia at the Philadelphia Museum of Art and the Pennsylvania Academy of the Fine Arts. Selected papers from ASCHA's Paris, New York, and Philadelphia symposia are here joined by essays specifically written for this book.

ReVisioning: Critical Methods of Seeing Christianity in the History of Art, as well as the mission of the Association of Scholars of Christianity in the History of Art, aims to develop and apply methods of art history that are academically rigorous as well as responsive to the art's Christian content. What is intended is an expanded discourse on works of art that employ religious, specifically Christian, themes, iconography, subjects, and forms through the development of a diversity of methodologies that are fitting to and effective in critiquing and interpreting this art.

Emerging out of the mission and activities of the Association of Scholars of Christianity in the History of Art, *ReVisioning* offers essays that examine specific works of art from the history of Christianity and the visual arts. *ReVisioning* opens with two introductory essays by the book's co-editors that establish a theoretical foundation and historical context for the issues of methodology that the remaining essays address more specifically.

The development of art historical methods addressing the history of Christianity and the visual arts is best examined with reference to specific works of art from particular historical contexts. The fifteen historical essays that form this book's main corpus have been chosen, organized, and edited to provide a chronological overview of selective examples from the history of Christianity and the visual arts with the aim of identifying specific works of art that offered interesting methodological problems. In each essay, the author has introduced a topic, reviewed the relevant critical literature, suggested methodological issues manifested by this literature's engagement of the topic, and offered a new potential reading. These historical essays have been divided into three groups, corresponding to major periods of the history of Christianity and the visual arts: Early Christian to Medieval; Renaissance and Baroque; and nineteenth, twentieth, and twenty-first centuries.

In *Likeness and Presence: A History of the Image Before the Era of Art*, Hans Belting notes that prior to the Renaissance, visual imagery in the service of the Christian faith, collective liturgy, and private devotion

was not regarded as "art." Since many methods of art history have been conceived to address European (i.e., Renaissance) conceptions of "art," images, objects, and architectural achievements from before the Renaissance, as well as those from non-European cultures, pose particular scholarly challenges. Of concern is the fact that works of art may fail to maintain their original character as sites of religious revelation and devotion, or may fail to retain an echo of that mode of being, if sufficient methodological sensitivity is not present. *ReVisioning* addresses these issues with five essays that apply a range of methodologies, including iconographic, theological, contextual, semiotic, and historicizing methods, to a diversity of religious visual imagery.

As Christianity began to develop a particular visual language, artists borrowed forms, themes, motifs, and symbols from both Judaism and the Classical pre-Christian world around them. This process of visual evolution and transformation has led to issues of iconographic controversy in which the interpretation of figures and symbols depends on context and repetition. In "Iconographic Structure: Recognizing the Resurrected Jesus on the Vatican Jonah Sarcophagus," Linda Møskeland Fuchs critically investigates the issues latent in the iconographic identification and interpretation of a central group of figures in one of the most celebrated Christian sarcophagi of the third century. Fuchs combines a careful reading of the figures' poses and arrangement in the context of the overall composition of the sarcophagus design, comparable examples from other early Christian funerary art, biblical text, and contemporary theological writings to construct a compelling proposition that the Vatican Jonah sarcophagus features what may be the earliest known depiction of the resurrected Jesus. Her essay demonstrates how scholarship in the history of Christianity and the visual arts should begin with a study of the art objects themselves and attempt to situate those works within their artistic, cultural, and theological contexts.

In the history of Christianity and the visual arts, works have been, and continue to be, at once visual and religious experiences. In fact, the capacity of works of art to be both aesthetic and theological objects is one of the principal reasons that these works of art persist in their effect on the viewer. "Icon as Theology: The Byzantine *Virgin of Predestination*," by Matthew Milliner, employs one of the most celebrated works of Byzantine art in the United States, the so-called Princeton Madonna, as a case study in how a visual image performs theologically. After briefly surveying a history of methodological issues evident in Byzantine studies, his essay

critically examines the problems for the art historian in simultaneously critiquing the icon as an art object and appreciating it as theological credo.

Rachel Hostetter Smith's "Marginalia or Eschatological Iconography?: Providence and Plenitude in the Imagery of Abundance at Orvieto Cathedral" examines the use of flora and fauna imagery as symbols of prosperity. Initially employed in Roman art, these symbols were converted to Christian use as signs of God's providence. This essay specifically explores the connections between imagery, considered to be marginal and merely decorative, in the art and architecture of Orvieto Cathedral and the celebration of the Feast of the Palombella and Pentecost.

As the relationship between the visual arts and the Christian church evolved in Europe, images were frequently employed as texts for the illiterate. This understanding of imagery is evidenced in Medieval images of the Arma Christi, with their isolated objects floating within undefined image fields, disembodied grimacing heads, and strangely decontextualized forms. While such images may appear strange to the twenty-first-century viewer, to the medieval worshiper they were recognized as signs of Christ's passion and the salvation that his death offered. In "Iconography of Sign: A Semiotic Reading of the Arma Christi," Heather Madar examines a c. 1460 German print of the Mass of St. Gregory. This essay probes the relationship between seeing and believing, dating back to Pope Gregory's vision in the eighth century, that fundamentally shaped the character of Christian art. Employing semiotic theory, this essay suggests that the Arma Christi functioned primarily as signs and that it is precisely their nature as signs that explains the visual characteristics and the fundamental interpretative flexibility of these images.

The interpretative elasticity of Christian symbols allowed by the fluid play of signs within the Arma Christi is further demonstrated in its adaptation in new cultural contexts, such as sixteenth-century Mexico. In "Hybridizing Iconography: *The Miraculous Mass of St. Gregory* Featherwork from the Colegio de San José de los Naturales in Mexico City," Elena FitzPatrick Sifford examines a featherwork mosaic of the *Miraculous Mass of St. Gregory* created by an indigenous artist for Pope Paul III. This grafting of an artistic practice of featherworking that predated the arrival of Europeans with a composition drawn from a fifteenth-century German engraving presents particular methodological issues for scholars. This essay looks at the meanings pertinent to the indigenous population in the wake of the European conquest and subsequent Christianization of the Americas.

European art of the **Renaissance and Baroque periods is considered** by many scholars to be the zenith of the history of Christianity and the visual arts. Despite voluminous scholarship in these areas, many unaddressed issues regarding the interchange between art and Christianity persist. *ReVisioning* includes five essays that discuss work from the Early Renaissance in Italy, the Northern Renaissance, the High Renaissance in Italy, the Reformation in Germany, and the Counter-Reformation in Spain in order to examine how shifting conceptions of art and changing theological contexts affected the relationship between Christianity and the visual arts.

The issue of transmission of religious meaning and experience from artist to viewer contributed, in fifteenth-century Italy, to the development of artistic strategies of visually representing three-dimensional space in two-dimensional images. In "Reading Hermeneutic Space: Pictorial and Spiritual Transformation in the Brancacci Chapel," Chloë Reddaway examines the development of pictorial space as theological experience. She argues that the use of pictorial space by Masolino da Panicale (c. 1383– c. 1447), Masaccio (1401–1428), and Filippino Lippi (c. 1457–1504), in which the viewer is absorbed into and compositionally completes the sacred scenes, establishes a transformative relationship between the realm of divine activity evidenced in the image and the liturgical space of the chapel. This essay develops a method of critical-devotional reading, which takes seriously the nature of religious art as sacramental, revelatory, and inspirational, within a critical assessment of work's historical and contemporary contexts.

The capability of various methodologies to critically examine works of visual art as devotional devices is further explored in Matthew Sweet Vanderpoel's "Reading Theological Place: Joachim Patinir's *Saint Jerome in the Desert* as Devotional Pilgrimage." Treating *Saint Jerome in the Desert* (c. 1520) by Joachim Patinir (c. 1480–1524) as a devotional text, this essay investigates the mystical theology underpinning Patinir's visual language of pilgrimage and landscape. Patinir's iconography suggests that rather than discarding religious symbolism, the artist turned to a mystical theology of Christian Neoplatonism. The pilgrimage of life was depicted in numerous texts and images that indicated that the life of the Christian should be considered as a form of meditative, religious pilgrimage. Through a consideration of this medieval tradition, both in systematic texts such as Hugh of St. Victor's *Didascalicon* and specific devotional works of Low Countries and Rhineland mysticism, *Saint Jerome in the Desert* can be seen

as in harmony with a variety of lay piety movements that were spreading concomitantly with Patinir's activity.

In "Reading Theological Context: A Marian Interpretation of Michelangelo's Roman *Pietà*," Elizabeth Lev explores one of the most famous works in the history of art by situating it in the context of Michelangelo Buonarroti's (1475–1564) youth in distinctively Marian Florence. Michelangelo's 1500 *Pietà* adapts a motif popular in Northern Europe, where emphasis was often placed on the tortured body of the dead Christ, by refocusing the viewer/worshiper's attention toward the serene beauty of Mary, as a perfect image of both the Christian and the Roman Church.

A devotional work of an entirely different type is found in Lucas Cranach the Elder's *Passional Christi und Antichristi*. A Lutheran antipapist pamphlet of 1521, this work combines prayer and propaganda in the development of a Protestant aesthetic. In her essay, "Reading Visual Rhetoric: Strategies of Piety and Propaganda in Lucas Cranach the Elder's *Passional Christi und Antichristi*," Bobbi Dykema employs a method informed by iconography, semiotics, and hermeneutics to argue that the *Passional* employs such strategies as binary opposition, sequencing, spatial treatment, and a complex interplay of text and image to persuade the reader-viewer of the rightness of the Lutheran cause, both affirmatively in the sense of the true religion of Christ and negatively in the sense of the pamphlet's antipapal message.

Like many essays in *ReVisioning*, "Reading Devotion: Counter-Reformation Iconography and Meaning in Gregorio Fernandez's *Cristo yacente* of El Pardo," by Ilenia Colón Mendoza, examines how the history of Christianity and the visual arts is both connected across centuries of tradition and also continually reinterpreting that tradition. In seventeenth-century Spain, the medieval influenced *Cristo yacente*, or supine Christ, became increasingly popular as devotional aids and vehicles for spiritual contemplation. The Valladolidian sculptor Gregorio Fernández was among the most accomplished sculptors of this type. Within Counter-Reformation Spain, these highly realistic polychrome wooden sculptures played a key role in the liturgical ceremony as they were understood not only as metaphors for the Eucharist but also as embodiments of the promise of resurrection.

Although the secularizing intellectual, social, and political movements of late-eighteenth and early-nineteenth-century Europe and the United States did not signify an end to the history of Christianity and the visual arts, artists did increasingly look outside of the institution of the

church for patronage and inspiration. Artists continued to address Christian themes and motifs from personal motivations and with individual interpretations that were sometimes beyond the boundaries of traditional Christian doctrines. Works of art with distinctly Christian subjects and themes created within a secular context offer particular methodological challenges and opportunities. *ReVisioning* includes six essays addressing distinct contexts and issues from the nineteenth century to the present.

In "Historicism and Scenes of 'The Passion' in Nineteenth-Century French Romantic Painting," Joyce Carol Polistena examines the cultural and religious context in mid-nineteenth-century France, which fostered a pronounced revival of Christianity. Examining *The Pietà* (1844) by Eugène Delacroix (1798–1863) and *Christ in Gethsemane* (1855) by Paul Delaroche (1797–1856), this essay explores ways in which aspects of Christ's humanity and divinity were represented in a historical context of contention between faith and agnosticism.

Throughout its history, the visual culture of the United States has reflected that nation's dual occupation with religion and commerce. Kristin Schwain's "Consuming Christ: Henry Ossawa Tanner's Biblical Paintings and Nineteenth-Century American Commerce" examines the exhibition of works by Tanner, including *Behold! The Bridegroom Cometh* (1908) and *Christ and His Mother Studying the Scriptures (Christ Learning to Read)* (1910), in the Furniture Gallery at John Wanamaker's Philadelphia department store. This showing of large overtly religious paintings alongside mass-produced commodities poses challenges to scholarly methods in that the intermingling of fine art, commercial culture, Christian belief, and modern life, which was characteristic of many aspects of nineteenth-century American culture, does not fit the urge, by both religious conservatives and secular progressives, for defining and separating categories of "spiritual" and "materialist."

Engaging modernist art, as artists increasingly turned from the narratives and beliefs of the church to personal interpretations of the spiritual, scholars have, at times, needed to develop biographical, yet critical, methods of examining the artist's own, sometimes private, motivations. "Figuring Redemption: Christianity and Modernity in Max Beckmann's *Resurrections*," by Amy K. Hamlin, examines the process of creation and reception of two depictions of the resurrection by one of the most celebrated German artists of the twentieth century. These two works, the first completed in 1909 and the second begun in 1916 but left unfinished at the artist's death in 1950, demonstrate Beckmann's obsessive struggle to

produce works that were at once religious and modernist. Rather than regarding Beckmann's efforts as a failure, this essay considers these history paintings of religious subjects not only as an attempt to escape from the chaos and pain of modern reality, such as war and fascism, but also as visualization of creative redemption.

The methodological challenges of addressing religious art within a modernist context become accentuated when the artist himself, such as in the case of Francis Bacon, openly professes his atheism. In "Embodiment as Sacrament: Francis Bacon's Postwar Horror," Rina Arya examines how Bacon articulated his doubts in visual terms employing distinctly Christian subjects, such as the crucifixion and the Pope. In a post-Christian context of the "death of God," Bacon reinforced the sacramental in a meeting between the sacred and the profane, where the body mediates as a threshold between life and death. By reinterpreting conventional motifs in a contemporary idiom, Bacon reinvigorated the fundamental urgency of Christian iconography.

Paul Pfeiffer is a contemporary artist who operates, in part, within the conceptual space of contemporary sacred art opened up by Francis Bacon. Pfeiffer's art, in digitally manipulated photography and video, aligns diverse secular subjects, such as professional athletes and game show contestants, with explicitly religious themes. Focusing on one particular work, "Media, Mimesis, and Sacrifice: Paul Pfeiffer's Contemporary Christological Lens," by Isabelle Loring Wallace traces the artist's development of the sacrificial figure in contemporary culture. Rather than choosing between a secular or religiously informed reading, this essay attempts to bring these concerns together in an effort to answer the ultimate question begged by Pfeiffer's work: "What is the relevance of Judeo-Christian thematics to contemporary art and life?"

As part of the *Art for Faith's Sake* series, *ReVisioning* affirms and critically examines the rich and complicated relationship of the church and the visual arts. This history testifies to the fact that "the creation of resources for the church at worship" is a far more complex task than might be initially supposed.[36] As Marcia Hall notes in her book *The Sacred Image in the Age of Art*, "The sacred image is a genre that serves two masters, art and the Church."[37] While Hall carefully examines the tensions between the artist's creative impulse and the demands of religious purpose, *ReVi-*

36. Art for Faith's Sake series statement.

37. Marcia B. Hall, *The Sacred Image in the Age of Art: Titian, Tintoretto, Barocci, El Greco, Caravaggio* (New Haven: Yale University Press, 2011) 1.

sioning demonstrates that this relationship between art and faith, mani-
fested in works that are equally spectacular and subtle in their marriage of
profound theological content and exquisite visual form, demands careful
scholarly examination from varying methodological perspectives. Essays
in *ReVisioning* describe the enterprise of artists, many of them unnamed,
overcoming theological and historical obstacles that might have prevented
the establishment and initial cultivation of the dynamic and diverse tradi-
tion that is the history of Christianity and the visual arts. These essays
observe how the history of Christianity and the visual arts developed,
from its formative steps in the third and fourth centuries to an opulent
flowering in the fourteenth and fifteenth centuries. The development of
iconography, such as the *Virgin of Predestination* and the Arma Christi,
evidence how artists succeeding in visualizing theology.

Having made a place for themselves within the church, though not
without certain periods of controversy and iconoclasm, visual artists
served, at least historically, "a higher purpose" in the context of liturgy
and meditation.[38] Artists discussed in the second section of *ReVisioning*,
including such eminent and diverse figures as Masaccio, Patinir, Michel-
angelo, Cranach, and Fernandez, demonstrate that the history of art can-
not be accurately written without an acknowledgement of Christianity
and liturgical theology, nor can the history of "the church at worship" be
written without addressing the visual arts.[39] And yet, for several centu-
ries, the church has largely neglected the visual arts. In fact, if the history
of secularization, reviewed earlier, is regarded by some as advancement,
there may be a corresponding retreat, on the part of the church, from the
arena of the visual arts. The third section of *ReVisioning* recounts how
the history of Christianity and the visual arts is now a tradition largely
sustained by artists, such as Beckmann and Pfeiffer, who are not Chris-
tians. Their art, like that of Tanner, who was a Christian, not only exists
outside of the church but also, in the case of Bacon's art, even outside the
realm of faith. If artists, working within the tradition of Christianity and
the visual arts, have been creating "for faith's sake" for nearly two millen-
nia, the most recent chapters of this history present difficult challenges
and contradictions.

The shared premise of *ReVisioning* and the *Art for Faith's Sake* se-
ries is that there is no such thing as theologically-neutral art. Nor is there
theologically-neutral scholarship of art. While the history of Christianity

38. Art for Faith's Sake series statement.
39. Ibid.

and the visual arts remains vigorous, there is still more work to be done by scholars in the fields of art history and theology to bring this history to light.

The essays collected in *ReVisioning: Critical Methods of Seeing Christianity in the History of Art* demonstrate the rich breadth and diversity of visual materializations of Christian beliefs, practices, debates, narratives, themes, motifs, and symbols in art. Individually, these essays represent a series of specific propositions in revising the methodological assumptions brought to a particular work of art. In many cases, this means attempting to recover an experience of the work of art as it was meant to be experienced. However, in looking back to history, these essays also address the present and the future. Collectively, these essays represent a call to the field of art history to set aside previously held secularist prejudices and engage in a more open, generous, liberal, and critical scholarly dialog.

As positive models, the essays in this book suggest how the critical and scholarly study of the history of Christianity and the visual arts benefits from a careful consideration of the methodologies with which scholarly work is conducted. These essays represent a diversity of potential responses to the complex problem of addressing art with distinctly Christian themes and motifs in academically rigorous methods. They do not represent a conclusive list of possible approaches. The readers may find each of these methods to be more or less successful. Nevertheless, these essays represent both a challenge to the field of art history and a foundation for further work exploring the scholarly discourse concerning the history of Christianity and the visual arts.

Recent scholarship in the field of art history points to growing interest in the complex and sometimes contradictory history of Christianity and the visual arts. In *Reluctant Partners: Art and Religion in Dialogue*, Ena Giurescu Heller, former executive director of the Museum of Biblical Art, traces some of this development. What is evident from Heller's text is that, since the latter decades of the twentieth century, serious art historical work has begun to rediscover ways in which works of art function as sites of sacred encounter. Recognizing and cultivating conversations about Christian content, art historians are exercising a variety of interpretive frameworks assuring that religious imagery will not be overlooked. Referencing an apparent conversation concerning the title of her 2004 book, Heller notes "[Doug] Adams, who is one of the pioneers of the field, is so encouraged by recent developments as to suggest that the partnership between art and religion has advanced from a 'reluctant' to an 'expectant'

stage."[40] We believe that many of these expectations of a development of methods of art history that critically, intentionally, and strategically engage the history of Christianity and the visual arts are, in part, already being realized.

40. Ena Giurescu Heller, "Introduction: Interpreting the Partnership of Art and Religion," in *Reluctant Partners: Art and Religion in Dialogue* (New York: Museum of Biblical Art, 2006) 11.

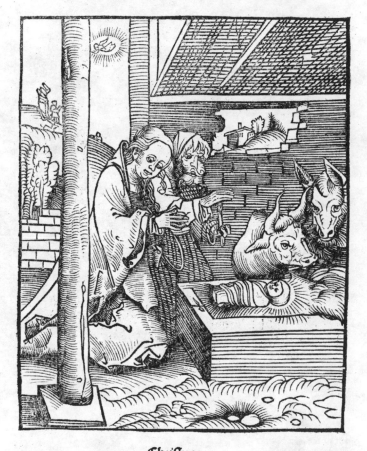

Christus

Die füchß haben yre gruben / vnd die fogell der lufft yre nester/
Aber d̄ son des menschen hat nicht do er seyn heubt legte. Lu.9.
Dießer ab er woll reich war / dennoch vmb vnsert willen ist er
arm worden/ vnd seyn armut hat vns reich gemacht. z. Cor. 8.

Figure 2. Lucas Cranach the Elder, *Nativity of Christ*, 1521, woodcut, 3.73 x 4.63
in. (9.5 x 11.8 cm), in Lucas Cranach the Elder, Passional Christi und Antichristi,
Wittenberg: Johannes Grau. Permission of Pitts Theology Library, Emory University.

Methodological Issues from the Fields of Art History, Visual Culture, and Theology

LINDA STRATFORD

Scholarly methodologies themselves rise from ideological presuppositions. In the field of art history, for example, competing ideological notions of aesthetic autonomy versus aesthetic contingency have given rise, respectively, to disciplinary oscillation between object-oriented and contextual methodologies; these in turn have engendered various art historical "schools" (e.g., the historical, or contextual schools [Ernst Gombrich, Meyer Schapiro] versus ahistorical, formalist schools [Heinrich Wölfflin, Henri Focillon, Erwin Panofsky])[1] over the course of the twentieth century. This process continues today. Not surprisingly, within the particular range of approaches by which scholars have addressed the history of Christianity in the history of art, one finds a varied collection of theoretical and epistemological presuppositions prompting various schools of method. These various methods have arisen from a range of philosophical and theological perspectives. What follows is a summary of these schools and approaches with suggestions for wider application by which to address the subject of Christianity in the history of art.[2]

Methodological interest in the internal development of styles and movements found vibrant practice in the field of art history following the influence of Heinrich Wölfflin in the early twentieth century.[3] Wölfflin

1. Donald Preziosi, *The Art of Art History: A Critical Anthology* (New York: Oxford University Press, 1998).

2. This summary is meant not to be comprehensive, but representative of the various methodologies employed by English-speaking writers exploring the intersection of art and Christian faith in the last several decades.

3. Heinrich Wölfflin, *Principles of Art History: the Problem of the Development of*

27

systematized art historical analysis with his pictorially driven scheme analyzing works along a Renaissance-Baroque continuum. This served as a powerful impetus for formalism as an art historical method over ensuing decades. Later, Erwin Panofsky, for whom questions of form and style proved inadequate, challenged this methodology. Panofsky developed the practice of iconography, investigating meaning as it was communicated in works of art through signs and symbols.[4] Iconographical analysis employed a vocabulary of cultural signs by which the art historian discussed a work's subject matter in addition to, or beyond, its *formal* properties.

While some may contend that formalist methods are basically indifferent to the history of Christianity and art, at least within the realm of representational work (i.e., an open or closed composition is the same if it is a landscape or the crucifixion), iconographic methods admit issues of religion as significant. One art historian applying an iconographic methodology to the history of Christianity in art is Jane Dillenberger, author of numerous books on art and faith including; *The Religious Art of Andy Warhol* (Continuum, 1998); and *Image and Spirit in Sacred and Secular Art* (Crossroad, 1990).[5] Dillenberger has practiced what she terms "spiritual detective work" in discerning religious meaning. This "detective work" is responsible for today's understanding that Andy Warhol was a deeply religious man despite the fact that his religious life was so very secret. Dillenberger found his works "when studied searchingly, yield up their burden of meaning and disclose their religious content" via conventional and modern iconography.[6] This iconography suggested the continuing influence of the Byzantine Catholic tradition of his youth. Dillenberger explores, for example, a series of prints and paintings using egg motifs (the egg having a long history of symbolic associations with immortality); a cross series; and a series based on religious master paintings in which

Style in Later Art, trans. Marie Donald Mackie Hottinger from the 7th German ed. (London: Bell and Sons, 1932; 1st German ed., 1915). Wölfflin composed an analytical scheme by which compositional features (linear versus painterly; planar versus recessed space; closed versus open form; multiplicity versus unity; and absolute clarity versus relative clarity) deemed works Classical or Baroque in character.

4. Erwin Panofsky, "Iconography and Iconology," in *Meaning in the Visual Arts: Papers in and on Art History* (Garden City, NY: Doubleday, 1955) 26–55.

5. See *Style and Content in Christian Art,* 2nd ed. (1986; repr., Eugene, OR: Wipf and Stock, 2005); Another example of the perpetuity of the iconographic method is found in the work of Leo Steinberg. See Leo Steinberg, *The Sexuality of Christ in Renaissance Art and in Modern Oblivion* (Chicago: University of Chicago Press, 1996).

6. Jane Daggett Dillenberger, *The Religious Art of Andy Warhol* (New York: Continuum, 1998) 11.

Warhol playfully employed spiritually meaningful puns. In *The Last Supper (Wise Potato Chips)* of 1986 a huge Wise potato chip logo offers a striking play upon the notion of sacred wisdom. In *The Last Supper (Dove)*, Dove soap and General Electric logos suggest divinity and purity.

> The wit and humor of juxtaposing the sacred and the secular engage and startle the viewer. What was Warhol up to here? . . . Dove in word and image is familiar from Dove soap packages, and GE from packaged light bulbs: electricity and soap, thus power and cleanliness. Some will remember the old adage "Cleanliness is next to Godliness." [7]

Dillenberger's work has also employed a formalist methodology to some degree, allowing her to venture religious meaning within style. In the case of Andy Warhol, Dillenberger suggested that the flattened and stylized golden forms of Byzantine Catholic iconography, so present in Warhol's youth, continued to function as aesthetic intermediaries between the secular and the sacred in the chosen forms of his adult artistic career. Silkscreened images, with their depiction of material items in compressed space, she suggested, functioned in a manner reminiscent of stylistically compressed Byzantine icons.[8]

Both formal and iconographic analysis, however, have been under criticism for some time. John Walford's study of Jacob van Ruisdael serves as one example.[9] Prior to Walford, writing on Ruisdael had concentrated primarily on the contribution of the painter to the seventeenth-century Dutch landscape tradition, one associated with low horizons, high clouded skies, and broad expanses offering an interplay of the two. By contrast, Walford preferred to explore landscape from the perspective of religious devotion, asking the viewer to take note of the sacred content of Ruisdael's panoramas and the ideological thrust of vegetative forms and skies. Walford was a student of Hans Rookmaaker who was known for being a forthright Christian and for employing Christian critique in his writings on art. For Rookmaaker, there was no theologically neutral content in art. All content, whether dressed in "religious" subject matter or not, was measured in terms of its biblical truthfulness.[10] Walford furthered

7. Ibid., 92.

8. Ibid., passim. See also James Romaine, "The Transfiguration of the Soup Can: Andy Warhol's Byzantine Orthodox Aesthetic," in *Beauty and the Beautiful in Eastern Christian Culture*, ed. John McGuckin (New York: Theotokos, 2013) 232–42.

9. John Walford, *Jacob Van Ruisdael and the Perception of Landscape* (New Haven: Yale University Press, 1992).

10. Graham Birtwirstle, "H.R. Rookmaaker: The Shaping of His Thought," in *The*

Rookmaaker's Reformed Protestant paradigm of art history, challenging formalist and iconographic methods with art historical analysis mining religious content from pictorial motifs. Ruisdael's landscapes, Walford contends, served as divine revelation, something his practice sought to reveal.[11]

In addition to religious content, interest in the *context* from which form and iconographic phenomena arise has expanded art historical methodologies over the course of the twentieth century and into the present. Venerated art historian Meyer Schapiro pioneered the emphasis on extra-pictorial context, with particular interest in the surrounding social world. His methodology was informed by a moderated Marxism, one rejecting base-superstructure determinism while yet recognizing the impact of material and ideological conditions upon formal features. Up until this time, scholars working from a Marxist perspective had largely ignored style; however, Schapiro's methodology, based on ideological presuppositions shared with Frankfurt School theorists[12] allowed Marxist-inspired inspection that would reveal not only the hidden interests of the dominant class, but also the *mediating* function of art, stressing the analogous tasks of art and social revolution.

Schapiro was influenced by the theories of Theodor Adorno who himself was interested in "the cognitive character of an art that expresses social antinomies in its own rigorous formal language."[13] As mentioned

Complete Works of Hans Rookmaaker, ed. Marleen Hengelaar-Rookmaker (Carlisle: Piquant, 2002) 1:xix.

11. James Romaine, "You Will See Greater Things Than These: John Walford's Content-oriented Method of Art History," in *Art as Spiritual Perception: Essays in Honor of E. John Walford*, ed. James Romaine (Wheaton, IL: Crossway, 2012) 23–38. In his introductory essay in this festschrift for John Walford, Romaine explores possible parallels between Walford's methodology and the creative process that he ascribed to Ruisdael. If this is true, it is an example of how a scholar's methodological assumptions shape the history that they write. As another example of similar method, see Jules Lubbock, *Storytelling in Christian Art from Giotto to Donatello* (New Haven: Yale University Press, 2006). Art historian Jules Lubbock has interpreted well-known works of Early Renaissance art as works primarily designed to help viewers reflect upon the ethical and religious significance of biblical stories. He argues that Early Renaissance artists developed their highly innovative techniques to further these religious objectives; innovative and oft-celebrated Renaissance techniques were not ends in themselves.

12. The Institute for Social Research, founded at the University of Frankfurt in 1923: Theodor Adorno, Max Horkheimer, Herbert Marcuse, and Walter Benjamin. See Andrew Arato and Eike Gebhardt, eds., *The Essential Frankfurt School Reader* (New York: Continuum, 1982).

13. Eike Gebhardt, "Introductory Note," in ibid., 204.

above, style had up to that point been ill-treated in the Marxian tradition, seen as the derivative effect of a dominant economic base. However, Schapiro, like Adorno, sought within style, clues to a society's impulses for change. Where acrobats, shopkeepers, wild beasts, and foliage swirled around highly ornamental Romanesque columns, Schapiro proposed shaping factors startlingly social in origin. He interpreted the sudden, distinct display of fantasy creatures and forms in Romanesque sculpture as expressive of an "underground," urban, secular spirit emerging in Western European civilization.[14] Donald Kuspit recognized Schapiro's interest in the significance of the zigzag style seen in dialectically tense figures of Romanesque sculpture; such discoordinate structure, Kuspit claimed, evidenced not only social tension and contemporary conflicts with theological heresy, but also "tension between a self-proclaimed universal institution [the Christian church] and . . . an individual struggling to articulate his own existence and possibilities in the face of this institution."[15]

Schapiro countered an overly spiritualized view of Romanesque art with analysis that included the socio-historical context from which form and iconographic phenomena arose. What Schapiro and others to follow recognized was that writing through a formalist or iconographic lens alone carried with it risks that a widened methodology disallowed. What was at risk was the failure to recognize the full import of a piece.[16] Writing on "The Conditions of Artistic Creation" in an essay of that title in 1974, T. J. Clark called for "a critical history, uncovering assumptions and

14. In his 1939 essay "From Mozarabic to Romanesque in Silos," his interest was in "the *critical correlation of the forms and meanings* in the images with *historical conditions* of the same period and region." The result of this particular study was to show "how new conditions in the Church and the secular world led to new conceptions of the traditional themes or suggested entirely new subjects" (Meyer Schapiro, "From Mozarabic to Romanesque in Silos," in *Romanesque Art: Selected Papers* [New York: Braziller, 1977] 28–101, esp. 29). John Williams later refuted Schapiro's approach. See John Williams, "Meyer Schapiro in Silos: Pursuing an Iconography of Style," *The Art Bulletin* 85 (2003) 442–68.

15. "In medieval times the institution was the Church; in modern times . . . it is Capitalism" (Donald B. Kuspit, "Meyer Schapiro's Marxism," *Arts Magazine* 53 [1978] 142–44, esp. 144).

16. For an example of this methodology, see T. J. Clark, *The Absolute Bourgeois: Artists and Politics in France 1848–1851* (Greenwich, CT: New York Graphic Society, 1999), which explores the failure of revolutionary art in mid-nineteenth century France. The generation of 1848 did not promote and support revolutionary artists because forces of order prevailed via state institutions of art.

allegiances." Clark asked "[W]hy should art history's problems matter? On what grounds could I ask anyone else to take them seriously?"[17]

Indeed, resurgent empiricism in the latter half of the twentieth century moved the discipline of art history from primary interest in the internal development of styles and movements, to interest in the social history those styles and movements represented. Art historian Debora Silverman offers one such example. In her well-known study of art nouveau, she explored what she claimed to be the "counter-socialist impulse" of the movement. Art nouveau bridged handcraft to aristocratic culture, she claimed, avoiding perceptions of a "democratizing" art of the sort championed by William Morris in England.[18] More recently, in her study *Van Gogh and Gauguin: The Search for Sacred Art*, Silverman has claimed that *religious* concerns "can be treated with the nuance and historical complexity that scholars have shown in reconstructing the class ambivalences, shifting markers of social perception, and gendered assumptions of avant-garde painters and their visual forms." She has proposed new readings of some of van Gogh and Gauguin's major paintings in light of theologically specific assumptions "broadening the historical field to include religion as part of a social analysis of modernist art."[19] Silverman closely inspects for example, van Gogh's *The Sower* (1888), which presents a peasant laborer in the act of tossing seeds. In light of van Gogh's strain of Dutch Protestantism, she suggests a reading of the painting that takes into account the painter's "labor theology" and the anti-supernaturalism of his particular Christian tradition.[20] She explores what she suggests is a correlated emphasis on maximum materialization of the painting surface, manipulation of craft optical tools, and other "labor forms of paint." This arises, Silverman claims, from emphasis on the primacy of *enacted* faith, in imitation of Christ, and faith-based appreciation of the sanctity of lowly labor.[21]

On the other hand, Silverman suggests that Gauguin's Catholic formation led him to explore contrasting themes—themes of ascent and visionary subjectivity. In *The Vision After the Sermon: Jacob Wrestling*

17. T. J. Clark, "The Conditions of Artistic Creation," in *Art History and Its Methods: A Critical Anthology*, ed. Eric Fernie (London: Phaidon, 1995) 249.

18. Debora Silverman, *Art Nouveau in Fin-de-Siécle France: Politics, Psychology, and Style,* Studies on the History of Society and Culture (Berkeley: University of California Press, 1989).

19. Debora Silverman, *Van Gogh and Gauguin: The Search for Sacred Art* (New York: Farrar, Straus and Giroux, 2000) 13.

20. Ibid., 6.

21. Ibid., 7–8.

with the Angel (1888), Gauguin developed practices to dematerialize the narrative, in an approach opposite that of van Gogh. "Heads bowed, eyes closed, and hands locked together, they projected the contours of their inner vision onto a dream landscape . . . an unmistakably 'non-natural' color field of 'pure vermilion.'"[22] Gauguin emerges in the study as a penitent sensualist who turned to painting to address the irresolvable questions of the Catholic catechism. The ways each of the two painters approached theologically specific assumptions, problems, and preoccupations explains "the differences between them even as they tried to work together on similar subjects in similar sites."[23]

While art historians such as Debora Silverman have turned to sociologically and theologically inflected questions to expand art historical methodology, theologians as well have broadened their interests, seeking to address visual art with greater rigor. Gordon Graham in *The Re-enchantment of the World: Art versus Religion* (2007; 2010)[24] cited what he called a "significant void" in the treatment of art and religion, a void he said demanded further attention. Graham and others have joined the task of furthering understanding of the ways in which Christian consciousness is embodied in works of art past and present—a consciousness that Graham and others claim has been insufficiently mined to-date.[25]

22. Ibid., 49.

23. Ibid., 4.

24. Gordon Graham, *The Re-enchantment of the World: Art versus Religion* (New York: Oxford University Press, 2007).

25. One of the early pioneers of this tasking of bridging art and theology was John Dillenberger. This theologian's influential texts on art and faith include *Images and Relics: Theological Perceptions and Visual Images in Sixteenth-Century Europe*, Oxford Studies in Historical Theology (New York: Oxford University Press, 1999), a study that provides distinct religious contexts for the works of Matthias Grunewald, Albrecht Durer, Lucas Cranach the Elder, Michelangelo, Hans Holbein the Younger, Hans Baldung Grien, and Albrecht Altdorfer. Other important works by Dillenberger include *The Visual Arts and Christianity in America: From the Colonial Period to the Present* (New York: Crossroad, 1989; Eugene, OR: Wipf and Stock, 2004); *A Theology of Artistic Sensibilities: The Visual Arts and the Church* (London: SCM, 1986; Eugene, OR: Wipf and Stock, 2004); and with Jane Dillenberger, *Perceptions of the Spirit in Twentieth Century Art* (Indianapolis: Indianapolis Museum of Art, 1977). Other pioneers include John W. Dixon Jr. (see *Images of Truth: Religion and the Art of Seeing* [Atlanta: Scholars, 1996]; *The Christ of Michelangelo: An Essay on Carnal Spirituality* [Atlanta: Scholars, 1994]; and *Art and the Theological Imagination* [New York: Seabury, 1978]; and Doug Adams (with Diane Apostolos-Cappadona, Adams edited *Art as Religious Studies* [New York: Crossroad, 1987], a collection of essays revealing Judeo-Christian meanings in works of art past and present). Diane Apostolos-Cappadona would go on to publish voluminously in the field, producing numerous studies on the intersection

Catholic theologian Richard Viladesau, author of *Theological Aesthetics: God in Imagination, Beauty and Art* (1999) has provided a helpful overview from the field of theological aesthetics (the practice of theology in relation to sensible knowledge—sensation, imagination, feeling, and the arts). He begins his survey with Mary Gerhart's contention that "a sea change is needed in the field of religious studies, one that must take place in the nexus of the field of theology, the field of art, literature and religion, and the field of science and religion."[26] Viladesau observes this interdisciplinary engagement has indeed begun. "Within religious studies, there has been increasing scholarly engagement with religion as ideology and as spirituality, with a correlative interest in the aesthetic and communicative dimensions of religious practice and thought."[27] Viladesau gives particular examples from within the English-speaking world of those who in the past several decades served in the vanguard of such practice.[28]

The field of theological aesthetics, as described by Viladesau, is guided by the following central concerns: the impact of nonverbal expression (as apart from scriptural revelation); the conditions whereby art acts as a site of divine revelation; the nature of representation; the revelatory power of representation; and the notion of transcendence. These central concerns suggest methodologies promising for those taking up the history of

of art and Christian faith.

26. Viladesau cites Gerhart's article "Dialogical Fields in Religious Studies," *Journal of the American Academy of Religion* 62, no. 4 (1994) 997–1011, in his preface to Richard Viladesau, *Theological Aesthetics. God in Imagination, Beauty and Art* (New York: Oxford, 1999).

27. Ibid. Viladesau, Associate Professor of Theology at Fordham University, is also author of *The Beauty of the Cross: The Passion of Christ in Theology and the Arts from the Catacombs to the Eve of the Renaissance* (New York: Oxford, 2008); and *Theology and the Arts: Encountering God through Music, Art and Rhetoric* (Mahwah, NJ: Paulist, 2000).

28. Viladesau, *Theological Aesthetics*, preface. Viladesau cites pioneers of the field of theological aesthetics: Nicholas Wolterstorff, *Art in Action: Toward a Christian Aesthetic* (Grand Rapids: Eerdmans, 1980); Hans Urs von Balthasar, *Seeing the Form*, vol. 1 of *The Glory of the Lord: A Theological Aesthetics,* trans. Erasmo Leiva-Merikakis, ed. Joseph Fessio and John Riches (San Francisco: Ignatius, 1983); Garrett Green, *Imagining God: Theology and the Religious Imagination* (Grand Rapids: Eerdmans, 1989); Frank Burch Brown, *Religious Aesthetics: A Theological Study of Making and Meaning* (Princeton: Princeton University Press, 1989); Jeremy Begbie, *Voicing Creation's Praise: Towards a Theology of the Arts* (Edinburgh: T. & T. Clark, 1991); Richard Harries, *Art and the Beauty of God* (London: Mowbray, 1993); J. Daniel Brown, *Masks of Mystery: Explorations in Christian Faith and the Arts* (Lanham, MD: University Press of America, 1997); and John J. Navone, *Toward a Theology of Beauty* (Collegeville, MN: Liturgical, 1996).

Christianity in the visual arts. These issues are indeed primary in the work of theologian David Brown, for example, whose five volumes contributing to the field of theological aesthetics were the subject of a 2010 conference at the Institute for Theology, Imagination and the Arts (ITIA), St. Mary's College, St. Andrews University.[29]

That being said, it has largely been within the field of art history that methodologies addressing theological issues have arisen, while maintaining focus on actual works of art. One such example is Shelley Perlove and Larry Silver's *Rembrandt's Faith: Church and Temple in the Dutch Golden Age* (2009).[30] In this study, Perlove and Silver shift traditional emphasis from Rembrandt's skill as a Baroque painter, to his *theological* insight. They argue that Rembrandt was keenly aware of, and interested in, religious issues of his day. He was a serious student of the Bible, exploring connections between Hebrew scripture and the New Testament. He drew upon these connections in planning his works. This, the authors contend,

29. September 2010 Institute for Theology, Imagination and the Arts (ITIA) Conference, "Theology, Aesthetics and Culture: Conversations with the work of David Brown," St. Mary's College, St. Andrews University, 4–6 September 2010. See David Brown, *Tradition and Imagination: Revelation and Change* (New York: Oxford University Press, 1999); *Discipleship and Imagination: Christian Tradition and Truth* (New York: Oxford University Press, 2000); *God and Enchantment of Place: Reclaiming Human Experience* (New York: Oxford University Press, 2004); *God and Grace of Body: Sacrament in Ordinary* (New York: Oxford University Press, 2007); and *God and Mystery in Words: Experience through Metaphor and Drama* (New York: Oxford University Press, 2008).

Other scholarship that points to renewed discourse between visual art and Christianity on the part of theologians includes that of John DeGruchy, author of *Christianity, Art and Transformation: Theological Aesthetics in the Struggle for Justice* (New York: Cambridge University Press, 2008 [2001]); John Drury, author of *Painting the Word: Christian Pictures and Their Meanings* (New Haven: Yale University Press, 1999); William Dyrness, author of numerous studies including *Reformed Theology and Visual Culture: The Protestant Imagination from Calvin to Edwards* (New York: Cambridge University Press, 2004); and *Visual Faith: Art, Theology, and Worship in Dialogue* (Grand Rapids: Baker Academic, 2001); Andrew Greeley; and Robin Jensen, Professor of the History of Christian Worship and Art at Vanderbilt University Divinity School (see Robin M. Jensen and Kimberly J. Vrudny, *Visual Theology: Forming and Transforming the Community through the Arts* [Collegeville, MN: Liturgical, 2009]; and Robin Jensen, *Face to Face: Portraits of the Divine in Early Christianity* [Minneapolis: Fortress, 2004], which examines portrayals of divinity in early Christian art, raising broader questions about the relationship between art and theology against the backdrop of Roman portraiture. Jensen's works include *The Substance of Things Seen: Art, Faith, and Christian Community* (Grand Rapids: Eerdmans, 2004); and *Understanding Early Christian Art* (New York: Routledge, 2000).

30. Shelley Perlove and Larry Silver, *Rembrandt's Faith: Church and Temple in the Dutch Golden Age* (University Park: Pennsylvania State University Press, 2009).

explains his predilection for especially "Pauline" subjects such as The Stoning of Saint Stephen, a subject unconventional for Netherlandish art; and the many images of the Samaritan Woman whose conversion "became one of Rembrandt's favorite themes—indeed a virtual obsession—during his critical period of the mid 1650's," one that highlighted the perspective of the Jews in Jesus' day.[31] The authors contend that Rembrandt's images were inspired by formulations derived from cross-referencing the Old and New Testaments, study that stimulated fresh imagery by which to display Christian principles based on Jewish tenets.

Another who has brought theology to bear upon art historical conversation, while yet maintaining focus on actual works of art, is critic Eleanor Heartney. Heartney's *Postmodern Heretics* suggests a Catholic sensibility at work in much contemporary art. Debora Silverman claimed Gauguin was agitated throughout his life by problems associated with being a "lapsed Catholic."[32] Heartney similarly claims that a "Catholic imagination" haunts many artists today, compelling them to explore the sensate body. This arises out of a particular Catholic mindset of "fleshliness" "which celebrates the body and emphasizes the physical and sexual aspects of human experience."[33] While explorations of the body (one thinks of the work of Andres Serrano, Chris Ofili, Robert Mapplethorpe, Karen Finley, and David Wojnarowicz) often evoke the ire of religious fundamentalists, Heartney claims that the work of these "postmodern heretics" as she calls them "provides striking evidence that it is time to move beyond the long standing but erroneous belief that avant-gardism is by definition antithetical to religious sensibility."[34]

Contemporary accounts such as Heartney's benefit from the methodological shift that has expanded the range of perspectives available to historians exploring the history of Christianity in the visual arts. As a result, writers such as Heartney are able to bring attention to religious content where it might otherwise have been missed. In the process, historians have also come to appreciate the *limits* of historical interpretation, which itself has spawned new appreciation of religious content. Essentially, many historians have come to realize (with input from sociology and anthropology) that cultural fields themselves reside within fields of discourse

31. Ibid., 41.

32. Silverman, *Van Gogh and Gauguin*, 5.

33. Eleanor Heartney, *Postmodern Heretics: The Catholic Imagination in Contemporary Art* (New York: Midmarch Arts, 2004) 22.

34. Ibid., 23.

and power.[35] Seeing works of art as visual "sign-systems" allowed Eleanor Heartney to recognize in artists she calls "postmodern heretics," markers of Catholic sensibility. The point recognized by many, is that aesthetic experience, like language, is an inter-subjective practice subject to continuing inflection.

This "linguistic turn" in methodology has inspired the phenomenological approach employed by a number of art historians today, an approach that concentrates on the inter-subjective process of subject/object relationship, making the experience of the spectator, rather than that of the creator, the point of departure for art historical writing. Furthermore, this recognition of the limits of historical interpretation has spawned not only a diversity of historical practice but has also expanded an appreciation of the correlative roots of religious belief and aesthetic experience.

Art historian Ronald R. Bernier is one who has worked from awareness of epistemological limits as the starting point for an art historical methodology. As Bernier explains, the inadequacy of language—something apothatic theology and postmodern deconstructors have in common[36]—brings with it the consolation that something transcends our ordinary and finite phenomenal being.[37] An art historical methodology based on the "unrepresentable" promises important perspectives for today's art historians. As Bernier explains of his use of the "sublime" as an analytical starting point, contemporary notions of negation in continental philosophy correspond strikingly with the Christian tradition of the *via negativa* by which the divine is appreciated as ineffable, abstract experience.[38] He has evoked this notion to address religious content in video artist Bill Viola's series *The Passions*. The series is composed of more than two hundred video pieces chronicling various human emotions; each is made from 35-mm film shot at high speed and then drastically slowed down. In the process, layers of human emotion and expression that would otherwise be imperceptible, appear to the spectator. Bernier suggests that Viola's interest in representing what is normally "unrepresentable" to our perceptual faculties corresponds to apophatic descriptions of God by

35. Sociologist Pierre Bourdieu, for example, has explored ways in which aesthetic "disposition" is created by surrounding elites. See Pierre Bourdieu, *Distinction: a Social Critique of the Judgment of Taste* (Cambridge, MA: Harvard University Press, 1984).

36. Ronald R. Bernier, *Beyond Belief: Theoaesthetics or Just Old-Time Religion?* (Eugene, OR: Wipf and Stock, 2010) 64.

37. Ibid., 7.

38. Ibid., 65.

which God is seen in "traces" but is essentially ineffable, understood only in abstract terms.

One thinks of Robert Rosenblum's earlier account of Romanticism in which Rosenblum described the northern Romantic tradition "as if the mysteries of religion had left the rituals of church and synagogue and had been relocated in the natural world."[39] Moody Romantic landscapes, contemplative individuals pitted against the vastness of nature, and sublime skies seemed to fulfill the transcendental expectations of religion. Rosenblum explained that the religious sensibility of the northern Romantic tradition continued well into the twentieth century as abstract artists such Mondrian and Kandinsky sought meditatively to penetrate beneath the material surfaces of things.

Indeed, in addressing the spiritual potential of abstract art, Donald Kuspit has cited the numinous effect generated by the negativity of silent abstraction of the sort found in the work of Agnes Martin, Robert Irwin and James Turrell.[40] Claiming that when art is reduced to ordinary communication it loses its spiritual power, Kuspit goes on to explain that the "spiritual integrity of abstract art depends on a certain degree of 'silence.'" Kuspit reminds us that Ad Reinhardt connected his own painting with "a long tradition of negative theology in which the essence of religion . . . is protected . . . from being pinned down or vulgarized."[41]

On the other hand, practitioners of visual culture, a field emerging in the mid-1990s, have explored the intersection of art and religion in a significantly different manner.[42] These practitioners both challenge and cross the historical boundaries of what has been considered visually and spiritually meaningful. "Art," with its hierarchical connotations, is replaced with "visual culture" or "material culture," allowing for a wider,

39. Robert Rosenblum, *Modern Painting and the Northern Romantic Tradition: Friedrich to Rothko* (New York: Harper & Row, 1975) 14.

40. Donald Kuspit, "Concerning the Spiritual in Contemporary Art," in *The Spiritual in Art: Abstract Painting 1890–1985,* ed. Maurice Tuchman et al., 313–25 (New York: Abbeville, 1986) 317.

41. Ibid., 319. Theologian David Brown, mentioned earlier as the subject of a 2010 ITIA Conference, also incorporates the theological sublime in his interest in the ways religious experience is mediated through the arts. Finding aesthetic experience a means of addressing what he calls the inadequacy of present theology, he calls theologians to employ and appreciate the role of aesthetic metaphors to express divine truths that are not apprehensible through scripture alone.

42. See Whitney Davis, *A General Theory of Visual Culture* (Princeton: Princeton University Press, 2011).

more participatory frame by which to discuss objects of visual encounter. Sally M. Promey has explained, "art history itself, especially in the process of canon formation, can be seen as an inherently 'iconoclastic' discipline, granting standing, and thus visibility, to some visual practices and denying it to others." [43] A visual or material culture methodology admits into discussion a wider range of spaces and objects that indeed facilitate, or give record of, religious conviction.

Along with Promey, David Morgan has explored the ways in which religion happens "materially" and how the act of looking, widely understood, contributes to religious formation. Morgan's study *The Art of Warner Sallman* (1940) countered the mistaken assumption that Protestantism lacks significant visual practice. Popular reception of Warner Sallman's *Head of Christ* for example, provided an iconographically distinctive image deployed widely in Protestant communities. In addition to wide distribution of his ubiquitous portrait of Christ, Sallman's publishers provided images for bookmarks, calendars, prayer cards, tracts, Bibles, lamps, clocks, plates, buttons, stickers, stationery, and illustrated Sunday School materials.[44] As Morgan explains, Sallman's imagery achieved a normative stature; his image of Christ informed at least two generations of mid- to late-twentieth-century Christians in North America and abroad.[45] Instead of dismissing these images as "bad art" Morgan sees this imagery and its wide dissemination as a "crucial part of a cultural system that has shaped religious piety and social identity among millions of American Protestants."[46]

Those working from the perspective of visual culture offer a challenge to historians of differing methodologies who by implication must make the case for the epistemological underpinnings of what is traditionally

43. Sally M. Promey, "The 'Return' of Religion in the Scholarship of American Art," *Art Bulletin* 85 (2003) 581–603.

44. David Morgan, *Icons of American Protestantism: The Art of Warner Sallman*, (New Haven, CT: Yale University Press, 1996) 19.

45. Promey and Morgan served as co-directors of a multi-year interdisciplinary collaborative project, "The Visual Culture of American Religions," funded by the Henry Luce Foundation and the Lilly Endowment. Their culminating text, *The Visual Culture of American Religions* (Berkeley: University of California Press, 2001) is a collection of essays exploring the lived religion of ordinary people through messages conveyed by means as broad-ranging as murals, billboards, postcards, and television portrayals. This study furthered the notion that visual culture does not merely reflect belief but is instrumental in *constituting* it.

46. Morgan, *Icons of American Protestantism*, 2.

deemed "art." The field of "visual culture" begs the question. If art historians continue to operate under the assumption that the work of art is indeed a special object set apart from the rest of material culture, a demonstration of such is in order.

Scholarship on Christianity in the history of art stands in need of its own methodological reflection. This reflection will require 1) consideration on the part of art historians and theologians of imagery that does not appear to "fit" within the bounds of traditional religious discourse, necessitating a widened awareness of what makes for sacred Christian content,[47] 2) a reconsideration of what is considered "fit" for professional discourse on art on the part of art historians and critics, along with the willingness to cross certain ideological boundaries (i.e., Christianity and postmodern thought) and 3) theological insight afforded by interdisciplinary borrowings. It may also be important to ask how adequate religious understanding may be inserted without falling into religious "dominion."

It is the hope of this study that methodological dialogue on the subject of Christianity in the history of art will not only benefit an understanding of that history, but suggest wider applications within the fields of history and criticism than may appear at first glance. What may be most challenging is an understanding of the trajectory of art history as less a history of autonomy from religion (as if the two were in competition), than a dialectical history of both continuity and rupture. In the modern process of stating *why it can't be* (in regard to religion) we have failed to recognize *where it in fact is*. At points, sometimes where it is least expected, and as recent scholarship has demonstrated, the dynamic of religious engagement will be readmitted in the historical narrative where modern scholarly habit may have effaced its existence. At other points, rejection of Christian faith as it has been lived out in the West will be more fully read, having acknowledged the continued presence of holy sensibilities. Rather than treat sacred and secular distinctions in binary opposition, they may be admitted as inseparable components, each nurtured by the very structures they seek to suppress.

The *Art for Faith's Sake* series of which this study is a part, was initiated by Cascade Books to bring attention to aesthetic material of interest

47. Margaret Miles notes that most of our accounts of Christian history are based on verbal texts, which tend to be written for privileged in society. Frequently these have been monastic authors—male, and highly educated. This leaves out the contributions of those whose cultural contributions are not verbal . . . and the latter are arguably the larger part of the human race. See Viladesau, *Theological Aesthetics*, 16.

to faith communities. The series is meant to expand reflection on liturgical art and to provide resources for its interpretation. Particular to the project of *ReVisioning* is the work of scholarly reflection on methodologies useful when writing about works of art with Christian content. Much like *liturgy* (the Greek roots of which refer to "work" or "service"), the task of addressing works bearing religious themes constitutes a sobering charge. Challenges include developing an eye for theological relevance; moving into consideration of "affective space" without sacrificing scholarly rigor; and maintaining religious perspective without overly inflating that perspective. It is the hope of co-editors James Romaine and myself that this volume will contribute to the task of re-visioning that will be required by scholars responsibly taking up this charge.

PART I

Methodological Issues of Iconography in Early Christian and Medieval Art

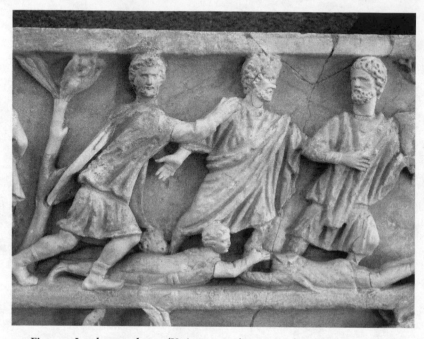

Figure 3. Jonah sarcophagus (Vatican 31448), upper right central scene, third quarter of the 3rd century, marble, 27 $^3/_{16}$ x 87 $^{13}/_{16}$ x 7 $^7/_{16}$ in. (69 x 223 x 19 cm). Museo Pio Cristiano of the Vatican Museums, Vatican City. Photo by Linda Fuchs, courtesy of the Vatican Museums.

Iconographic Structure

Recognizing the Resurrected Jesus
on the Vatican Jonah Sarcophagus[1]

LINDA MØSKELAND FUCHS

Salvation was suggested by André Grabar as the most prominent theme of early Christian art in his 1961 A. W. Mellon Lectures in the Fine Arts.[2] While Grabar was the first to introduce this proposition to an American audience, his method of framing early Christian art in association with salvation had been previously discussed in the early twentieth-century work of Joseph Wilpert and Henri Leclercq, and in even earlier observations by Edmond Le Blant.[3] As support for this interpretation of early

1. This essay is developed from two conference papers: "A Textual Variant in Early Christian Art: The 'Jonah Sarcophagus' and Origen on Peter's Journey to Emmaus [Luke 24:34]," *Byzantine Studies Conference, Abstracts of Papers* 32 (University of Missouri, St. Louis, 2006) 93 (http://www.bsana.net/conference/archives/2006/abstracts_2006.pdf); and "Resurrection as a Paradigm for Interpreting Third-Century Christian Art," North American Patristic Society Conference, May 22–24, 2008, Chicago, IL.

2. These lectures, presented at the National Gallery of Art, Washington D.C., were published in André Grabar, *Christian Iconography: A Study of its Origins*, Bollingen Series 35, no.10 (Princeton: Princeton University Press, 1968) 10–11.

3. Joseph Wilpert, *Roma sotterranea: Le pitture delle catacombe romane* (Rome: Desclée, Lefebvre, 1903) 32–41, 89–94, 290–96; Edmond Le Blant, *Les sarcophages chrétiens de la Gaule* (Paris: Imprimerie Nationale, 1886); Fernand Cabrol and Henri Leclercq, *Dictionnaire d'archéologie chrétienne et de liturgie* (Paris: Letouzey et Ané, 1907–1953) 1:53—in this dictionary (*DACL*) see especially, Henri Leclercq, "Défunts (Commémoraison des)," in vol. 4, pt. 1, cols. 435–40; Henri Leclercq, "Le Blant," in vol. 8, pt. 2, cols. 2186–87; Henri Leclercq, "Sépulture: *Ordo Commendationis Animae*," in vol. 15, pt. 1, cols. 1266–72; and Henri Leclercq, "Coupe: IX. Coupe de Podgoritza," in vol. 3, pt. 2, cols. 3008–11, fig. 3336.

Christian imagery, Le Blant, and those scholars who followed him, cited a ninth-century liturgical prayer, a *commendatio animae,* which prayed for the dead, "God, deliver him as you delivered Noah from the flood, . . . Daniel from the den of lions, . . . three youths from the burning fiery furnace . . ."[4] However, this foundation for salvation as a theme is weak because it rests on a prayer in use six centuries later.[5]

In his own study, Grabar separated image-signs of early Christian catacombs and sarcophagi into two types: those related to sacraments of the church (baptism and communion) and those suggesting divine intervention for the salvation or preservation of individual believers. This

4. *"Libera, Domine, animam ejus, sicut liberasti Noe de diluvio . . ."* It seems to be this prayer that Marilyn Stokstad cites in *Medieval Art.* In her words, "The Catacomb of Priscilla is a veritable painting gallery filled with images of salvation . . . The artist could have been inspired by Jewish and Christian prayers, which enumerated examples of God's intervention on behalf of His people. 'Deliver, O Lord, the soul of thy servant as thou didst deliver Noah in the flood . . . Isaac from the sacrificing hand of his father . . . Daniel from the lion's den . . . the three children from the fiery furnace . . .'" (Marilyn Stokstad, *Medieval Art,* 2nd ed. [Boulder, CO: Westview, 2004] 17). The lack of specific attribution is likely due to the survey format of her textbook.

Vincenzo Fiocchi Nicolai, Fabrizio Bisconti, and Danilo Mazzoleni have provided a brief historical overview of developments in early Christian iconography with bibliography up to 1958. They cite Wilpert as an early proponent of "soteriologic and sacramental" themes and Stommel as one of the earliest to propose "hope in immortality and the resurrection." (Stommel, however, was addressing Constantinian sepulchral sculpture, not art of the third century). Confusion arises when terms like *soteriologic* (signifying "concerning salvation" in a theological context) are substituted for the broader term *salvation,* as in the summary statement by Fiocchi Nicolai, Bisconti, and Mazzoleni (or its translation) above (Vincenzo Fiocchi Nicolai, Fabrizio Bisconti, and Danilo Mazzoleni, *The Christian Catacombs of Rome: History, Decoration, Inscriptions,* 2nd ed. [Regensburg: Schnell & Steiner, 2002] 103). See Eduard Stommel, *Beiträge zur Ikonographie der konstantinischen Sarkophagplasti* (Bonn: Hanstein, 1954).

5. Also, only one-third of the characters mentioned by this prayer for the dead are depicted in third-century Christian art. As Leclercq admitted, the reverse is possible, that sarcophagus images led to the prayer: "On pouvait donc être tenté d'admettre que ces formules avaient été inspirées par la vue des sujets figurés sur les sarcophages, qu'elles en étaient le produit, et non le point de départ" (Henri Leclercq, *DACL,* s.v., "Sépulture: *Ordo Commendationis Animae,"* vol. 15, 1, cols. 1266–72). Le Blant's study of funerary inscriptions in Gaul revealed some similarities between epitaph language and much later funerary prayers. He also perceived similarities to the language of funerary prayers on a fifth-century glass bowl from Podgoritza, Herzegovina, but the identifications of characters on the bowl is not consistently identical to the language of the prayers, and could as easily be attributed to common ways of referring to Bible characters (Cf. "Daniel in the lion's den"). Indeed, the bowl is a questionable source, suspect on many levels due to its inaccuracies, such as naming the companion of Eve as Abram, not Adam. While the prayer may reflect the accumulated content of some earlier prayers, prayers with similar content are not known from the third century.

theory that *salvation*, as rescue from physical peril, was the predominant theme of early Christian art remains a formative paradigm through which its iconography is often interpreted.

More recently, scholars have expanded the terms and themes applied to early Christian art. John Beckwith ascribed resurrection and salvation to catacomb painting, adding "life after death," which, while closely tied to resurrection, could include more generic visual motifs like pastoral scenes or a meal scene.[6] Ernst Kitzinger inclined toward a general theme of "deliverance and security through divine intervention."[7] Thomas Mathews has suggested that "magic provides the first coherent theme of Christian art."[8] He based this primarily on equating miracles of Christ with magic, but less than a tenth of scenes created before Constantine portray miracles of Jesus. Robin Jensen named both the general theme of deliverance or salvation as well as the more specific theme of resurrection.[9] She noted that, while initially scholars had stressed religious literary sources over images, other scholars, such as Kitzinger, later sought to disengage images from the literature of religion as much as possible. Jensen rightly suggests that the time has come to incorporate more textual scholarship into the advances made in examining the visual images on their own terms.

Although salvation is a theme that has often been ascribed to third-century Christian funerary art, reading this art in terms of a theme of *resurrection* may be more useful in identifying and describing early Christian iconography. In Christian theology, salvation refers primarily to the saving of souls from the penalty of sin. However, in the literature on early Christian art, salvation is more often applied to rescue from physical danger, eluding death, or divine intervention in a general sense. To make this case, examples such as Noah saved from the flood and Daniel saved from lions have been cited.

6. John Beckwith, *Early Christian and Byzantine Art*, 2nd ed., Pelican History of Art (New York: Penguin, 1979) 21.

7. Ernst Kitzinger, *Byzantine Art in the Making: Main Lines of Stylistic Development in Mediterranean Art, 3rd–7th Century* (Cambridge, MA: Harvard University Press, 1980) 20.

8. Thomas F. Mathews, *The Clash of Gods: A Reinterpretation of Early Christian Art* (Princeton: Princeton University Press, 1993) 66.

9. For a collated survey of subjects depicted in Christian art before Constantine, see Graydon Snyder, *Ante Pacem: Archaeological Evidence of Church Life before Constantine*, rev. ed. (Macon GA: Mercer University Press, 2003) 87; and Robin M. Jensen, *Understanding Early Christian Art* (New York: Routledge, 2000) 67–68, 92.

Most third-century Christian art—catacomb painting and sarcophagus relief sculpture—was created for burial purposes. Salvation as rescue from physical peril would not directly address the situation of individuals who have finished their earthly lives. Subjects with resurrection themes would be better suited to this context. For Christians, *resurrection* represented an outright conquering of death. The Apostle Paul wrote in a letter to Christians in Corinth, "O death, where is your victory?"[10] For Christians, the resurrection was a distinctive premise of their faith. In Paul's previously quoted letter he also wrote, "If there is no resurrection of the dead, then Christ has not been raised; and if Christ has not been raised, then our proclamation has been in vain and your faith has been in vain."[11] As we will see, third-century Christians developed funerary iconography that expressed their hope of resurrection.

For Christian art created before Constantine declared Christianity to be a legal religion of the Roman Empire, the most complete motif census has been prepared by Graydon Snyder.[12] More items could perhaps be added, but his census, the single most complete and representative sampling,[13] will serve the purposes of this investigation. As this essay will show, when distinctively Christian art begins to flourish in the third century, most of the biblical motifs selected appear to be linked to biblical texts connected with resurrection, a theme suited to Christian burial art.

The figure that appears most frequently in early Christian art is the prophet Jonah. Among known surviving Christian images that precede Constantine's rule, three episodes of the Jonah story—Jonah resting under the gourd vine, Jonah cast into the sea, and Jonah spewn from the mouth of the sea creature—are the first, second, and third most frequently depicted motifs. Taken together, these three Jonah motifs outnumber all other non-Jonah motifs combined, accounting for about 60 percent of the total images in Snyder's motif census.[14]

As a representation of resurrection in early Christian art, the Jonah motif(s) had both biblical and Roman cultural bases. Matthew 12:38–42, 16:4, and Luke 11:29–32 are the key gospel passages in which Jesus referred to his own time-limited burial ("three days in the heart of the

10. 1 Cor 15:55 (NRSV). Paul was borrowing from Hos 13:14.
11. 1 Cor 15:16–17 (NRSV).
12. Snyder, *Ante Pacem*, 87.
13. Jensen, *Understanding Early Christian Art*, 68–69, 195n6.
14. Computed from Snyder, *Ante Pacem*, 87.

earth") as the "sign of Jonah."[15] Accordingly, Christians understood the iconography of Jonah as a symbol of Jesus' resurrection and an expression of their own hope. Linked with the burial function of the sarcophagus, Jonah iconography would have been a powerful statement of faith in the resurrection of the dead.

Images of Jonah also reflect a preference in early Christian art for Old Testament subjects. Roman culture valued tradition more than new ways, an outlook reflected in Roman criticism of Christianity as an upstart religion. Christians responded that the holy scriptures of the Jews were also the scriptures of Christians, and that Moses preceded Homer.[16] Jews had received the unusual favor of being able to legally practice their religion in the Roman Empire, and Christians sought the same favor on the basis of using the scriptures employed by Jews. When Christians in Rome sought to signal their faith, they wisely chose primarily Old Testament characters and motifs, a practice reflected in third-century Christian catacomb painting and sarcophagus carving.

The association of the predominant Jonah motif with the resurrection of Jesus in the Gospels prompts an investigation of resurrection themes associated with other early Christian art motifs. In fact, 92.8 percent of the images in Snyder's census may be associated with resurrection.[17] After representations of Jonah (59.7 percent), the next 19.4 percent of images depicting frequently occurring subjects (with their resurrection references) are: Noah in the Ark[18] (4.4 percent), Daniel[19] (3.3 percent), the Baptism of Jesus[20] (3.3 percent), Abraham Sacrificing Isaac[21] (2.8 percent),

15. "Then some of the scribes and Pharisees said to him, 'Teacher, we wish to see a sign from you.' But he answered them, 'An evil and adulterous generation seeks for a sign; but no sign shall be given to it except the sign of the prophet Jonah. For as Jonah was three days and three nights in the belly of the whale, so will the Son of man be three days and three nights in the heart of the earth'" (Matt 12:38–40 [RSV]).

16. The second-century Christian writer Tatian, in his *Address to the Greeks* 31 and 36–40, builds an argument that Moses and the Hebrew prophets preceded well-known Greeks, such as Homer, Orpheus, and Musaeus (see the full text at http://www.ccel.org/ccel/schaff/anf02.iii.ii.xxxix.html, accessed 10/27/2011).

17. Percentages are based on the motif counts in the chart of Snyder, *Ante Pacem*, 87. This is the largest survey to date of Christian motifs preceding the legalization of Christianity in AD 313, and as such is representative of the body of work.

18. 1 Pet 3:18–21.

19. Dan 12:2–3.

20. Rom 6:2–7; Col 2:12.

21. Heb 11:17, 19.

the Raising of Lazarus[22] (2.8 percent), and Moses Striking the Rock[23] (2.8 percent).[24] Less frequently depicted motifs which also can be associated with resurrection constitute another 13.7 percent of the total images in Snyder's census: Adam and Eve, Three Young Men in the Fiery Furnace,[25] Multiplication of the Loaves, Women at the Tomb of Jesus, Meeting of the Resurrected Christ, and Moses before the Burning Bush.[26]

22. John 11:1–44.

23. 1 Cor 10:1–4.

24. Paul's use of 1 Cor 10:4 (perhaps based on an interpretation in the Jewish Targum of Onkelos on Num 21, concerning the miracle of water from the rock in the desert as a rock which accompanies the Israelites) is discussed early in patristic literature. Cf. also Ps 78:35. Irenaeus (writing c. AD 177–200) follows Paul's interpretation that "the Rock was Christ Himself," adding that "Jesus now give(s) to His believing people power to drink spiritual waters, which spring up to *life eternal* (John 4:14)." Irenaeus, *Fragment,* 52 [ANF]. Origen said, "For all bear the surname of rock who are the imitators of Christ, that is, of the spiritual rock which followed those who are being saved, [1 Cor 10:4] that they may drink from it the spiritual draught . . . neither against the rock on which Christ builds the church, nor against the church will the gates of Hades prevail," Origen, *Commentary on Matthew* 12.10–11 (ANF). Resurrection is implied in the statement that the gates of Hades will not prevail against the church. Cf. Tertullian, *On Baptism* 9.3–4.

25. Tertullian, *On the Resurrection of the Flesh* 58 [sec. 6–10, Sources Chrétiennes; hereafter SC]: "that the fires of Babylon injured not either the mitres or the trousers of the three brethren . . . ought to inspire in us the belief that they are proofs and documents of our own future integrity *and perfect resurrection.*" Cf. Irenaeus, *Against Heresies* 5.5.2 [SC 153]; Hippolytus, *Commentary on Daniel* 2.28.

26. Adam & Eve (1 Cor 15:20–22, 44–49; Rom 5:12–21), 2.2 percent; Three Young Men in the Fiery Furnace (Dan 3; Heb 11:35), 2.2 percent; Multiplication of Loaves (Matt 15:32–38; 16:6–12), 1.1 percent; Women at the Tomb of Jesus (Matt 28:1–10; Mark 16:1–8; Luke 24:1–8; John 20:1–13), 0.6 percent; Meeting of the Resurrected Christ (Matt 28:1–10; Luke 24:1–34; 1 Cor 15:3–5), 0.6 percent; and Moses and the Burning Bush (Mark 12:26–27; Luke 20:37–38), 0.6 percent. With respect to Multiplication of Loaves: "Jesus said . . . 'Do you not remember the . . . seven loaves for the four thousand, and how many baskets you gathered? [*seven baskets*]. How could you fail to perceive that I was not speaking about bread? Beware of the yeast of the . . . Sadducees!' Then they understood that he had not told them to beware of the yeast of bread, but of the *teaching of the* Pharisees and *Sadducees*" (Matt 16:8–12 NRSV). "*Sadducees . . . say there is no resurrection . . .* " (Matt 22:23 NASB). By parallelism of placement in the argument, the seven loaves and seven baskets are linked to a caution about the teaching of the Sadducees, who "say there is no resurrection." In the catacombs of Rome, paintings of seven baskets (from feeding the 4000; linked to the Sadducees) outnumber paintings of twelve baskets resulting from feeding 5000, suggesting the message, "Beware of the teaching that there is no resurrection."

If N. Denzey is correct that a painting cycle in the Capella Greca of the Priscilla catacombs commonly identified in the past as representing Susanna would be more appropriately identified as including a *Noli me tangere* scene (Mary Magdalene meeting the resurrected Jesus), then the percentage of resurrection motifs in Snyder's

Having located resurrection associations for more than 92 percent of the motifs named in Snyder's census of Christian art before AD 313, it is possible to build a case study of one of the earliest Christian sarcophagi with multiple Biblical scenes. The Jonah sarcophagus now in the Vatican's Museo Pio Cristiano (Vatican 31448, formerly Lateran 119; Color Plate 2) dates stylistically to the third quarter of the third century.[27] The sarcophagus was discovered in the Roman cemetery below the Basilica of St. Peter during the Renaissance; an engraving of the ten-scene sarcophagus front and a description of its provenance were published posthumously in a book by Bosio in 1632.[28] Identifications of scenes on this sarcophagus

census of Christian art before Constantine could increase by 1–2 percent. On Denzey's interpretation, see footnote 79. N. Denzey, *The Bone Gatherers: The Lost Worlds of Early Christian Women* (Boston: Beacon, 2008) 111.

27. The execution of a repetitious pattern is often a stylistic key to dating. Sea waves on the Jonah sarcophagus are drilled as curved furrows running in parallel waves, irregularly strengthened by small braces crossing some of the furrows. Similar treatment of waves is found in the Port Sarcophagus in the east portico of the octagonal court of the Belvedere in the Museo Pio Clementino in the Vatican, a sarcophagus dated by Giandomenico Spinola to AD 250–260. See Giandomenico Spinola, *Il Museo Pio-Clementino*, vol. 1: *In Settore Orientale del Belvedere, il Cortile Ottagano, e la sala degli animali* [Guide Cataloghi dei Musei Vaticani, no. 3] (Vatican City: Tipografia Vaticana, 1996) PE 4 (Portico est, no. 4), pl 4, 35–37. A similar technique is also found in the wavy lions' manes on some lion hunt sarcophagi from the second quarter of the third century. The lion hunt sarcophagi have been presented together by Bernard Andreae in *The Art of Rome* (New York: Abrams, 1977) and dated AD 230–270. The ones displaying this drilled furrow technique with small bracing bridges are fig. 590, the Mattei II sarcophagus (AD 250) [not yet in parallel waves]; fig. 593, the Giustiniani sarcophagus (AD 253–260) [some parallel waves]; fig. 591, at Reims (AD 260–265) [employs parallel waves]; fig. 594, the Praetextatus sarcophagus (AD 260) [parallel waves]; and fig. 595, the Mattei I sarcophagus (c. AD 270) [thicker, straighter stone between the furrows, with some parallelism]. A highly stylized use of the technique is found on a *lenos* (tub-shaped) sarcophagus fragment now in the Museo Capitolino at Rome, dated c. AD 275, in the mane of a lion attacking an antelope, [color pl. 139]. See Andreae, *The Art of Rome*, 452–453, fig. 590–591; 593–595. The closest parallels to the waves on the Vatican Jonah sarcophagus are dated around AD 260.

28. Antonio Bosio, *Roma sotterranea* (Rome: Grignani, 1632; reprinted by Pontificia Commissione di Archeologia Sacra & Edizioni Quasar, 1998) 103. The sarcophagus was initially placed in a Vatican area cemetery. On the cemetery, see Eva Margareta Steinby, *La Necropoli della via Triumphalis: Il tratto sotto l'Autoparco vaticano, Memorie*, vol. 17 (Rome: Quasar, 2003) 25–27. Constantine later filled the cemetery with earth to create the foundation of a funerary basilica honoring St. Peter (AD 319–329) [Richard Krautheimer, *Rome: Profile of a City, 312–1308*, 2nd ed. (Princeton: Princeton University Press, 2000) 27]. This basilica was replaced by the present St. Peter's Basilica (built AD 1506–1626). After the Vatican Jonah sarcophagus was unearthed during the Renaissance, it was transported to a garden of the Medici family at Monte Pincio and placed along a *viale* to be used as a fountain. Giuseppe Bovini and Hugo Brandenburg, *Repertorium der christlich-antiken Sarkophage*, ed. F. W. Deichmann,

were first published in the eighteenth century by Bottari.[29] To date, most approaches to this sarcophagus have identified and described individual scenes, rather than considering the work as a unified program. While this sarcophagus is arguably the third-century Christian sarcophagus most frequently introduced in surveys of art history, the upper central scene, the heart of the composition, has eluded consensus in identification. This essay examines this upper central scene of six figures (Figure 3) to explore how it may relate both to a theme of resurrection, so prominent in third-century Christian art, and to other scenes on the sarcophagus.

Hurdles to interpreting the Vatican Jonah sarcophagus include difficulties posed by the object itself and limits created by some methodologies applied to it. Much of the scholarship addressing Christian sarcophagi has been devoted to cataloging the considerable corpus—providing images and brief identifications of the scenes, and suggesting chronological placement. As scholarship proceeds, it is now more feasible to draw on methodological tools gained through studies of Roman sarcophagi in order to recognize compositional hierarchies or pairings of elements in the common placements of scenes—tools that will assist in determining cognitive links between parts and the relative priority of elements. A distinctly Christian hermeneutical tool necessary to examine a Christian sarcophagus—a tool infrequently mentioned—is to consider Old Testament writings in light of the New Testament and vice versa, for Christians understood these scriptures as an integrated whole.[30] Another principle to guide the interpretive limits of the iconography will be to consider the function of the object—in this case, the funerary function of a sarcophagus. It

Deutsches Archaologisches Institut (Wiesbaden: Franz Steiner, 1967) 1:30 (no. 35). See Steinby, *Necropoli*, 25–27. See Krautheimer, *Rome*, 27. Bovini and Brandenburg name Bosio as their source. Cf. Bosio, *Roma sotterranea*, chap. 2, 26–27. Bovini and Brandenburg, *Repertorium*, 1:30. Later, the sarcophagus was located at the Palatio dela Valle in Rome, as mentioned by the Codex Barberini at the beginning of the seventeenth century. See Cod. Barberin. XLIX, 32 f. 13: "*Romae in palatio dela Valle ex antique arca seu loculo marmoreo sepulcrali,*" cited by Johannes Ficker, *Die altchristlichen Bildwerke im Christlichen Museum aus Laterans* (Leipzig: Seemann, 1890) 60–64, no. 119. Bottari said that it was filled with earth when it was standing in a garden of the Medici family. Bosio Bottari, et al., *Sculture e pitture sagre estratte dai cimiterj di Roma: Pubblicate gia dagli autori della Roma sotterranea ed ora nuovamente date in luce colle spiegazioni per ordine di n. s. Clemente XII,* (1737–1754), 1:186 re: pl. 42: "*sta in un viale del giardino di Villa Medici ripieno di terra, esposto all'inclemenza dell'aria, e dell'acqua, logoro in qualche parte, e in una costituzione da logorarsi sempre più*" (hereafter, Bottari, *Roma sotterranea*).

29. Bottari, *Roma sotteranea*, 1:192.

30. While typology is sometimes discussed in this context, the interpretive strategy proposed in this essay is broader, and includes other types of cross-referencing of Biblical content.

is also advisable to determine how pertinent concepts drawn from biblical writings were being considered in more nearly contemporary Christian writings of the second and third centuries.

To identify and interpret the iconographic structure of the Vatican Jonah sarcophagus, we should consider compositional strategy options employed in Roman art to organize visual information on reliefs and sarcophagi on the basis of either time or hierarchical importance. Two compositional formats commonly used on third-century sarcophagi are frieze arrangements and central plans. Frieze sarcophagi display a sequential narrative, generally read left to right as in a Western book. Centrally-planned sarcophagi have a prominent central motif (such as a portrait of the deceased, an inscription, or a narrative scene), paired ends of secondary importance, and tertiary filler designs between the center and ends.[31] Identification of the iconographic program of the Vatican Jonah sarcophagus is complicated by the fact that this work's structure is a composite of these two formats, with the possible faint suggestion of a shape from a third type of Roman sarcophagus—the garland sarcophagus, echoes of which may be used to organize the three Jonah scenes. In addition, both upper and lower registers appear—a combination not unknown, but uncommon, on traditional Roman sarcophagi—in order to include more scenes and content.

The outer ends of the front face of the Vatican Jonah sarcophagus are divided into upper and lower levels. Moving inward, a sequence of three Jonah scenes wraps from the top edge of the sarcophagus, down to the lower edge and around the two upper central scenes, loosely forming a wide U-, crescent-, or garland-shaped frame ending near the top edge. From left to right, these three Jonah scenes are: Jonah cast into the sea and swallowed by a serpentine sea creature; Jonah spewn onto land; and Jonah resting under the gourd vine. The perception of the Jonah scenes as a downward plunge and upward resurgence is most apparent in the descending angle of the crossbeam of the ship's sail and the mirrored ascending inclination of Jonah resting beneath the gourd vine.[32] Because these

31. The most common centrally-planned type is the relatively economical strigil sarcophagus. Strigil sarcophagi fill in the spaces between center and ends with repetitive tall S-curves and reverse S-curves shaped like a strigil—a cleansing tool used to scrape oil from the body.

32. The narrative expressed as a visual composition physically echoes the development of a literary conflict and its resolution, sometimes now diagrammed as an arrow descending from upper left to lower right followed by a second arrow rising from its lower left to its upper right. This pattern of a diagonal descending from the upper left toward the lower center and a second diagonal rising from the lower center toward the upper right seems to appear in some Roman battle sarcophagi, such as the Portonaccio

Jonah scenes cover nearly 60 percent of the front of this sarcophagus, an interpretation of this sarcophagus' iconographic program—including the upper central figure group which has been so challenging to identify— should give weight to the context, the Jonah theme, as it was interpreted by third-century readers of the New Testament.

In the water above the second Jonah scene (Jonah spewn from the sea creature), is Noah in a chest-shaped ark with approaching dove. It may be that this scene does not serve primarily as an emblem of salvation in the sense of rescue from a flood. Instead, if one uses the Christian herme- neutical principle of interpreting the Old Testament in light of the New Testament, a search of the New Testament for Noah (narrowed by atten- tion to funerary themes pertinent to a sarcophagus) reveals a resurrection theme in 1 Peter 3:18–21: it states that in Noah's ark eight persons were saved through water, corresponding to baptism, "which now saves you through the resurrection of Jesus Christ." As metaphor-based teaching su- percedes the story narrative in this case, Noah may be read as a suggestion of resurrection.

In the outer frame surrounding the heart of the sarcophagus' icono- graphic program, at the far left and right sides of the lower level, are scenes of fishermen. At left, a man hands a basket to a youth. At right, an angler fishes with a pole, perhaps alluding to Christ's commissioning of Peter and others: "Follow me, and I will make you fish for people."[33] Fisher- men appear infrequently in Roman catacomb paintings. In this context they may signify Christian identity more than funerary themes. On this sarcophagus, the fishermen's settings merge visually with the water into which Jonah is cast and may be linked conceptually to the figure of Peter to be discussed later.

The upper level outer end scenes include, at the left, Jesus raising Lazarus from the dead and, at right, an unusual scene of a shepherd near two sheep emerging from the columned entrance of a rich ashlar masonry building—not a common shepherd's hut. This shepherd scene may evoke Psalm 49, recited by Jews when sitting sheva for the dead. After calling to

sarcophagus. (See B. Andreae, *The Art of Rome*, 433, fig. 504). An early Christian re- flecting on Paul's resurrection exposition (1 Cor 15), and Paul's quotation there from Hos 13:14, "Where, O death, is your victory? Where, O death, is your sting?" (1 Cor 15:55, NRSV), might recall a battle sarcophagus conflict when viewing the diagonal thrusts of the Jonah scenes on the Vatican 31448 sarcophagus.

33. Matt 4:18–20; Mark 1:14–20 (NRSV). The "fisherman of Lyon" carries a basket of the same shape and relative size. Sculpture in the Musée de la civilisation gallo- romaine. Photo available in Geneviève Roche-Bernard and Alain Ferdière, *Costumes et Textiles en Gaule Romaine* (Paris: Errance, 1993) 32.

rich and poor, stating that even wise men die, that stupid and senseless people think their houses last forever,[34] and that man is like the beasts that perish,[35] the Greek Septuagint translation of this Psalm says that "Death will shepherd them."[36] The concept that Death shepherds contrasts vividly with the more common Christian notion of the Good Shepherd of Psalm 23 and John 10:11, 14, and suggests that this scene may function in part as a *memento mori*, a reminder that all must die. Finally, it should be noted that the upper left and right corners of the composition are framed by columned architectural structures, visually linking these scenes of Jesus raising Lazarus from death and Death as shepherd, and perhaps contrasting their messages of hope and acceptance. Garrucci noted that, in the Lazarus scene, the pose of Jesus is copied from some of the celebrated models of statues depicting Greek orators. They pull back the *pallium* on the flank with a covered left hand, like the Sophocles of the Lateran, and extend the right with the index finger outstretched in an attitude of command.[37]

If so, attention is being drawn to the *words* of Jesus when he raises Lazarus, notably his declaration,

> I am the resurrection and the life. Those who believe in me, even though they die, will live, and everyone who lives and believes in me will never die.[38]

Before identifying and interpreting the most challenging iconographic elements of the sarcophagus, it is worth noting how seamlessly the Vatican Jonah sarcophagus brings together subjects from the Old and New Testaments, such as Jonah and Lazarus. Early Christians viewed both the Hebrew Bible (Old Testament) and writings now known as the New Testament as inspired revelation from God.[39] As such, they were understood to inform one another. The iconographic structure of the Vatican Jonah sarcophagus encourages the viewer to consider Old Testament characters in light of their significance in the New Testament, rather than primar-

34. Ps 49:10–11.

35. Ps 49:12.

36. Ps 49:14. This translation and others throughout the paper are my own, unless otherwise noted. Ps 49:14 = Ps 48:15 in the Septuagint (LXX): "ὡς πρόβατα ἐν ᾅδῃ ἔθεντο θάνατος ποιμαίνει αὐτούς . . ." (http://www.septuagint.org/LXX/Psalms/48). Gentile Christians in third-century Rome would probably have had access to the Old Testament through the Greek Septuagint translation.

37. Raffaele Garrucci, *Storia della arte cristiana nei primi otto secoli della chiesa*, vol. 5, *Sarcofagi ossia Sculture cimiteriali* (Prato: Giachetti, 1879) 17–18.

38. John 11:25–26 (NRSV).

39. 2 Tim 3:16.

ily through their lengthier treatment in Old Testament narratives. This reflective method, developed from an understanding of unified scriptures, is well-documented in second- and third-century Christian writing and was well-suited to a late antique appreciation of clever layering of meaning.

At the upper center of the Vatican Jonah sarcophagus' composition, two scenes are separated by a tree (Color Plate 3). The central placement of these scenes suggests their primary importance. These two scenes are framed—at left, right, and below—by scenes from the Jonah narrative. The use of two scenes instead of one at the upper center of the Vatican Jonah sarcophagus is unusual. The scene at the viewer's left is Moses striking a rock, which miraculously yields water.[40] The upper right scene takes precedence because part of it occupies the exact center, left-to-right, of this sarcophagus. Optimal interpretive strategy should focus on this unique scene, for it is likely key to interpreting the other scenes and the program as a whole.

The upper right central scene of the Vatican Jonah sarcophagus depicts three walking figures, two prone figures touching the feet of the center figure, and a third head at the feet of that central figure. Identifying this scene has been complicated by a lack of props or signs of place. A tree separates this scene from the scene to its left, suggesting an outdoor setting, but otherwise the background is blank. Remaining clues include the number and gender of figures, their dress and poses.

Identification of the figures must precede interpretation of this scene. The most common previous identifications of this scene have been

40. This scene may represent either an event from Exod 17:1–10 or from Num 20:1–13, but the New Testament thought on the miracle of bringing water from a rock is likely more relevant. In 1 Cor 10:1–4, the rock is Christ, the source of spiritual drink. The scene to the right, paired with the rock scene, is the principal subject of this paper. It includes Christ and Peter, as will be shown—both of whom are suitably paired with a *Miracle from the Rock* scene. The Greek names of the rock (πέτρα; *petra*) and of Peter (Πέτρος; *Petros*), the figure at left in the upper central right scene, form a homonym link between the two scenes.

a *Harassment of Moses*[41] and an *Arrest of Peter*.[42] However, both of these identifications present difficulties. Identifying these figures as a *Harassment of Moses* puts this scene out of left-to-right sequence with its supposed solution scene, *Moses Striking Water from a Rock*.[43] Scenes of an *Arrest of Peter* do not appear before the fourth century and, when they do appear, they do not include prone figures. Paul Styger proposed a modification of the *Arrest of Peter* identification by suggesting that Peter appears between two (standing) public servants (Latin *apparitore*: lictors, scribes, military aids, or priests). Styger rightly observed that the central character displays a speaking gesture and that "it is exaggerated to say that the gestures of the *apporitore* are forceful."[44] Among the less commonly repeated

41. *Harrassment of Moses* was chosen by Dinkler, Gerke, and Snyder, as well as Bovini and Brandenburg. Erich Dinkler wrote, "The scene to the right of the tree is unique and controversial, perhaps representing Moses attacked by the people who 'murmur for water' (Exod. 17:3; Num. 20:2–5) or by the men of Korah (Num. 16:1–2)" (cited in K. Weitzmann, ed., *Age of Spirituality* (Princeton: Princeton University Press, 1979) 405–6 (cat. no. 361). F. Gerke allowed for the harassment of either Moses or Lot, preferring Moses. Lot was named by Erich Becker, "Die Fluchtszene des Jonasarkophages: Nicht Petri Befreiung, sondern Lots Rettung," *Römische Quartalschrift für Altertumskunde und für Kirchengeschichte* 26 (1912) 165–80; esp. 168. See Friedrich Gerke, *Die christlichen Sarkophage der vorkonstantinischen Zeit*, Studien zur spätantiken Kunstgeschichte im Auftrage des Deutschen Archäologischen Instituts, no. 11 (Berlin: Gruyter, 1940) 39.

Snyder repeats a *Harassment of Moses* identification. G. Snyder, *Ante Pacem*, 78. Bovini and Brandenburg also repeat an identification of the scene as Harassment of Moses, without specifying support (*Repertorium*, 1:31, no. 35).

42. Giovanni Battista de Rossi, *Bullettino di archeologia cristiana* (1863) 80; Garrucci, *Storia della arte Cristiana*, 5:1 and 17–18. Manuel Sotomayor, *San Pedro en la iconografía paleocristiana: Testimonios de la tradición cristiana sobre San Pedro en los monumentos iconográficos anteriores al siglo sexto* (Granada: Facultad de Teología, 1962) 63nn106–7, 173–87.

43. Ficker identifies Moses in this scene, but does not specify Harassment. See Johannes Ficker, *Die altchristlichen Bildwerke im Christlichen Museum des Laterans* (Leipzig: Seeman, 1890) 60–64 (no. 119).

44. Of about 59 sarcophagus scenes which Manuel Sotomayor identifies as an "arrest of Peter," all are dated by him to the first half of the fourth century, except for the upper central scene on Vatican 31448 (Lateran 119). In the fourth-century examples, the men standing beside the central figure also wear pillbox-style military hats. Sotomayor, *San Pedro*, 63nn106–7, 173–87. In Sotomayor's list of apocryphal writings on Peter, the example he cites as earliest, the *Acts of Sts. Processus and Martinianus*, has been dated from any time after Constantine to the sixth century. (Some offices named in it do not exist before Constantine.) Sotomayor, *San Pedro*, 25–31. Paul Styger, "Neue Untersuchungen über die altchristlichen Petrusdarstellungen," *Römische Quartalschrift* 27 (1913) 17–74, esp. 59–63, no. 3, "Die Fluchtszene."

Garrucci states that "Peter in tunic and *pallium* walks with rapid steps, led by two bailiffs [*birri*]. They are clad in tunic and short *chlamys*. Two youths in scant tunics cast

identifications of this scene are: the capture of Christ;[45] a plague in the desert;[46] a scene of adoration or worship;[47] Lot being dragged away while people of Sodom hold onto the feet;[48] and the baptism of Cornelius who, as described in Acts 10:25, fell at Peter's feet in worship.[49]

Figure 4. Jonah sarcophagus (Vatican 31448), detail, left prone figure in the upper right central scene, third quarter of the 3rd century, marble, 27 $^3/_{16}$ x 87 $^{13}/_{16}$ x 7 $^7/_{16}$ in. (69 x 223 x 19 cm). Museo Pio Cristiano of the Vatican Museums, Vatican City. Photo by Linda Fuchs, courtesy of the Vatican Museums.

themselves on the road trod by the Apostle, seeking to touch his feet out of reverence and to kiss them" (Garrucci, *Storia della arte Cristiana*, 5:1 and 17–18; pl. 307 "Peter between two *apporitores*"). On the broad semantic range of *apporitores* see Charlton Thomas Lewis and Charles Short, *A Latin Dictionary Founded on Andrews' Edition of Freund's Latin Dictionary* (Oxford: Clarendon, 1980) s. v. "*apparitore*": "a servant, esp. a public servant (lector, scribe, military aid, priest, etc.)." Variations in Latin spelling are common: *apparitore/apporitore*. The more recent exhibition catalogue Picturing the Bible says of this scene, "The scene is uncertain and without parallel, but it recalls the biblical passage describing Peter's escape from prison in Jerusalem with the aid of an angel (Acts 12:3–11)." See Jeffery Spier, ed., *Picturing the Bible: The Earliest Christian Art* (New Haven: Yale University Press, 2007) 207, no. 39. However, a single angel with Peter does not explain the third walking figure, nor the prone figures clasping the feet of the center character.

45. Bottari sees the capture of Christ "represented by the flight of the Apostles and the numbing blow of the disturbance which took place at this same instance" (*Roma sotteranea*, 1:192).

46. Orazio Marucchi, *Guida del museo cristiano Lateranense* (Rome: Tipografia Vaticana, 1898) 35.

47. De Waal, who surveyed the literature on this scene from 1863–1911, observed that "Catholic archeologists" tended to identify the scene in question as an arrest of Peter, following de Rossi, while "Protestant archeologists" generally identified the scene as the *Harassment of Moses*. Anton de Waal, "Zur Klärung einer noch unerklärten Szene auf einem lateranensischen Sarkophage," *Römische Quartalschrift für Altertumskunde und für Kirchengeschichte* 25 (1911) 137–48, esp. 145, 147.

48. E. Becker identified the scene as a rescue of Lot by two flanking angels, while residents of Sodom cling to Lot's feet. No such clinging by people of Sodom is mentioned in the scriptural account. E. Becker, "Die Fluchtszene des Jonassarkophages: Nicht Petri Befreiung, sondern Lots Rettung," *Römische Quartalschrift* 26 (1912) 165–80, esp. 168.

49. Wilpert, *I Sarcophagi cristiani antichi*, 1:192.

Figure 5. Jonah sarcophagus (Vatican 31448), detail, hem of the left prone figure in
the upper right central scene, third quarter of the 3rd century, marble, 27 3/$_{16}$ x 87
13/$_{16}$ x 7 7/$_{16}$ in. (69 x 223 x 19 cm). Museo Pio Cristiano of the Vatican Museums,
Vatican City. Photo by Linda Fuchs, courtesy of the Vatican Museums.

Past identifications of this scene have not fully considered the
genders of the figures. The three walking figures are bearded and wear
garments of thick fabric with bold folds, garments that do not reach the
ankles. These clothing characteristics suggest that these figures are male.
However, the identification of the prone figures is more complex. No pre-
vious identifications of these prone figures have considered the possibility
that they may be women. In fact, prone female figures would be inconsis-
tent with most previous interpretations of this scene.[50] However, the visual
evidence suggests that these figures are women. First, the horizontal figure
at left wears ankle-length or longer garments, common for third-century
women, and different from the clothing of the standing males in this scene
(Figure 4). Second, this garment is hemmed with a scalloped border (Fig-
ure 5). Hem decoration (*instita*) is perceived by some to be a mark of a
married woman.[51] Third, this figure wears a Roman matron's double set of
belts. An inner belt draws up some length of the garment, but is hidden by
fabric blousing over the belt, leaving a fold line at the hips. A broad second
belt gathers the garment's fullness at the thick waist. Indeed, this figure's
clothing strongly suggests that it is a woman.

50. Previous interpretations are discussed elsewhere in this essay. Interpretations
that permit but would not require women include the desert scenes (*Harassment of
Moses* or plague).

51. Horace, *Satires* 1.2.29; Ovid, *Ars Amatoria* 1.32. William Smith, William
Wayte, and G. E. Marindin, *A Dictionary of Greek and Roman Antiquities* (London:
Murray, 1890) s.v. "Instita."

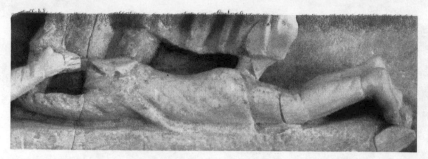

Figure 6. Jonah sarcophagus (Vatican 31448), detail, right prone figure in the upper right central scene third quarter of the 3rd century, marble, 27 $^{3}/_{16}$ x 87 $^{13}/_{16}$ x 7 $^{7}/_{16}$ in. (69 x 223 x 19 cm). Museo Pio Cristiano of the Vatican Museums, Vatican City. Photo by Linda Fuchs, courtesy of the Vatican Museums.

Skeptics of this reading of these prone figures as women may note that the horizontal figure at the right, by contrast, does not have long garments (Figure 6). However, the lower legs of this prone figure, which is also missing its head, are not original. That this part of the scene has been restored is demonstrated both by the lighter color of the newer marble as well as by an extensive restoration bill, dated 1757, from the workshop of Bartolomeo Cavaceppi which itemized the repaired sections.[52] While the sarcophagus slab was in Cavaceppi's workshop for cleaning and restoration, it was dropped. The rectangular slab of the front surface, previously separated from the rest of the sarcophagus for display purposes, broke into five large pieces. Nearly one hundred small carved pieces were needed to restore the work, including the legs of this horizontal figure at right. It is possible that this figure originally had longer clothing for a female. While only a part of this original figure, from the shoulder to the thighs, remains, that section is consistent with identifying this figure as female. One visual clue suggesting that the original prone torso represents a female figure is the right-angle corner of the outer garment ending at the hips, and touching the ground line. Two principle garments of Roman women—the *tunica* and *palla* (of Greek origin, as *chiton* and *himation*)—are rectilinear.[53] Outdoors, a Roman woman would wear a *palla* as a wrap.[54] The most

52. Cristina Gennaccari, "Museo Pio Cristiano: Documenti inediti di rilavorazioni e restauri settecenteschi sui sarcophagi paleocristiani," *Bollettino: Monumenti, musei e gallerie pontificie* 16 (1996) 153–285. Pages 197–205 present all of Cavaceppi's bill for the restoration of the Jonah sarcophagus.

53. See Carolyn G. Bradley, *Western World Costume* (New York: Appleton-Century-Crofts, 1954) 77–78.

54. A common way to wear a *palla* was to begin with one corner in front of the

common men's everyday outerwear (cloaks, mantles and overgarments) had curved lower edges or rounded corners.[55]

Moreover, garments of men and women in third-century sculpture, are often distinguishable by texture. Roman women favored thin, fine fabrics. Roman men wore heavier fabrics that created bold folds. In this scene, the thin fabrics worn by the prone women contrast vividly with the full-bodied fabrics and strong fold structure of the walking men's garments.

Having considered the genders of the group of walking men and prostrate women, one may then begin to explore their specific identities. The primary literary sources for the creation of third-century Christian art in Rome are found in the Greek Septuagint text of the Old Testament and writings now known as the Greek New Testament, particularly from the Western text tradition commonly used at Rome. Indeed, the images that surround this unidentified scene (e.g., depictions of Jonah, Lazarus, and Noah) are drawn from the Bible. Therefore, a potential key to identifying this scene may be identifying a biblical narrative in which multiple women clasp the feet of an individual man. The only possible narrative to meet

left shoulder, to bring the fabric around the back, under the right arm, across the front and then over the left shoulder again, leaving the right hand free for tasks. A corner appeared below the back of the left shoulder where the end of the garment fell and a straight lower edge was visible along the back near the hips. This lower edge inclined slightly upward toward the right. On the right prone Mary of the Jonah sarcophagus, a *palla* is arranged this way. Cf. Judith Lynn Sebesta and Larissa Bonfante, *The World of Roman Costume* (Madison: University of Wisconsin Press, 1994) 245.

55. Tortora and Eubank's observation that Roman clothing tends to use rounded or elliptical forms seems to apply more to the garments of men (such as the toga and men's various outdoor-wear cloaks and mantles) than to the garments of women. See Phyllis Tortora and Keith Eubank, *A Survey of Historic Costume* (New York: Fairchild, 1989) 54–55. They list as the most important outdoor garments for cold weather the following cloaks and capes: *paenula*—semicircular, closed at front with a hood; *lacerna*—rectangular, with rounded corners and a hood; *laena*—a circle of cloth, folded to a semicircle, thrown over the shoulders and pinned at the front; *birrus* or *burrus*—resembling a modern hooded poncho . . . *paludamentum*—large white or purple cloak like a Greek *chlamys*, worn by emperors or generals; *military cloaks*—including the *abolla*, a folded rectangle fastening on the right shoulder and worn by officers; *sagum*, like the *abolla* generally red, a single layer of thick wool worn by ordinary soldiers and, in time of war, by Roman citizens (51).

The common men's outer garments that are not military wear appear to have rounded edges or corners. Tortora and Eubank have noted intriguing parallels between Greek and Roman fashion and architecture: Greek clothing design and the Greek post-and-lintel architectural system are both primarily rectilinear. The Roman arch of architecture combined curves with straight lines, features found in ordinary Roman menswear (excluding military clothing).

this criteria is found in Matthew 28, where a group of women meet and worship the newly risen Jesus,[56]

> So the women hurried away from the tomb, afraid yet filled with joy, and ran to tell his disciples. Suddenly Jesus met them. "Greetings," he said. They came to him, *clasped his feet* and worshiped him. Then Jesus said to them, "Do not be afraid. Go and tell my brothers to go to Galilee; there they will see me."[57]

In this center right scene, two prone figures clasping the feet of the central figure, and the third head at that central figure's feet, seem to represent the first recorded encounter between the resurrected Jesus and a group of women. Who are these women? In Matthew's Gospel, "Mary Magdalene and the other Mary" (the mother of James and Joses) came to look at the grave.[58] Gospel writers variously name a third woman as a witness of the resurrection of Jesus—either Salome, Joanna, or the mother of the sons of Zebedee (James and John). They all may have been present, but gospel writers take note of different women.[59] Recognizing this scene as

56. De Waal and Wilpert correctly observe that the act of prostration at someone's feet may signify an act of worship, but neither of them noted that only one biblical passage, Matt 28:8, describes more than one person clasping the feet of an individual. de Waal, "Zur Klärung," 145, 147. See Wilpert, *I Sarcophagi cristiani antichi*, 1:192.

A search of all Bible references to "feet" reveals that one person may grasp the feet of another when life and death hang in the balance, as when the Shunammite woman pleads with Elijah for the life of her son (2 Kgs 4:27). Similarly, though without specific mention of clasping of feet, Abigail falls 'at' or 'on' the feet of David when pleading for the lives of her household. 1 Sam 25:24 (= 1 Kgs 25:24, LXX: ἐπί).

57. Matt 28:8–10.

58. Matt 28:1; 27:61; 27:56. Sometimes Joseph (more Hebraic) is rendered Joses (more Roman).

59. Mark writes of Salome at the Crucifixion and arriving at the empty tomb, although in the ending of Mark (as in John), Mary Magdalene is the only woman mentioned meeting Jesus after the resurrection. (On the location of Mark in Rome, see Eusebius *Hist. Eccl.* 2.15.2, which cites Papias as stating that "Peter mentions Mark in his first Epistle, and . . . he composed this [gospel] in Rome itself.") Matthew identifies one of the women who had been following Jesus from Galilee, attending to his needs and watching at the Crucifixion as "the mother of Zebedee's sons" (Matt 27:55–56). Tatian, in his account of the resurrection in his second-century *Diatesseron* appears to draw from Luke 24:10 the name of Joanna as a witness to the Eleven. Tatian includes "Mary Magdalene, and Joanna, and Mary the mother of James and the rest who were with them," in his description of those who "came and took hold of his feet and worshipped him." The phrase "and the rest who were with them" gives room for variation when identifying the third woman depicted with the two women named Mary. *Diatesseron* 53.31–6. *Ante-Nicene Fathers*, vol. 9, http://www.ccel.org/ccel/schaff/anf09.iv.iii.liii.html.

the meeting described in the Gospel of Matthew identifies four of the six figures in the upper right central scene of the Vatican Jonah sarcophagus. The resurrected Jesus is the standing male in the center, whose feet are clasped by two worshipping women—Mary the mother of James and Joses (likely at left, wearing garments of a matron) and Mary Magdalene (likely at right). To the left of Jesus' feet and above the back of the prone Mary at left is the head of the third woman—Salome, Joanna, or Zebedee's wife.

Having identified the prone women and the central male figure as a meeting of the resurrected Jesus with a group of women, who are the men to the right and left of Jesus? In the Gospels, the first males to meet Jesus after the resurrection are the pair on the road to Emmaus.[60] In this sarcophagus scene, standing males flanking Jesus may be these men: Cleopas and, according to Origen, Simon Peter.[61] Origen's identification of Peter as the companion of Cleopas seems to follow a Western text reading of Luke 24:34 recorded in Codex Bezae (manuscript D) in which Cleopas announces to disciples in the upper room that "The Lord has really risen

60 Luke 24:13–35.

61. Origen named Simon seven times as the companion of Cleopas (*Contra Celsum* 2.62; 2.68 [Ante-Nicene Fathers, vol. 4]; *In John* I.30; I.50; *Homilies on Jeremiah* 20.8.4; 20.9.3; *Homilies on Luke* frag. 256 [Fathers of the Church series, hereafter FC]). Twice in *Contra Celsum*, Origen indicates that he draws the account of Simon and Cleopas from Luke's Gospel:

> For it is related in St. Luke's Gospel, that Jesus after His resurrection took bread, and blessed it, and breaking it, distributed it to Simon and Cleopas; and when they had received the bread, "their eyes were opened, and they knew Him, and He vanished out of their sight" (*Contra Celsum* 2.68, ANF, vol. 4; see *Contra Celsum* 2.62).

In Origen's *Commentary on John*, adjacent verses name "Simon and Cleopas" and state that "Andrew, the brother of Simon Peter, found his own brother Simon . . . " indicating that Simon of the Emmaus story is Simon Peter.

> (30) But Simon and Cleophas too, talking "together of all the things which had happened" to Jesus, say to the risen Christ himself, though they did not yet know that he had risen from the dead, "Are you alone a stranger in Jerusalem, and do not know the things that have been done there in these days?" And he said, "What things?" and they answered, "The things concerning Jesus of Nazareth who was a prophet, mighty in work and word before God and all the people; and how our chief priests and princes delivered him to be condemned to death, and crucified him. But we hoped that it was he who would redeem Israel."
>
> (31) Besides these, when Andrew, the brother of Simon Peter, found his own brother Simon, he said, "We have found the Messias, which is being interpreted, the Christ" (Origen, *Commentary on John* 1.30–31, FC).

and has appeared to Simon [Peter]."[62] **Consonant with this, Paul writes**

62. Origen may have based this understanding on a reading of Luke 24:34 known through the Western text tradition. Codex Bezae (fifth century, manuscript D) is the main extant Greek example of the "Western" text tradition employed in the geographically "Western" areas of Italy, Gaul, and North Africa. It was used as a secondary text in Egypt. See Bruce Metzger, *The Text of the New Testament: Its Transmission, Corruption and Restoration*, 2nd ed. (New York: Oxford University Press, 1968) 51, 213–14. That the Western tradition was available in Alexandria as early as the days of Origen's mentor Clement is made clear by the work of R. J. Swanson, "The Gospel Text of Clement of Alexandria," PhD diss., Yale University, 1956, which revealed that the quotations of Matthew and John in Clement's *Stromata* appear in a two-to-one ratio of Egyptian (Alexandrian) to Western text. See also Metzger, *Text*, 214n1. The Western text tradition would have been favored in Rome, where the Vatican Jonah sarcophagus was found. In Codex Bezae, a one-letter distinction employing λέγοντες [*legontes*], rather than λέγοντας [*legontas*], conveys nominative, not accusative, case. If this word "saying" is in the nominative case, it refers to the subject "they" (the two who returned from Emmaus to Jerusalem), whereas if "saying" is in the accusative case, it refers to the object, the "eleven"—the twelve disciples of Jesus minus Judas—assembled in Jerusalem.

Luke 24: 33, "And they [the subject] arose that very hour and returned to Jerusalem and found gathered together the eleven and those who were with them [the object]." Verse 34, "*saying* [λέγοντες (*legontes*)—nom. or λέγοντας (*legontas*)—acc.] 'The Lord has really risen and has appeared to Simon.'"

Crehan noted that the Sahidic text, which probably antedates the writings of Origen, makes it clear that the ambiguous participle of v. 34 belongs to the two and not to the eleven. In Horner's translation of the Sahidic it runs: "They returned to Jerusalem, they found the Eleven gathered together with those who were with them, saying, Really the Lord rose, and was manifested to Simon. They also said the things which happened in the road and how he was manifested to them . . ." The same subject is supposed for the participle and for the next sentence, which must itself belong to the two from Emmaus. See Joseph H. Crehan, "St. Peter's Journey to Emmaus," *Catholic Biblical Quarterly* 15 (1953) 418–26, esp. 421. Broadly speaking, evidence for Peter's journey from Emmaus is found in Codex Bezae (manuscript D) and Old Syriac, in the Coptic versions (Bohairic and Sahidic) and in Origen's writings from two different periods of his life, when he had access to various textual traditions. Simon and Cleopas are named together in Origen's *Commentary on John*, written in Alexandria AD 228–231, and in his works of the Caesarean period, including *Contra Celsum*, written near AD 248. Crehan explains how λέγοντες is in this context better Greek than λέγοντας, concluding that the quality of Luke's Greek would favor the reading λέγοντες:

> *legontas* after another participle in the accusative with no *kai* [and] to connect the two is something which Luke could hardly have written. His usual practice of coupling two dependent participles with *kai* can be seen in the adjacent chapter 23,2, and elsewhere too he conforms to normal Greek usage. On the other hand the unemphatic use of *kai autoi* [and they] at the opening of verse 34 [vs. 33 above] here is the thirteenth case of this usage in Luke's writing up to this point. The word *legontes* is therefore better Greek than *legontas* . . . [422–23].

Luke may have sought to enhance narrative drama by constructing a *second surprise* identification when he concealed the identity of Cleopas's companion. It may

that the risen Jesus appeared "first to Cephas [Simon Peter] and then to the twelve"[63]

The scene in question seems to be a conflation of two episodes of Jesus' post-resurrection appearances. The coupling of two episodes as a unit has both Biblical and art historical precedent. Luke 24:1–11 presents women discovering the empty tomb of Jesus and their witness to the resurrection, and this is immediately followed in verses 13 to 34 by the men's encounter with Jesus on the Emmaus road. In fact, verse 13 makes it clear that these two events occurred on the same day. Also, the visual conflation of multiple scenes has been documented in Roman funerary art as early as the first quarter of the second century.[64]

On the Vatican Jonah sarcophagus, the visual conflation of two episodes—the resurrected Christ appearing first to a group of women and then to a pair of men—seems to reflect Luke's awareness that Jewish tradition, as attested by Josephus, did not admit testimony by women.[65] The main scene of the Vatican Jonah sarcophagus seems to provide an emphatic doubling of episodes testifying to the resurrection of Jesus: Mary the mother of James and Joses, Mary Magdalene, and a third female are shown as first witnesses, while Cleopas and Simon Peter form a second pair of witnesses, males whose testimony would be legally admissible under Jewish law.[66] In a visual declaration of Christ's triumph over death on this sarcophagus, the female witness group had temporal priority, but the male pair had legal priority as witnesses, reflecting first-century Jewish

be that an early scribe missed the intended construction of a second surprise for the reader—revealing Simon Peter—when the pair returning from Emmaus met the other assembled disciples. This may have resulted in a misunderstanding of which group was speaking in Luke 24:33–34, and, thus, in a one-letter difference from the Western text type of Luke 24:34 appearing in the Alexandrian text type.

63. 1 Cor 15:3–5

64. Diana Kleiner sees compression of episodes within a single scene as early as the Trajanic or early Hadrianic eras in a funerary circus relief. D. E. Kleiner, *Roman Sculpture* (New Haven: Yale University Press, 1992) 236, fig. 201. Alice Christ has described such conflation in an Adam and Eve scene on the fourth century sarcophagus of Junius Bassus. See Alice Christ, "The Sarcophagus of Junius Bassus: Patron, Workshop and Program," PhD diss., University of Chicago, 1992, 255–64.

65. *Antiquities of the Jews* 4.8.15.219. Luke's inclusion of Jesus' statement, later in the same chapter as the resurrection appearances to the women and to the men en route to Emmaus, that "You are witnesses of these things" indicate that Luke is keenly aware of the importance of appropriate witnesses (Luke 24:48).

66. The priority of Jesus' appearance to the women validates their witness within the Christian community.

culture. In the third-century visual image, as in the first-century Christian Gospels, both male and female testimony are included.

Apprehension of this scene of the resurrected Jesus is gradual, revealed first through identifying those who saw the resurrected Jesus and then by perceiving their response to him. The strategy of delayed comprehension evident in the Vatican Jonah sarcophagus may reflect the use of a Greco-Roman literary device—a recognition scene. This narrative structure, described by Aristotle in the *Poetics*, is used by Luke in his Gospel to veil the identity of Jesus on the Emmaus road. Kasper Larsen has observed that the longer the postponement in recognition, the greater is the impact of the recognition, noting that in Luke 24 "Jesus holds people in the dark by speaking of himself in the third person, acting as if he was going to continue on and acting ignorant of what had been happening."[67] Another common feature of Greco-Roman recognition scenes is that observers blame themselves for not recognizing the stranger previously. In Luke's Gospel, the friends of Jesus say to each other, "Were not our hearts burning within us while he was talking to us on the road, while he was opening the scriptures to us?"[68] Larson observed that the ending of the Emmaus story atypically subverts the genre, for Greco-Roman recognition scenes usually conclude with "awe and amazement, [the characters] typically falling at each others' feet with tears."[69] In Luke's narrative, the men who met Jesus on the way to Emmaus do not fall at his feet, for he vanishes at their table. However, the designer of the Vatican Jonah sarcophagus includes this expected feature of a literary recognition scene—falling at the feet— by combining the Emmaus road witness episode with that of women falling at the feet of the resurrected Jesus. Both this sarcophagus scene and the scriptural text on which it is based reflect use of this contemporary literary device, the recognition scene, to dramatically reveal the resurrected Jesus.

The identification of the sarcophagus' resurrection scene has been elusive for several reasons: the scene's uniqueness, a lack of props as clues, misapprehension of the female gender of the prone figures, the absence

67. This quotation is from a conference paper presented at the annual meeting of the Society of Biblical Literature by Kasper Bro Larsen, "Eumaeus in Emmaus? Luke 24:13–35 and the Recognition Scenes of Greco- Roman Literature," SBL, Session 24–107: "Formation of Luke–Acts," New Orleans, LA, 24 November 2009. For development of similar ideas in print, concerning the Gospel of John, see K. B. Larsen, *Recognizing the Stranger: Recognition Scenes in the Gospel of John* (Boston: Brill, 2008).

68. Luke 24:32.

69. Larsen, "Eumaeus in Emmaus? Luke 24:13–35 and the Recognition Scenes of Greco-Roman Literature," SBL Conference, Nov. 24, 2009.

of certain original parts (including the legs of the right prone figure), the conflation of two unfamiliar scenes into one, and the fact that the Western text reading of Luke 24:33–34 is not commonly published in our day, though this would have been the reading most likely in use at Rome in the third century (see footnote 62).[70] The process of identification employed here highlights the need for carefully developing methods and terminology to read third-century Christian art in the context of the beliefs and documents of third-century Christians.

Having identified the men flanking Jesus as Cleopas and Simon Peter, it may be possible to further discern Peter as the figure to the viewer's left of Jesus. This figure leans to the right, as if in a run. In the gospel resurrection narratives, the only persons who are said to run are Mary Magdalene, Peter, and John. Of these, only Peter runs in Luke 24, the chapter with the Emmaus road incident as well as the appearance of the resurrected Jesus to women.[71] The running feet may serve to identify Peter.

An odd feature of the Vatican Jonah sarcophagus is that while this figure (Peter) moves forward rapidly to grasp the figure beside him (Jesus), he turns his head to face the viewer. In Roman relief sculpture, narrative characters usually turn their faces in profile or three-quarter view, even if their bodies are positioned frontally.[72] On reliefs, direct gaze or

70. Origen's *Commentary on John* 1.30, written in Alexandria AD 228–231, mentions Simon and Cleopas in the context of the discussion on the road to Emmaus.

71. Mary Magdalene, Peter, and John: John 20:1–9. Peter running: Luke 24:12.

72. Kleiner, *Roman Sculpture*, 250, 285.
Of twenty-seven heads on the Vatican Jonah sarcophagus, about half are original. All but two of the lost or damaged heads have been replaced with restorations. Jesus in the upper central scene retains an original full, loose hairstyle characteristic of the period of the reign of Gallienus (AD 253–268), but the face is partially restored below the eyes. The head of Jesus in the Lazarus scene differs because it was entirely replaced by Cavaceppi. The restored heads are generally thinner, with pointed, sharply-carved features. This is true of the restored lower part of the face of the resurrected Jesus and the heads of Simon Peter, Cleopas, and Mary the mother of James and Joses.
Even though the head of the figure identified here as Peter is restored, several factors suggest that this figure's frontal gaze probably reflects the way the sarcophagus was originally prepared:

1) The most damaging incident known to have affected the sarcophagus was confined to the workshop of Cavaceppi, where multiple individuals would have seen the sarcophagus before it was dropped and damaged. A feature as odd as a head turned frontally to face the viewer while that figure was leaning into a run as he touched the man beside him was likely noted.

2) The peculiar frontal head-turn is an unlikely innovation for a restorer to create. A principle of textual criticism, *lectio difficilior potior* ("the more difficult reading is stronger"), argues that an unexpected choice of reading is more likely to be the

eye-contact with the viewer is generally reserved for funerary portraits, usually in the exact center or upper center of a visual field. This frontal gaze in Roman funerary art may have prompted the viewer to consider his own mortality. On traditional Roman sarcophagi, the face of the deceased was sometimes placed on the body of a character from Roman mythology, such as Endymion or Rhea Silvia.[73] One third-century sarcophagus in the British Museum replaces the usual idealized face of Endymion with a portrait of a crew-cut male.[74] On the Vatican Jonah sarcophagus, the shifting of the upper central scene slightly off-center (the space of one figure to the right) places the portrait of the deceased at dead center of the sarcophagus field, the dominant portrait position in Roman funerary tradition.

This scene with the Emmaus road episode has two points of focus: it highlights Jesus at the scene's center and Peter beside him, centered in the overall width of the sarcophagus. Peter and Christ are visually and thematically linked to scenes below. Below Jesus, a vertical triple cycling of the body of Jonah's sea creature, recalls Jesus' words, "For just as Jonah was for three days and three nights in the belly of the sea monster, so for three days and three nights the Son of Man will be in the heart of the earth."[75] Below Peter is the upturned crescent tail of the sea creature that swallowed Jonah. This variant from the typical bracket-shaped tail on a *ketos* appears to set Peter apart almost like the upturned crescent moon found elsewhere framing a portrait of the deceased on a Roman funerary *cippus*.[76] Thus, in three ways, the character Peter seems to be distinguished

original one than a safe alternative reading, This methodological principle would seem to have transfer value for evaluating a sculptural restoration here. Restorers tend to introduce expected additions if there is a gap or lack of information.

3) This head is placed at the exact center, from left to right, of the upper row of the sarcophagus. The center is the most common portrait position on Roman funerary monuments, and funerary portraits are frontal. (Flexibility of position could occur when a Roman mythological figure in a narrative scene bore a portrait of the deceased, but a central position was still favored.)

73. A drawing of a sarcophagus in the Palazzo Mattei depicts Rhea Silvia with the face and Severan hairstyle of a particular deceased woman, not as an ideal Rhea Silvia. See Carl Robert, ed., *Die antiken Sarkophagreliefs*, vol. 3.2: *Einzelmythen: Hippolytos–Meleagros* (Berlin: Mann, 1904) pl. LX, illus. 188. Lauren Donovan kindly drew my attention to this.

74. Hellmut Sichtermann, *Späte Endymion-Sarkophage: Methodisches zur Interpretation,* Deutsche Beitrage zur Altertumswissenschaft 19 (Baden-Baden: Bruno Grimm Verlag für Kunst und Wissenschaft, 1966) 19, 68–75, fig. 47 (69), and detail fig. 49 (71). Michael Koortbojian, *Myth, Meaning and Memory on Roman Sarcophagi* (Berkeley: University of California Press, 1995) fig. 50.

75. Matt 12:40 (NRSV).

76. Franz Cumont, *Recherches sur le symbolisme funéraire des Romains* (Paris:

for a portrait of the deceased (central position on the sarcophagus, frontal gaze, and upturned crescent below), though the original portrait has been replaced by a restoration. Given strong emphasis on Simon Peter in this sarcophagus, the three Jonah scenes may here refer not only to the resurrection of Jesus (and his power to raise the deceased), but also to Simon's patronym, Bar-Jonah, or "son of Jonah."[77] In addition, the upward gaze of Noah seems to rest on Jesus and Peter in the upper register, recalling a link to Peter's teaching on resurrection, in which he names Noah, saying, "In [the ark] only a few people, eight in all, were saved through water, and this water symbolizes baptism that now saves you also . . . by the resurrection of Jesus Christ."[78]

Recognizing that the upper-central scene of the Vatican Jonah sarcophagus represents the resurrected Jesus is significant not only for reading the overall iconographic program of this sarcophagus, but also for understanding the theme of resurrection of the body within third-century Christian art. If the identification presented here is correct, the scene is one of the earliest very rare direct visual images of the resurrected Jesus.[79] Since explicit depictions of the resurrected Jesus have been virtually unknown in Christian art of the third and fourth centuries, the upper central scene of the Vatican Jonah sarcophagus is all the more remarkable.[80]

Geuthner, 1942) xx.

77. When Jesus gave Simon the nickname Peter, Jesus also mentioned Peter's patronym, Bar-Jonah:

"Who do you say that I am?" Simon Peter replied, "You are the Christ, the Son of the living God." And Jesus answered him, "Blessed are you, Simon Bar-Jonah! For flesh and blood has not revealed this to you, but my Father who is in heaven. And I tell you, you are Peter, and on this rock I will build my church." Matt 16:15b–18a (ESV).

78. 1 Pet 3:18–21 (NIV).

79. Nicola Denzey observes that, in the *Capella greca* of the Priscilla catacomb, one of several scenes previously identified as "Susanna and the Elders," includes a tomb building and may be better identified with the account in John 20 in which Mary Magdalene, Simon Peter, and the beloved disciple arrive at the tomb, where she meets the resurrected Jesus. Denzey refers to the scene by the name it bears in Medieval and Renaissance art, *"Noli me tangere,"* adding that, *"It has been thought to be entirely absent from early Christian art.* But the attribution makes sense of many of the puzzles in the fresco. It explains why we find a tomb structure in a garden when there is no tomb in Susanna's but there is in the Gospel of John." Denzey notes that other scenes identified as Susanna in the *Capella greca* may present a *cursus vitae* (a synopsis of the deceased's life). See N. Denzey, *Bone Gatherers*, 111.

80. Pierre du Bourguet's survey of early Christian art finds "surprising omissions." He observes, "In Christianity, the salvation of the soul is attained through the Passion, the Resurrection and the Ascension of the Savior. Yet there is no iconographic reference, no allusion, however indirect, to these" (*Early Christian Art*, trans. by Thomas

Usually third-century Christians made visual reference to Jesus' victory over death through representations of Jonah, which comprise about 60 percent of the surviving images made by Christians before Constantine. Yet the history of scholarship of early Christian art demonstrates how often these indirect references to resurrection may be misread. The challenges of identifying and interpreting the iconographic content of the Vatican Jonah sarcophagus may also serve as an appeal for the continued development of methodological principles with which to approach early Christian iconography.

Burton [New York: Reynal, 1971] 60). Bourguet overstated the case. Jonah was linked in the gospels to Jesus' own death and resurrection, and Jonah was the character most often depicted in Christian art before Constantine's *Edict of Milan*. See a chart of image distribution in this period in Snyder, *Ante Pacem*, 87. A qualified exception to the lack of representations of Jesus crucified is a graffito sketch insulting the Christian Alexamenos for worshiping a god depicted with an ass's head on a cross. Thomas F. Mathews, *The Clash of Gods: A Re-interpretation of Early Christian Art* (Princeton: Princeton University Press, 1993) 50–51, fig. 33. Later, in the fourth century, the resurrection was conveyed as a victory over death by a trophy hung with a wreath and displaying a prominent Chi-Rho symbol. Three examples are shown in Wilpert, *I Sarcofagi cristiani antichi*, vol. 1, pl. 146, nos. 1–3.

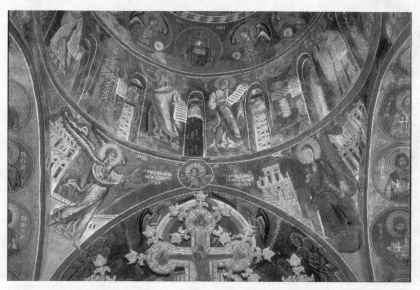

Figure 7. Theodore Apsevdis (?) Hetoimasia at Panagia tou Arakos Church (east pendentives and drum) 1192, fresco, c. 6 x 9 in. (15.25 x 22.9 cm) cross-section, Lagoudera, Cyprus. Photo permission of Slobodan Ćurčić.

Icon as Theology

The Byzantine *Virgin of Predestination*

MATTHEW J. MILLINER

When the College of New Jersey, now Princeton University, was founded in 1746 by uncompromising defenders of the Calvinist doctrine of predestination, art history was not central to the curriculum.[1] By the late nineteenth century, however, the Scottish Presbyterian College President James McCosh, believing students to be lacking in "visual skills," pushed for the establishment of a "School of Art,"[2] eventuating in a Department of Art & Archaeology. Through a more disciplined focus on the history of art, the department distinguished itself from "art appreciation" models. In so doing, Princeton's department became the art historical "model and the mold for most institutions of higher learning in America."[3] The

1. Jonathan Dickinson, the college's first president, defended the doctrine the same year as the college was founded. See Jonathan Dickinson, *A Vindication of God's Sovereign Free Grace* (Boston: Rogers and Fowle, 1746). Jonathan Edwards, another of the founders and the institution's third president, did the same. See his 1754 "Freedom of the Will," *The Works of Jonathan Edwards*, vol. 1: *The Freedom of the Will*, ed. Paul Ramsey (New Haven: Yale University Press, 2009).

2. McCosh promoted the importance of exposing undergraduates to a variety of fields in contrast to Harvard's Charles Norton, who argued for almost unlimited curricular freedom. See J. David Hoeveler Jr., *James McCosh and the Scottish Intellectual Tradition: From Glasgow to Princeton* (Princeton: Princeton University Press, 1981) 234–36.

3. Marilyn Aronberg Lavin, *The Eye of the Tiger: The Founding and Development of the Department of Art & Archaeology, 1883–1923, Princeton University* (Princeton: Princeton University Press, 1983) 5. The Department of Art & Archaeology was founded in 1883. At that time, one could study studio art at Yale or art in connection to literature at Harvard, but for art history proper, one had to attend Princeton, which

department anticipated developments in the field of art history that were more than a century away.[4] But how its first professor came to the subject is a story that is both relevant to the history of the study of art in America and, more specifically, to methodological issues that still evidence themselves in the academic study of Byzantine art.

Allan Marquand was the son of the wealthy Henry Marquand, who was instrumental in founding the Metropolitan Museum of Art. Allan Marquand attended the College of New Jersey, studied in Berlin, and then earned his PhD from Johns Hopkins, where he studied with the famous pragmatist Charles Sanders Pierce.[5] He then returned to his alma mater to teach logic. However, President James McCosh detected some departures from Calvinist Orthodoxy in Allan Marquand's lectures. McCosh—evidently not interested in alienating Allan's very generous father—gently suggested that Allan Marquand teach philosophy *of art* instead. Marquand declined, saying he would, however, teach the *history* of art, provided it would become a regular elective offered for credit.[6] This was agreed, and the lectures eventually led to the establishment of the independent department in 1883. In short, Allan Marquand could not be trusted as a philosopher, so he was consigned to the study of images. Marquand's obituary puts it this way:

> It was Dr. McCosh's suspicion of Marquand's Calvinism that shifted the brilliant young metaphysician tactfully from the more or less contentious history of philosophy to the then quite harmless history of art. It was a step in which chance and policy seemed to conspire with predestination.[7]

Though largely self-taught in what was still a nascent field of study in America, Allan Marquand flourished as an art historian, eventually

was a forerunner in the field thanks to Allan Marquand's suspect Calvinism.

4. The department "show[ed] no preference for high art (salon painting, marble sculpture) over low art (crafts and artifacts) and the objects pursued would be approached directly as manifestations of material culture in a historical context." Lavin, *Eye of the Tiger*, 12.

5. Considering Pierce's suggestion that the essence of belief is more habitual and pragmatic than propositional, I imagine Allan Marquand might have been open to this paper, which argues that theological beliefs are built into one of Marquand's own material acquisitions.

6. Betsy Rosasco, "The Teaching of Art and the Museum Tradition: Joseph Henry to Allan Marquand," *Record of the Princeton University Art Museum* 55, nos. 1 and 2 (1996) 30.

7. Ibid.

becoming both department chair and director of the University's museum, where he continued to build what was becoming an important collection. One of his most significant acquisitions was a fifteenth-century Cretan "Virgin of the Passion" type icon (Color Plate 4) possibly attributed to the Cretan painter Andrea Rico di Candia (also known as Andreas Ritzos) or his son Nicholas. Known as the "Princeton Madonna" it was purchased by Allan Marquand at a New York auction in 1911 and given to the Museum in 1920.[8] A very similar painting once hung in Florence's Uffizi Gallery, which Arthur Frothingham had called "perhaps the most beautifully executed of the early portable Byzantine paintings in Italy."[9] It was therefore with singular delight that Homer Eaton Keyes made a direct parallel of Princeton's Art Museum to the Uffizi. Princeton University, he wrote, having acquired "almost an exact duplicate of the Florentine work, may well lay claim to possessing the finest Byzantine painting in America."[10] Princeton, Keyes seemed to suggest, was finally on a level cultural playing field with Europe thanks to Marquand's acquisition. But there was more to this image than catching up with America's cross-Atlantic betters.

The Virgin of the Passion type icon is rooted in the twelfth-century Komnenian art of the Byzantine world, that last great artistic effusion before the sack of Constantinople in 1204, from which the Empire would never fully recover. The first known art historical instance of this type of iconography can be dated precisely to 1192, a fresco known as *Virgin Arakiotissa* on the island of Cyprus (Color Plate 5). The image was popularized as a portable icon in fifteenth-century Crete to meet a growing continental demand for icons in the *maniera Graeca*—tokens of the Byzantine Empire that had permanently collapsed in 1453. Such was the melancholic context of the Princeton Madonna's production.

8. The painting has been traced to the private chapel of the Beltramini family in Venice. See ibid., 52n250.

9. Arthur L. Frothingham, Jr., "Byzantine Artists in Italy from the Sixth to the Fifteenth Century," *American Journal of Archaeology and of the History of the Fine Arts* 9, no. 1 (1894) 46. Frothingham's confidence in calling the icon "Byzantine" is because he mistakenly equated Andreas Ritzos with the fourteenth-century mosaicist Andrea Taffi. Frothingham, it seems, assumed that the Byzantine style could not have been contemporary with advanced Renaissance art.

10. Homer Eaton Keyes, "The Princeton Madonna and Some Related Paintings," *American Journal of Archaeology* 17, no. 2 (1913) 210. Though Keyes followed Frothingham's erroneous conflation of Ritzos and Taffi, his calling the painting "Byzantine" was not entirely inaccurate. Although probably painted after the official end of Byzantium in May of 1453, such an artificial demarcation of Byzantine art history is suspect. The Virgin of the Passion, as this paper explains, is clearly a Byzantine type.

In the nineteenth century, the Virgin of the Passion iconography was popularized again under the aegis of the Redemptorist Order of priests, who were personally directed by Pope Pius IX to spread this icon around the world. Hence, major churches devoted to this image are scattered throughout the globe: Boston, Brooklyn, Curitiba, Rome, Chicago, Manila, and Singapore, to name some of the most significant. Lesser churches and schools devoted to this particular image are frankly innumerable, such that the Virgin of the Passion has been called "perhaps the most popular religious icon of the twentieth century."[11]

In the Princeton Madonna, Mary holds the Christ child in a traditional iconographic format; however, unexpectedly, angels appear above them bearing tidings of Christ's future passion. One angel hovers to the right of Mary with a cross, the other to her left with the lance and sponge. Christ's face, cheek to cheek with his mother's in similar icons, is here wrenched away as he engages the angel with the cross. The theme of the Passion, alluded to in so many icons of Mary and the Christ child, is here made explicit, even obvious. Mary's baby is going to die. While the iconography of the Virgin of the Passion type is fairly straightforward, its theological significance is, as this essay will demonstrate, significantly more complicated.

The Virgin of the Passion is a statement of visual theology that challenges McCosh's assumption that art was a theology-free zone, an assumption shared by many of the minds that shaped the field of art history. Making this case involves a theological interpretation of the painting that plumbs Byzantine art and theology. Proceeding directly to this interpretation is not possible, however, as methodological issues must first be considered. What has theology proper to do with the history of Byzantine art? When the history of the discipline is considered, the answer is far less than one might initially suppose.

In the last fifty years, the scholarship on Byzantine art has mirrored the developments in the broader discipline of art history, while remaining—as Byzantinists themselves frequently complain—more than a few years behind the times. In first half of the twentieth century, Byzantinists appeared to be concerned primarily with aesthetics, dating and iconographical origins. When a certain date and/or source for a given object was achieved or a relevant aesthetic was extracted, the art historian

11. Timothy Kelly and Joseph Kelly, "Our Lady of Perpetual Help, Gender Roles, and the Decline of Devotional Catholicism," *Journal of Social History* 32, no. 1 (1998) 5.

could—theoretically speaking—rest. Upon this sturdy empirical founda-
tion, more recently scholars have focused more on viewer response. Re-
quiring attention to conditions such as liturgy or landscape, these scholars
situate Byzantine art more broadly in its social milieu. Among these new
responses is the occasional claim that Byzantine art is "theology in color,"
and it is this theme that this essay seeks to expand. But the relative rarity of
approaching Byzantine art *as* theology, and the criticism that arises when
Byzantine art is so approached today, may be due to historiographical is-
sues that stretch much more deeply into the past.

Giorgio Vasari's caustic dismissal of "Greek" art in his *Lives of the
Most Excellent Painters, Sculptors and Architects* (1550/68) popularized
an enduring prejudice against Byzantine images that has yet to be fully
overcome.[12] As art history became a formalized discipline, this blockade
against Byzantine art was renewed through a triumvirate of Enlighten-
ment rationalism, Romantic notions of artistic freedom, and Catholic
or Protestant prejudice against Orthodox Christianity.[13] However, the
middle of the nineteenth century witnessed a gradual shift.[14] The revival
of interest is Byzantine art, whether academic or more popular, is admit-
tedly complex,[15] ranging from the political and religious interests of the

12. This prejudice clearly predated Vasari, even if he was most responsible for its
dissemination. Such a view was essential to the invention of a "middle age" between
the Classical past and humanist present. In the words of Matteo Palmieri (c. 1430):
"Where was the painter's art before Giotto tardily restored it? A caricature of the art of
human delineation! [T]he real guides to distinction in all the arts, the solid foundation
of all civilisation, have been lost to mankind for 800 years and more. It is but in our
own day that men dare boast that they see the dawn of better things." Matteo Palmieri,
Della Vita Civile, cited in W. H. Woodward, *Studies in Education during the Age of the
Renaissance,* trans. William Harrison Woodward (Cambridge: Cambridge University
Press, 1906) 67.

13. J. B. Bullen, *Byzantium Rediscovered* (London: Phaidon, 2003).

14. Robert Nelson, *Hagia Sophia, 1850–1950: Holy Wisdom, Modern Monument*
(Chicago: University of Chicago Press, 2004) 36. Bullen, *Byzantium Rediscovered,*
8, 65. Bullen names 1852 the *annus mirabilis* for Byzantium's rediscovery because
Théophile Gautier's book *Italia,* covering San Marco, and the second volume of John
Ruskin's *The Stones of Venice* were both published that year.

15. Bullen summarizes his study by suggesting that interest in Byzantine art could
serve as a symbol of "decadence and depravity" as well as an "emblem of saintliness
and disembodied spiritual purity," as authoritarian or egalitarian, manly or feminine.
Bullen, *Byzantium Rediscovered,* 227.

French,[16] to a revolt against the Classical or Gothic styles.[17] However, theology, the disciplined reflection upon God which saturated the Byzantine world, was frequently excluded from the study of Byzantine art.[18] Adolphe Napoléon Didron made important strides in recovering theology for the study of Christian art. "Without some reference to theology," he insisted, "Christian archaeology can never be made in any degree useful . . . Theology is in truth a noble science and has been far less deeply studied than it deserves."[19] But this plea to take theology seriously shows how little it was considered as useful for scholars of Byzantine imagery. When Didron published the painter's manual of Dionysios of Fourna in 1845, even he succumbed to this distaste, complaining that Greek artists are "enslaved to traditions as the animal to its instinct" precisely *because* "the invention and the idea belong to the fathers, the theologians of the Catholic church."[20]

A laudable attempt to reverse the Vasarian curse on Byzantine art came from John Ruskin. His purple prose caused the Renaissance to instead be perceived as the time of decline. "It is evident that the title 'Dark Ages,' given to the mediaeval centuries, is, respecting art, wholly inapplicable," wrote Ruskin. "They were, on the contrary, the bright ages; ours are the dark ones . . . They were the ages of gold; ours are the ages of

16. Bullen, *Byzantium Rediscovered*, 53. For example, the Byzantine style of Sacré Cœur in Paris was erected to "call Frenchmen back to the Church after a century of bloodshed, insubordination to the rule of God, rationalism, materialism and apostasy." Ibid., 92.

17. Ibid., 58.

18. There were, of course, exceptions. Prussian leader Friedrich Wilhelm IV, for example, was interested in early Christian and Byzantine art precisely because of its theological content. He hoped to "reform the German Protestant church by returning to early Christian liturgy and architecture," which is evidenced in his (unrealized) early Christian designs for the Protestant Cathedral of Berlin. Nelson, *Hagia Sophia*, 40. In France, neo-Byzantine interest, and buildings, grew from the "passionate religious convictions of their respective patrons." Bullen, *Byzantium Rediscovered*, 56. Likewise, the modern painter Maurice Denis specifically went to Byzantium because it was, as he called it in *Notes sur la peinture religieuse*, "the most perfect type of Christian art." Quoted in Bullen, *Byzantium Rediscovered,* 103–4.

19. Adolphe Napoléon Didron, *Christian Iconography*, trans. Margaret Stokes (London: Bell & Sons, 1886) 2:13.

20. Nelson, *Hagia Sophia,* 46. Nelson explains that Didron probably obtained this idea from the Canons of the Seventh Ecumenical Council, which dictates: "[T]he making of icons is not the invention of painters, but [expresses] the approved legislation of the Catholic Church . . . The conception and they are therefore theirs [the Church Fathers] and not of the painter; for the painter's domain is limited to his art, whereas the disposition manifestly pertains to the Holy Fathers who build [the churches]." Quoted in Nelson, *Hagia Sophia,* 46.

umber."[21] Still, he advised his readers to only visit the church of Murano when "worshippers and objects of worship" are absent,[22] lest the readers be infected by a Christianity in paralysis.[23] William Morris[24] and William Butler Yeats[25] admired Byzantium in a similar way, which was not dissimilar to that of the Bloomsbury Group, where Byzantine art's theological milieu was aestheticized away.

Robert Nelson explains that "as the aesthetic importance of . . . Byzantine mosaics rose [in the early twentieth century] their religious significances disappeared."[26] The Byzantine art enthusiast and Bloomsbury Group bohemian Clive Bell asserted that "in so far as a picture is a work of art, it has no more to do with dogmas or doctrines . . . than with the interests and emotions of daily life."[27] When Roger Fry, also a Bloomsbury member, was appointed as director of paintings at the Metropolitan Museum of Art, the taste for Byzantium—yoked to the aesthetic of post-impressionism—migrated to America.[28] Fry's take on Byzantine art was also "entirely secular."[29] The famous financier J. P. Morgan acquired Byzantine artifacts because they were "sufficiently removed from the theological and social conflicts of contemporary America."[30] The Blisses, founders of

21. John Ruskin, *Modern Painters* (New York: Bryan, Taylor, 1894) 318. Yet he would add, "I do not mean metaphysically, but literally. They were the ages of gold; ours are the ages of umber."

22. John Ruskin, *Works of John Ruskin*, eds. E. T. Cook and Alexander Wedderburn (New York: Longmans, Green, 1904) 53.

23. Nelson, *Hagia Sophia*, 68. For a full treatment of Ruskin's religious views, see Michael Wheeler, *Ruskin's God* (Cambridge: Cambridge University Press, 1999).

24. Morris's appreciation of Byzantium was based more on its ability to exemplify dignified labor, underwrite British political interests in Turkey, and inspire modern art than for its theological value. See Nelson, *Hagia Sophia*, 105; and Bullen, *Byzantium Rediscovered*, 164.

25. Yeat's take on Byzantium displayed the mysticism of one who "desires not union necessarily with God but with the aesthetic," a utopia that is "secular and aesthetic." Nelson, *Hagia Sophia*, 40. See also Bullen, *Byzantium Rediscovered*, 12–13.

26. Robert Nelson, "Art and Religion: Ships Passing in the Night?," in *Reluctant Partners, Art and Religion in Dialogue*, ed. Ena Giurescu Heller (New York: Museum of Biblical Art, 2004) 105.

27. Ibid., 106.

28. Kostis Kourelis, "Byzantium and the Avant-Garde: Excavations at Corinth, 1920s–1930s," *Hesperia* 76, no. 2 (2007) 416–17. Bullen indicates that "Post-Impressionist" art, a term coined by Fry, was also referred to as "Proto-Byzantine," although the latter term did not stick. Bullen, *Byzantium Rediscovered*, 181.

29. Ibid., 178.

30. Kourelis, "Byzantium and the Avant-Garde," 416–17. Kourelis continues,

the premiere collection of Byzantine art in America, Dumbarton Oaks, expressed little interest in the religious value of the work, emphasizing instead the "courtly, secular aspects of Byzantium."[31] Later in the twentieth century, the French art historian and critic George Duthuit considerably advanced the connections between Byzantine and modern art, converging with the interests of the American artist Barnett Newman.[32] But Duthuit's version of Byzantium was marked by an "absence of religious devotion and the strong role of theology."[33]

The atmosphere was initially different in early twentieth-century Russia. Prior to 1880, the dominance of Western styles in Russia meant "the art of icon painting had few apologists."[34] But the rediscovery of icons, culminating around a show of old Russian art of 1913 brought a renewed interest in Byzantine art.[35] Icons informed, and in many ways led, the work of the Russian patristics scholar and theologian Sergius Bulgakov.[36] His associate Pavel Florensky seamlessly merged the roles of art historian and theologian. "The icon—apart from spiritual vision," explained Florensky, "is not an icon at all but a board."[37] Florensky's efforts to save icons at the Trinity Monastery resulted in brilliant art historical lectures richly informed by theology.[38] Florensky's methodological direction could not

"Morgan's attraction to the oriental Middle Ages was complex, springing from a High Episcopalian distrust of Catholicism and a sense of class superiority over those Irish and Italian immigrants who claimed a direct clerical heritage with the western Middle Ages" (417).

31. Robert Nelson, "Private Passions Made Public: The Beginnings of the Bliss Collection," in *Sacred Art, Secular Context: Objects of Art from the Byzantine Collection of Dumbarton Oaks, Washington, D.C.*, ed. Asen Kirin (Athens: Georgia Museum of Art, 2005) 44.

32. Glenn Peers, "Utopia and Heterotopia: Byzantine Modernisms in America," *Studies in Medievalism* 19 (2010) 78.

33. Peers, "Utopia and Heterotopia," 83. For a similar, formal connection between Byzantine and modern art, see Clement Greenberg, "Byzantine Parallels," in *Art and Culture: Critical Essays* (Boston: Beacon, 1965) 167.

34. Jefferson J. A. Gatrall and Douglas Greenfield, eds., *Alter Icons: The Russian Icon and Modernity* (University Park: Pennsylvania State University Press, 2011) 5.

35. Gatrall and Greenfield, *Alter Icons*, 4–5, 12. It is significant that neither the words "Orthodox" nor "icon" were used in the exhibition.

36. According to Aidan Nichols, Bulgakov not only appeals frequently to the icon, but for him it is a *locus theologicus*. The icon of the *Deesis* organized his Little Trilogy and encapsulates his sophiology. Aidan Nichols, OP, *Wisdom from Above: A Primer in the Theology of Sergei Bulgakov* (Herefordshire, UK: Gracewing, 2005) 291.

37. Pavel Florensky, *Iconostasis*, trans. Donald Sheehan and Olga Andrejev (Crestwood, NY: St. Vladimir's Seminary Press, 1996) 64.

38. Pavel Florensky, *Beyond Vision: Essays on the Perception of Art*, ed. Nicoletta

be fully explored, however, because after repeated imprisonments, he was executed in 1937.[39] The theological perspective of Bulgakov and Florensky was quickly eclipsed in the early twentieth century by secular interest in the icon. Andrei Rublev's *Trinity* was moved from church to museum, and the history of the icon in Russia was rewritten "along national and secular lines."[40] The institutions in charge of the icon's storage and study "underwent a profound secularization, in a very literal sense, as control over the most ancient of Russian icons passed to a new class of secular priests (*cleris saeculum*)."[41] All this is to say that Byzantine art as theology is one possible future of the discipline that was, at least temporarily, interrupted.[42]

Surveying the historiography of the discipline especially in America in the mid-twentieth century, Kurt Weitzmann saw theology emerging as an interest. He could look back to a time when "the principles of *l'art pour l'art* influenced historical research," such that Byzantine art was only valued formalistically for its "technical perfection."[43] In his view, art historians were finally realizing that Byzantine artists "had great rational capabilities of expressing content by pictorial means with remarkable precision, thus conveying religious truths in conformity with the accepted theology of orthodoxy."[44] But while the course of the twentieth century brought advances to the history of Byzantine—chiefly from the discoveries at St.

Misler, trans. Wendy Salmond (London: Reaktion, 2002).

39. For a fine biographical essay on Florensky, see John McGuckin, "Florensky and Iconic Dreaming," in *Alter Icons: The Russian Icon and Modernity*, ed. Jefferson J. A. Gatrall and Douglas Greenfield (University Park: Pennsylvania State University Press, 2011) 210–26. For a full biography, see Avril Pyman, *Pavel Florensky: A Quiet Genius* (New York: Continuum, 2010).

40. Gatrall and Greenfield, *Alter Icons*, 11.

41. Ibid., 7.

42. Even Leonid Ouspensky, whose view of the icon was expressly theological, may have failed to see how theology and Christian experience permeated icons in the seventeenth century and onwards—what he calls a time of "spiritual decay." See Vera Shevzov's appreciative critique of Ouspensky in "Between Purity and Pluralism: Icon and Anathema in Modern Russia, 1860–1917," in *Alter Icons: The Russian Icon and Modernity*, ed. Jefferson J. A. Gatrall and Douglas Greenfield (University Park: Pennsylvania State University Press, 2011) 50–73.

43. Kurt Weitzmann, "Byzantine Art and Scholarship in America," *American Journal of Archaeology* 51, no. 4 (1947) 418.

44. Ibid. Examples of this kind of sensitivity would include P. A. Michelis, "Neo-Platonic Philosophy and Byzantine Art," *Journal of Aesthetics and Art Criticism* 11, no. 1 (1952) 21–45. He suggests Byzantine art could not be appreciated until an "anthropocentric [approach] had turned to a theocentric approach" (21).

Catherine's Monastery at Mt. Sinai[45]—scholarly publications from the end of that century frequently displayed a continued antipathy to theology. Indeed, Jeffrey Hamburger has indicated that despite the attention to theology in Hans Belting's *Likeness and Presence,* the book cast theology "almost entirely in negative terms. Theology has been characterized, if not as irrelevant to the formation of Medieval images, as a baleful influence on the history of Medieval art. To theology is opposed anthropology."[46] Michael Camille agreed, seeing a need for "theological underpinning that Belting does not provide . . . Belting's problem ultimately is . . . how to talk about and use the sacred while positioning oneself totally outside it."[47]

In other recent studies concerning Byzantine images, theology is not undervalued, but feared. Marie-José Mondzain's ambitious and exciting book, *Image, icône, économie,* contains an informed analysis of the Byzantine arguments for icons, but is spiked with an open prejudice against the theology it so instructively investigates. For Mondzain, iconophiles triumphed over iconoclastic imperial autocracy only to establish an "iconocracy"[48] led by "iconocrats"[49] representing God the Father's "program of universal conquest."[50] Not only did this triumphant optocracy dictate the agenda for the remainder of the Byzantine Empire, it is one to which we in the twenty-first century are still unconsciously captive.[51] "There are no great differences between submitting to a church council or to CNN."[52] In an attempt to escape the reach of the iconophile agenda, Mondzain's book concludes with an appeal that is hardly encouraging for further exploration of theology: "It is up to us to be done with belief and its *holocausts.*"[53]

45. Kurt Weitzmann, *The Monastery of Saint Catherine at Mount Sinai, the Icons,* vol. 1, *From the Sixth to the Tenth Century* (Princeton: Princeton University Press, 1976). Projected later volumes, unfortunately, have not been published.

46. Jeffrey Hamburger, "The Place of Theology in Medieval Art History: Problems, Positions, Possibilities," in *The Mind's Eye: Art and Theological Argument in the Middle Ages* (Princeton: Princeton University Press, 2005) 12–13.

47. Michael Camille, "Review of H. Belting's *Bild und Kult: Eine Geschichte des Bildes vor dem Zeitalter der Kunst,*" *Art Bulletin* 74, no. 3 (1992) 516–17.

48. Marie José Mondzain, *Image, Icon, Economy: The Byzantine Origins of the Contemporary Imaginary,* trans. Rico Franses (Palo Alto, CA: Stanford University Press, 2004).

49. Ibid., 169.

50. Ibid., 168.

51. Ibid., 173.

52. Ibid., 223.

53. Ibid., 225; emphasis Mondzain's.

As mentioned above, there have been more appreciative uses of theology in recent scholarly study of Byzantine art as well,[54] resulting in part from an emphasis on the Byzantine viewer. Because this school of interpretation was initially located at the Courtauld Institute of Art, this approach has been termed the "London School of Looking,"[55] but indeed it was much wider than London. The best work done in the history of Byzantine art in the last decade has shed more and more light on what Robin Cormack called the "complex arena of [Byzantine] viewing."[56] This includes the suggestion that for the Byzantine, "icons were accepted as a mode through which one reaches closer to an explanation of God than any verbal definition could ever do."[57] Cormack also, however, points out that "the [Byzantine] viewer may have been less concerned with Christian theology than with the hope of favour or salvation."[58] Salvation, however, is theological as well. There may have been, in the words of one recent study, "a stark contrast between the theology of learned churchmen and the response to images . . . in everyday situations."[59] This is an important reminder for the art historian. But the divide between intellectual, word-based leaders and more popular, image-based religion can also be overplayed.[60]

A perspective that involves taking theology very seriously, even for the uneducated Byzantine believer, is emerging. Considering developments in

54. Charles Barber, *Figure and Likeness: On the Limits of Representation in Byzantine Iconoclasm* (Princeton: Princeton University Press, 2002). Glenn Peers, *Subtle Bodies: Representing Angels in Byzantium* (Berkeley: University of California Press, 2001). Kenneth Parry, *Depicting the Word: Byzantine Iconophile Thought of the Eighth and Ninth Centuries* (Leiden: Brill, 1996).

55. Robert Nelson, "To Say and to See: Ekphrasis and Vision in Byzantium," in *Visuality Before and Beyond the Renaissance: Seeing as Others Saw,* ed. Robert Nelson (Cambridge: Cambridge University Press, 2000) 146. Despite the important strides made in this direction, Nelson admits "the history of Byzantine vision, as a mathematical, physiological, and even moral or theological subject, remains poorly studied" (152).

56. Robin Cormack, *Painting the Soul: Icons, Death Mask and Shrouds* (London: Reaktion, 1997) 77.

57. Ibid., 112.

58. Ibid., 82.

59. Leslie Brubaker and John Haldon, *Byzantium in the Iconoclastic Era c. 680–850: A History* (Cambridge: Cambridge University Press, 2011) 785.

60. Hamburger, "Place of Theology," 13–14. For an additional list of recent studies challenging this perspective, see Richard Viladesau, *Theology and the Arts* (New York: Paulist, 2000) 250n14.

the fields of theology,[61] philosophy,[62] psychology,[63] neurology,[64] and visual culture,[65] the time for interpreting Byzantine art as distinctly visual theology has arrived. Perhaps theography would be a better term for this phenomenon than theology, because the Byzantine Greek term *graphein* is used for both writing *and* drawing. But neologisms aside—if theology has been historically understood as the "queen of the sciences," then Byzantine art has not merely taken its place under that regency, but participates in it.

Art historian Robin Jensen argues that art in early Christianity "serves as a highly sophisticated, literate, and even eloquent mode of theological expression."[66] Charles Barber summarizes iconophile thought by suggesting that the Byzantines "elevated the status of the work of art to the realm of theology and effectively cast the artist in the role of theologian."[67] After erecting an "art as theology"[68] infrastructure, Andreas Andreopou-

61. A catholic sampling from the flood of publications has been collected in Gesa Elsbeth Thiessen, *Theological Aesthetics: A Reader* (Grand Rapids: Eerdmans, 2004). This burgeoning field, however, more often chooses philosophers of aesthetics over art historians as conversation partners. See James Alfred Martin, *Beauty and Holiness: The Dialogue between Aesthetics and Religion* (Princeton: Princeton University Press, 1990) 96. Balthasar admits as much in his article, "In Retrospect," in *The Analogy of Beauty,* ed. John Riches (Edinburgh: T. & T. Clark, 1986) 217.

62. Hans Georg Gadamer insists that "art is knowledge [*Erkenntnis*] . . . which is certainly different from that of science, but equally certainly is not inferior to it." *Truth and Method,* 2nd rev. ed., trans. Joel Weinsheimer and Donald G. Marshall (New York: Continuum, 2004) 97.

63. For example, see Rudolf Arnheim, *Art and Visual Perception: A Psychology of the Creative Eye* (Berkeley: University of California Press, 1954); and Rudolf Arnheim, *Visual Thinking* (Berkeley: University of California Press, 1969).

64. Antonio Damasio, *Descartes' Error: Emotion, Reason, and the Human Brain* (New York: Avon, 1994).

65. For a perspective on the study of religion that broadens to include material culture, see David Morgan, *Religion and Material Culture: The Matter of Belief* (New York: Routledge, 2010), as well as chapter 1 of David Morgan, *The Sacred Gaze: Religious Visual Culture in Theory and Practice* (Berkeley: University of California Press, 2005). For a view as to how this methodology applies to more popular religious images, see David Morgan, *Visual Piety: A History and Theory of Popular Religious Images* (Berkeley: University of California Press, 1999). See also John E. Cort, "Art, Religion, and Material Culture: Some Reflections on Method," *Journal of the American Academy of Religion* 44, no. 3 (1996) 613–32; and the journal *Material Religion: The Journal of Objects, Art and Belief.*

66. Robin Jensen, *Understanding Early Christian Art* (New York: Routledge, 2000) 3.

67. Barber, *Figure and Likeness,* 138.

68. Andreas Andreopoulos, *Art as Theology: From the Postmodern to the Medieval* (Sheffield, UK: Equinox, 2007).

los went on to study the theology and iconography of the Transfigura-
tion from an Orthodox perspective.[69] In the preface, the theologian and
patristic scholar Andrew Louth wonders, "It is difficult to understand why
no one thought of doing it before."[70] Byzantine icons, enlivened by shifting
liturgical light, have been called "the most subtle art and the most theo-
logically complex pictures because they do not simply represent theology
but enact it."[71] The gold ground of the icon is "the place where optics and
theology coincide."[72] To these developments we could add the revival of
Orthodoxy in post-Soviet Russia, which has altered the previous condi-
tion of the history of Byzantine and post-Byzantine art.

The late renewal of interest in the art historical thought of Bulga-
kov and Florensky is especially promising. Not only did Florensky clearly
foresee the limitations of Erwin Panosfky's thought on perspective,[73] but
his focus on logical antinomies means he dodged most postmodern bul-
lets before they were even fired.[74] What's more, a recent article in *Word
& Image* by Joseph Masheck, a former editor-in-chief of *Art Forum*, has
argued that that disciple of Freud so influential to many art historians,
the psychoanalyst Jacques Lacan, may have obtained his idea of "the gaze"
from Florensky, who had been translated into French just when Lacan was
developing his ideas.[75] Something similar can perhaps be said for the in-
fluential theories of Mikhail Bakhtin.[76] This gives reason for historians of

69. Andreas Andreopoulos, *Metamorphosis: The Transfiguration in Byzantine The-
ology and Iconography* (Crestwood, NY: St. Vladimir's Seminary Press, 2005).

70. Ibid., 13.

71. Rico Frances, "When All That Is Gold Does Not Glitter: On the Strange History
of Looking at Byzantine Art," in *Icon and Word: The Power of Images in Byzantium*, eds.
Antony Eastmond and Liz James (Burlington, VT: Ashgate, 2003) 22.

72. Frances, "When All that Is Gold," 18. See also Bissera Pentcheva, *The Sensual
Icon: Space, Ritual, and the Senses in Byzantium* (University Park: Pennsylvania State
University Press, 2010).

73. Pavel Florensky, "Reverse Perspective," in *Beyond Vision: Essays on the Percep-
tion of Art*, ed. Nicoletta Misler, trans. Wendy Salmond (London: Reaktion, 2002)
197–272.

74. For a discussion of Florenksy's preemption of critical theory, consult Stephen
C. Hutchings, "Making Sense of the Sensual in Pavel Florenskii's Aesthetics: The Dia-
lectics of Finite Being," *Slavic Review* 58, no. 1 (1999) 96–116, esp. 98.

75. Joseph Masheck, "The Florenskian Icon 'In' Lacan?" *Word & Image* 26, no. 1
(2010) 52–58.

76. Bakhtin has coined the notion of "chronotope," which he defined as the "in-
trinsic connectedness of temporal relationships as they are artistically expressed in
literature." Mikhail Bakhtin, "Forms of Time and of the Chronotope in the Novel," in
The Dialogical Imagination: Four Essays by M. M. Bakhtin, ed. Michael Holquist, trans.

Byzantine art to believe they have long been ahead of the broader field of art history, not behind it. Most recently, Clemena Antonova has critiqued and expanded Florensky's theologically-informed theory of "reverse perspective."[77] Her alternative to Florensky's reverse perspective is "simultaneous planes," which grounds icons in the notion that "a timelessly eternal God to whom all moments in time exist simultaneously should be able to see all points in space simultaneously as well."[78] Antonova also provides a compelling case that such theological notions of time reached any Byzantine believer—educated or not—who participated in the liturgy. The intentional use of verb tenses in the Eastern Orthodox liturgy, such as "this *is* the night" in the Easter Vigil, transmitted concepts from "high" theology to the level of the normal believer.[79] This provides an important complement to Cormack's viewer perspective referenced above, showing theology to have perhaps saturated Byzantium more deeply than scholars had assumed. "The theological view," writes Clemena Antonova, " needs to be combined with visual studies in order to address the problem of how a visual image can intuit a theological dogma, analyzable in conceptual terms."[80] Antonova's approach has drawn criticism on historical grounds, but an appeal to the Byzantine sense of timelessness does not necessitate historical confusion because the notion is a Byzantine one, and exploring it consequently takes us deeper into the Byzantine mind. As we shall see, Antonova's compelling development of theologically-informed Eastern Orthodox aesthetics is of great help in interpreting the Virgin of the Passion. A theological interpretation of the Princeton Madonna nicely encapsulates these developments. When viewed theologically, new and unexpected significance is infused into this seemingly innocent icon of Mary; which is to say, in acquiring a Virgin of the Passion icon, Allan Marquand also acquired an unexpected theology of predestination, the very doctrine that may have prompted his doubts about Calvinism.

Caryl Emerson, (Austin: University of Texas Press, 1981) 84. According to Antonova, "this grew largely out of Russian concerns in the first quarter of the twentieth century, which we mentioned in the case of Florensky." Clemena Antonova, *Space, Time and Presence in the Icon: Seeing the World with the Eyes of God* (Burlington, VT: Ashgate, 2010) 24.

77. Antonova, *Space, Time and Presence*, 169. Florensky borrowed the term from Oscar Wulff, "Die umgekehrte Perspektive und die Niedersicht," in Oscar Wulff, *Kunstwissenschaftliche Beiträge, August Schmarsow gewidmet* (Leipzig: Hiersemann, 1907) 1–40.

78. Antonova, *Space, Time and Presence*, 107.

79. Ibid., 130.

80. Ibid., 166.

Predestination has a long and complicated history in Catholic and Protestant Christianity.[81] However, the doctrine appears far different when viewed in the context of Eastern Christianity. A church father so central to Byzantine thought on this issue was Athanasius, who in the fourth century was engaged in a dispute over an interpretation of the eighth chapter of Proverbs: "The LORD possessed me at the beginning of his work, the first of his acts of long ago. Ages ago I was set up, at the first, before the beginning of the earth."[82] Whereas the Arians, who denied Christ's full divinity, had interpreted this passage as proof that Christ was created ("the first of his acts") Athanasius interpreted the first act as Christ's establishment of salvation. "It was his purpose, for our sake," wrote Athanasius, "to take upon himself, through the flesh, the whole inheritance of judgment against us and thus henceforth to adopt us in himself . . . antecedent grace was stored up for us in Christ."[83] For Athanasius, "predestination" did not involve an impossible-to-determine number of saved or damned individuals, as it did for John Calvin.[84] Instead, the number was bound in the person of Christ. "[He] prepared beforehand the economy of our salvation in his own Word, through whom he also created us . . ."[85] It is frequently remarked that this understanding of predestination was ignored in verbal theology, until it was recovered in the twentieth century.[86] However, when Byzantine art itself is understood as theology, and Byzantine artists as theologians, the Athanasian position may have been more present than was supposed. Indeed, this Eastern perspective on what could fairly be called "predestination"[87] was intentionally grafted onto church frescoes in the twelfth century—the result of a theological dispute that was settled in paint.

81. For a recent treatment in the broader tradition, see Matthew Levering, *Predestination: Biblical and Theological Paths* (Oxford: Oxford University Press, 2011).

82. Prov 8:22–23 (NRSV).

83. Athanasius, *Orations against the Arians*, trans. Khaled Anatolios (New York: Routledge, 2004) 136.

84. John Calvin, *Institutes of the Christian Religion* 3.21, ed. John T. McNeill, trans. Ford Lewis Battles, (Louisville: Westminster John Knox, 1960) 2:920.

85. Athanasius, *Orations Against the Arians*, 135.

86. F. Stuart Clarke, "Lost and Found: Athanasius' Doctrine of Predestination," *Scottish Journal of Theology* 29 (1976) 435–50.

87. I use the term "predestination" loosely, not to squeeze Orthodox theology into Catholic and Protestant categories but to isolate a specific question to which Eastern theology can bring a fresh perspective (even if Eastern theology cannot be similarly parsed).

In 1156, Constantinople was embroiled in a eucharistic controversy. The ideas, which would soon be deemed heretical, were logical enough: the Eucharist is offered to the Trinity. The Eucharist, however, is Christ, and Christ is *in* the Trinity. Because Christ can't be offered to himself, evidently the Eucharist was *not* offered to the entire Trinity, but only to the Father and the Holy Spirit. The debate dragged on, and Nicholas of Methone was responsible for the final resolution. Yes, he argued, the Eucharist is the Son. Yes, the Eucharist is offered to the entire Trinity, including the Son. This mystery exceeded any syllogism. Nicholas's proof text for this position came from the liturgy, specifically from the famous prayer embedded at the end of the Cherubic hymn: "For you are the one who offers and is offered, who receives, and is distributed."[88]

Adopting Nicholas's argument, the Council of 1156–57 determined that the entire Trinity received the Eucharist. But this was Byzantium, where word and image worked symbiotically, so a mere textual reference—even if it was liturgical—was insufficient. Images were marshaled as well. The Council decided that fresco painters should place an image of the entire Trinity—Father, Son and Holy Spirit—near the locus of eucharistic consecration.[89] They did not need to invent a Trinitarian symbol, for one was already on offer in what is known as the *Hetoimasia*, or "Prepared Throne." Representing God's presence, this symbol depicts the invisible Father on the throne, the Son represented by the Gospel book and instruments of the Passion, and the dove of the Holy Spirit. The image's inclusion in frescoes and mosaics means that art historians can easily trace the effects of the Council of 1156–57. It is now possible to turn to the island of Cyprus, where both the *Hetoimasia* decreed by the Council, and the first known Virgin of the Passion, appeared.

The Prepared Throne, a symbol of the Trinity, has been interpreted in various ways throughout the history of art.[90] In short, whereas once scholars interpreted as merely a sign of judgment, later art historians have conceded that the symbol takes on different shades of meaning depending

88. The original text is: "Σὺ γὰρ εἶ ὁ προσφέρων καὶ προσφερόμενος, καὶ προσδεχόμενος καί διαδιδόμενος." *Liturgy of John Chrysostom* (Oxford: Oxford University Press, 1999) 23.

89. This is argued convincingly by Gordana Babić, "Les discussion christologiques et le décor des églises byzantine au XIIe siècle," in *Frühmittelalterliche Studien: Jahrbuch des Instituts für Frühmittelalterforschung der Universität Münster* 2 (1968) 387–97. See also Aston L. Townsley, "Eucharistic Doctrine and the Liturgy in Late Byzantine Painting," *Oriens Christianus* 58 (1974) 138–53.

90. Ida Sinkević, *The Church of Saint Panteleimon at Nerezi: Architecture, Programme, Patronage* (Wiesbaden: Reichert, 2000) 35–36.

on its context. The Prepared Throne takes on even more nuances of meaning when it appears in domes, especially on the island of Cyprus.[91] The Prepared Throne with the Arma Christi was uniquely popular in Cyprus, no doubt because of that island's connection with the true cross, a part of which Helen had deposited at Stavronikita monastery on Cyprus.[92]

There may, however, be an additional level of meaning, one that, so far, has not yet been considered. At least as it operates at Lagoudera, the Prepared Throne signifies God's primordial intention to save the world before it falls; which is to say, it can be understood to symbolize predestination in the Eastern understanding that we've already seen from Athanasius, who describes God's preemptive provision "prepar[ed] beforehand (προετοιμάζει)."[93] The term, προετοιμάζει is related to the words frequently depicted by Byzantine artists near the Prepared Throne, ἑτοιμασία (lit. preparation). The Prepared Throne at Lagoudera may not be merely eschatological, but protological as well.[94]

Support for this interpretation comes from the fact that Psalm 9:7, the basis for the eschatological interpretation of the symbol, was not the only Septuagint verse associated with it. There was another psalm quotation with the Greek word ἑτοιμασία in it, Psalm 89, which is not only about judgment, but is a psalm about God's creation of the world as well.[95]

91. Annemarie Weyl Carr, *A Byzantine Masterpiece Recovered: The Thirteenth-Century Murals of Lysi, Cyprus* (Houston: Menil Collection, 1991) 50, 53. For a list of domes with such themes in Cyprus, see Athanasios Papageorghiou, "The Paintings in the Dome of the Church of the Panagia Chryseleousa, Strovolos," in *Medieval Cyprus: Studies in Art, Architecture, and History in Memory of Doula Mouriki* (Princeton: Princeton University Press, 1999) 151.

92. For an excellent book-length exploration of the theme of the cross with a focus on Cyprus, see Andreas Stylianou and Judith Stylianou, *By This Conquer* (Nicosia: Publications of the Society of Cypriote Studies, No. 4, 1971).

93. See note 85 above. Greek text quoted in Karl Barth, *Church Dogmatics*, II/2 (Edinburgh: T. & T. Clark, 1957) 108.

94. In addition to the liturgical meaning, Nicolaïdès suggests that the *Hetoimasia* at Lagoudera signifies the sovereignty of Christ, connected as it is to the cupola, and he interprets the instruments of the Passion as soteriological. I do not see this as mutually exclusive with my protological interpretation. Andréas Nicolaïdès, "L'église de la Panagia Arakiotissa à Lagoudéra, Chypre: Étude iconographique des fresques de 1192," *Dumbarton Oaks Papers* 50 (1996) 40.

95. Th. Von Bogyay, "Zur Geschichte der Hetoimasie," in *Akten Des XI. Internationalen Byzantinistenkongresses München 1958*, eds. Franz Dölger and Hans-Georg Beck (Munich: Nendeln Liechtenstenin Kraus, 1978) 59. The relevant line in the Septuagint from Ps 9:8 (9:7 in standard Bibles) reads "καὶ ὁ κύριος εἰς τὸν αἰῶνα μένει, ἡτοίμασεν ἐν κρίσει τὸν θρόνον αὐτοῦ." (But the LORD sits enthroned forever; he has established his throne for justice). Psalm 88:15 in the Septuagint (89:14 in standard Bibles) reads

In addition, a late Byzantine, bilateral icon of Mary with Christ contains a *Hetoimasia,* on which an open gospel book explicitly conveys a note of predestination: "Come, blessed of my Father, inherit the kingdom prepared (ἡτοιμασμένην) for you from the foundation of the world" (Matt 25:34).[96] The message of the dome and drum at Lagoudera is, furthermore, not exclusively about the end of time (Figure 7). The scrolls held by Jonah, Gideon, Elijah, Elisha, Daniel, and David do bear vaguely eschatological messages.[97] But this is complicated by Moses, also in the drum, who contains the standard verse about creation;[98] Solomon and Isaiah who prophecy the birth of Mary just below him;[99] Habbakuk, who speaks of how God's praise fills the earth;[100] and Jeremiah who speaks of wisdom.[101] The Lagoudera drum and dome are a complex combination of references to creation, salvation and judgment. Should the artist have wished to sound the theme of judgment, he could have included the Deesis, as at the similar and later Cypriot domes at Strovolos,[102] Trikomo,[103] or Lysi;[104] but he did not. He might also have included the Virgin, as at the very similar dome at St. Nicholas Chalidou in Attika, but he chose to present the Prepared Throne in isolation, which makes the protological interpretation

"δικαιοσύνη καὶ κρίμα ἑτοιμασία τοῦ θρόνου σου, ἔλεος καὶ ἀλήθεια προπορεύσεται πρὸ προσώπου σου." (Righteousness and justice are the foundation of your throne; mercy and truth go before you.)

96. Maria Vassilaki, *Mother of God: Representation of the Virgin in Byzantine Art* (Athens: Benaki Museum, 1999) 410–13.

97. For example, Jonah's inscription reads: "Now the word of the Lord came to Jonah son of Amittai, saying, 'Go at once to Nineveh, that great city, and cry out against it; for their wickedness has come up before me'" (Jonah 1:1–2, NRSV).

98. "In the beginning when God created the heavens and the earth" (Genesis 1:1, NRSV). For the other inscriptions, see David Winfield and June Winfield, *The Church of Panaghia tou Arakos at Lagoudera, Cyprus: The Paintings and Their Painterly Significance* (Washington, DC: Dumbarton Oaks Research Library and Collection, 2005) 130.

99. "Many women have done excellently, but you surpass them all" (Prov 31:29 NRSV).

100. "God came from Teman, the Holy One from Mount Paran. His glory covered the heavens, and the earth was full of his praise" (Hab 3:3 NRSV).

101. "He found the whole way to knowledge, and gave her to Jacob his servant and to Israel whom he loved" (Bar 3:36 NRSV).

102. Papageorghiou, "Paintings in the Dome," 155. The drum at Strovoulos, which more clearly references judgment with a Prepared Throne and a Deesis, contains only scrolls relating to judgment.

103. For Trikomo, see Carr, *Byzantine Masterpiece,* 49.

104. Ibid., 54–55.

possible.[105] Additional, albeit suggestive, evidence that this could be the throne prepared before the foundation of the world, is that David and June Winfield, the fresco restorers at Lagoudera, have suggested that the prepared throne would have been the first medallion painted in the church.[106] Perhaps the painter as theologian might have wanted to start the fresco program where God did: in the beginning.

The understanding of time developed by Byzantine theologians supports this understanding. For Basil the Great, angels inhabited the timeless realm with God.[107] For Gregory of Nazianzus, "things which produce Time are beyond time."[108] John of Damascus summarizes this Byzantine perspective on time in this way: "with His divine, all seeing, and immaterial eye [God sees] all things at once, both present and past and future, before they come to pass."[109] Should we add Athanasius's view of predestination to this perspective on time, this new interpretation of the Prepared Throne is amplified. Antonova concludes her compelling study by suggesting "There are many other aspects of the role of time in icon art that should be explored before we come to a satisfactory idea of its significance . . . leading towards an Eastern Orthodox aesthetics."[110] This interpretation of the Prepared Throne is one such instance.[111] Successive vision can function soteriologically; which is to say, God—who is beyond time—sees election, salvation, and judgment all at once, each of which are symbolized by the cross. That this has eluded art historians may be the result of our projecting Western temporality onto Byzantine art. This new

105. The protological theme, furthermore, also directly addresses the concern for devotional worship and individual salvation that Carr identifies in the dome of Lysi. Ibid.

106. "The Etoimasia shows considerably more evidence of plaster working than do the roundels of the angels, and it is reasonable to assume that this is the roundel where the painter started to work." Winfield and Winfield, *Church of Panaghia*, 123.

107. Philip Schaff and Henry Wallace, eds., *Nicene and Post-Nicene Fathers: Second Series*, vol. 8, *Basil: Letters and Select Works* (New York: Cosimo, 2007) 54.

108. Gregory Nazianzen, *Faith Gives Fullness To Reasoning: The Five Theological Orations of Gregory Nazianzen* (Leiden: Brill, 1991) 247.

109. St. John of Damascus, "The Orthodox Faith," in *Fathers of the Church*, vol. 37: *St. John of Damascus: Writings*, trans. Frederic Chase (New York: The Fathers of the Church, 1958) 203.

110. Antonova, *Space, Time and Presence*, 154.

111. For another, Robert Ousterhout suggested this element in Byzantine art when he explained that a funeral chapel at Chora "dramatically emphasizes the promise of salvation by means of imagery simultaneously invoking past, present, and future." Robert Ousterhout, "Temporal Structuring in the Chora Parekklesion," *Gesta* 34, no. 1 (1995) 65.

interpretation of the Prepared Throne has the advantage that it retains the established title "Prepared Throne," while adding another level of meaning: prepared not just for judgment, but from the foundation of the world as well. It is possible that "average" Byzantine worshippers, schooled in timelessness by the liturgy, might have grasped this perspective—one that education could possibly obscure.

It is not coincidence that the first Virgin of the Passion, with the angels hovering bearing the instruments of the Passion, appears just below the Prepared Throne at Lagoudera in Cyprus. The angels are not merely proleptic anticipations of the Passion, illustrating the prophecy of Simeon, who is depicted across the nave.[112] They also activate the throne prepared from the foundation of the world, obviated by the resemblance of Mary's throne to the Prepared Throne. The instruments of the Passion, known in the West as the Arma Christi, contain a distinct meaning in the East, attached as they are to a unique theology of predestination in Christ. These angels are inhabitants of Basil's timeless realm who convey Athanasius's understanding of predestination in the person of Christ. The angels hovering above Mary and Christ in the Princeton Madonna retain distant echoes of this perspective on the doctrine of election. If "the historical theologian must look not only to explicitly theological texts, but also to works of art,"[113] then the theological record is altered. The Athanasian understanding found visual form in the work of the wise theologian-painter of the church at Lagoudera,[114] and was consequently echoed anywhere those mysterious angels with the instruments of the Passion appear.

In his book on predestination, the twentieth-century Catholic theologian Reginald Garrigou-Lagrange wrote, "The chiaroscuro effects of this sublime doctrine are incomparably greater than those we admire in the works of the greatest artists."[115] But at least one artist, the painter at Lagoudera, was able to communicate the sublimity of that doctrine as well. Accordingly, when the deep background of the Princeton Madonna

112. Henry Maguire, "The Iconography of Symeon with the Christ Child in Byzantine Art," *Dumbarton Oaks Papers* 34–35 (1980–1981) 263.

113. Viladesau, *Theology and the Arts*, 127.

114. For arguments that the name of the painter at Lagoudera is Theodore Apsevdis, see Maria Panayotidi, "The Question of the Role of the Donor and of the Painter: A Rudimentary Approach," in *Deltion* 17 (1993–1994) 143–56; and Sophocles Sophocleous, "Le Peintre Theodoros Apsevdis et son entourage, Chypre 1183 et 1192," in *Byzantinische Malerei: Bildprogramme—Ikonographie—Stil*, ed. Guntram Koch (Wiesbaden: Reichert, 2000) 307–20.

115. Reginald Garrigou-Lagrange, *Predestination*, trans. Dom Bede Rose (London: Herder, 1939; Rockford, IL: Tan, 1989) 335.

is understood, the prejudice against theology in the historiography of Byzantine art, and the theological prejudice against images that helped inaugurate art history in America, are both subtly undermined. By directing Allan Marquand to teach the history of art, College of New Jersey President James McCosh was actually sending him *deeper* into theological terrain. When the exiled philosopher turned art historian lifted up his bidding card at an auction hall in 1911 to purchase what would become the Princeton Madonna, he was not only buying an attractive painting to rival those in the Uffizi. He also purchased an ancient answer to a vexing theological question. That icons might offer such answers is finally something that the discipline devoted to studying them is more consistently willing to entertain.

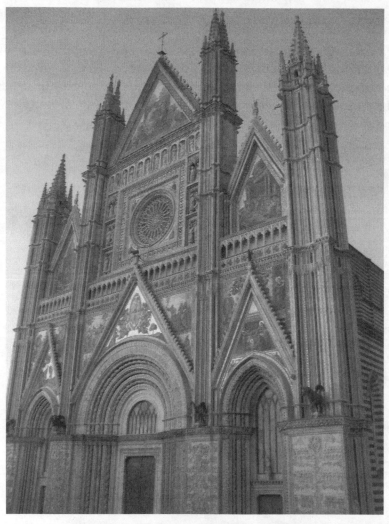

Figure 8. Orvieto Cathedral, 13th–14th c., Orvieto, Italy.
Photo permission of Rachel Hostetter Smith.

Marginalia or Eschatological Iconography?

Providence and Plenitude in the Imagery of Abundance at Orvieto Cathedral[1]

RACHEL HOSTETTER SMITH

From its origins in the third and fourth centuries, a significant element of Christian art has been richly foliated imagery. Wreaths and garlands burgeoning with fruits and flowers often populated by insects, birds, and other small creatures as well as borders of vinescrolls and brightly colored flowers are elements that typically appear in foliate imagery. Between the early eighth and tenth centuries, this imagery had come to pervade Christian art and architecture; its development reached a culmination between the fifteenth and seventeenth centuries. Known for its lavish embellishment inside and out, the Cathedral of Orvieto in Italy (Figure 8) evidences both the pervasive appearance of foliate imagery in the fifteenth and seventeenth centuries as well as the multiplicity of ways it was employed.[2]

Despite the omnipresence of this imagery, foliated motifs have commonly been dismissed as mere decoration. Not only has the significance of foliated imagery been overlooked generally but also the study of the Cathedral of Orvieto evidences this problem. What has been widely viewed as embellishment or filler is in actuality imagery laden with deep

1. This essay is developed from a paper, "Providence and Plenitude: The Imagery of Abundance in Christian Art and Architecture," delivered at the ASCHA symposium "History, Continuity, and Rupture: A Symposium on Christianity and Art," May 2010.

2. For an overview of the cathedral, see Eraldo Rosatelli, *The Cathedral of Orvieto: Faith Art Literature* (Perugia: Quattroemme, 2000). See also Lucio Riccetti, *Il duomo di Orvieto* (Roma: Editori Laterza, 1988). For information specifically on the Chapel of the Corporal, see Catherine D. Harding, *Guide to the Chapel of the Corporal of Orvieto Cathedral* (Perugia: Quattroemme, 2004).

symbolism and intentional meaning. What might be perceived as visual marginalia is central to the primary text. Certain questions remain to be asked concerning the prevalence of foliated motifs in early Christian and medieval art. Where did this imagery come from? What did it mean? And why did it become so prevalent in Christian art and architecture?

An historical investigation that draws on a wide variety of Roman sources reveals the beliefs and perceptions that informed these motifs, first as they appeared in their original pagan context and then as they were adopted and adapted by the Christian church, developing an iconography that could communicate effectively to their intended audiences as Christianity spread. The Cathedral of Orvieto affords the opportunity for a close theological reading of these elements in a specific context that demonstrates their significance as part of a carefully constructed system of signs that embodied ideas essential rather than peripheral to the faith.

The Cathedral of Orvieto is primarily known for one of two things: as the site where the Pope instituted the Feast of Corpus Christi or for the dramatic apocalyptic narrative frescoes (Color Plate 6) by Luca Signorelli (c. 1445–1523). Interest in these aspects of the cathedral and its history has tended, however, to eclipse other components of the cathedral and its decoration. For most of the last century, art historical research has focused on what are seen as the primary works of art—altarpieces, sculptures, and narrative fresco programs, for example, and the interpretation of major iconographical motifs like the Tree of Jesse or the Tree of Life. Only recently has the scope of art historical inquiry expanded to include the need to situate those works within their larger historical and physical contexts and to consider the role of infrastructure, framing, and other so-called "marginalia"—elements that can affect the reception of those works and alter their interpretation in significant ways. Although a great deal has been written on the Signorelli frescoes, there is virtually no mention of the foliate imagery that frames the scheme much less any consideration of its interpretation as a part of the whole of the completed program. Even relatively recent in-depth studies of the program of the San Brizio Chapel such as *How Fra Angelico and Signorelli Saw the End of the World* by Creighton E. Gilbert and *Signorelli and Fra Angelico at Orvieto: Liturgy, Poetry and a Vision of the End-time* by Sara Nair James focus on the apocalyptic vision depicted in the primary narrative registers without consideration of the significance of the infrastructure that underpins the whole.[3]

3. For an overview of Signorelli's work, see Tom Henry Laurence Kanter, *Luca Signorelli* (New York: Rizzoli, 2002). For in-depth studies of the program of the San

The Cathedral of Orvieto was constructed in the late thirteenth to fourteenth centuries at the behest of Pope Nicholas IV to commemorate the Miracle at Bolsena, an event that came to represent God's assurance to the faithful in times of spiritual pilgrimage and doubt.[4] Foliate imagery can be found throughout the architecture and art of the cathedral.[5] For example, the vinescroll framework of the reliefs on the four pillars of the façade, created in the early fourteenth century by Lorenzo Maitani (c. 1275–1330), chronicles the outworking of God's relationship with mankind from Creation to Last Judgment. Inside the cathedral, foliate imagery is found on the architectural and painted infrastructure framing the frescoed narrative scenes in the central choir depicting the life of the Virgin Mary and in the Chapel of the Corporal with its eucharistic theme, both dating to the fourteenth century. The ribs of the Gothic vaults of the Chapel of the Madonna di San Brizio with its fifteenth and sixteenth century frescoes by Fra Angelico and Luca Signorelli are painted to look like festal garlands heavy with fruit complementing its eschatological theme.

In the medieval mind, the things of this world—and nature in particular—served as signs of divine truth and a higher reality.[6] This mindset permeated the imagery of the Middle Ages and informs an understanding of what appears at Orvieto. The inclusion of such foliate imagery establishes the underpinning of God's abundant provision—plenitude—as one confronts God's plans for reconciling mankind to himself—providence.

Brizio Chapel, see Jonathan B. Riess, *Luca Signorelli* (New York: Braziller, 1995). See also Creighton E. Gilbert, *How Fra Angelico and Signorelli Saw the End of the World* (University Park: Pennsylvania State University Press, 2003); and Sara Nair James, *Signorelli and Fra Angelico at Orvieto: Liturgy, Poetry and a Vision of the End-time* (Burlington, VT: Ashgate, 2003).

4. The Miracle of Bolsena recounts the experience of a Bohemian priest who undertook a pilgrimage to Rome in 1263–64 to pray at the tomb of St. Peter because of his doubt about the doctrine of transubstantiation. On his journey home from Rome, he stopped in Bolsena where, on celebrating the Mass he saw blood dripping from the host onto the altar cloth—the Corporal—affirming his faith in the truth of transubstantiation. Pope Urban IV, who was in residence in nearby Orvieto at the time, heard of this event and asked that the cloth be brought to Orvieto as verification of the miracle. After doing so, he established the Feast of Corpus Christi for celebration by the entire Christian Church.

5. Even today it is employed in the sacred events celebrated at the cathedral like the Feast of the Palombella on Pentecost that culminates with the dramatic arrival of the dove of the Holy Spirit to a canopy draped with evergreen garlands mounted in front of the entrance to the church.

6. Nature and culture were inextricably entwined in the medieval mind. But just as nature and culture were seen as informing each other in medieval thought, so too were the material and the spiritual, the secular and the sacred, the temporal and the eternal.

It reflects the promise of God's provision manifest in the Eucharist that is eschatological in implication, pointing to God's ultimate intent for his creation. In order to understand this imagery in a Christian context, it is first necessary to investigate its origins in the ancient pagan world and then to see the ways in which the early Christians appropriated these widely understood symbols in order to embody specifically Christian concepts and doctrine.

An investigation of the origins of this imagery reveals that the early Christian church appropriated these forms from pagan antiquity in order to convey key elements of the faith. In his book *The Ara Pacis Augustae and the Imagery of Abundance in Later Greek and Early Roman Imperial Art*, David Castriota traces the origins and multifaceted uses of this imagery in the pagan pre-Christian world.[7] Examining works such as the Ara Pacis Augustae (13–9 BC) (Color Plate 7), he presents a meticulous analysis of the foliate motifs and their meanings. Drawing on a wide range of texts from the ancient Mediterranean world, he demonstrates how a powerful and symbolic vocabulary of flora and fauna was widely understood in the ancient Mediterranean as themes of the peace and prosperity enjoyed by the Roman world under Augustan rule.[8]

Castriota introduces a number of concepts as key to understanding the message of peace and prosperity embedded in foliate imagery that

7. David Castriota, *The Ara Pacis Augustae and the Imagery of Abundance in Later Greek and Early Roman Imperial Art* (Princeton: Princeton University Press, 1995).

8. Foliate imagery pervades, even dominates, the monument. It accounts for well over half of the surface area of the sculptural relief on the exterior. It does not just provide the framework for the figural panels but underpins those scenes, filling the entire lower register. Inside the altar, the walls of the surround are adorned with reliefs depicting garlands heavily laden with fruits, appropriate to that sacred space. Castriota demonstrates the widespread usage of such garlanded imagery for altars in the ancient world. The notion that there had previously been a Golden Age when "the oaks themselves gave forth honey" was revived as a major theme of Augustan literature. Quote from the poet Tibullus c. 55–19 BC, see Castriota, *Ara Pacis Augustae*, 221n63. But now it celebrated Augustan rule as the establishing of a new order that brought about a new "Golden Age" under Octavian. For more on this promotional strategy, see Castriota, *Ara Pacis Augustae*, 124–69. In the hymn "What Makes the Crops Rejoice" from *The Georgics*, for example, Virgil hails Octavian as "a great provider," a "godlike man" who "may become like a deity of land." From the translation of the poem in Linnea H. Wren and David J. Wren, *Perspectives on Western Art: Source Documents and Readings from the Ancient New East through the Middle Ages* (New York: Harper & Row, 1987) 126–27. This idea of provision is developed more fully in the Tellus relief of the Ara Pacis, linking the "interrelated themes of the fertility of the earth, the bounties of nature, and the blessings of peace." From the commentary on the Tellus relief in Wren and Wren, *Perspectives on Western Art*, 125.

are also essential to the meaning in Christian imagery: polycarpophoric, polytheriotrophic, and theonomous imagery, and the numen mixtum. In the ancient world the tradition of polycarpophoric imagery—including "many fruits"—and panspermia—"a mixture of seeds"—involved the simultaneous flowering and fruiting of plants from all the seasons. It signified an "unnatural bounty" that only the supernatural power of the gods could provide.[9]

Theriotrophic tendril ornament renders plant life that supports and nourishes animals; polytheriotrophic then refers to the support of many different kinds of animal life, again suggesting variety and abundance. Tendril compositions are fundamentally "theonomous"; that is, they signify the generative power of divinities.[10] Castriota demonstrates that the people of the ancient Mediterranean world "had long become used to tendril ornament as an emblem of divine power" so that "for any spectator of the period attuned to the notion of a bountiful new order, this long-accumulated religious and artistic experience would have been ample preparation for absorbing the imagery of divinely sanctioned peace that unfolded ornamentally across the looming expanse of stalks and volutes brimming with the gifts of Rome's heavenly protectors."[11]

In both the ancient Greek and Roman worlds, a large variety of plants and their produce: laurel, ivy, grape, oak, pine, pomegranate, poppy, fig, olive, myrtle, apple, pear, wheat or barley, and various types of nuts were commonly found symbols of fertility and divine beneficence at altars and sanctuaries.[12] The most prevalent plant in ancient sanctuaries was, however, acanthus. J. J. Pollini has demonstrated that acanthus alludes to "the attributes of Apollo" reflecting "the prophetic renewal and transformation ushered in by the Golden Age."[13] This "imagery of abundance," as Castriota dubs it, was generously employed by Augustus. It appears on artifacts

9. See Castriota, *Ara Pacis Augustae*, 13–33. For more information on polycarpophoric ornament— panspermia specifically, ritual offerings consisting of a wide array of seeds or fruits, see ibid., 247.

10. For polytheriotrophic ornament, see ibid., 41–57. On theonomous ornament, see ibid., 58–86.

11. Ibid., 72–73.

12. Ibid., 31.

13. J. J. Pollini, "The acanthus of the Ara Pacis as an Apolline and Dionysiac Symbol of Anamorphosis, Anakyklosis, and Numen Mixtum," in *Von der Bauforschung zur Denkmalpflege: Festschrift für Alois Machatschekn zum 65. Geburtstag*, eds. Martin Kubelík and Mario Schwarz (Vienna: Phoibos, 1993) 181–217. For a discussion of acanthus imagery in antiquity, see Joseph Rykwert, "The Corinthian Order," in *The Necessity of Artifice* (New York: Rizzoli, 1982).

as diverse as cups and vases and in the frescoes of the Garden Room of the Villa Livia. Barbara Kellum has convincingly argued that the many varieties of laurel, which in the ancient world was understood to have purifying and healing properties, depicted on Augustan artifacts came to be metonymous with Augustus himself.[14] According to Kellum, so effective was this campaign of Augustus, first Emperor of Rome, to promote the Pax Augustae that when a Roman saw laurel, he or she thought of Augustus. Equally clear associations with Christ also occurred as this same imagery was appropriated by Christians.

The numen mixtum refers to the balancing of the forces of Apollo and Dionysos, a balance that creates the homonoia or concord that makes possible not only stability but what the historian Diodorus Siculus (fl. c. 60 BC – c. 21 BC) referred to as "abundant peace."[15] This "mixture" or balance is essential because order is a necessary condition for prosperity. Underlying the burgeoning vegetation there is an orderly structure—a matrix that restrains the growth so that it feeds and nurtures without choking the life it contains. The tendrils grow in regular spiral forms that create a discernible pattern. As in a garden, it is a sign of the careful cultivation that must occur to allow for optimal produce. It reflects the synergy of perfect order and ebullient life, of the divine and nature. These ancient ideas came to inform the imagery adopted by the early Christian church to manifest the doctrine of the incarnate Word—of Christ as both the generative source of the original creation and the regenerative power that came with his death and subsequent resurrection. It quickly permeated the art and architecture of the church, as a few salient examples demonstrate, establishing a symbolic language that would communicate complex and profound theological concepts effectively for centuries to come.[16]

At the mausoleum of Santa Costanza in Rome (c. 350) the subject of the grape harvest appears rendered in a crisp spritely pattern of vines

14. Barbara Kellum, "The Construction of Landscape in Augustan Rome: The Garden Room at the Villa ad Gallinas," *Art Bulletin* 76, no. 2 (1994) 211–24.

15. Castriota, *Ara Pacis Augustae*, 105. On the numen mixtum, see ibid., 106–23.

16. For discussion of the tensions between the pagans and Christians and the appropriation of pagan imagery for Christian purposes, see Thomas F. Mathews, *The Clash of Gods: A Reinterpretation of Early Christian Art* (Princeton: Princeton University Press, 2003). For more information on the origins of Christian art beyond Mathews, see Michael Gough, *The Origins of Christian Art* (New York: Praeger, 1973); Josef Strzygowski, *Origin of Christian Church Art*, trans. O. M. Dalton and H. J. Braunholtz, (New York: Hacker, 1973); and André Grabar, *Christian Iconography: A Study of Its Origins* (Princeton: Princeton University Press, 1968).

in the mosaic ceiling of the ambulatory.[17] Appropriated from pagan Roman floor mosaics, the so-called "unswept floor" design also found in the vault mosaics presents a profusion of sprigs of pine and fruit trees, birds feasting on grapes amidst musical instruments, and bowls and pitchers scattered seemingly at random suggesting the joyous abandon of the heavenly banquet awaiting the believer. A peacock stands as a reminder of the resurrection and immortality.[18] These mosaic "carpets" so often used for paving the floors of pagan Roman structures have been lifted to the vaults overhead drawing the focus heavenward to a visual feast that adumbrates the princely banquet that awaits the believer in the life to come, highly fitting for the mausoleum of the emperor Constantine's daughter.[19]

In his book *Landscape and Memory* historian Simon Schama explores the origins of the Verdant Cross, which conflates the edenic tree of life with the cross of the crucifixion. The attribution of miraculous life-giving powers to the cross itself was widespread and soon became attached to the plant or tree form that was fully consistent with established symbols in the ancient pagan Mediterranean world.[20] The Old English poem "The

17. The theme of the grape harvest was common in early Christian images. The Good Shepherd sarcophagus from the late fourth century in the Lateran Museum presents Christ as the Good Shepherd amidst a grape harvest, two themes that have their source in Scripture. While these motifs are certainly symbolic referents to the sacrament of the Eucharist, it is the happy profusion of vines heavy with bunches of grapes that creates the most immediate and lasting impact. The scene throbs with life, the entire surface covered, populated with birds nibbling on vines and plump energetic cherubs milking sheep and tending to the grape harvest. Bounty and vigor abound—conceptions appropriate for the casket of a believer who has passed into the abundance of life eternal on his death. For information on early Christian art and architecture, see André Grabar, *Early Christian Art AD 200–395* (New York: Odyssey, 1968); John Beckwith, *Early Christian and Byzantine Art*, 2nd ed. (New York: Penguin, 1979); Richard Krautheimer, *Early Christian and Byzantine Architecture*, 4th ed. (New York: Penguin, 1986); Gertrud Schiller, *Iconography of Christian Art*, vol. 1, trans. Janet Seligman 1969 (New York: New York Graphic Society, 1971); and Paul Corby Finney, *The Invisible God: The Earliest Christians on Art* (New York: Oxford University Press, 1994).

18. For widely used sources for Christian symbolism, see George Ferguson, *Signs & Symbols in Christian Art* (Oxford: Oxford University Press, 1954); and Gertrude Grace Sill, *A Handbook of Symbols in Christian Art* (New York: Macmillan, 1975).

19. Notably, even Costanza's porphyry sarcophagus, now in the Vatican Museum, is decorated with interlaced tendril ornament and garlands like that found on the Ara Pacis.

20. Simon Schama, *Landscape and Memory* (New York: Knopf, 1995) 214. In the fourth century "the emperor Theodosius I erected a large golden cross, encrusted in gems and in the form of a burgeoning, flowering plant" in the Holy Sepulcre in Jerusalem, Schama recounts. The "palmate form of the tree-cross," as he puts it, may well derive from perceptions of the unusual fecundity of the palm which was considered

Dream of the Rood" takes the relationship between the tree and the cross one step further, describing how the humble Rood—the cross—came to be covered in gold and gems—transformed—to reveal its true worth. As the Rood explains, "Now the time has come that men far and wide upon earth honor me—and all this glorious creation—and pray to this beacon. On me God's Son suffered awhile; therefore I tower now glorious under the heavens, and I may heal every one of those who hold me in awe."[21] In the medieval mind, the spiritual "healing" power described by the Rood extended to physical ailments. This property was first recounted in the story of the finding of the true Cross by St. Helena in the Holy Land and confirmed by figures with the stature of the Venerable Bede. But it was not only fragments of the true cross that were attributed miraculous regenerative powers but images of the cross as well. St. Willibald, the eighth-century English missionary to Germany, recounted an event from his own childhood that reveals the power attributed to the stone crosses erected in the British Isles. Willibald had fallen deathly ill so his parents laid his body at the foot of one of those crosses promising God that if he were healed they would dedicate him to the church. He was and they did, marking the beginning of Willibald's service to the church.[22]

These stone crosses are commonly decorated with spiraling vegetal tendrils that support and nourish birds and other "animal" life bearing witness to this regenerative power. These designs appear on the sides of the Ruthwell Cross (c. 700), one of the best-known of such early stone crosses. The narrative scenes of the Gospel depicted on the front and back make the meaning of this "marginalia" on the sides quite clear.[23] The

"a source of life in arid places, producing honey, bread, and even, according to Pliny, a kind of wine . . . Pliny also repeated one of the many stories of palms that perpetually revived themselves, new leaves constantly appearing at the site from which dead fronds had dropped" giving them "a magical aura of immortality."

21. The first appearance of "The Dream of the Rood" in manuscript form dates to the late tenth century but the poem may have been conceived a full three centuries earlier. For commentary and the translation of the poem quoted here, see M. H. Abrams, *The Norton Anthology of English Literature*, vol. 1 (New York: Norton, 1974).

22. C. H. Talbot, "Huneberc of Heidenheim: The Hopoeporican of St. Willibald, 8th Century," in *The Anglo-Saxon Missionaries in Germany, Being the Lives of SS. Willibrord, Boniface, Leoba and Lebuin together with the Hodoepericon of St. Willibald and a selection from the correspondence of St. Boniface* (London: Sheed and Ward, 1954).

23. For more on the Ruthwell Cross and Ritual and the Rood, see Brendan Cassidy, *The Ruthwell Cross* (Princeton: Princeton University Press, 1992). On the link between images of the cross and contemporary literary sources see Éamonn Ó. Carrigáin, *Liturgical Images and the Old English Poems of the Dream of the Rood Tradition* (London and Toronto: British Library and University of Toronto Press, 2005).

tendril decoration is theriotrophic just like that found in pagan antiquity. Moreover, the regular, spiral interlace vines follow a clear pattern, conforming to an established order. They appear cultivated to nurture and sustain the creatures that harbor there.

In his article "Seeing and Reading: Some Visual Implications of Medieval Literacy and Illiteracy," Michael Camille linked the images of all manner of creatures nibbling on tendril ornament commonly found in the margins of Medieval manuscripts to the monastic practice of ruminatio.[24] Camille convincingly argues that the rendering of such images around the primary text or image served as a kind of mnemonic device—a reminder to the reader to masticate or "chew" on the Word of God that nourishes the spirit just as earthly food bolsters the body. Understanding this adds yet another dimension to the appearance of feasting birds and other living creatures in the imagery of abundance employed in so many different contexts.

The detectable matrix seen in tendril ornament is an essential element of images depicting the work of divine providence in Christian imagery. Depictions of the Tree of Jesse, like that in the stained glass window at Chartres Cathedral or the wooden cathedra in the Cloisters Museum in New York, present the lineage of the house of David to Mary and Christ at the very top, tracing the means by which God would bring the Messiah into the world and through him the redemption of mankind.[25] In the Middle Ages, as in antiquity, gardeners often trained plants in the form of an espalier to encourage just the right kind of growth that would bring forth fruit of the best quality and greatest quantity.[26] These meticulously pruned and trained trees and vines extend their branches outward in nearly symmetrical pairs creating a lattice stretching ever upwards, their form a veritable anagogicus mos, to borrow the term used by the Abbot Suger of St.

24. Michael Camille, "Seeing and Reading: Some Visual Implications of Medieval Literacy and Illiteracy," in *Art History* 8 (1985) 26–49. Camille has had a significant impact on the understanding of marginalia in Medieval art. For the development of this early work and its expansion to the consideration of the function of "marginalia" in other aspects of Medieval art, see Michael Camille, *Image on the Edge: The Margins of Medieval Art* (Cambridge, MA: Harvard University Press, 1992).

25. On the Tree of Jesse, see Arthur Watson, *Early Iconography of the Tree of Jesse* (London: Oxford University Press, 1934); and Michael D. Taylor, "Historiated Tree of Jesse," *Dumbarton Oaks Papers* 34 (1980–1981) 125–76.

26. For information on the Medieval gardens and how the Cloisters gardens are designed to include the diversity of species cultivated in the Middle Ages and reflect the practices employed for optimal produce, see Bonnie Young, *A Walk Through the Cloisters* (New York: Metropolitan Museum of Art, 1988).

Denis, marking the "upward-leading way."[27] This ordered structure of the espalier plots the line from Jesse to Christ, which is often shown sprouting from a densely packed root ball lodged in the cavity of Jesse's prone body emphasizing the preparation and nurture involved in the cultivation of this lineage. God's providence is evident in this form of the ancestral tree that bodies forth divine intention, tracing his plan for making possible new and everlasting life.

This meticulously interlocking plan is made manifest in the twelfth-century Cross of Bury St. Edmunds.[28] The front of the cross is carved to represent a tree hewn to form the cross on which the Christ was crucified, revealing the pruned stubs of branches that sprouted at regular intervals.[29] The back of the cross depicts figures of the Old Testament prophets linked by their prophecies inscribed on scrolls, each providing a connection to the next. It is an ordered progression that culminates in the death and resurrection of Christ and, thus, in the regeneration of the human race. The animate order of God's plan is even more fully celebrated in the twelfth-century apse mosaic of San Clemente in Rome that pictures the cross as the Tree of Life. The elegantly spiraling tendrils which sprout from the foot of the cross have obliterated all chaos leaving only a glorious harmony resonating throughout the universe.[30]

This brief overview reveals just how varied and ubiquitous the imagery of abundance is in early Christian and medieval art and architecture. It clearly demonstrates the way that foliate imagery was used to bear witness to Christ's vivifying power[31] in so many different contexts and lays the

27. On the anagogicus mos, see Erwin Panofsky, *Abbot Suger on the Abbey Church of St.-Denis and Its Art Treasures*, trans. Erwin Panofsky, second edition by Gerda Panofsky-Soergel (Princeton: Princeton University Press, 1946, 1979) 64–65.

28. For an in-depth analysis of the Cross of Bury St. Edmunds, see Elizabeth C. Parker and Charles T. Little, *The Cloisters Cross: Its Art and Meaning* (New York: Metropolitan Museum of Art, 1994).

29. For an article on the pruned vines employed in the ribbed vaulting of German churches: Ethan Marr Kavaler, "Nature and the Chapel Vaults at Ingolstadt: Structuralist and Other Perspectives," *Art Bulletin* 87, no. 2 (2005) 230–48. This builds on ideas introduced by Kavaler in an earlier article: Ethan Marr Kavaler, "Renaissance Gothic in the Netherlands: The Uses of Ornament," *Art Bulletin* 82, no. 2 (2000) 226–51.

30. For literature related to the Tree of Life, see Suzanne Lippincott Mallory, "The Tree of Life in Christian Iconography," thesis, George Washington University, 1967; Sharon Ann Coolidge, "The Grafted Tree in Literature: A Study in Medieval Iconography and Theology," PhD diss., Duke University, 1977; and Frederick Hartt, "Lingum Vitae in Medio Paradisi The Stanza d'Eliodoro and the Sistine Ceiling," *Art Bulletin* 32 (1950) 115–45.

31. This central mystery of the Christian faith is described perhaps most poignantly

foundation for grasping the significance of this ornament as it appears in the structure and space of Orvieto Cathedral, specifically in the sculptural reliefs on the façade and the fresco paintings of the San Brizio Chapel.

In his book *Sketches and Studies in Italy and Greece*, John Addington Symonds introduced the cathedral this way, "Finished as it is, the façade of Orvieto presents a wilderness of beauties . . . A statue stands on every pinnacle; each pillar has a different design; round some of them are woven wreaths of vine and ivy; acanthus leaves curl over the capitals, making nests for singing birds and Cupids . . . On every square inch of this wonderful façade have been lavished invention, skill, and precious material."[32] This description captures the particular quality of this cathedral that is unusually festooned in foliage and all manner of adornment, both inside and out. Even the alternating green and white striped stonework of the building underscores the symbolism of new life and generative power that serves as the backdrop for all of the other imagery that appears at the cathedral. In medieval art, green was commonly used to signal the new life made possible through the cross of Christ.[33] So widespread was this usage that when it appears in a sacred context, even as the choice of building material, its significance should not be overlooked.

in the opening passages of the first chapter of the Gospel of John which make clear the multiple yet unitary identity of Christ—the Word who became flesh—as Creator, Sustainer, Redeemer, and Lord. It definitively links the Creator of Genesis, with the Christ of the Gospels, and the Apocalyptic Judge and King of Revelation. The Hunt of the Unicorn Tapestries (dating to around 1500) now in the Cloisters Museum are understood on one level to present an allegory of the incarnation and crucifixion. One of the most distinctive features of the tapestries is their use of a foliate landscape, burgeoning with flowers and fruits and all kinds of living creatures. While the plants in an actual garden of necessity follow the dictates of nature, each blooming in their appointed season, the designers of the Unicorn Tapestries were bound by no such constraint. Instead, they depict the plants of all seasons simultaneously in full flower and fruit, defying the laws of nature. This visible breaking of the bonds of nature carries in it a key theological idea. It is a sign that the Christ, represented in the shape of the Unicorn in the tapestries, has broken the temporal cycle of life and death to which all of creation had been condemned. This seemingly "unnatural" fecundity of the earth signals the inauguration of a new, more abundant life that is not bound by the strictures of the old law. It signifies the coming of the New Age. See John Williamson, *The Oak King, The Holly King, and the Unicorn: The Myths and Symbolism of the Unicorn Tapestries* (New York: Harper & Row, 1986). This idea bears a strong correspondence to the theonomous aspect of such imagery in pagan antiquity as it relates to the bountiful new order of a Golden Age.

32. John Addington Symonds, *Sketches and Studies in Italy and Greece,* Third Series, new ed. (New York: Scribner's Sons, 1898) 144.

33. See for example, the bright green of the cross on which Christ's body hangs in the stained glass window of the passion story at Chartres Cathedral.

The façade reliefs created by Sienese sculptor Lorenzo Maitani in the early fourteenth century employ generative foliate imagery in the prominent use of the espalier. Each of the four pillars of the façade at Orvieto bears a vine, carefully trained and cultivated, that upholds the sacred histories presented there.[34] Although a significant amount has been written on the Maitani reliefs (primarily in Italian), the species of the vines is barely mentioned, reflecting a failure to recognize the way in which that information expands and deepens the theological understanding of the histories depicted there. From left to right the pillars represent Genesis with a tree of the creation and fall, the Old Testament with a tree of the law, the New Testament with a tree of the gospel, and Revelation with a tree of judgment. Together they present the viewer with the unity of the doctrines of creation, fall, redemption, and judgment that reveals the hand of God at work in history to bring about the restoration of mankind—and all creation—to himself.

The first, on the far left of the façade, employs a vine of ivy (Figure 9). It presents the story of the good of the creation to the first murder—of Abel by his brother Cain—ending with the toil that is the lot of fallen humanity at the top. Ivy is closely associated with death and the immortality of the soul. Because it is evergreen, it is a symbol of faithfulness and eternal life. The ivy, which clings to its support, is also a symbol of attachment and undying love. Because of its tenacity it becomes associated with Christ. The ivy vine twines in and out of these events, creating an infrastructure that literally bears the weight of the story of mankind's fall; it is a sign of God's faithfulness, undying love, and promise of help in spite of mankind's rejection.[35]

34. On Maitani's façade reliefs, see A. Nardini Despotti Mospignotti, *Lorenzo del Maitano e La Facciata del Duomo d'Orvieto* (Roma: Tipografia dell'Unione Cooperative Editrice, 1891); and Fulvio Cervini, "Tralci di vita e paradise di marmo: Per una lettura iconografica della facciata," in *La facciata del duomo di Orvieto: teologia in figura* (Milano: Silvana Editoriale, 2002).

35. See Mirella Levi D'Ancona, *The Garden in the Renaissance* (Firenze: Leo S. Olschki, 1977). For plant symbolism, see Celia Fisher, *Flowers and Fruit* (New Haven: Yale University Press, 1998).

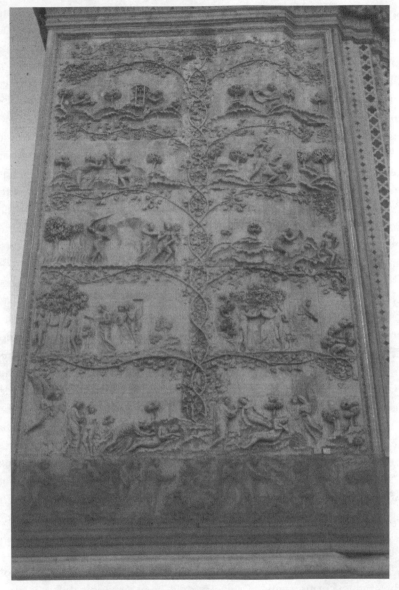

Figure 9. Lorenzo Maitani, Genesis Relief, early 14th c.,
Orvieto Cathedral, Orvieto, Italy. Photo permission of Rachel Hostetter Smith.

The second pillar employs an acanthus vine to present the messianic prophecies. The leading vine running up the center of the espalier depicts the Tree of Jesse with Mary enthroned at the top. The acanthus vine loops around each of the prophets, which run from Abraham to the Angel of the Annunciation who flies toward Mary, a progression that demonstrates the outworking of God's plan for the redemption of humankind and the inauguration of its fulfillment in the incarnation of the Christ in Mary. Acanthus is a particularly apt choice for the support for this part of the sacred history. Tough and sinewy as pictured on the relief, it is another resilient evergreen that thrives in harsh and rocky environments, ubiquitous in the Mediterranean world. When one recalls its association with Apollo and the prophetic renewal and transformation ushered in by the coming of the golden age in the ancient pagan world, its appearance here becomes especially poignant. Culminating in the annunciation to Mary and the impending conception of the Christ this panel signals just that—the inauguration of a new age in which the old killing order of the Law that could not be kept by man no longer holds sway.

The third pillar (Figure 10) that also bears an acanthus vine tells the story of the life of Christ from the annunciation through the passion and crucifixion. It culminates in a second annunciation at the very top, this time of the resurrection to the women at the tomb. It is significant that the panel begins with a group of prophets at the bottom that proceed along the leading vine up the center of the espalier. They bear witness to God's faithfulness, his promises fulfilled by the coming of the Christ represented in the lateral branches of the espalier. Notably, the scenes depicted from the life of Christ each reflect an aspect of testimony to or recognition of the identity and purpose of the coming of Christ Jesus. As an ancient symbol of prophesy, renewal, transformation, and the inauguration of a golden age the acanthus vine is especially fitting for this subject, for with the coming of the Christ, the resurrection is assured. We are, from a theological perspective, already living in that new age.

The fourth pillar, like the first, bears a vine of ivy to link the Fall of the original creation with its redemption. The ivy is visibly different from the first in a number of ways. It is lush; burgeoning with life and full with leaves. The narrative scenes begin at the bottom with the Resurrection of the dead, the Last Judgment, and the descent of the damned into hell. These are followed in ascending order by the angels leading the blessed to heaven, the saints and Christ the Judge seated at the top. Notably, Christ is presented enthroned in a mandorla, a sign of the divine revealed to mankind. This panel is not only a celebration of humankind's redemption but of God's sovereignty that is both merciful and just.

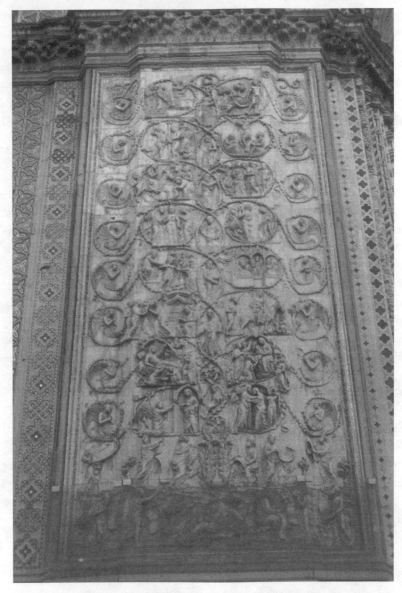

Figure 10. Lorenzo Maitani, New Testament Relief, early 14th c.,
Orvieto Cathedral, Orvieto, Italy. Photo permission of Rachel Hostetter Smith.

It is significant that each of these four panels read from the bottom up reflecting the unfolding of divine providence that is the ultimate anagogicus mos, the upward leading way of God's plan of redemption. The ivy espalier of the first and last pillars serve as a visible testament to God's sovereignty, linking humankind's fallen state, presented at the top of the one, with the depiction of his unwavering rule on the other. Instead of abandoning his rebellious creatures he persisted in bringing about their restoration. The ivy vines should be understood not just as a promise of redemption but also as an eschatological reality, for, from a divine perspective, where all of history is known to God, it is already fulfilled, complete in God's time. The espalier form of the ivy and acanthus on these pillars makes manifest the underlying order of God's providence, bearing witness to his faithfulness, resilience, and undying love. And the ebullient ivy of the culminating scene of the ruling Christ reflects the release from the constraints of sin and death and celebrates the abundant life that is come. But as John Addington Symonds observed, the entire façade is littered with acanthus framing the scenes and decorating the pinnacles. The liberal use of this ancient foliate language in Christian architecture effectively projects this celebratory message of divine promise and the inauguration of a new, specifically Christian, golden age.

More than a century later, the Chapel of the Madonna di San Brizio, with a fresco program inspired by the Book of Revelation that was begun by Fra Angelico in the mid-fifteenth-century and completed by Luca Signorelli in the early sixteenth century, presents yet another significant manifestation of the imagery of abundance in the painted foliate decoration of the ribs of the vaulting.[36] In his book on Signorelli, Tom Henry Laurence Kanter writes, "The Gothic structure of the Cappella Nova . . . make[s] the ceiling frescoes read as a vision of Paradise glimpsed through the crossed bowers and festoons of a monumental pergola."[37] The

36. Refer to note 3 for sources on Signorelli and on Signorelli's frescoes at the Cathedral of Orvieto in particular.

37. Kanter, *Luca Signorelli*, 50–51. The complete passage explains the development of the design more fully: "The Gothic structure of the Capella Nova and the pre-existing painted embellishment of its architectural members constrained Signorelli to work within an archaic scheme that could accommodate only minimal spatial illusion among the ceiling frescoes. On the walls of the Chapel he turned necessity into a virtue by designing a fictive architectural system of startling novelty, including painted stone arches that reinforce the actual arches of the vaulting in such a way as to make the ceiling frescoes read as a vision of paradise glimpsed through the crossed bowers and festoons of a monumental pergola." Kanter provides no reference to what is known about the painting of the ribs beyond this statement.

distinctive foliate decoration of the architectural framing of this space cre-
ates not only a visual infrastructure for the narrative depicted there, but
provides a theological frame that supports and extends the meaning of
the painted program. It is unknown who painted the ribs of the vaulting.
It is only known that they preceded Signorelli and that he chose to work
with the existing decoration instead of changing it. The primary scenes
by Signorelli, depicting the end times leading up to the separation of the
blessed from the damned, all take place under the scenes by Fra Angelico
and Signorelli visually manifesting the authority of Christ the judge who
is accompanied by scenes of figures who bear witness to the truth of the
gospel and his rightful rule.[38] But the symbolism of the foliate infrastruc-
ture within which all of this takes place gives these events a whole new
resonance.[39]

The painted evergreen boughs take the form of festal garlands laden
with fruits and flowers, with roses and pomegranates prominently dis-
played. The evergreen recalls God's faithfulness and promise of new life.
But the rose, which was a symbol of victory and triumphant love in pagan
antiquity, came to represent the love and victory implicit in the messianic
promise of Christianity because of its thorns. According to St. Ambrose,
the rose originally had no thorns when it grew in Paradise. With human-
kind's fall, the rose grew thorns as a reminder of sin while its beauty and
fragrance continued to remind of a Paradise, now lost.[40] This is a pro-
foundly eschatological symbol that embodies both where we came from—
Paradise—while generating a longing for where we are bound—Paradise
regained—by revealing the wretchedness of our present state and the great
price paid for that restoration in its reference to the crown of thorns. The
wild rose also symbolizes the Virgin Mary, the pure and unblemished ves-
sel through which the Messianic promise would be fulfilled.[41] The pome-

38. The primary scenes of the Entrance Bay—the Deeds of the Antichrist, Signs of
the End of the World, the Destruction of the World and the Resurrection of the Flesh,
and the scenes of the Altar Bay—the Expulsion of the Reprobate, the Punishment of
the Damned, the Reception of the Blessed, and the Crowning of the Elect, all take
place under the authority of Christ the Judge. Surrounding Christ are scenes of the
Prophets, Apostles, the Instruments of the Passion, the Martyrs, Patriarchs, Doctors
of the Church, and Virgins.

39. See Helmut Wohl, "Ornament," in *The Aesthetics of Italian Renaissance Art*
(Cambridge: Cambridge University Press, 1999) 201–21.

40. For an extensive discussion of the symbolism of the rose, see D'Ancona, *The
Garden in the Renaissance*, 330–55.

41. See Alva William Steffler, *Symbols of the Christian Faith* (Grand Rapids: Eerd-
mans, 2002) 23.

granate was an attribute of Persephone in pagan mythology. It symbolized her periodic return to earth in spring—thereby symbolizing the rejuvenation of the earth and the new life it brings forth. In Christianity it became associated with prosperity and the promise of abundant life because of the many seeds enclosed in a single fruit.[42] When the fruit is split open to reveal the seeds as seen here it symbolizes "the generosity and boundless love of God the creator"[43] who willingly gave up his son for humankind's redemption. Moreover, the glistening red juice that encases each seed represents the blood of Christ. When touched it stains black leaving a visible and poignant reminder of the sin that demanded such a sacrifice to be wiped clean.

Framed by these festal bowers, the apocalyptic narrative of the fresco program takes on a strangely celebratory tone. They serve as a reminder that God is indeed in his heaven and thus all must be right with this world despite the chaos that ensues. The rise of the Antichrist and all of the horror that proceeds from it is only one more step in God's providential plan for the redemption of his creation. It is not the end of the story. It is only a part of the story whose end is already ensured. The foliated rib vaulting acts as a theological lens through which one may see these events more clearly. It is a sign of God's presence and unwavering intent. It is central not peripheral to the pictorial program. The human actors depicted in these scenes are like the small birds and animals sustained by the abundant vegetation found on the Ara Pacis Augustae. Divine provision is evident throughout this turbulent history; but perhaps most clearly with the resurrection of the flesh. The festal bowers are in effect theonomous, a manifestation of the sustaining and generative power of God.

In her book, *On Beauty and Being Just*, philosopher Elaine Scarry describes the life-sustaining and vitalizing effects of encounters with beauty and plenitude.[44] The goodness and well-being implicit in plenitude result, she argues, in the compulsion to preserve and replicate those things, motivating one to seek after them. This potent imagery plumbed a kind of collective consciousness, using a vocabulary that communicated clearly to

42. For a comprehensive study on the pomegranate in the ancient world, see Friedrich Muthmann, *Der Granatapfel: Symbol des Lebens in der Alten Welt* (Bern: Schriften der Abegg-Stiftung, 1982); and Eleana Chirassi, "Il Melograno," in *Elementi di Culture Precereali nei Miti e Riti Creci* (Roma: Edizioni dell'Ateneo, 1968); D'Ancona, *The Garden in the Renaissance*, 312–18.

43. See Steffler, *Symbols of the Christian Faith*, 34.

44. Elaine Scarry, *On Beauty and Being Just* (Princeton: Princeton University Press, 1999).

the peoples of the ancient Mediterranean. Adopted by the early Christian church, the imagery of abundance continued to speak powerfully for centuries to follow. While it may often appear on the margins of a work, as it commonly does at Orvieto Cathedral, it provides, in actuality, a theological underpinning to the whole that is fundamentally eschatological. Like a recurring chorus in a great oratorio or requiem mass that recalls the primary theme of the composition, the foliate imagery at Orvieto Cathedral—and in so much of Christian art—gives visible form to God's provision in all things, asserts the providential outworking of his purposes in the history of his creation, and points, as an eschatological sign, to the promise of restoration, which is, from a divine perspective, already complete.[45]

45. Rev 22:1–3 (NIV) describes the abundant provision and healing properties of the tree of life as follows, "Then the angel showed me the river of the water of life, as clear as crystal, flowing from the throne of God and of the Lamb down the middle of the great street of the city. On each side of the river stood the tree of life, bearing twelve crops of fruit, yielding its fruit every month. And the leaves of the tree are for the healing of the nations. No longer will there be any curse. The throne of God and of the Lamb will be in the city."

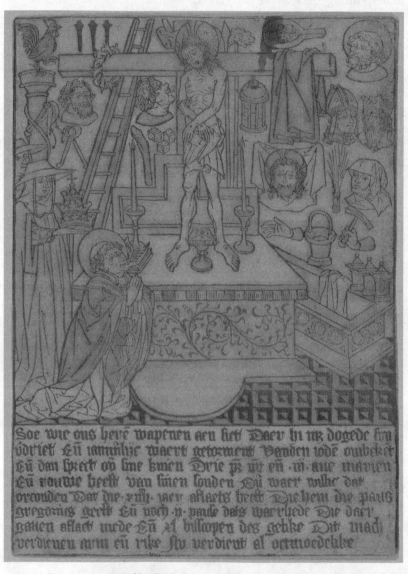

Figure 11. *Mass of St. Gregory*, c. 1460, woodcut, 9 x 7 in. (25 x 18 cm). Germanisches National Museum, Nuremberg. Permission of Germanisches National Museum.

Iconography of Sign

A Semiotic Reading of the Arma Christi

HEATHER MADAR

Medieval images of the Arma Christi can appear shockingly strange to the contemporary viewer. Isolated objects recalling events of Christ's passion, such as nails or a pillar, float within undefined image fields, disembodied heads of Christ's mockers grimace and leer, and forms are strangely de-contextualized from any larger narrative context. Their identification as objects associated with Christ's passion does not account, with any degree of satisfaction, for these objects' visual uncanniness. Yet they appeared frequently in European devotional art between the thirteenth and fifteenth centuries both alone and in conjunction with other popular themes. Examining three diverse examples: a 1330–50 ivory devotional booklet (Figures 12–13); a page from the Psalter and Hours of Bonne of Luxembourg, created before 1349 (Color Plate 1); and a c. 1460 print of the Mass of St. Gregory (Figure 11), this essay critically examines the Arma Christi as flexible signs.

While the Arma Christi are most commonly found within prayer books and other devotional materials, they appear in a wide range of media and also in public works such as altarpieces, frescoes, and scrolls. Apart from iconographical studies, the most common methodological approach to these images has been to situate them within trends in late medieval devotional practice such as passion-centered meditation, devotional art, and the cult of relics. While these are clearly key to any discussion of these images, their appearance and use is not satisfactorily explained solely by their context and meaning. This essay suggests that the Arma Christi functioned primarily as signs, and it is precisely their nature as signs that

elucidates the visual characteristics and the fundamental interpretative flexibility of these images.

In fact, despite their frequent appearance, images of the Arma Christi are surprisingly lacking in standardization, whether in the number and identification of the objects shown, the nature of their depiction, or their composition. The earliest images of the Arma Christi consisted of a limited range of objects. These generally included the cross, lance, crown of thorns, nails, rod with sponge, and scourge. As Arma images proliferated, the number of instruments depicted increased. In addition to the original items, other objects mentioned within the gospel texts were included, such as the pillar of the flagellation or the blindfold used during the mocking of Christ, along with utilitarian objects such as the pail of vinegar, the hammers used to nail Christ to the cross, or the lanterns held at Gethsemane. Additionally, a number of figural or gestural details were used for scenes that could not be depicted through an object, such as spitting heads for the mocking of Christ. Furthermore, even some items not actually appearing in the gospels, such as tufts of Christ's hair or Veronica's veil, became a part of the Arma Christi's iconography. Their presence is consistent with the late medieval penchant for inventing extra-gospel details, and to the cultic significance attached to the Veronica from the thirteenth century on.[1]

The Arma Christi generally indicate the most representative object from each individual moment of the passion, with, for example, the flagellation signified by the pillar, and the deposition by the pincers. Yet the Arma allowed the passion narrative to be flexible, with a choice of which objects, and thus which events to include. In a fourteenth-century ivory devotional booklet, the circular objects signifying the thirty pieces of silver indicate the Betrayal, while the events around Christ's arrest are not referenced.[2] The narrative could also be expansive, with many moments represented by multiple objects—both the scourge and the pillar for the flagellation or the robe and the dice, for example.

This wide range of Arma Christi representations indicates not only the utility but also the fundamental interpretative flexibility of these images. To fully account for this flexibility requires a semiotic turn and a reading of the Arma Christi as signs. Robert Suckale first suggested such a reading in his 1977 essay, "Arma Christi: Überlegungen zur Zeichenhaftigkeit Mittelalterlicher Andachtsbilder," writing, "Using our terminology,

1. Flora Lewis, "Rewarding Devotion: Indulgences and the Promotion of Images," *Studies in Church History* 28 (1992) 179.

2. The arrest is shown in narrative scenes within the booklet.

we have a collection of signs in front of us in the Arma images."[3] His argu-
ment re-framed the Arma Christi, and suggested a rich avenue of analysis.
This essay attempts to build on Suckale's insight and further explore what
it means to understand the Arma Christi as signs in both a medieval and
modern context using three canonical examples of Arma Christi imagery
from a popular print, an illuminated manuscript, and an ivory booklet.
This essay is not arguing that the Arma Christi should be understood as
reflecting one specific scholastic theory of signs as opposed to another.
However, these images clearly reflect a diffuse, although culture-specific
understanding of signs, and their intended operation was enabled by
medieval sign theory. Moreover, it is precisely their nature as signs that
allowed their remarkable versatility and success as devotional images.

The earliest known image that includes the Arma Christi is the sixth
century apsidal mosaic from San Michele in Affricisco in Ravenna, which
shows Christ flanked by two angels bearing the lance and the rod with
sponge.[4] The instruments continue to appear in both Western European
art of the early and high Middle Ages and in Byzantine art. The Arma are
typically related to Last Judgment iconography and are also understood
as the weapons by which Christ triumphed over the forces of evil, and
signified his majesty and sovereignty, hence their designation as the *arma*,
or weapons, of Christ.[5] This association persisted throughout the Middle
Ages where they could be understood as the arms of Christ in a heraldic
sense, and were depicted in shield form on some occasions.[6]

Developments in the cult of relics occurring in the twelfth and thir-
teenth centuries have been seen as a factor in the increased popularity of
the Arma as subject matter. Gertrud Schiller notes the new relics of the
passion that arrived in Western Europe as a result of the crusades and
the Latin conquest of Constantinople in 1204, particularly the pincers,

3. "nach unserer . . . Terminologie haben wir in den Arma-Bildern eine Sammlung
von Zeichen vor uns." Robert Suckale, "Arma Christi: Überlegungen zur Zeichenhaft-
igkeit Mittelalterlicher Andachtsbilder," *Städel-Jahrbuch* 6 (1977) 188. Suckale states
that the Arma Christi are central to an understanding of medieval meditative practice
and its development.

4. Gertrud Schiller, *Iconography of Christian Art,* trans. Janet Seligman (Green-
wich, NY: New York Graphic Society, 1972) 2:186.

5. The interpretation of the Arma as the weapons of Christ against the devil con-
tinues into the later middle ages. Jeffery Hamburger, *The Rothschild Canticles: Art and
Mysticism in Flanders and the Rhineland c. 1300* (New Haven: Yale University Press,
1991) 85.

6. Rodney Dennys, *The Heraldic Imagination* (New York: Clarkson Potter, 1975)
96–100.

hammer, dice, and ladder.[7] St. Louis's purchase of relics for the Sainte Cha-
pelle between 1239 and 1246 also created a prominent cache of passion
relics in Western Europe. The later Middle Ages also saw an increased
stress on the exhibition of relics, and a desire for their visibility. This was
manifested in the shift in reliquary form from enclosed caskets conceal-
ing the objects within to ostensories. This type of reliquary, which first
appeared in the early thirteenth century, made the contents visible by
sheathing them in glass or crystal.[8] The Arma's stress on the visual con-
sumption of sacred objects parallels the new visibility of relics in the same
time period.

Further contributing to the rising popularity of the Arma Christi
were their status from the thirteenth century on as indulgenced images
and their connection to the newly popular theme of the mass of St. Greg-
ory. The legend of the Mass of St. Gregory describes unbelievers challeng-
ing the doctrine of transubstantiation while Pope Gregory was celebrating
mass. As a result, an image of Christ as the Man of Sorrows surrounded
by the Arma Christi appeared over the altar, instantly quelling any doubts
regarding the real presence of Christ in the sacrament.

Images of the Mass of St. Gregory became indulgenced around 1400.
Several devotional texts from the fourteenth century mention the indul-
genced status of the Arma Christi, ascribing the granting of this status to
Pope Innocent IV at the first Council of Lyon in 1245.[9] The Arma Christi
image type thus received official sanction and promotion by the church.
While Flora Lewis describes the primary significance of the Mass of St.
Gregory indulgence as encouraging devotion to the Man of Sorrows, it is
clear that the Arma were also understood as key to this image type.[10] The
inscription on a fifteenth-century print of the Mass of St. Gregory states:

> Verily, anyone who sees and reflects on Our Lord's weapons (the
> weapons by which He suffered and was lamentably tortured),
> and then kneeling says three Our Fathers and three Hail Marys
> and repents his sins will earn an indulgence of 14,000 years,
> granted by Pope Gregory and two other popes (this is the truth),
> who also grant an indulgence, as well as forty bishops. This can
> be earned by both poor and rich. Earn it now, humbly.[11]

7. Schiller, *Iconography*, 190.

8. Ibid., 82.

9. Lewis, "Rewarding Devotion," 181.

10. Ibid., 184.

11. Henk van Os, *The Art of Devotion in the Late Middle Ages in Europe*, trans.

Encouraged by indulgences and thus church sanction, the Arma Christi and the Mass of St. Gregory were mutually reinforced as devotional images.

The popularity of Arma Christi imagery increased dramatically in the later Middle Ages.[12] They became a widespread motif in the fourteenth and fifteenth centuries and were frequently depicted into the sixteenth century.[13] The Arma began to be shown as isolated objects separate from a larger narrative context in this period and were also frequently depicted with other newly popular passion-centered devotional themes, in particular the Man of Sorrows and the Mass of St. Gregory.

The primary meaning of the Arma Christi in this period shifted from their original Last Judgment context to a focus on the suffering of Christ during the passion.[14] This popularity is undoubtedly connected to new trends in devotional practice, which has provided the main interpretative key for these images. The Arma reflect the heightened stress on Christ's suffering, which encouraged the pious to follow every step of the passion, focusing on the torments experienced by Christ.[15] A passage from the well-known fourteenth-century *Meditationes Vitae Christi* provides a clear example of these trends:

> One of them seizes him . . . another leads him to the column, another strips him, another beats him while he is being led, another screams, another begins furiously to torment him, another binds him to the column, another assaults him, another scourges him, another robes him in purple to abuse him, another places the crown of thorns.[16]

Michael Hoyle (Princeton: Princeton University Press, 1994) 112.

12. Gertrud Schiller, *Iconography*, and Rudolph Berliner, "Arma Christi," *Münchner Jahrbuch der Bildenden Kunst* 6 (1955) 35–116, provide a discussion of the development of the Arma Christi. See also Anthony Paul Bale, *The Jew in the Medieval Book* (Cambridge: Cambridge University Press, 2006).

13. The decline in popularity in the sixteenth century is particularly noticeable in Protestant lands. Examples of Arma Christi imagery are found in Catholic contexts through the eighteenth century, albeit in lesser numbers.

14. Schiller comments, "The introduction of the Instruments of the Passion into the arts of the Late Carolingian period . . . is connected with the new interest in Christ's suffering that began to be shown by theologians and the faithful under Louis the Pious." Schiller, *Iconography*, 185.

15. There is a considerable literature on late medieval devotion and devotional art. See Hans Belting, *The Image and its Public in the Middle Ages: Form and Function of Early Paintings of the Passion* (New Rochelle, NY: Caratzas, 1990); Sixten Ringbom, *Icon to Narrative: The Rise of the Dramatic Close up in Fifteenth Century Devotional Painting* (Doornaspijk: Davaco, 1984); and Hamburger, *The Rothschild Canticles*.

16. Pseudo-Bonaventure, *Meditations on the Life of Christ*, trans. Isa Ragusa and

The passage also demonstrates the stress placed on the specific objects of torment within devotional literature.

The link between Arma images and contemporary devotion to Christ's suffering is underlined by the predella panel from a 1346 altarpiece by Bartolommeo da Camogli for a Florentine flagellant confraternity.[17] The cross, flanked by various Arma Christ, is in the center of the predella with kneeling confraternity members on either side. The confraternity members, who gaze raptly at the objects, are headed by four flagellants, identified by their white hoods and habits. Significantly, the Arma are represented here as the focus of devotion for flagellants, a group that focused on penitential acts in imitation of Christ's suffering. Images of the Arma generally do not distinguish between objects involved in Christ's physical as opposed to his mental torment. Yet in this image, designed for a community that focused on the corporeal nature of Christ's passion, the only objects shown are those which can be directly related to an act that harmed Christ's body, and objects from the flagellation are given prominence. Arma associated with moments of psychological torment, such as the mocking, or that do not specifically relate to Christ's physical experience of the passion, such as the betrayal or Gethsemane, are absent. This also highlights the interpretative flexibility and even the customizable nature of the Arma motif.

Interpreting the Arma Christi, some scholars have emphasized the links between specific instances of relic devotion and particular images of the Arma Christi. Annette Lermack connects the depiction of the Arma within the Psalter of Bonne of Luxembourg, wife of John the Good of France, to the passion relics held in the Sainte Chapelle, noting the presence of a number of these objects within the image.[18] In at least one case,

Rosalie Green (Princeton: Princeton University Press, 1961) 318.

17. This image is discussed in Kathleen Giles Arthur, "Cult Objects and Artistic Patronage of the Fourteenth Century Flagellant Confraternity of Gesù Pellegrino," in *Christianity and the Renaissance: Image and Religious Imagination in the Quattrocento*, eds. Timothy Verdon and John Henderson (Syracuse, NY: Syracuse University Press, 1990) 350. Arthur uses the image to support an argument about the use of a mock pillar in Flagellant rites, but it clearly has bearing on Arma Christi representations.

18. Annette Lermack, "Spiritual Pilgrimage in the Psalter of Bonne of Luxembourg," in *The Art, Science and Technology of Medieval Travel*, eds. Robert Odell Burke and Andrea Kann (Burlington, VT: Ashgate, 2008) 102. The Sainte Chapelle relics most famously included the crown of thorns. Other relics included a fragment of the cross, sponge, lance, reed scepter, a fragment of the Holy Sepulcher, Christ's blood, a scarlet cloak, and a fragment of the shroud. See Daniel Weiss, *Art and Crusade in the Age of St. Louis* (Cambridge: Cambridge University Press, 1998) 221n15.

a literal link between relic devotion and the Arma Christi may be posited. An early fifteenth-century triptych depicts a Man of Sorrows surrounded by the instruments. Given the presence of a small piece of coniferous wood inserted into the main panel, Henk Van Os suggests that the wood was a relic of the cross (said to be made of cedar) and that the triptych was therefore the centerpiece of local devotion to passion relics.[19]

Discrepancies between contemporary meditative practices and Arma Christi images suggest that devotional practices alone do not provide a fully satisfying interpretative frame for these images. Arma Christi images hardly seem ideal for stimulating empathetic responses, unlike Man of Sorrows imagery with their pitiful images of the tortured body of Christ, or narrative scenes from the passion with detailed depictions of each torment. By contrast, it is difficult to imagine anything less provocative of deep emotion than the impartial depiction of objects, no matter how loaded these individual objects are with significance.

While many medieval devotional images focused on a meditative, moment-by-moment reenactment of the passion, the appearance of the Arma Christi works against such a use. Although the objects imply the progress of the narrative, as images, their presentation relentlessly rejects a narrative reading. They are abstracted from a narrative context through lack of details, like setting and figures, and through their spatial placement in relationship to the other objects, which rejects narrative sequencing in favor of compositional considerations. In the devotional booklet, for example, the third panel features the nails and hammer (the crucifixion), pincers (the deposition), silver (the betrayal), footprints (the carrying of the cross), and blindfold (the mocking). It could be argued that the Arma thus parallel a trend in late medieval devotional art towards iconic types, which are abstracted from their narrative context and are thus able to be invested with more wide-reaching meditational utility.[20] Yet the Arma are not purely iconic, but rather vacillate between narrative and iconic. While the individual objects cue distinct moments, their presentation as a group paradoxically references the singular moments of the passion as a totality by compressing each narrative moment into a representative object, which is then bundled with other similarly representative objects.

The objects also bear no real relation to each other in terms of size and there seems to be little logic governing sizing.[21] In the devotional booklet,

19. Ringbom, *Icon to Narrative*, 120.

20. See ibid., passim.

21. Schiller suggests that the instruments are shown in reference to their

the pincers are more than twice the size of the pail, while one piece of silver is half the size of Christ's foot. Another striking example is the side wound. In the Psalter page, the wound is the same size as both the pillar and cross, while the wound in the booklet appears roughly three-quarters the length of the rod with sponge. The relentlessly non-hierarchical nature of the Arma Christi also means that objects of peripheral importance in the biblical narrative, indeed, objects that may not even appear in the Gospels, are given representative status equal to central objects from the passion narrative. In a c. 1460 print of the Mass of St. Gregory, for example, the pincers, cock, scourge, nails, lantern, and pail are all approximately the same height and are two-thirds the size of the truncated pillar.

There is also little concern shown with the outward appearance of the objects, which typically are schematic, showing only enough detail to secure their visual identification. This is despite contemporary fascination with the visual characteristics of objects connected to the passion. The fifteenth-century pilgrim Friar Felix Fabri described the pillar of the flagellation: "The piece which stands in this place is one palm and the thickness of three fingers in width, and four palms in height, and is of a purple color, sprinkled with red spots."[22] The *Meditationes* similarly noted how "the column to which he was bound shows the traces of his bleeding."[23] Similar discussions can be found on the subject of the exact material of the crown of thorns. While the *Golden Legend* stated that the crown of thorns was plaited out of furze, Fabri was concerned to specify that the crown of thorns not be understood as made of sea-thorns, but rather of common thorns growing in Jerusalem.[24]

Despite textual evidence documenting considerable interest in the appearance of these objects, there is no sustained attempt to invest the Arma Christi with particularizing detail—they are pictograms rather than portraits. The schematic nature of these renderings suggests that, while these images were indeed intended to lead to contemplation of the individual objects, they functioned differently than an emotionally charged figure or narrative. These schematic renderings indicate that what is of

importance in the crucifixion narrative. The distinction does not hold as more peripheral objects are frequently shown the same size as objects more central to the narrative. Schiller, *Iconography*, 191.

22. Friar Felix Fabri, *The Wanderings of Felix Fabri*, trans. Aubrey Steward (London: Palestine Pilgrim's Society, 1897) 349.

23. Pseudo-Bonaventure, *Meditations*, 329.

24. Jacobus de Voragine, *The Golden Legend*, trans. William Granger Ryan (Princeton: Princeton University Press, 1993) 207; Fabri, *The Wanderings*, 356.

concern here is not the objects in and of themselves, but rather what they represent: the Arma Christi were signs, whose primary function was to point beyond themselves and to act as signifiers of the passion. While the various visual oddities and the narrative incoherence of these images cannot be explained through reference to medieval devotional practice alone, when understood as signs, their strangely abstracted, impartial depiction becomes comprehensible.

The identification of the Arma Christi as signs is not simply a modern methodology retroactively applied, but was present very early in the development of the motif. The appearance of the Arma in the context of last judgment imagery is related to Christ's statement that "the sign of the Son of Man" will appear at the time of the second coming.[25] A semiotic reading of the Arma also speaks to medieval semiotics, a highly developed branch of medieval theology and philosophy. A reading of medieval semiotic theory provides further support that a reading of the Arma as signs is a contextually valid interpretative move.

The importance of sign theory within medieval philosophy and theology is well recognized. Michael Camille and others have also demonstrated its relevance to medieval art historical analysis.[26] Although there was not a defined "science of signs" in the Middle Ages, and there are few medieval treatises that deal exclusively with signs, discussions of signs—their nature, classification, and function—nevertheless constituted a prolific discourse. Peter Lombard's *Sentences*, a foundational textbook of medieval theology, opened with a statement on signs.[27] Semiotics played a role in numerous medieval discussions, such as debates over the nature of

25. Matt 24:30 (NRSV).

26. Michael Camille, "The Book of Signs: Writing and Visual Difference in Gothic Manuscript Illumination," *Word and Image* 1 (1985) 133–48. Works by Meyer Schapiro, particularly his *Words and Pictures: On the Literal and the Symbolic in the Illustrations of a Text* (The Hague: Mouton, 1973); and "On Some Problems in the Semiotics of Visual Art: Field and Vehicle in Image-Signs," *Simiolus: Netherlands Quarterly for the History of Art* 6, no. 1 (1972–1973) 9–19, have been seen as central early treatments of semiotics and medieval art. See also Wallis Mieczyslaw, *Arts and Signs* (Bloomington: Indiana University, 1975), particularly chap. 2, "Mediaeval Art as a Language." For more recent discussions of medieval art that engage with semiotics see, for example, essays by Paul Crossley and Jonathan Alexander in *Medieval Art: Recent Perspectives: A Memorial Treatment to C. R. Dodwell*, ed. Gale Owen-Crocker and Timothy Graham (Manchester: Manchester University Press, 1998).

27. "By God's prevenient grace, it has become clear to us that the study of the sacred page is principally concerned with things or with signs." Peter Lombard, *The Sentences: Book 1: The Mystery of the Trinity*, trans. Giulio Silano (Toronto: Pontifical Institute of Mediaeval Studies, 2007) 5.

the sacraments, the interpretation of scripture, heraldry, linguistic theory, logic, theories of cognition and memory, and even the investiture controversy. It has been suggested that the pervasiveness of sign theory in medieval intellectual thought not only influenced scholars, but also more broadly shaped a worldview.[28] The Arma Christi reflect this culturally specific understanding of signs and signification.

St. Augustine's influential discussion of signs is understood as the foundation of medieval sign theory.[29] His oft-repeated definition of the sign, found in his *De Doctrina Christiana* states that "a sign is a thing which causes us to think of something beyond the impression the thing itself makes upon the senses."[30] The sign thus possesses a twofold relation to the signified object on the one hand and the intellect on the other. Signs, moreover, are understood to play a central role in cognition. Augustine states that "all doctrine concerns either things or signs, but things are learnt by signs."[31] Although Augustine's theory of signs is primarily focused on linguistic signs, as is much of the medieval sign theory that followed, sign theory was understood to encompass the entire range of possible signifiers.

An increasingly elaborate sign theory was developed in the late-thirteenth century, with semiotic concerns continuing to occupy theologians in the fourteenth century. The thirteenth-century theologian Roger Bacon, commonly seen as the most important medieval sign theorist, wrote a treatise on signs, *De Signis*, one of the few treatises specifically focused on signs extant from the Middle Ages, and included a discussion of signs in his *Compendium of the Study of Theology*.[32] Bacon's discussion of signs includes a detailed categorization of signs. Following Augustine's categorizations, he names the two main categories of signs as natural signs and conventional signs. Bacon's sign system has direct bearing on visual

28. For discussions of medieval sign theory, see Brigitte Miriam Bedos-Rezak, "Medieval Identity, A Sign, A Concept," *American Historical Review* 105, no. 5 (2000) 1489–1533; Umberto Eco et al., *On The Medieval Theory of Signs* (Amsterdam: Benjamin, 2000); and Ross Arthur, *Medieval Sign Theory and Sir Gawain and the Green Knight* (Toronto: University of Toronto Press, 1987).

29. See, for example, Marcia Colish, *The Mirror of Language: A Study of the Medieval Theory of Knowledge* (Lincoln: University of Nebraska Press, 1983) vii.

30. Augustine, *On Christian Doctrine* 2.1, trans. D.W. Robertson (New York: Liberal Arts, 1958) 57.

31. Augustine, *On Christian Doctrine* 1.2, 8.

32. T. S Maloney, "The Semiotics of Roger Bacon," in *Mediaeval Studies* 45 (1983) 120–54.

art as he explicitly mentions visual images, seeing them as one type of the second mode of natural signs:

> wherein the sign represents [something] by configuration and an expression of likeness, as in the case of the traces of things and images and those things that are like other things. For example, a footprint in the snow and an image of [St.] Nicholas or some other signifies the one whose it is.[33]

Bacon's discussion of images as natural signs is predicated on the assumption of the mimetic nature of images. His statement parallels Augustine's comments on the conventional nature of visual representation, "where pictures or statues are concerned . . . no one errs when he sees the likeness, so that he recognizes what things are represented."[34]

A reading of the Arma through medieval semiotics is clearly appropriate due to the simple fact that the Arma were identified by tradition as signs, specifically as the sign(s) of the Son of Man. Several other aspects of medieval semiotic theory have important implications for the Arma Christi. First, as images, the Arma are explicitly recognized by medieval semiotics as a type of sign, as indeed are all images, and as a type of sign recognized to possess a transparency of signification. Second, Augustine's discussion of signs is seen to contain a fundamental dualism, where the sign is merely a reflection of an ultimate reality. Brigitte Miriam Bedos-Rezak states, "Early Christian doctrine seems to have privileged the Classical dualism between the sign and the thing referred to by the sign, whereby only the thing, though ideal and not of this world, has reality."[35] This assumption has important implications for depictions of the Arma Christi. As signs, the Arma denote the greater reality of the original objects of the passion. Their transparency of meaning is guaranteed through their mimetic properties as images, themselves understood as signs. The schematic nature of the object depictions therefore plays an intentional role in signification, as the key is mere likeness to point beyond to the referent, the ultimate truth.

Modern semiotic terminology provides a way to further analyze the nature of the Arma Christi as signs by providing precise categories to analyze their means of signification. Following Charles Sanders Peirce's taxonomy of signs, which categorizes signs according to the nature of

33. Roger Bacon, *Compendium of the Study of Theology*, trans. Thomas S. Maloney (Leiden: Brill, 1988) 57.

34. Augustine, *On Christian Doctrine* 2.25, 61.

35. Bedos-Rezak, "Medieval Identity," 1489–1533.

the sign's relationship to its object, the **Arma Christi** can be identified as iconic signs. In the Arma, the signified (the actual objects) are recognizable through the clear, intentional visual resemblance of the signifiers (the individual Arma).[36] Icons, for Peirce, are centrally about likeness.[37] As Marcel Danesi states "Icons can be defined simply as signs that have been constructed to resemble their referents in some way."[38] The depiction of the pillar of the flagellation, for example, is visually identifiable as a pillar, and the link to the specific pillar of the flagellation is made clear by the larger framing context (image, text, culture).

Yet the Arma also bear characteristics of Peirce's second type of sign, the indexical sign, which signifies through direct connection. Peirce states: "an index stands for its object by virtue of a 'real connection with it'"[39] and "stand[s] unequivocally for this or that existing thing."[40] Peirce further notes that a photograph can function as an indexical sign, given its "optical connection with the [photographed] object."[41] While any of the Arma could be seen as indexical signs to some degree, the side wound provides a particularly clear example of an indexical sign in the way it was understood and used. In the Psalter, the accompanying text states that the dimensions of the depicted wound (two and three-sixteenths of an inch) correspond precisely to the size of the actual wound. The written text thus makes clear that the depiction must be understood in a literal sense as a representation of the actual wound. Devotion to the wound also stressed the wound as the entry point to a mystical journey, which would culminate in the beholder's spiritual union with Christ. The depiction of the wound in the Psalter visually invites entry through its subtle rings of color, which give an almost palpating effect when viewed intently, and draw toward the

36. For an overview of Peirce's semiotic theory, see Marcel Danesi, *The Quest for Meaning: A Guide to Semiotic Theory and Practice* (Toronto: University of Toronto Press, 2007), particularly chap. 2; T. L. Short, *Peirce's Theory of Signs*, (Cambridge: Cambridge University Press, 2007), particularly chap. 8; and Charles Sanders Peirce et al., *Peirce on Signs: Writings on Semiotic* (Chapel Hill: University of North Carolina Press, 1991).

37. "Most icons, if not all, are *likenesses* of their objects." Charles Sanders Peirce, *The Essential Peirce: Selected Philosophical Writings* (Bloomington: Indiana University Press, 1998) 2:13.

38. Danesi, *The Quest for Meaning*, 41.

39. Peirce, *The Essential Peirce*, 14.

40. Peirce et al., *Peirce on Signs*, 252. The full quotation is "The Icon does not stand unequivocally for this or that existing thing, as the Index does."

41. Charles Sanders Peirce, *Collected Papers*, eds. Charles Hartshorne and Paul Weiss (Cambridge, MA: Harvard University Press, 1960) 3:359.

black abyss of the center, described as "door-like" by Annette Lermack.[42] This similarly suggests an understood direct correspondence. The triptych with the inserted wood plug provides a second example of an Arma image that could be understood as an indexical sign, where the wood of the cross infuses the painted representation of the cross with literal materiality.

Yet the Arma could also be symbols, the third of Peirce's categories, which signify not on the basis of visual similarity but through convention. According to Peirce, "a *Symbol* is a sign which refers to the Object that it denotes by virtue of a law, usually an association of general ideas, which operates to cause the Symbol to be interpreted as referring to that Object."[43] The side wound, for example could symbolize a mirror.[44] The pelican, a common symbol for Christ's sacrifice, appears among the Arma in some examples.[45] Of course, it is important to note that Peirce did not understand his three categories as rigid and fixed, and recognized that a signifier could have elements of one, two or even all three of his sign types. Peter Wollen thus states "'the great merit of Peirce's analysis of signs is that he did not see the different aspects as mutually exclusive."[46]

Sign theory also provides insight into the part/whole relationship of the Arma, taken individually or as a group, to the passion narrative. The Arma Christi have been seen as a synecdoche of the passion, in that the Arma, as individual objects, point to the whole of the passion, encompassing its meaning as a totality.[47] This, ultimately, is Robert Suckale's argument about the ramifications of the Arma as signs.[48] It is clear that

42. Lermack, "Spiritual Pilgrimage," 109.

43. Peirce, *The Essential Peirce*, 292.

44. Lermack, "Spiritual Pilgrimage," 109.

45. Suckale, "Arma Christi," 187.

46. Peter Wollen, *Signs and Meaning in the Cinema* (London: Thames and Hudson, 1969) 141.

47. The centrality of fragmentation and synecdoche in the late medieval period has been explored by Carolyn Bynum in *Fragmentation and Redemption: Essays on Gender and the Human Body in Medieval Religion* (New York: Zone, 1996) 280. Although she discusses the fragmentation of Christ's body in depictions of Christ's wounds, arguing that "in such paintings *pars* clearly stands *pro toto*" where "each fragment of Christ's body is the whole of God," she does not directly address the Arma Christi.

48. Suckale, "Arma Christi," 192. "Sie konzentrieren die gesamte Passion in einem Bild, in dem die Fülle der einzelnen Ereignisse wie das Ganze, zugleich gemeint in dem Reichtum seiner inhaltlichen Bezüge, zur Anschauung kommen. Sie summieren und zentrieren zugleich." Flora Lewis makes a similar observation, although it is not couched in semiotic terms, in "The Wound in Christ's Side and the Instruments of the Passion: Gendered Experience and Response," in *Women and the Book: Assessing the Visual Evidence,* eds. Lesley Janette Smith and Jane H. M. Taylor (Toronto: University

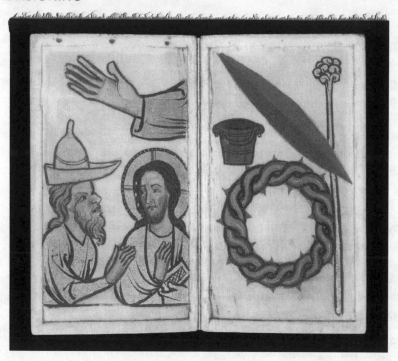

Figure 12. Devotional Booklet, left side, 1330–50, ivory, 4 x 2 in. (10.7
x 6 cm), the Victoria and Albert Museum, London. Permission of
the Victoria and Albert Museum.

the Arma functioned in precisely this way by appearing as a field of signs,
where the ultimate impact of the individual signs is to signify together
as a totality. A clear example of the Arma as field of signs is in their ap-
pearance within the c. 1460 Mass of St. Gregory print. The Arma appear
here as a screen above and behind the altarpiece, where they manifest
primarily as a group, rather than individually. This is in line with the
meaning of the Arma within the Mass of St. Gregory narrative, where
their appearance is not primarily intended to cue passion meditation, but
rather to remind of the original miraculous appearance at the altar. The
Arma could also be presented and read as individual signs, or vacillate
between singularity and totality. The 1330–50 ivory devotional booklet
features four images of the Arma Christi, which are placed after scenes of

of Toronto Press, 1997) 222.

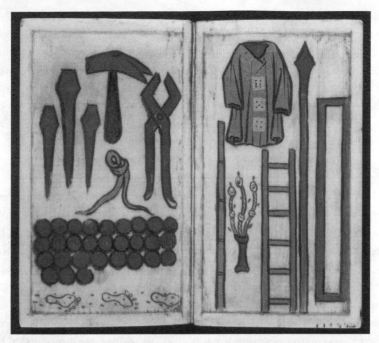

Figure 13. Devotional Booklet, right side, 1330–50, ivory, 4 x 2 in. (10.7 x 6 cm),
the Victoria and Albert Museum, London. Permission of The Victoria and
Albert Museum.

ten narrative moments from Christ's passion.[49] The booklet thereby offers
the pious beholder, likely a monk, two complementary visual treatments
of the passion for contemplation. The narrative images offer a straight-
forward, chronological sequence of the passion from the Last Supper to
the resurrection. Three of the four panels of the Arma Christi, however,
present the objects in non-narrative order both in terms of their grouping
in the individual panels and non-narrative ordering in which the object
of the four panels are apprehended.[50] Although the first panel shows three

49. Paul Williamson, *The Medieval Treasury: The Art of the Middle Ages in the Vic-
toria and Albert Museum* (London: Victoria and Albert Museum, 1986).

50. To be in narrative order, the panels should start with the pieces of silver, then
the items associated with the flagellation and the mocking, then the footprints, then
the crucifixion items in the following order—nails and hammer, garment and dice,
sponge and pail, lance and side wound, then the deposition items and finally the tomb.
The first panel shows the mocking of Christ through an outstretched hand together
with bust-length figures of Christ and a tormentor. The second shows the crown of
thorns from the mocking of Christ, and the side wound, bucket, and sponge from the
crucifixion. The third depicts Christ's footprints from the carrying of the cross, the
pieces of silver, given to Judas prior to the Last Supper (there are only twenty-nine

objects from the mocking of Christ, narrative coherence, as described above, is lost in the object selection of the subsequent panels. Moreover, were the panels to start from the beginning of the passion, they should begin with the silver pieces from the second panel.[51] The panels permit a focused meditation on each object, with each object signifying individually, yet the small size of the booklet and the presence of the accompanying narrative sequence also suggests that the objects could be visually grasped as a field of signs, which signified the totality of suffering.

A similar multivalence can be seen in a page from the Psalter and Hours of Bonne de Luxembourg, Duchess of Normandy, attributed to Jean le Noir and his workshop. The framing device, unified background, and compositional unity of this devotional book, created before 1349, allows the objects to be read as a totality, yet the visual and textual focus on the wound and the association of other objects with locally venerated relics indicates that the objects would have also signified singly.

The wide-ranging appearances of the Arma Christi, across several centuries and in a diversity of visual media, suggest that medieval and modern semiotics provide an interpretative framework for the Arma Christi. The Arma permitted meditation on individual moments of the passion narrative, provided a literal link to the sacred objects they signified, and, at the same time, could present totalized, meaningful images of the passion as a whole. The Arma moreover provide a particularly clear example of the transference of the medieval semiotic worldview into visual art. The straightforward signification employed by Arma Christi images, cued by their literal understanding as signs, was enabled by medieval image theology, and reflects an entrenched theological view of the mimetic transparency of images. This reading accounts for their distinctive visual qualities—their lack of particularized detail, non-narrative depiction and scale issues in particular. Semiotic theory also clarifies their means of

completed circles, but the outline of an additional circle is visible), the blindfold from the mocking, nails and hammer from the crucifixion and pincers from the deposition. The last panel shows a stick (perhaps the reed from the mocking), the flagellation scourge, lance, garment, and dice from the crucifixion, ladder from the deposition, and a hollow rectangle to indicate Christ's tomb.

51. Matthew is the only Gospel that specifically mentions the thirty pieces of silver (Luke mentions a promise/agreement of payment, but not specifically thirty pieces of silver). The payment is described as occurring prior to the Last Supper (Matt 26:14). A potential complication to the narrative ordering of these signs is that the thirty pieces reappear in Matthew when Judas gives them back, which occurs after Christ is handed over to Pilate (Matt 27:3). However, as noted above, the remaining objects of the passion are out of narrative order regardless of where the thirty pieces of silver are located.

signification, and suggests how a certain interpretative flexibility, enabled by their nature as signs, explains the popularity of the Arma Christi in late medieval devotional art.

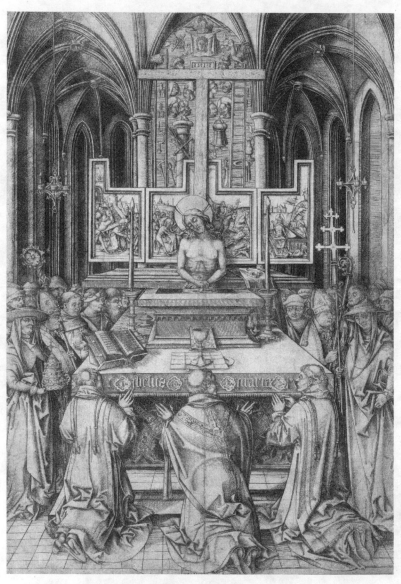

Figure 14. Israhel van Meckenem, *Mass of St. Gregory*, c. 1490–5,
engraving, 18 ¹/₄ x 11 ⁵/₈ in. (46.3 x 29.5 cm), the British Museum, London.
Permission of the British Museum.

Hybridizing Iconography

The Miraculous Mass of St. Gregory Featherwork from the
Colegio de San José de los Naturales in Mexico City

ELENA FITZPATRICK SIFFORD

In 1539, an indigenous artist at the Colegio de San José de los Naturales in Mexico City created a featherwork mosaic *Messe de Saint Grégoire, Miraculous Mass of St. Gregory*, (Color Plate 8). Commissioned by Nahua nobleman Diego Huanitzin for Pope Paul III, its iconography and composition are drawn from a fifteenth-century engraving by the German printmaker Israhel van Meckenem (c. 1445–1503). The engraving and featherwork depict the legend of the sixth-century Pope Gregory the Great, who, while consecrating the Host at the altar, received a vision of the Savior flanked by instruments of the passion. His miraculous vision was used as visual proof of the real presence of Christ during the Eucharist. The use of this iconography in the sixteenth century at the Franciscan College in Mexico probes the very act of "seeing" Christian doctrine by converted natives. It was commissioned for Pope Paul III as proof of the Indian's successful conversion in the midst of the period of evangelization. Its conception is pertinent to the indigenous population on the wake of the conquest of the Americas and the beginning of the Counter-Reformation on both sides of the Atlantic.

The featherwork, made by a Mexica artist using native techniques, was derived from an engraving (c. 1490–5) by Israhel van Meckenem (Figure 14), a prolific late fifteenth-century German printmaker and goldsmith. Van Meckenem created over eight versions of the *Mass of St. Gregory* during his career, indicating the commercial success of the theme in late-fifteenth-century Northern Europe. Most popular of the group is a

complex engraving, measuring 29.4 by 46.8 cm.[1] The image authenticates the Pope's legendary vision of Christ, one that was not documented, but became rooted in the popular imagination and visual culture. By the late Middle Ages the Gregory Mass became a popular iconographic scheme. Medievalist Caroline Walker Bynum argues that the idea of the real presence was circulating in medieval Europe, but was not affirmed until the sixteenth century during the Council of Trent.[2] The subject of the Gregory Mass, therefore, became popular for its efforts to tease through the issue of transubstantiation before it was made official church dogma during the Counter-Reformation.

Van Meckenem's engraving depicts St. Gregory kneeling before the altar, surrounded by clergymen on either side. Out of a sepulcher placed atop the altar arises Christ as the Man of Sorrows, his gaze downwards in humility and his arms clenched before him, displaying the stigmata. Behind him is a representation of a triptych altarpiece, showing scenes of the bearing of the cross and the resurrection. On the Gothic architectural interior directly behind Christ are the Arma Christi, the instruments of Christ's passion, including: ladder, pincers, cock, Veronica's veil, whipping column, nails, spear, and ointment. This iconography derives from medieval mysticism, and the fostering of a direct connection between an often illiterate worshipper and the illustrated Bible story or liturgical philosophy. The devotee was to meditate on each instrument in order to personally identify with Christ's suffering. Christ's presence on the altar during the Eucharist reminds the viewer of the miracle of transubstantiation as part of the Catholic Church's aims to assert the real presence during the Eucharist. Gregory and his attendants seem shocked and even frightened by the miraculous vision in this iconic print. In other versions by Van Meckenem, Christ's blood even flows from the wound in his side (inflicted by Longinus's spear) into the chalice before Gregory, visually asserting the dogma of transubstantiation of wine into blood.

Van Meckenem's image of Christ is derived from the *Imago Pietatis* (c.1300) from the Basilica of Santa Croce-in-Gerussalemme in Rome

1. Melanie Gesink Cornelisse, "Israhel van Meckenem's engravings of the Mass of Saint Gregory and the Santa Croce Imago pietatis icon," MA thesis, University of Texas at Austin, 1998, 1.

2. Caroline Walker Bynum, "Seeing and Seeing Beyond: The Mass of St. Gregory in the Fifteenth Century," in *The Mind's Eye: Art and Theological Argument in the Middle Ages*, eds. Jeffrey F. Hamburger and Anne-Marie Bouché (Princeton: Princeton University Press, 2005) 208–40.

(Color Plate 9).[3] The church had been the headquarters of the Carthusian order since the Middle Ages. To this day, they claim that their icon is a true image of Christ's physiognomy as received by Pope Gregory during his miraculous mass. During the thirteenth and fourteenth centuries, the Carthusians promoted the Mass of St. Gregory prints as a way of authenticating the Pope's vision and promoting pilgrimage to Santa Croce.[4] Van Meckenem's version of the print includes an inscription at the bottom that offers indulgences to the owner who recites seven *Pater Nosters* and seven *Ave Marias* before the image.[5] If completed, he promises twenty thousand years of indulgence in place of taking pilgrimage to Santa Croce. Van Meckenem thus circumvents the aims of the Carthusians by claiming the ability to impart indulgences without any official recognition from the church. He uses this promise as a marketing strategy to ensure the success of his print at a time when prints were a new and exciting commodity.[6]

Van Meckenem's print of the *Mass*, which was not authenticated by any ecclesiastical authorities, was wildly popular during his life and beyond, as evidenced by its use in Mexican featherwork some fifty years later. While we know that his prints traveled great distances, the modes of dissemination remain unclear. Print scholar Peter Parshall points out that his prints traveled quickly, reaching regions as far flung as the Baltics and Spain as early as the last decades of the fifteenth century.[7] The imagery of the Mass became firmly rooted in Spain by the early sixteenth century, evidenced by numerous versions of the subject painted on Spanish altar screens. Northern prints of the subject probably arrived in Spain via the fair in the city of Medina del Campo,[8] famous during the late Middle Ages for its lavish market full of both foreign and domestic goods. From Spain, it crossed the Atlantic and was reused at the Franciscan College in Mexico as a source for one of the earliest dated works of art in the Viceroyalty.

3. Because there is no record of Van Meckenem having traveled to Santa Croce, we can presume that he saw the *Imago Pietatis* through another print, perhaps one by his teacher, the Master E. S. (c. 1420–c. 1468), a German engraver, printmaker, and goldsmith.

4. Cornelisse, "Israhel," 2.

5. Ibid., 3.

6. Parshall claims that out of seven hundred prints attributed to his name, only 10 percent are not derived from copies of other prints. David Landau and Peter Parshall, *The Renaissance Print: 1470–1550* (New Haven: Yale University Press, 1994) 54.

7. Ibid., 57.

8. Donna Pierce et al., *Painting a New World: Mexican Art and Life* (Denver: Denver Art Museum, 2004) 97.

After the subjugation of the Aztec capital was complete in 1521, the Spanish conquerors set about on the spiritual conquest of the New World. The first friars arrived as early as 1523 and were members of the Franciscan order. The Dominicans, Augustinians, and Jesuits would follow. It was their mission to convert the native population to Christianity, as they believed that the New World could be a New Jerusalem, a land free of the sin and corruption of the Old World. This utopian spirit led the process that began with baptism ("conversion") and then focused on Christian catechesis, the ongoing explication of Christian dogma to native neophytes. Pedro de Gante was one of the first missionaries in the former Aztec capital, where he founded the Colegio de San José de los Naturales, a trade school where Mexica artists were instructed in the visual arts. Its students probably came from native artist families, and at this school they were trained in the Western pictorial tradition, creating Christian works using both native and imported techniques.

The visual arts played an important didactic role in the conversion process. Gante is known for his use of the so-called Testerian Catechisms, a pictographic writing technique used to instruct native converts. The subject of the transubstantiation was of keen importance in sixteenth-century Mexico City, where Spanish friars worked to convert natives to Christianity. Of great concern for church authorities was teaching the doctrine of the Eucharist to a culture of people who had practiced human sacrifice. Natives drew parallels between the sacrifice of Christ and the practice of human sacrifice, the ingestion of the host could be likened to sacrificial cannibalism, a practice that the Spanish adamantly denounced.

Friars advocated instead for the teaching of Christ as so-called perpetual sacrifice, celebrated with the rite of the Eucharist. Transubstantiation of the host, from the Latin term *hostia*, or victim, was to take the place of the sacrificial victim.[9] The dogma of transubstantiation was never as important as it became in the context of the conversion process occurring in early colonial New Spain.

Some of this conversion process can be detected in the subtle changes in iconography that occurred when the native artist interpreted the Van Meckenem print. The artist removes the scene from the Gothic interior of the original print. Instead, the scene is set within an ambiguous blue background, one that perhaps references an outdoor setting for the Gregory

9. Alessandra Russo, "Plumes of sacrifice: Transformations in sixteenth-century Mexican feather art," *Res* 42 (2002) 240.

mass.[10] This is unsurprising giving the popularity of outdoor worship in New Spain's *convento* complexes. This approach was meant to appeal to native converts, who had practiced most of their ritual and pageantry outside of pre-Hispanic temples. Nestled in the feather "sky" are the instruments of the passion that in the print appear on a defined architectural surface (a triptych behind the altar). In the Mexican version, these images are separated from a discrete physical space and curiously resemble native glyph symbols, found on pre-Hispanic codices and maps. Perhaps by separating the images from a defined and rational space, the native artist attempts to "translate" them into legible glyphs, used to meditate on the different stages of Christ's passion.

By stripping down these passion symbols into simplified glyphs, they recalled the prehispanic glyphic writing system found in Mixteca-Puebla folding screen and codex manuscripts. Although using a new Christian visual language, by taking these elements and isolating them in featherwork, manuscripts, and even sculpture, friars were able to more easily instruct neophytes in the new religion.

Instruction of the native using the Arma Christi, which became particularly popular in the Franciscan order, can be seen as well in atrial crosses erected in the atrium of mission churches. Stone crosses such as those at Acolman and the Villa de Guadalupe were carved with the instruments of the Passion. Friars were careful not to allow the inclusion of the actual body of Christ on the cross for fear that natives would draw direct connections to pre-Columbian sacrifice. Instead such crosses often included the Arma Christi and references to the Eucharist: the crown of thorns, stakes, pinchers, column, cock, chalice, and the host among others.

The host, resting atop a chalice, is prominently placed at the base of the famous atrial cross from the Villa of Guadalupe. Directly above this grouping is a stake, the implement used to nail Christ to the cross. Out of it runs a typically native stylized representation of human blood. The glyph's location on the cross suggests that the blood runs from the symbolic wound and into the Eucharistic chalice, creating a literalist interpretation of the transubstantiation that would be easily legible to native neophytes.

The inclusion of the traditional Arma Christi as well as emblems referring to the Eucharist very directly link atrial crosses to the Gregory Mass. The same lesson is being spelled out directly: the ability to communicate and translate the miracle of the sacrifice of Christ through the passion and

10. Pierce et al., *Painting a New World*, 96.

his eternal sacrificial gift of the Eucharist. Using the same iconography of the Arma Christi, the *Miraculous Mass of St. Gregory* featherwork is meant to celebrate the spiritual and intellectual conversion of the natives, and it does so using a fascinating melding of European iconography and aesthetics with Mexica technique, materials, and conception. It was created by a native artist in a school run by Christian friars, commissioned by an Indian governor for Pope Paul III. The caption that surrounds the image explains it as such: "Fashioned for Pope Paul III in the great city of Mexico of the Indies by the governor Don Diego under the care of Fray Pedro de Gante of the Minorites, AD 1539." It is not only the earliest surviving colonial feather mosaic, but also the only one that records the precise time, date, and patron. It exemplifies the complex conversations going on between and amongst natives and Europeans of different ranks in the early colonial period.

Furthermore, the fact that it was commissioned by Diego Huanitzin for Pope Paul III is an indication of the continued pre-hispanic tradition of elite gift giving, and may be a gesture of legitimizing Mexico as the "New Jerusalem," a land full of neophytes ready to accept Christianity. Perhaps Huanitzin commissioned the work to legitimize his people in the eyes of their new papal authority, and to convince the crown to have mercy on them. It perhaps asserts Mexicans as "true" Christians, capable of understanding the complexities of Christian doctrine, in this case, the miracle of transubstantiation.

This miracle, central to the faith, revolves around the body of Christ, a theme explored in the visual arts since early Christian times. The *imago pietatis*, legitimized by the miraculous vision of Pope Gregory, came to serve as a prototype which artists on both sides of the Atlantic used to record, disseminate, and legitimize the body of their Savior, Jesus Christ. Just as Gregory saw the truth of transubstantiation during his miraculous mass, the native artist, through didactic tools, could see the truth of Christianity.

The *Miraculous Mass of St. Gregory* was an appropriate subject because the eighth-century Pope "saw" the truth of transubstantiation and advocated for the importance of visually experiencing divine truth. *The Miraculous Mass of St. Gregory* featherwork probes questions of the didactic quality of art, and the act of seeing and believing that dates back to Pope Gregory's vision. Behind Gregory's vision are a host of theological debates regarding the ability to see the divine: Did Gregory see the physical body of Christ, or was Christ pictured within his mind's eye?

Thirteenth-century Dominican theologian Thomas Aquinas wrote that a visionary's "eyes [were] . . . affected as if they outwardly saw flesh, or blood, or a child."[11] Pope Gregory himself said that the prophet saw the "eternal brightness of God" through meditation and contemplation.[12] Under the proper conditions the devout could receive visions of the divine.

In Pope Gregory's writings on the Book of Job, he argues that true wonders are seen "with spiritual vision, purified with acts of faith and abundant prayers." He goes on to describe the visions of Pope Benedict, and shows a concern with vision and light. Gregory's writings and the legend of his miraculous mass show the development of a preoccupation with seeing divine truth. As art historian Cynthia Hahn describes his writings "The salient aspects of the Gregorian tradition that relate to vision in the Early Middle Ages have to do with the capacity of visual imagery to strike the soul, instantaneously and with completeness."[13]

It is just this type of "soul striking" imagery that may have compelled Huanitzin to commission the *Miraculous Mass of St Gregory* featherwork. Executed in the most precious and luminous of materials, the patron's aim was to prove that natives had seen, learned, and absorbed Christian truth. Not only could it be a metaphor for the Indian's ability to see divine truth but it could provide a platform from which the Pope could see the "truth" of native conversion.

This type of art, made in the colonial period, but displaying an Indian quality, is often given the label *tequitqui*. The term applies primarily to objects made by native artists who had a tangible memory and understanding of their native culture before the arrival of the Spanish. Featherwork was an elite indigenous art practice long before the arrival of the Spanish. The Aztec kings, in fact, had their own aviaries where they raised tropical birds solely for the purpose of creating featherwork textiles. Franciscan friar Bernardino de Sahagún describes the art of featherwork in his *Historia General*, explaining that they were drawn on maguey leaf or fig tree paper that was reinforced with cotton and glue.[14] Over this base precious

11. Bynum, "Seeing and Seeing," 211.

12. Carlo Bertelli, "The Image of Pity in Santa Croce in Gerusalemme," in *Essays Presented to Rudolf Wittkower on his sixty-fifth birthday*, ed. Douglas Fraser et al. (London: Phaidon, 1967) 52.

13. Cynthia Hahn, "Visio Dei: Changes in Medieval Visuality," in *Visuality Before and Beyond the Renaissance: Seeing as Others Saw*, Cambridge Studies in New Art History and Criticism, ed. Robert Nelson (Cambridge: Cambridge University Press, 2000) 169–96, esp. 181.

14. Bernardino de Sahagún, *Historia general de las cosas de Nueva España*

feathers were applied using bone tools. Detailed lines were achieved with closely overlapped layers adding to the intrinsically iridescent quality of the feathers. Some of the birds used were: parrot, hummingbird, quetzal, troupial, spoonbill, and heron.[15] Possessing the feathers of these tropical birds in the landlocked Basin of Mexico was a symbol of the expanse and power of the empire. Only elites and sacrificial victims were so honored.

The sheer brilliance and technical refinement of featherwork was admired by the Spanish, who in turn found a way to "Christianize" it, as was done at Gante's school. One could easily compare the brilliantly colored accomplishments of these works to European stained glass, enamels, and manuscript illumination.

In the case of the *Mass* featherwork, the artist takes a European print source and alters it to fit into a native worldview. This syncretic process is related to one that art historian Samuel Y. Edgerton calls the "principle of expedient selection."[16] This term refers to the process by which friars chose the symbols and theories that would most directly speak to natives during conversion. Edgerton explains this process carried out by missionary friars who "used the visual arts for conversion purposes . . . [they chose] from the vast store of European artistic motifs and Christian stories just those that would evoke in Indian eyes reassuring resemblances to certain indigenous preconquest concepts."[17] While Edgerton places most of the agency in the hands of Christian friars, his approach can prove useful when looking at the feather mosaic. Perhaps this strategy of expedient selection was also made by the artist in response to the new religion.

As discussed above with the Arma Christi, the Mexica artist used Christian symbols, a European source given to him by a friar, and reinterpreted these symbols into glyph-like elements recalling the prehispanic literary past. The aesthetics of the object speak to its hybridity, one that cannot be credited only to the ingenious manipulations of a native friar, but must also be considered the intent of both native patron and artist. The *Mass* featherwork was made by a native artist creating a Christian liturgical object using native techniques, thus infusing them with a new hybridized meaning.

(Barcelona: Linkgua, 2008).

15. Pierce et al., *Painting a New World*, 96.

16. Samuel Y. Edgerton, *Theaters of Conversion: Religious Architecture and Indian Artisans in Colonial Mexico* (Albuquerque: University of New Mexico Press, 2001) 113.

17. Edgerton, *Theaters of Conversion*, 2.

What occurs, then, when native featherwork is seen by Europeans and appropriated for use in liturgical objects? Art historian Alessandra Russo takes an interesting approach by analyzing the significance of feathers in Judeo-Christian cosmology and using that to understand them within this newly hybrid colonial context. She argues that feathers occupied a liminal space in sixteenth-century European thought; they were associated with deviltry and paganism as well as with divinity. Sahagún compares the feathers of Huitzilopochtli, the Mexica patron god, with the feathered helmet of the Roman god Mars in his *Florentine Codex*.[18] Feathers could also be seen as symbolic of divine intervention, what with the Holy Spirit as white dove and the preponderance of winged angel iconography. But these European conceptions of feathers are tied to their *symbolic* quality. The import is placed on their association with pre-Christian iconography (as in the case of the Mars helmet association), or on their status as an integral component of aviary iconography. In the prehispanic context, however, feathers were important for their metonymic purposes—their actual *essence* was sacred. They were connected to human sacrifice not because they were "symbols" of it, but because they *embodied* it.

Following Russo's logic, perhaps the Spanish commissioned feather mosaics using Christian iconography in order to erase pagan associations with feathers, and to reconstruct them as relevant in a sacred Christian context.[19] In the case of the *Mass of St. Gregory* featherwork, the Mexica governor Diego Huanitzin commissioned the work, thus fusing native elite gift giving with Spanish liturgical featherwork patronage. In the prehispanic context, featherwork was used for adornment in the form of headdresses, shields, and clothing. Transformed in the early colonial period, the technique was translated into a European idiom (for a European audience) by conforming to the format of a hanging picture. In this way the artist molded a native technique to fit European sensibilities.

Because of their brilliance and technical refinement, the materiality of featherwork has been oft discussed by scholars. It is with our period eye that we probe the hybridity of an object, asserting its European qualities (Christian imagery, German print source) and its indigenous qualities (featherwork, glyphic elements). Instead this object should be seen as a third signifier—with neither separately Spanish nor indigenous qualities.

Carolyn Dean and Dana Leibsohn's 2003 "Hybridity and Its Discontents: Considering Visual Culture in Colonial Spanish America" discusses

18. Russo, "Plumes of sacrifice," 237.

19. Ibid., 229.

the issue of visible and invisible hybridity.[20] They claim that scholars tend to look for signs of indigenous technique in order to mark an object as hybrid. However, there are arguably hybrid elements that may be invisible, taking the form of a purely European medium, but may have associations with or connections to prehispanic thought. In the case of the *Mass* featherwork, it is clearly hybrid in terms of technique (featherwork) and aesthetics (the "glyphic" Arma Christi). However, does this mean that the hybrid object is not orthodox Catholic?

We must probe both visible and invisible forms of hybridity, and understand that such hybridity is multi-faceted. Just because an object has "hybrid" elements, and was made by native artists, does not necessarily make it hybrid in terms of cosmological thought. In fact, the patron's intent was to show the triumph of the Christian faith amongst the native population on the wake of the conquest and the onset of the Counter-Reformation. By proving that they were true Christians, Huanitzin hoped to improve the fate of the native population who had been brutalized during the conquest. Russo argues that the featherwork was offered by Huanitzin under the guidance of Pedro de Gante in order to demonstrate the success of his missionary efforts.[21] By proving his people as true Christians, Tenochtitlan's governor hoped to win favor in the eyes of Rome and to receive better treatment in return. The early colonial landscape was one in which natives had to jockey for position under the church and crown. Positioning oneself as a true Christian could lead to upward mobility in the new colony. The featherwork thus was conceived as a celebration of the triumph of Christianity in the newly minted Viceroyalty, "truth" of the faith revealed to the native, much as the image of Christ appeared in a vision to Pope Gregory.

20. Carolyn Dean and Dana Leibsohn, "Hybridity and Its Discontents: Considering Visual Culture in Colonial Spanish America," *Colonial Latin American Review* 12, no. 1 (2003) 5–35.

21. Russo, "Plumes of sacrifice," 243.

Methodological Issues of Reading Theology in Renaissance and Baroque Art

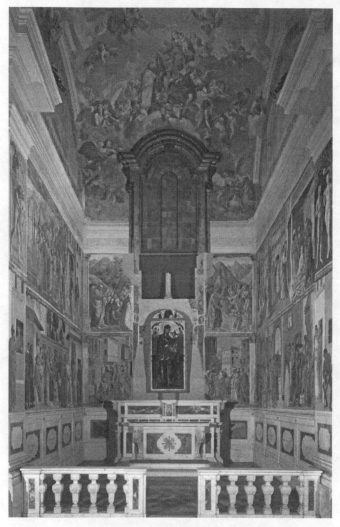

Figure 15. Brancacci Chapel, Santa Maria del Carmine, Florence.
Photo permission of Antonio Quattrone.

Reading Hermeneutic Space

Pictorial and Spiritual Transformation
in the Brancacci Chapel

CHLOË REDDAWAY

The frescoes of the Brancacci Chapel in the Carmelite Church of Santa Maria del Carmine (Figure 15), painted by Masolino da Panicale, born Tommaso di Cristoforo Fini, (c. 1383–c. 1447) and Masaccio, born Tommaso di Ser Giovanni di Simone, (1401–1428), in the 1420s and completed by Filippino Lippi (c. 1457–1504) in the 1480s, are among the most celebrated works of the early Italian Renaissance. They were much admired by contemporaries and future generations of artists, including Michelangelo Buonarroti (1475–1564) and Giorgio Vasari (1511–1574), and continue to be studied as revolutionary works that were definitive of their period and a strong influence on Western painting for several centuries thereafter. Scholarly discussions of the frescoes, however, often overlook the cycle's liturgical location and theological purposes. Viewed in this context, the frescoes unite theological content and visual form to describe a three-part history of salvation, from Genesis, to the life of St. Peter, to the contemporary viewer/worshiper's own spiritual experience.

Responding to the theological nature of the frescoes, this essay proposes a methodology for interpreting the cycle based on a critical-devotional approach intended to enrich our understanding of the images theologically.[1] This method explores how the artists portrayed spiritual

1. This essay is based on a paper given at the ITIA conference on the work of David Brown in St Andrews, 6–8 September, 2010, and derived from work for a forthcoming doctoral thesis (King's College London). The thesis proposes a methodology for the theological interpretation of images and tests this against a series of case studies of Florentine religious frescoes c. 1300–1500.

transformation through spatial composition, relating the corporeal, physically located viewer, in the three dimensional space of the chapel, to the two-dimensional picture plane and what it presents. The method reveals how, by integrating content and composition, and by using the natural focal point as the locus of divine activity, the artists connect the two dimensional space of the images with the three dimensional chapel space in which the viewer stands. This allows the viewer to experience the historical and meta-historical reality of the picture plane within their own space and time.

The chapel's fresco cycle, which covers three walls, consists of scenes from the life of Peter from his calling by Christ to his martyrdom. These are bracketed by depictions of the *Temptation* and *Expulsion* on the entrance pilasters, which situate Peter in the context of the history of salvation, in which he plays an important role, becoming increasingly conformed to Christ in his discipleship. Originally the vaults held the four evangelists and two lunettes showed the *Calling of Peter*[2] and the *Naufragio*.[3] These, along with *Peter Weeping*[4] and *Feed my Sheep*[5] on the altar wall, have been lost.[6] On the top register of the left wall is *The Tribute Money*,[7] showing the tax collector from Matthew's Gospel demanding payment, Christ telling Peter that he will find a coin to pay the tax in the mouth of a fish, and Peter paying the tax (Color Plate 10). On the left of the altar Peter preaches[8] and on the right baptizes.[9] On the right wall he heals a cripple who begs for alms[10] and resuscitates the devout Tabitha (Color Plate 11).[11] On the lower tier, beginning on the left pilaster, St. Paul visits Peter in prison. Next,

2. Matt 4:18–20.

3. Matt 8:23–27 and 14:28–33.

4. Matt 26:75.

5. John 21:15–18.

6. They are known from sinopie. Ornella Casazza describes the *Calling of St Peter* as being in the left lunette, and the *Naufragio* on the right. Ornella Casazza, *Masaccio and the Brancacci Chapel* (Florence: Scala, 1990) 15–16. Steffi Roettgen's diagram of the Chapel, however, inverts the scenes, putting the *Naufragio* on the left and the Calling on the right. Steffi Roettgen, *Italian Frescoes: The Early Renaissance, 1400–1470*, trans., Russell Stockman (New York: Abbeville, 1996) 98. This essay follows the program as described by Casazza, who was involved with the restoration program.

7. Matt 17:24–27.

8. Acts 2:14–40.

9. Acts 2:41.

10. Acts 3:1–8.

11. Acts 9:36–41.

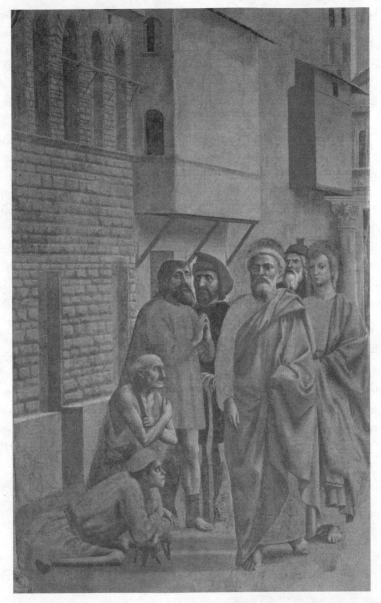

Figure 16. Masaccio, *St. Peter Healing with his Shadow*, 1420s, fresco, altar wall,
left side, lower register, Brancacci Chapel, Santa Maria del Carmine, Florence.
Photo permission of Antonio Quattrone.

Peter resuscitates the son of the ruler of Antioch and is enthroned there (Color Plate 10).[12] On the altar wall he heals cripples with his shadow[13] (Figure 16) and distributes alms above the body of the rich Ananias, who was struck dead for not sharing his wealth.[14] On the right pilaster Peter is led out of prison by an angel[15] and on the right wall he disputes with the magician, Simon Magus, in front of Nero, and is crucified upside down (Color Plate 11).[16]

The scenes may be read both horizontally and vertically. On the horizontal axis they are organized chronologically,[17] moving clockwise from top to bottom, with the Genesis elements acting as parenthesis around the whole. On the vertical axis they emphasize Peter's increasing conformity to Christ. Thus on the left wall Christ calls Peter (now lost); Christ invites Peter to model himself on him, by sacrificially paying the tax on behalf of others; and Peter acts like Christ by resuscitating a dead boy. The right wall shows Peter's initial lack of faith in the (lost) *Naufragio*; Peter acting with faith in performing miracles; and Peter dying for, and like, his Lord. On the left side of the altar wall was *Peter Weeping*, remorseful at his betrayal of Christ. Below this Peter preaches salvation, affirming rather than denying Christ, and his faith saves others as his passing shadow heals them.[18] On the right of the altar the lost top scene was *Feed my Sheep*, another commissioning event where Peter is commanded to take on Christ's role. Below this he baptizes, initiating people into Christ and washing away sins, and on the lower level his life-giving charity contrasts with the death brought to Ananias by his sin.

The small scenes of Peter in prison do not sit chronologically on the horizontal plane but contrast with the Genesis scenes above them. On

12. Jacobus de Voragine, *The Golden Legend* 3.23.

13. Acts 5:15–16.

14. Acts 5:1–6.

15. Acts 12:6–11.

16. Jacobus de Voragine, *The Golden Legend* 4.8.

17. Given the use of Matthew, Acts, and *The Golden Legend* as source texts the precise chronology of events is impossible to determine.

18. Another possible reading could be that the cripples are healed by their own faith. This may be visually indicated by the healed cripple's gesture of prayer, in contrast to the cripple on the ground whose arms are folded in ambivalence or lack of faith and the central figure who is in the process of coming to faith and of being healed. However, the faith of the sick does not receive specific remark in the text of Acts 5:12–16 (NRSV) on which this scene is based, which simply reports that as increasing numbers came to believe in the Lord they carried their sick into the streets "in order that Peter's shadow might fall on some of them as he came by."

the right Peter walks free from prison, led by the angel, while above him Adam and Eve are tempted into the bondage of sin. Their choice leads to expulsion; his to freedom. On the left, Peter talks to Paul from his prison cell, and Adam and Eve are expelled from Paradise. They are pushed out of the gates while Peter is imprisoned by bars. Paradoxically, their expulsion, itself a sort of imprisonment, is the result of sin while his incarceration is the result of virtue. The four pilaster scenes thus discuss freedom and restriction, sin and virtue. They present human choice and its implications as the context in which the viewer approaches the liturgical space of the chapel, where the mass is celebrated and the souls of the dead prayed for, and the context of Peter's mission.

These frescoes, particularly Masaccio's, were celebrated by contemporaries such as the humanist Cristoforo Landino for their naturalism, relief, and purity.[19] Vasari, with his interest in biography and connoisseurship, praised the talents and characters of the artists, singling out Masaccio as paving the way for "the good style" of "the moderns," situating him between Giotto's innovations and Michelangelo's mature genius, and claiming that all celebrated artists during and since Masaccio's time owed their excellence to studying his Brancacci frescoes.[20] Vasarian perspectives have endured into the twentieth century as scholars continue to focus on questions of attribution, influence, and situating these works within the canon of art history.[21] Attention has thus focussed on identifying key aspects of style and technique, and on determining chronology.

Brancacci scholarship was reinvigorated by a major restoration campaign in the 1980s, which enabled unprecedented analysis of the frescoes, revealing sinopie, and advancing understanding of the artists' techniques.

19. Cristoforo Landino describes Masaccio as a "very good imitator of nature, with great and comprehensive *rilievo*, a good *componitore* and *puro*, without *ornato*, because he devoted himself to the imitation of the truth and to the *rilievo* of his figures. He was certainly as good and skilled in perspective as anyone else at that time, and of great *facilita* in working, being very young." Translated and quoted in Michael Baxandall, *Painting and Experience in Fifteenth-Century Italy* (Oxford: Oxford University Press, 1972) 118. Baxandall interprets "imitator of nature" as implying "independence from pattern books and formulas, the stock figures and accepted arrangements" and studying from nature, using perspective and relief. See Baxandall, *Painting and Experience*, 119–21. Baxandall interprets as the use of light and shade to signify form, based on a specific light source, while *puro* and without *ornato*, imply a positive form of plainness suggesting clarity rather than bleakness. *Facilita* is a kind of fluency, suggesting quick work of a high quality, "something between our 'facility' and 'faculty'" (223).

20. Giorgio Vasari, *The Lives of the Painters* (London: Dent and Sons, 1927) 255–90.

21. See Roberto Longhi, "Fatti Di Masolino E Di Masaccio," *Critica d'arte* 2m (1940) 25–26.

Umberto Baldini and Ornella Casazza,[22] key figures in the restoration, were able to shed new light on issues of attribution and technique, and their analysis of the scenes focuses on formal elements, understood in terms of the artists' development, and the relationship of the images to earlier and later works. However, their work also makes brief reference to the potential resonances of some contemporary issues and the personal interests of the patron, with pointers to more detailed work by other scholars.[23]

This new era of Brancacci scholarship was also characterized by a growing interest in the social and cultural world of the frescoes, reflecting the influence of cultural history and the concept of the "period eye" in art history,[24] and drawing on the archival research of the 1970s that had done much to increase knowledge of the artists' lives, in particular.[25] Within this field of interest a small but significant discussion of the theological context and meaning of the frescoes emerged. While Cassaza's method considered the iconography as essentially illustrative of the relevant texts, with the scenes connected by their Petrine subject and by the "history of salvation," she offers little expansion or interrogation of this. However, other art historians, including: Nicholas Eckstein, Astrid Debold-von Kritter, Law Bradley Watkins, Jules Lubbock, and Andrew Ladis, have begun to question the frescoes' theology in more detail.

The contributors to Nicholas Eckstein's edited volume, *The Brancacci Chapel, Form, Function and Setting*—the most comprehensive recent assessment of the chapel—examine the relationship between the chapel, its patron, the Carmelites, religious confraternities, the neighborhood, ritualized charity, and contemporary Florentine concerns, including propapal policy and taxation, thereby greatly increasing our appreciation

22. Umberto Baldini and Ornella Casazza, *The Brancacci Chapel Frescoes* (New York: Thames & Hudson, 1992); Ornella Casazza, *Masaccio and the Brancacci Chapel* (New York: Scala, 1990).

23. See Ugo Procacci, "L'incendio della chiesa del Carmine del 1771," *Rivista d'Arte* 14 (1953) 141–232; Millard Meiss, "Masaccio and the Early Renaissance: the Circular Plan," in *Acts of the 20th International Congress of the History of Art*, vol. 2 (Princeton: Princeton, 1963); Luciano Berti, *Masaccio*, (Milan: Istituto editoriale italiano, 1964); Kurt Steinbart, *Masaccio* (Vienna: Schroll, 1948); and Peter Meller, *La Cappella Brancacci: problemi ritrattistici ed iconografici* (Milano: s.n., 1961).

24. For discussion of the "period eye," see Baxandall, *Painting and Experience*.

25. For a useful bibliography, see Diane Cole Ahl, ed., *The Cambridge Companion to Masaccio* (Cambridge: Cambridge University Press, 2002) 271–74.

of the original viewers' experience.[26] Even these scholars, however, have generally interpreted the iconography by reference to factors external to the composition of the images and their situation in a funerary chapel and, beyond some discussion of Carmelite propaganda and preaching, the theology of the scenes is given little consideration. This lacuna is, however, remarked upon and the paucity of theological analysis available to the art historian lamented.

Theologically-conscious analyses of the Brancacci Chapel are indeed rare. The 1970s doctoral work of Astrid Debold-von Kritter[27] gives greater weight to theological concerns, while acknowledging the influence of contemporary matters generally.[28] Another thesis, by Law Bradley Watkins, represents a more concerted, though less successful, attempt to offer a theological interpretation of the cycle. Watkins rejects socio-political and economic factors as explanations for the iconography, arguing that the frescoes relate primarily to their location in a chapel for the celebration of the mass, and function by physically perpetuating Christian spiritual transformation, as exemplified by Peter. Watkins' assessment is bold and often theologically persuasive but he undermines himself by exaggerating his claims and unrealistically dismissing all "external" influences.[29] At times his analysis ascribes a magical efficacy to the images, which dispenses with the viewer altogether, and negates his own emphasis on the images' physicality and corporeality, rendering them theologically impotent.[30]

Jules Lubbock's 2006 analysis of Christian narrative in art claims that Masaccio's frescoes present an imaginative response to contemporary doctrinal issues, using "narrative as a vehicle for doctrine."[31] Lubbock argues

26. Nicholas A. Eckstein, *The Brancacci Chapel: Form, Function and Setting* (Florence: Olschki, 2007).

27. Astrid Debold-von Kritter, "Studien Zum Petruszyklus in Der Brancacci-Kapelle," PhD diss., University of Berlin, 1975.

28. Having himself sinned, doubted and denied, and repented, received forgiveness, and been entrusted with the Church on earth and the keys of Paradise, Peter is an example and solace to repentant sinners.

29. See Lubbock's persuasive discussion of papal issues in the *Tribute Money*. Jules Lubbock, *Storytelling in Christian Art from Giotto to Donatello* (New Haven: Yale University Press, 2006) 208–25.

30. He appears to contradict himself, or at least shows some confusion on this point, as he also writes that the frescoes are there "to contribute to use" and that the viewer must be participant rather than onlooker. Law Bradley Watkins, "The Brancacci Chapel Frescoes: Meaning and Use," PhD diss., University of Michigan, 1976, 118.

31. Lubbock, *Storytelling*, 225.

for an interpretation based on pro-papal policy and the taxation of the church, making the frescoes "a major example of Carmelite propaganda for the primacy of the papacy against its many adversaries."[32] Although his analysis is brief, he offers a coherent interpretation of the images as a presentation of contemporary theology, bordering on propaganda, but without implying hypocrisy. Given the difficulties around uncovering authorial intention, especially without documentation, his assessment of the relation between narrative and composition, which interweaves the visual evidence with contemporary circumstance, is valuable. Nevertheless, his concern is primarily to illustrate the theme of Christian storytelling and his method is not dissimilar to others who interpret the frescoes through their contemporary context.

Andrew Ladis's 1993 monograph is unusual in employing a much more integrated methodology, combining technical, formal, iconographical, and contextual factors, with a strong theological awareness, illuminating polyvalent meanings in the frescoes.[33] Alongside Petrine biography and the history of salvation, he identifies a theme of human and divine vision and truth that suggests that mankind's post-lapsarian view of things is untrustworthy. By playing with perspective, emphasizing the unexpected, and combining visual and metaphorical elements, appearances are shown to be deceptive. Ladis pays little explicit attention to redemption and spiritual transformation, but this may be implicit in his understanding of the cycle as essentially a history of salvation. His approach demonstrates how compositional elements can relate to and impart meaning, and his analysis of heavenly and earthly vision is compelling, and recognizes the viewer's interactive role.

The late-twentieth-century approaches outlined above broadly represent three interpretative strategies. Baldini and Casazza focus on technique, attribution, and artistic development, accepting rather than interrogating the iconography and its relation to composition. Eckstein and others provide a detailed picture of the historical context and identify aspects of the imagery which might have resonated with contemporary audiences, but offer little additional theological insight.[34] The more theologically concerned scholars, Lubbock and Ladis, as well as Debold-von Kritter and Watkins, explore the theological sources, motives, and

32. Ibid., 223.

33. Andrew Landis, *The Brancacci Chapel, Florence* (New York: Braziller, 1993).

34. With the exception of a discussion of sermons. Peter Howard, "The Womb of the Memory: Carmelite Liturgy and the Frescoes of the Brancacci Chapel," in Eckstein, *The Brancacci Chapel*, 177–206.

function of the frescoes, with varying success. Of these, Ladis' interpretation stands out for its successful and theologically imaginative integration of contextual, formal, and theological factors.

These assessments have identified theological themes of salvation history, spiritual transformation, and earthly and divine vision, within the context of a funerary and eucharistic chapel. Scholars have also argued that the scenes demonstrate contemporary concerns including pro-papal policy, church taxation, charity, Carmelite history, and events in the patron's life. However, there is more to be said about the theology of the cycle, and too little attention has been paid to the depiction of divine activity, and to the interactive role of the viewer. A theologically-founded methodology of critical-devotional reading may redress the balance and, in particular, exploring the use of space as a medium of theological communication may be especially generative.[35]

A critical devotional method implies a theological interpretation of images that is neither naive, accepting unquestioningly the religious content in images, nor cynical, dismissing the possibility of integrity in religious images and focussing solely on socio-economic and political factors in their creation. Instead it takes seriously the nature of religious art as sacramental, revelatory,[36] and inspirational, within a framework of critical assessment, thereby increasing awareness of the capacity of Christian images to act as theological media. It is substantially informed by, but not restricted to, art historical assessments, also drawing upon other methods, including: textual hermeneutics;[37] the literary critical method of reader criticism;[38] the theological approach known as reception studies;[39]

35. The construction of a theological hermeneutic for the interpretation of images is a major part of my doctoral work, the subject of a recent short paper at the Society for the Study of Theology's annual conference, April 2011, and may be published in due course.

36. In the sense that the image reveals something about the divine to the viewer. This is not to argue that the image is necessarily divinely inspired in the sense of being literally directed by God, but simply that it makes manifest an aspect or aspects of God and of his activity in Creation.

37. See D. Ford and G. Stanton, eds., *Reading Texts, Seeking Wisdom* (London: SCM, 2003); S. E. Fowl, *Engaging Scripture: A Model for Theological Interpretation* (London: Blackwell, 1998).

38. See, for example, W. Iser, *The Implied Reader: Patterns of Communication in Prose Fiction from Bunyan to Beckett* (Baltimore: Johns Hopkins University Press, 1974). See W. G. Jeanrond, "After Hermeneutics: The Relationship between Theology and Biblical Studies," in *The Open Text: New Directions for Biblical Studies*, ed. F. Watson (London: SCM, 1993).

39. See M. Bockmuehl, *Seeing the Word: Refocusing New Testament Study* (Grand

its comparator, cultural history, with its project of "seeing things their way";[40] and its counterpart in art history of acquiring the "period eye."[41] Furthermore, this method recognises the essentially corporeal and located nature of art works, particularly frescoes, and incorporates a Christian understanding of sacred space, and the relationship of viewer and image within this. This allows attention to be paid to the relationship between the image, its pictorial space, its location, and the spatially located viewer: a web of relationships that may illuminate theological content.

The interpretative strategies that inform this method facilitate an ongoing, dynamic relationship with the object of study, and their methodological breadth of scope enriches understanding and appreciation of these objects. In employing this method, it is always necessary for the interpreter to be historically, subjectively, and personally conscious.[42] The interpretations produced using this method are neither exhaustive nor the final word on the subject but rather a constructive reading, intended to enrich appreciation of images as theological media.

As with any theological enterprise, theological interpretations of art can draw on the rich sources of revelation,[43] biblical Scripture, Christian tradition, human reason, and experience, as a sound basis underpinning all theological judgements.[44] Thus the proposed methodology involves the critical assessment of images through the lens of Christian doctrine, faith, and practice, taking account of the scope of reference that the subject matter may have, e.g., the nature and role of Peter in the New Testament, early Church, later theological writings, and Christian practices, or that may

Rapids: Baker Academic, 2006); and F. Watson, ed., *The Open Text: New Directions for Biblical Studies* (London: SCM, 1993).

40. See Coffey Chapman et al., eds., *Seeing Things Their Way: Intellectual History and the Return of Religion* (Notre Dame: University of Notre Dame Press, 2009).

41. See Baxandall, *Painting and Experience.*

42. With regard to this last, I readily acknowledge my own concerns as a theology scholar working on visual art, an art lover, though not an art historian, and a member of the Church of England who sometimes worships in the Roman Catholic Church and with the Society of Friends.

43. Revelation is used here in a broad sense, encompassing but not restricted to revelation in scripture. See n36 above.

44. For discussion of these theological sources and of their enduring relevance, see Tanner Webster et al., eds., *The Oxford Handbook of Systematic Theology* (Oxford: Oxford University Press, 2007); and Nigel Atkinson, *Richard Hooker and the Authority of Scripture, Tradition and Reason Reformed Theologian of the Church of England* (Carlisle, UK: Paternoster, 1997).

be indicated by formal elements of a work, e.g., the use of light, or the positioning of key figures.

The application of the critical-devotional method requires a detailed examination of the art itself. In the Brancacci frescoes, Masolino, Masaccio, and Filippino Lippi depict the essentially un-paintable subject of divine activity, its presence and effect, by their use of space.[45] Here the relation within each picture between figures and their space is composed so as to focus the eye on the person or space in whom or which there is a concentration of actual, or potential, divine activity. In these frescoes, it is the central point of each image, the composition being concentrated around this natural focal point.

The viewer, situated in the same three dimensional space as the frescoes but, initially at least, outside the two-dimensional pictorial plane, is then both drawn into the picture plane and can draw out of it the spiritual import that relates to his own life. Physically located in the chapel, the viewer interacts with the image and its setting, and may absorb the possibility of the divine activity in the image as real potential in his own, three dimensional, world. This process is accomplished in two particular ways, as described below, with the emphasis on the second.

Firstly, the viewer is able to move between, and simultaneously occupy, his own space and the pictures' space. This is because the pictorial space harmonizes three spatio-temporal levels of reality, which together are the context of human existence: the contemporary viewer's world in which he can identify with the spaces and people of his time; the (idealized) world of the New Testament; and the essentially un-located world of Genesis. The gate of Paradise glimpsed on the far left of the *Expulsion* joins the actual wall of the chapel, the viewer's space. Adam and Eve are thus propelled out of Paradise, into the New Testament world of the Petrine frescoes and into our world.

The cycle properly begins and ends with the *Temptation* and *Expulsion* on the pilasters, a reminder as the viewer enters and leaves the chapel of the original sin which is the beginning of the Christian story and the stain on human existence which necessitates all that follows. The viewer enters the chapel space and the Petrine story via the gateway of Eden, a sinner following the original sinners and seeking the help of a forgiven

45. Masolino and Masaccio have worked on very similar lines spatially and Lippi has followed their lead. The exception is the *Temptation*, whose dark, otherworldly space does not draw the viewer into a world much like their own, as the others do, but presents an almost mythical, mysterious background to the cycle as a whole.

sinner who became conformed to Christ. This spatial device creates a strong link between the events of Genesis, the coming of Christ in the New Testament and the mission of his disciple Peter, and the viewer himself.

The Petrine frescoes themselves repeatedly draw in the viewer both by contemporary references, and by physically including the viewer in the composition. The contemporary, the historical,[46] and the meta-historical[47]—actions, effects and consequences—thus convene in these scenes within the overarching narrative of the history of salvation. This is seen here in the progression from humankind's first sin, represented by the *Temptation*, to Christ's redemption, as demonstrated in the discipleship of Peter who is finally crucified like his Lord.

Secondly, the pictorial space is composed so as to focus the viewer's eye on the locus of divine activity that is always in the center,[48] and around which the figures group in variations on a semi-circle. In this simple but highly effective compositional strategy the viewer physically supplies the other half of the semi-circle.[49] His eye is drawn to the central focus around which the activity is concentrated, and his body is simultaneously positioned so as to complete the image, becoming part of the scene. This focus on central divine activity and on the viewer's physical involvement occurs throughout the cycle.

In the *Tribute Money*, Christ is central, the hub around which the disciples gather in an arc. His gesture cuts across the disputed territory between the tax collector demanding payment to his left and the angry Peter to his right, neutralizing the violently charged space between them and pointing toward the sea where Peter will find a fish with the coin to pay the tax. He also points meta-narratively toward Adam and Eve who,

46. This is not the place for a discussion of the historicity of the New Testament. To the contemporary viewer these events were historical and they are treated as such for the purposes of this paper.

47. Although much of the Old Testament would count as history on the assumptions of the note above, the Temptation and Expulsion take place so "early" in human history and have such far reaching consequences that this part of Genesis may be said to operate on different temporal plane to the New Testament accounts of Christ and the disciples.

48. This is an approximation. It may not always be the precise center, but it is close enough to be a natural focal point.

49. Of course, not all contemporary viewers would have been able to stand directly in front of the frescoes, being excluded by the altar rail, but this is the effect of standing in the privileged position of the celebrant. Furthermore, when viewed obliquely, the effect is retained, albeit in a weaker form.

expelled from Paradise, walk into the viewer's world, almost into the *Tribute Money*, toward the altar. The link is implicit: Christ's sacrifice will pay for the viewer's own sin.

On the left, Peter kneels in the center to catch the fish and take the coin. His crouching form preempts the neophyte on the altar wall, and this is indeed a form of spiritual rebirth for Peter. Redemption comes providentially at Christ's instruction, and the obedient Peter, playing his part in this metaphor for salvation, finds the coin that will pay for him, as well as for Christ, and is spiritually reborn. To the right, Peter pays the tax collector. A central V-shaped gulf separates the two men whose hands almost but do not quite touch, their distance emphasized by the prominent post in the foreground. The tax collector, blind to the significance of the encounter is unrepentant, a marginalized figure separated from Christ and the disciples.

On the altar wall, perpendicular to the *Tribute Money*, Peter preaches salvation (Figure 1). Unlike Christ, he does not take the central position. However, the listeners form the familiar arc in front of him, which the viewer completes into a circle. The apparently "empty" central space is explained by the significance of the scene, which lies in the words spoken, rather than their speaker. Since these are not depicted or inscribed, the space is the words. These are both message and messenger; the listeners are the ground on which they fall and where they may or may not take root.[50] Spiritual transformation here is potential rather than actual.

The baptism scene to the right shows that many were converted (Figure 17). The central figure, kneeling as Peter pours water over him, is the spiritual locus. Peter marginalizes himself as the agent, allowing the physical symbol of the water and the spiritual transformation effected in the neophyte to take center stage in a highly physical expression of spiritual rebirth. From the neophyte trembling with cold, to the beautiful figure in the water, to Peter's own magisterial presence, flesh is visibly being redeemed.

50. Mark 4:3–8.

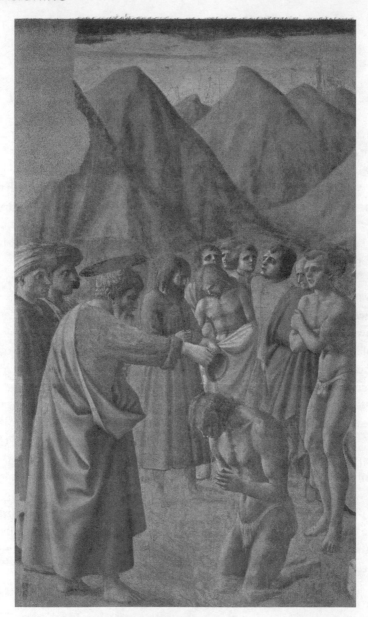

Figure 17. Masaccio, *The Baptism of the Neophytes*, 1420s, fresco, altar wall, right side, upper register, Brancacci Chapel, Santa Maria del Carmine, Florence. Photo permission of Antonio Quattrone.

Continuing along the upper register, the double scene of the *Healing of a Cripple and the Raising of Tabitha* again presents physical transformation as a sign of spiritual status (Color Plate 11). On the left Peter tells the cripple reaching out for alms that he has nothing to give him but Christ, and orders him to walk. The central space between Peter and the cripple, across which their hands reach, is, like the preaching scene, physically empty, but spiritually full. Peter gives the cripple Christ, and in so doing restores his health. The "empty" space here is filled with Christ and pregnant with the miraculous healing about to occur. This compositional, and theological, structure is mirrored in the resurrection of Tabitha on the right. Again there is an empty but active space between the upright Tabitha, radiant in white and surrounded by amazed onlookers, and Peter, standing outside the loggia. The space between them emphasizes that it is not Peter himself but the power of Christ that effects the resurrection.

Between these two narratives, contemporary Florentine life carries on. In the central foreground, two fashionable young men cross the piazza dividing the two scenes, oblivious to the miracles on either side, beautiful and blind. Literally walking between Peter to their left and Peter to their right, they are so caught up in their worldly concerns that they see neither him nor the spiritual transformations he (or rather Christ through him) effects. In a cycle full of hands giving and taking, reaching out and bestowing, and of limbs damaged and healed, these men have hidden their hands in their fine clothes and appear utterly inefficacious. As a potential locus of transformation they show no promise. As such they warn the viewer against worldly concerns and spiritual blindness.

The *Raising of the Son of Theophilus* parallels the structure of the *Tribute Money* above it. Here Peter stands to the left and the onlookers form the usual circle around him, completed by the viewer. The central space is occupied by the resurrected son of Theophilus who rises, hands lifted in wonder or prayer, directly below Christ in the *Tribute Money*. The vertical link is clear, as is the appropriate response, embodied by Paul, already on his knees in prayer.[51] The enthroned Theophilus appears a marginal figure beside the real king above. In the center of the left section two men apparently discuss the miracle. They have not knelt, but their attention to the event suggests at least potential for divine activity here.

51. The identification of this figure as St. Paul is based on his similarity to the figure of St. Paul visiting St. Peter in prison and the absence of additional saints in scenes other than the *Tribute Money*.

On the right, Theophilus and a Carmelite brother kneel before Peter on the Chair of Antioch. He seems strangely lacking in volume and the structure of the throne is unclear. Either the wall covering acts as a cloth-of-honor masking the structure of the throne, or this is a painting of Peter on cloth (or rather, a painting of a painting).[52] Either way he floats, hands in prayer, eyes gazing upwards, detached from those around him. Although the central figure, attended to by all, he is on another plane, pointing beyond himself to Christ. He is both central, and "other-where," the strangeness of his own physicality pointing beyond the physical.

This disengagement recurs in *Peter Healing with his Shadow*. Striding out of the picture plane, a Florentine-looking street, apparently into the chapel, into the viewer's space, Peter's passing shadow cures the cripples. There is nothing particularly physical in the curing, the shadow itself is not prominent and Peter makes no gesture. The cripples have seen his redeemed humanity and that is transformative. Their eyes, and that of the viewer, are progressively opened, developing from the glazed expression of the cripple on the ground to the clear sight of the standing man, so that they represent three stages of being cured. Their physical change represents a spiritual change as the deformed human being is made whole again. The focal point and spiritual center is the gaze of the standing, cured, cripple with his hands in prayer looking at Peter. Touched simply by Peter's shadow he has seen salvation and been healed.

On the other side of the altar, in the *Distribution of Alms*, Peter stands to the side of a circle of figures and again his *physical* agency, giving out coins, is downplayed (Figure 18). The spiritual activity is the charitable nature of the act, not the physical nature of the coins, and the virtue of charity itself occupies the center of the scene. Beneath the hands giving and receiving, the dead body of Ananias who would not give alms freely is a clear contrast to the mother and child receiving charity and, therefore, life in Christ.

In the scenes of the *Disputation with Simon Magus* and the *Crucifixion*, Lippi adopts the familiar format of the circle of figures around a spiritual locus. On the right, Nero points angrily at Peter who has been duelling with the magician. In the center an idol lies broken on the floor, horizontally aligned with the resurrected Tabitha above. Nero does not comprehend the difference between the false magic of Simon Magus and the true miracles of Peter. This should be a moment of conversion, but in Nero that possibility is as dead as the idol is broken. Nothing can come of

52. Lubbock, *Storytelling*, 218.

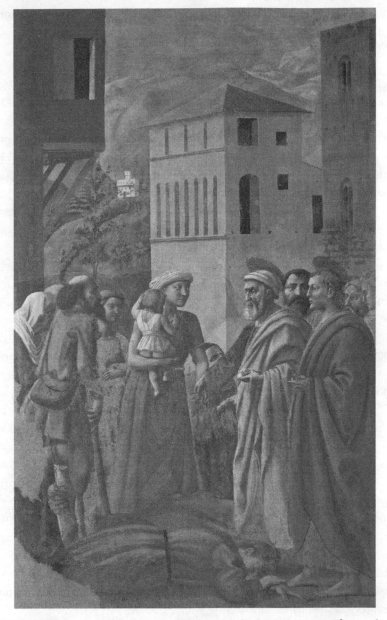

Figure 18. Masaccio, *The Distribution of Alms/Death of Ananias*, 1420s, fresco, altar wall, right side, lower register, Brancacci Chapel, Santa Maria del Carmine, Florence. Photo permission of Antonio Quattrone.

this particular void. On the left, the story ends with the Peter's crucifixion, with two figures, to the right and left of the arc of onlookers, looking out at the viewer, involving them in the scene.

Below the *Temptation* and *Expulsion* on the pilasters are scenes of Peter in prison. As discussed above, these scenes interact with the Genesis scenes above them to address questions of freedom, virtue, and sin. On the left Paul visits Peter, obedient to Jesus' teaching[53] and the central space between them is their meeting point, the locus of Paul's Christian action. This is also a reminder of humankind's freedom and its consequences. In Eden, Adam and Eve disobeyed God and were cast out; paradoxically, on earth, virtue may result in imprisonment. On the right, an angel leads Peter out of prison while the guard sleeps, reminding the viewer that, just as the angel easily enters the prison, rendering its physicality meaningless, so the physical death of the disciple is not the final thing it seems.

Examining the Brancacci frescoes, using this theological approach, draws the viewer into greater understanding of how the artists depict divine activity through their use of space, and physically engage the viewer through the spatial relations between picture plane, chapel space, and viewer, identifying the use of the central point of the image as the spiritual focus. The compositions are built around this to concentrate the eye upon it and this space is occupied by the most spiritually charged figure, the one in whom spiritual transformation is actual or potential.

Mostly, Peter does not take center stage, and where he does, the central point is not Peter but divine grace as he points beyond himself to Christ. This is shown in Peter's crouching obedience by the sea, through his upward gaze and prayerful hands in the *Chairing of Antioch*, and by obvious analogy in the *Crucifixion*. He is indeed filled with grace, a towering physical and spiritual force, but it is divine grace itself, spiritual transformation, that is the focal point, and more often he stands aside. Where no specific transformation can be shown, as in the preaching and almsgiving, "empty" space is used to signify the divine activity. This is reminiscent of the empty tomb, which signifies the resurrection, and of the kenosis of God, which precedes the incarnation. Emptiness here is not void but pregnant with spiritual possibility.

The viewer's eye is directed compositionally toward these central spaces and, as he stands in front of each scene, he becomes part of it, completing the semi circle motif. The contemporary references invite him to

53. Matt 25:36.

see that the world of the frescoes is his world as well as that of the New and Old Testaments, and that the three converge in the Christian life.

While looking at the images can reveal the truths they seek to convey, the images are self-conscious of their two dimensionality.[54] In the process of looking, the viewer is required to make judgements about the relationships between appearances and reality. Spiritual discernment is required to see that the fruit that looked good to eat brought tragedy, that the sick can be cured, that the dead rise, and that the innocent savior has paid for the sins of the guilty. The physical is a metaphor for the spiritual, paralleling the transubstantiation of the mass, which was celebrated in this funerary chapel. This playing with seeming and reality, with transformation and signification, tells the viewer that there is more to life than meets the human eye. The eye of faith can see that human existence has been redeemed, the price has been paid for us; like the cripples looking at Peter, we have only to see this salvation and we are transformed.

54. For a discussion of sight and perception in the Brancacci frescoes, see Andrew Ladis, *The Brancacci Chapel, Florence* (New York: Braziller, 1993).

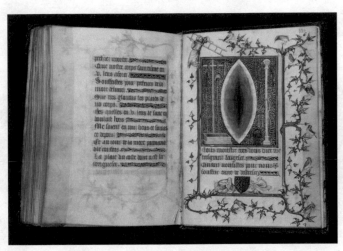

Color Plate 1. Jean le Noir, *Psalter of Bonne of Luxembourg*, fol. 330v, 331r, before 1349, illuminated manuscript, 4 x 3 in. (12 x 9 cm), the Metropolitan Museum of Art, New York. With permission of the Metropolitan Museum of Art/IAP.

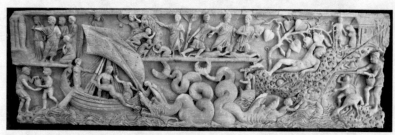

Color Plate 2. Jonah sarcophagus (Vatican 31448), third quarter of the 3rd century, marble, 27 3/16 x 87 13/16 x 7 7/16 in. (69 x 223 x 19 cm). Museo Pio Cristiano of the Vatican Museums, Vatican City. Photo courtesy of the Vatican Museums.

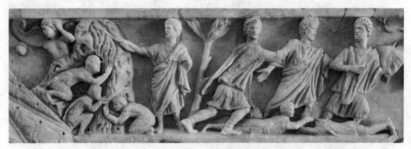

Color Plate 3. Jonah sarcophagus (Vatican 31448), upper two central scenes, third quarter of the 3rd century, marble, 27 3/16 x 87 13/16 x 7 7/16 in. (69 x 223 x 19 cm). Museo Pio Cristiano, Vatican City. Photo by Linda Fuchs, courtesy of the Vatican Museums.

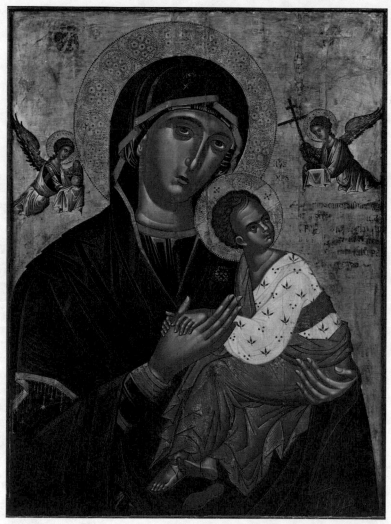

Color Plate 4. Andrea Rico di Candia (?), *Virgin of the Passion*, mid-late 15th century, tempera on wood panel, 35 $^{13}/_{16}$ x 30 $^{5}/_{16}$ in. (91 x 77 cm), Princeton University Art Museum. With permission of Princeton University Art Museum. Photo by Bruce M. White.

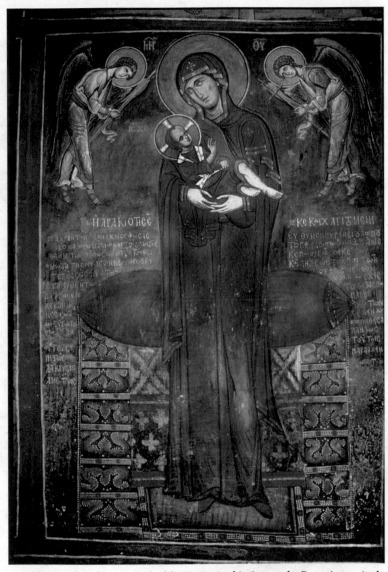

Color Plate 5. Theodore Apsevdis (?), Virgin Arakiotissa at the Panagia tou Arakos Church (south wall of nave), 1192, fresco, c. 4 x 7 in. (10.16 x 17.8 cm), Lagoudera, Cyprus. Photo permission of Slobodan Ćurčić.

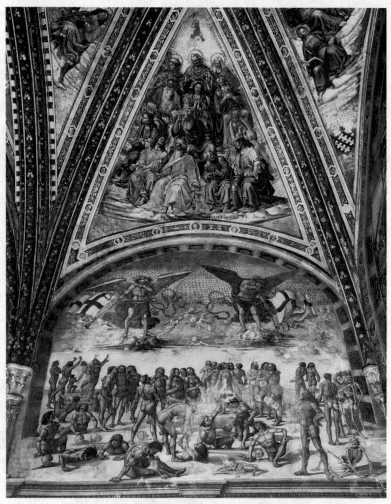

Color Plate 6. Luca Signorelli, *Resurrection of the Dead*, 1499–1504, fresco,
Chapel of the Madonna di San Brizio, Orvieto Cathedral, Orvieto, Italy.
Photo permission of Gianni Dagli Orti/Art Resource, New York.

Color Plate 7. *Ara Pacis Augustae*, relief detail, 13–9 B.C., marble, Rome.
Photo permission of Rachel Hostetter Smith.

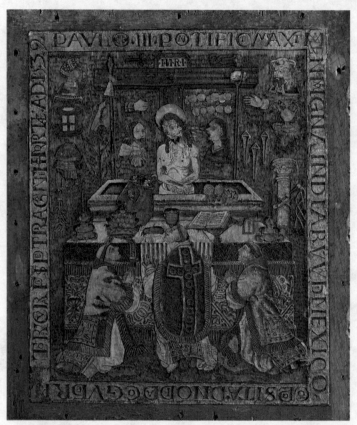

Color Plate 8. *Messe de Saint Grégoire*, 1539, feathers on wood panel, 26.8 x 22 in. (68 x 56 cm), Musée des Jacobins, Auch, France. With permission from Musée des Jacobins.

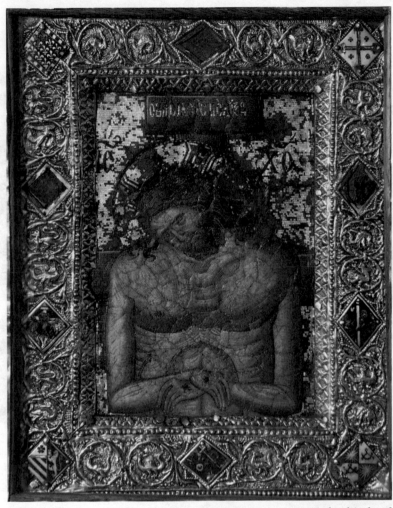

Color Plate 9. *Imago Pietatis*, Italo Byzantine Icon, c. 1300, mosaic (multicolored stones, gold, silver, wood), 10 x 11 in. (23 x 28 cm), Bascilica of Santa Croce en Gerusalemme, Rome. Permission of Fondi Edifici di Culto.

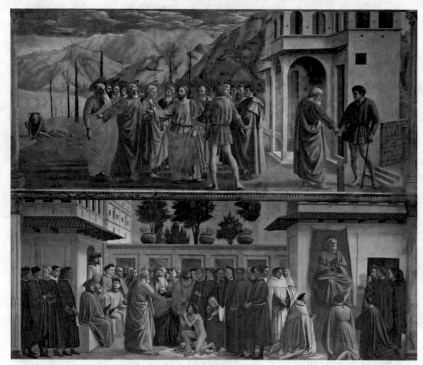

Color Plate 10. (top) Masaccio, *The Tribute Money*, 1420s, fresco, left wall, upper register, Brancacci Chapel, Santa Maria del Carmine, Florence; (bottom) Masaccio, *The Raising of the Son of Theophilus*; *The Chairing of Antioch*, 1420s, completed 1480s, fresco, left wall, lower register. Photo permission of Antonio Quattrone.

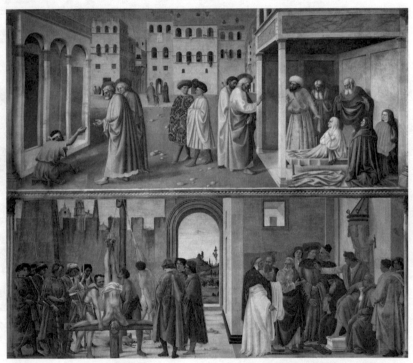

Color Plate 11. (top) Masolino, *St Peter Healing a Cripple*; *The Raising of Tabitha*, 1420s, fresco, right wall, upper register, Brancacci Chapel, Santa Maria del Carmine, Florence; (bottom) Filippino Lippi, *The Crucifixion of St. Peter*; *The Disputation with Simon Magus*, 1480s, fresco, right wall, lower register, Brancacci Chapel. Photo permission of Antonio Quattrone.

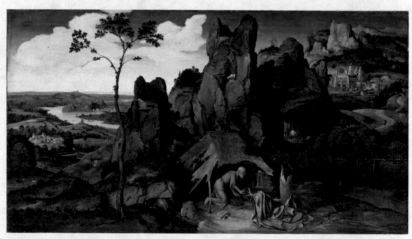

Color Plate 12. Joachim Patinir, *Saint Jerome in the Desert*, c. 1515, oil on panel, 30.7 x 54 in. (78 x 137 cm), Louvre, Paris. Permission of Réunion des Musées Nationaux / Art Resource, New York.

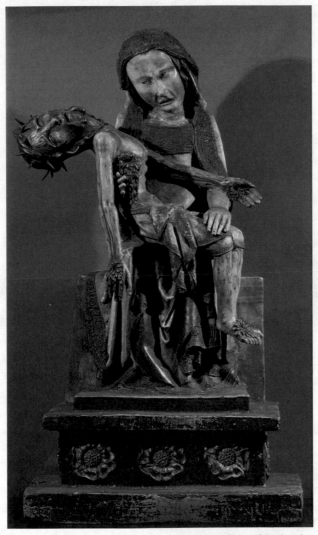

Color Plate 13. *Roettgen Pietà*, c. 1360, wood, 35 in. (89 cm) high, Rheinische Landesmuseum, Bonn. Photo permission of Erich Lessing.

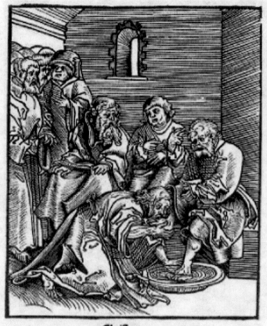

Chꝛiſtus.

Szo ich ewꝛe fueſze habe gewaſchen ð ich ewꝛ herꝛ vñ meyſter
bin/viĺl mehꝛ ſole yr cinander vnter euch die fuſſe waſchen. Hie/
mit habe ich auch ein antzeygung vñ beyſpiel geben/ wie ich ym
than habe/ alſzo ſole yr hinfur auch thuen. Warlich warlich
ſage ich euch/ð knecht iſt nicht mehꝛ dan ſeyn herꝛe/ ſzo iſt auch
nicht ð geſchickte botte mehꝛ dañ ð yn geſandt hat. Wiſt yr das!
Selig ſeyt yr ſzo yr das thuen werdṫ. Johan. 13.

Color Plate 14. Lucas Cranach the Elder, *Christ Washing the Disciples' Feet*, 1521, woodcut, 3.73 x 4.63 in. (9.5 x 11.8 cm) in Lucas Cranach the Elder, *Passional Christi und Antichristi*, Wittenberg: Johannes Grau. Permission of Pitts Theology Library, Emory University.

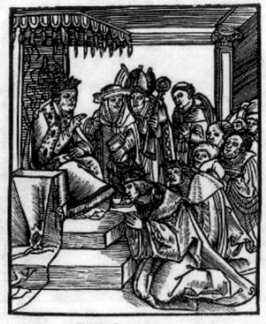

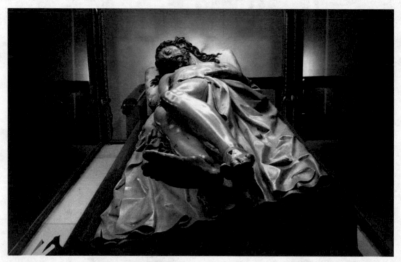

Color Plate 16. Gregorio Fernández, *Cristo yacente*, 1615, polychrome wood, resin, ivory, and glass, lifesize, Convento de Capuchinos El Pardo, El Pardo, Madrid. Author photo, permission of Patrimonio Nacional.

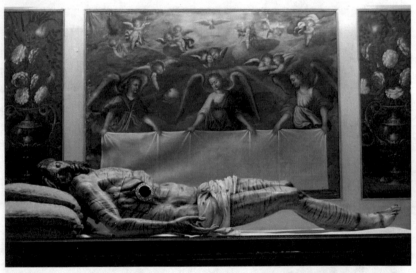

Color Plate 17. Gaspar Becerra, *Cristo yacente*, c. 1563, polychrome wood, glass, gold, and silver, lifesize, Monasterio Descalzas Reales, Madrid. Author photo, permission of Patrimonio Nacional.

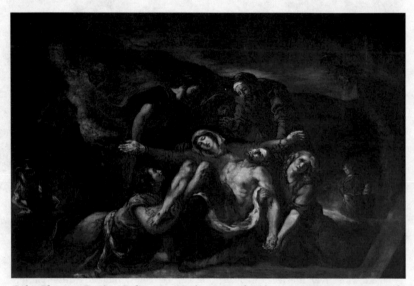

Color Plate 18. Eugène Delacroix, *Pietà*, 1844, oil and wax on canvas 11.6 x 15.5 ft. (3.56 x 4.75 m), Church of Saint Denis du Saint-Sacrement, Paris. Photo permission of Christian Murtin.

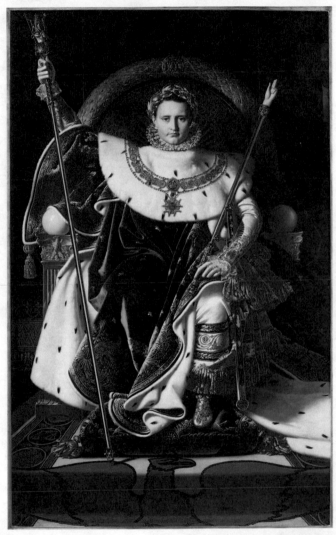

Color Plate 19. J.-A.-D. Ingres, *Napoleon on his Throne*, 1806, oil on canvas, 8.75 x 5.25 ft. (2.66 x 1.6 m), Musée de l'Armée, Paris. Permission of Réunion des Musées Nationaux / Art Resource, New York.

Color Plate 20. Henry Ossawa Tanner, *Christ and His Mother Studying the Scriptures*, c. 1909, oil on canvas, 48 x 40 in. (122 x 101.6 cm), Dallas Museum of Art. Permission of Dallas Museum of Art.

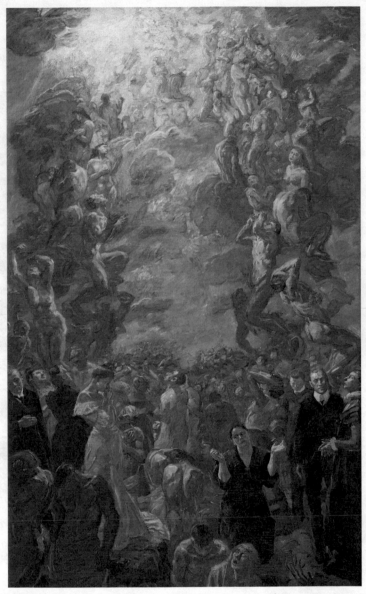

Color Plate 21. Max Beckmann, *Resurrection*, 1908–1909, oil on canvas, 155 x 98 in.
(395 x 250 cm), Staatsgalerie Stuttgart. Permission of Staatsgalerie Stuttgart. Artists
Rights Society (ARS), New York.

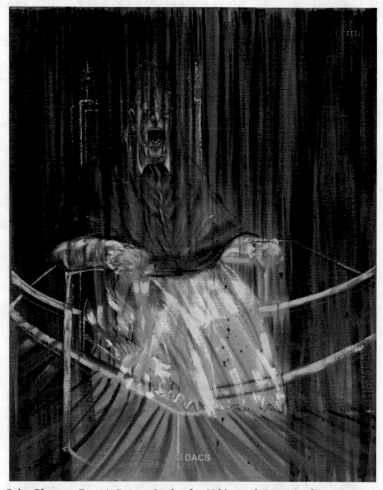

Color Plate 22. Francis Bacon, *Study after Velázquez's Portrait of Pope Innocent X*, 1953, oil on canvas, 60 1/4 x 46 1/2 in. (153 x 118 cm), Des Moines Arts Center. Permission DACS. © The Estate of Francis Bacon. All rights reserved, DACS 2013. Photo by Prudence Cuming Associates Ltd.

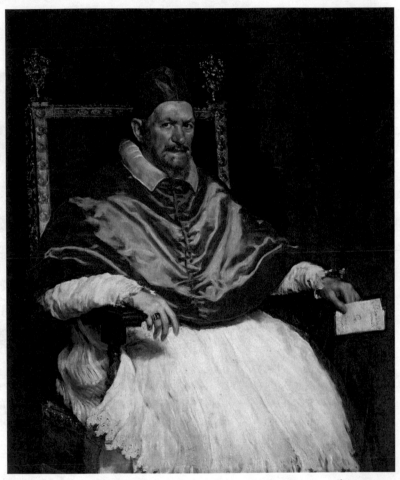

Color Plate 23. Diego Velázquez, *Portrait of Pope Innocent X*, 1650, oil on canvas, 44 7/8 x 46 7/8 in. (114 x 119 cm), Galleria Doria Pamphilj, Rome. Permission of Bridgeman Art Library.

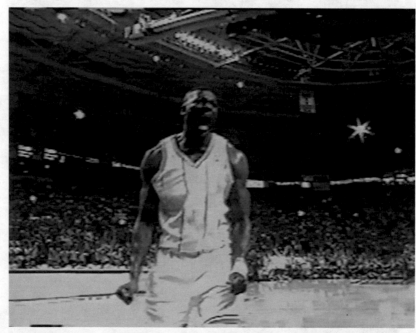

Color Plate 24. Paul Pfeiffer, *Fragment of a Crucifixion (After Francis Bacon)*, still detail from projected images 3 x 4 in. (7.6 x 10.2 cm), digital video loop, projector, metal armature, DVD player, 5-second video loop. Permission of Paula Cooper Gallery, New York.

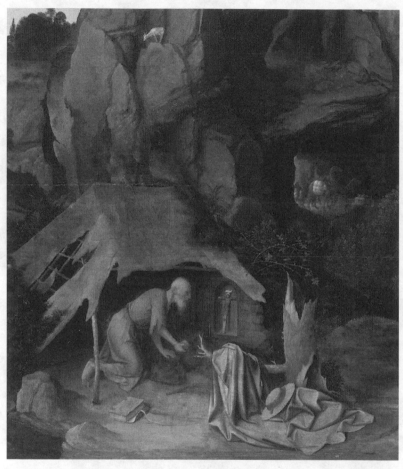

Figure 19. Joachim Patinir, *Saint Jerome in the Desert*, detail, c. 1515, oil on panel, 30.7 x 54 in. (78 x 137 cm), Louvre, Paris. Permission of Réunion des Musées Nationaux /Art Resource, New York.

Reading Theological Place

Joachim Patinir's *Saint Jerome in the Desert* as Devotional Pilgrimage[1]

MATTHEW SWEET VANDERPOEL

Saint Jerome in the Desert (c. 1515) (Color Plate 12) by Joachim Patinir (c. 1480–1524), now in the Musée du Louvre, defies convenient categorization given its combination of diverse elements: landscapes that seem to look ahead to the genre's growth and development in later Dutch art as well as elements of pilgrimage and religious iconography that seem to belong to a medieval devotional past. Patinir holds this tension between sentiments of secularism and religious devotion within an idiosyncratic distinctiveness of style in composition and execution. Interpretations of this painting have offered a variety of methodological approaches, all privileging certain aspects of the image and marginalizing others. Patinir's *Saint Jerome in the Desert* provides a unique case study to examine methodological issues that arise at the intersection of historical periodization, religion, and stylistic innovation. Ultimately, *Saint Jerome in the Desert* illustrates the methodological potential of interpreting artwork within a religious discourse that encompasses both texts and images.

Briefly putting the painting into its historical and theological context can bring its internal contrasts into clearer focus. Because of the focus on a saintly figure, the depiction of the eremitical life, and the imagery of pilgrimage, Patinir's *Saint Jerome in the Desert* seems to rest within the broader category of "the pilgrimage of life." The iconography of Patinir's

1. This essay is developed from a paper, "The Pilgrimage of Life: Artistic Innovation in Devotional Art, 1470–1530," delivered at the ASCHA symposium "History, Continuity, and Rupture: A Symposium on Christianity and Art," May 2010.

Saint Jerome in the Desert shows that rather than discarding religious symbolism, the artist has turned to a different cache of medieval theological imagery—the mystical. Informed by the mystical theology of Christian Neoplatonism, the pilgrimage of life was depicted in numerous texts and images that indicated that the life of the Christian should be considered as a form of meditative, religious pilgrimage. This trope of devotional spirituality was common in the Flemish art of the fifteenth century. The pilgrimage of life undergoes an apparent transformation, however, between its visual representations by Bruges masters, such as Gerard David (c. 1460–1523), and Patinir's own production in Antwerp. Secluded natural settings and predominant figures typify his precursors, but Patinir instead opts for landscapes that are almost encyclopedic in scope and that dwarf the saintly figure in the foreground. While explicitly devotional in imagery, a cursory examination may seem to indicate a non-religious focus in the painting as a whole.

This demonstrably large shift has prompted various interpretations of Patinir's oeuvre. Ludwig von Baldass places Patinir near the start of a linear progression of secularization, the advance of which irrevocably erodes the presence of religious subject matter.[2] Filling in this narrative, other scholars have suggested that the religious material of Patinir is an inutile ornament to the "autonomous aesthetic" of the landscape.[3] Walter Gibson, in a study of "world landscape" in the sixteenth century, traces the remarkable diversity of Patinir's iconographical and visual forebears from various European traditions drawn together in a novel landscape style. Nevertheless, his primary concern being to show the roots of landscape's rise, he does not contribute to the interpretation of Patinir as a devotional artist.[4] In contrast, Reindert Falkenberg has argued compellingly for interpreting Patinir's oeuvre as within the type of the pilgrimage of life.[5] However, reviewers commented that his emphasis on a binary division between the sinful world and the virtues of a saintly life was an insufficient method of interpreting the whole landscape as a specific iconographic program.[6]

2. Ludwig von Baldass, "Die niederländische Landschaftsmalerei von Patinir bis Bruegel," *Jahrbuch der Kunsthistorischen Sammlungen in Wien* 34 (1918) 111–57.

3. Reinder Falkenberg criticizes Robert Koch on this point in *Joachim Patinir: Landscape as an Image of the Pilgrimage of Life* (Philadelphia: Benjamins, 1988) 6–7.

4. Walter S. Gibson, "Joachim Patinir," in *Mirror to the Earth* (Princeton: Princeton University Press, 1989) 3–16.

5. Falkenberg, *Joachim Patinir*.

6. See Edwin Buijsen, "Review of *Joachim Patinir: Landscape as an Image of the Pilgrimage of Life*," *Simiolus* 19, no. 3 (1989) 209–15; and Lawrence Goede, "Review of

Recent scholarship has stressed discontinuity insofar as Patinir's work is a product of a radically new art market in Antwerp, distinguished principally by a concern for including imagery of merchants and commerce.[7] This market condition is understood to be deeply tied to the style of art produced. For instance, Maryan Ainsworth, in a study of Gerard David, asserts that David and Patinir are "diametrically opposed" as Patinir's bold, encompassing vision offers a fundamental contrast to the private, meditative images of David (Figure 20).[8]

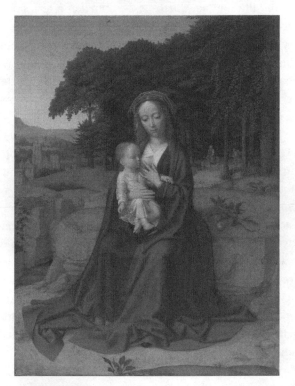

Figure 20. Gerard David, *The Rest on the Flight into Egypt*, c. 1512–15, oil on panel, 20 x 17 in. (50.8 x 43.2 cm), the Metropolitan Museum of Art, New York. Permission of the Metropolitan Museum of Art/IAP.

Joachim Patinir: Landscape as an Image of the Pilgrimage of Life (Oculi: Studies in the Arts of the Low Countries, II)," *Art Bulletin* 72, no. 4 (1990) 655–57.

7. D. Ewing, "An Antwerp Triptych: Three Examples of the Artistic and Economic Impact of the Early Art Market," lecture delivered at the symposium "Antwerp: Artworks and Audiences," Smith College, Northampton, MA, November 11–12, 1994.

8. Maryan W. Ainsworth, *Gerard David: Purity of Vision in an Age of Transition* (New York: Abrams, 1998) 251–52.

While the apparent impossibility of neatly reconciling the landscape with the religious material may seem to be a result of positivism's relatively recent decline, the interpretive challenges Patinir's paintings offer have a longer heritage in historiography. The scholarly vocabulary for the fifteenth- and sixteenth-century art of Northern Europe—"Northern Renaissance," *ars nova*—presupposes a fundamental disconnect between a distant medieval past and a more relevant early modern era. The phenomenon is rooted in Jacob Burckhardt's magisterial *The Civilization of the Renaissance in Italy*: the "new birth" is described as a series of interwoven cultural developments (i.e., emergence of Italian despots, renewed interest in antiquity, etc.) that resulted in "a process of world-wide significance."[9] Here, the historiographical bounds were set for the discussion of the fourteenth through sixteenth centuries. Newness, classicism, and development were the terms joined together to establish a scholarly discourse centered on discrete periodization.

Erwin Panofsky brought these historiographical practices to bear on Northern European art, indebted to both Burckhardt's categorization of a broad cultural zeitgeist and Heinrich Wölfflin's work to identify coherent stylistic practices within these cultural processes.[10] Panofsky's *Gothic Architecture and Scholasticism* lays out his methodological presuppositions. The art historian "cannot help dividing his material into 'periods'" and "he must needs try to discover intrinsic analogies between such overtly disparate phenomena as the arts, literature, philosophy, social and political currents, religious movements, etc." Despite Panofsky's acknowledgment of the danger of manufacturing false unity, he asserts Gothic architecture shares "a palpable and hardly accidental concurrence" with Scholasticism.[11] Such presuppositions were present in his influential study on early Netherlandish art.[12]

This art historical tendency to see periods as internally coherent and having clear chronological bounds is echoed by the problematic interpretation of the late medieval period within the historical-theological discipline. Johan Huizinga's *The Autumn of the Middle Ages*, first published

9. Jacob Burckhardt, *The Civilization of the Renaissance in Italy*, trans. Ludwig Geiger (London: Swan Sonnenschein, 1904) 171.

10. See Heinrich Wölfflin, *Renaissance and Baroque*, trans. Kathrin Simon (Ithaca, NY: Cornell University Press, 1964).

11. Erwin Panofsky, *Gothic Architecture and Scholasticism* (New York: New American Library, 1976) 1–2.

12. See Erwin Panofsky, *Early Netherlandish Painting* (Cambridge, MA: Harvard University Press, 1953).

in 1919, described the thirteenth and fourteenth centuries as a time of pessimistic excess and decadence, a dramatic final burst of energy in a culture soon to become bankrupt.[13] In response, Heiko Oberman's *The Harvest of Medieval Theology* worked to challenge older interpretations of the period as the woeful decline of Scholasticism or merely as a foil to Luther's Protestantism.[14] However, late medieval theology persists in being a contested area of study given the plurality of competing interpretations that cast narratives of the era's religious life in divergent, and often simplistic, terms.[15]

Patinir's *Saint Jerome in the Desert* calls for a methodology that resists a tendency toward reductive religious characterization. By being willing to expand the study of devotional theology to the entire discourse thereof, a more robust method of relating the religious subject matter to the landscape material comes into focus. Bret Rothstein suggests considering primary texts not as sources to art historical examination, but rather "counterparts or analogs" to art, precisely because of the unique nature of image production as something greater than a composite of textual precedents.[16] This is a fruitful starting point for allowing greater reciprocal exchange between textual and visual objects.

Patinir's art, at the very conclusion of the late medieval period, was executed in a profoundly religious culture. Richard Kieckhefer has described it as a "preached culture,"[17] wherein the sacraments of confession and penance predominated. Susan Schreiner, following Anne Thayer, points out that the Netherlands was a site of "rigorist" penance that saw new emphases on Christ's passion and devotional pilgrimage.[18] Understanding the connections between the Netherlands' spiritual saturation and its visual arts requires looking back to medieval precedents.

A rich devotional theology informed the development of the pilgrimage of life in the creative arts. Central to this are the Victorine regular

13. See Johan Huizinga, *The Autumn of the Middle Ages*, trans. Rodney J. Payton and Ulrich Mammitzsch (Chicago: University of Chicago Press, 1996).

14. See Heiko Oberman, *The Harvest of Medieval Theology: Gabriel Biel and Late Medieval Nominalism* (Cambridge, MA: Harvard University Press, 1963).

15. Norman P. Tanner, *The Church in the Later Middles Age* (New York: Tauris, 2008) 185.

16. Bret L. Rothstein, *Sight and Spirituality in Early Netherlandish Painting* (Cambridge: Cambridge University Press, 2005) 18–19.

17. Richard Kieckhefer, "Major Currents in Late Medieval Devotion," in *Christian Spirituality* (New York: Crossroad, 1987) 2:77.

18. Susan Elizabeth Schreiner, *Are You Alone Wise?: The Search for Certainty in the Early Modern Era* (Oxford: Oxford University Press, 2010) 42–43.

canons, notably Hugh and Richard of St. Victor, who encouraged the practice of a mystical devotion: a contemplation of all creation by means of reciprocal textual and visual guides that aimed toward an imageless, non-discursive experience of the divine. Hugh's *On the Sacraments of the Christian Faith* posits a basic taxonomy between God's work of foundation and work of restoration. The former refers to "the creation of the world and all its elements" and the latter to incarnation of the second person of the Trinity.[19] This restoration is done by a transformation of the prior elements into sacraments that point to God.[20] Thereby creation provides the basis for the contemplation of God.

This approach is more clearly tied to aesthetics in the *Didascalicon* of Hugh. His discussion of nature and art is particularly pertinent: he writes that just as art is revelatory of its artist, so nature reveals its creator.[21] The immediate consequence is that nature becomes privileged as a site for religious experience. But the use of art in the metaphor has the further effect of establishing art as an acceptable basis for knowledge. It follows that a painting of nature forms a ladder that ultimately presents the viewer with the chance to contemplate the Creator, God. And, to perceive this ladder, the viewer must be willing to consider all sorts of things as simulacra.

The subsequent devotional program has a broad view of God's activity in all created things, an affirmative theology termed cataphaticism, and the desire to use these symbols and experience the transcendent incomprehensibility of God, a negative approach termed apophaticism. This "simultaneity of affirmation and negation"[22] occupies a nuanced position that celebrates the whole breadth of created experience as a gift and as something to be ultimately moved beyond. Rothstein describes a similar paradox in early Netherlandish art between "transcendent spirituality and daily (not to say entirely worldly) display."[23] It is worth noting, though, that in the Victorines we find this same point of tension as an essential ingredient in devotional practice; it is not a point of simple incongruity between a normative theology and quotidian life.

Remarkably, the Victorines encouraged the use of visual diagrams as mandalic counterparts to their mystical texts. Richard's *The Mystical*

19. Hugh of Saint Victor, *On the Sacraments of the Christian Faith (De Sacramentis)*, trans. Jroy J. Deferrari (Eugene, OR: Wipf and Stock, 2007) 3.

20. Ibid., 182.

21. Paul Rorem, *Hugh of St. Victor* (Oxford: Oxford University Press, 2009) 63.

22. Steven Chase, *Contemplation and Compassion: The Victorine Tradition* (Maryknoll, NY: Orbis, 2003) 47.

23. Rothstein, *Sight and Spirituality*, 18.

Ark is an extended treatment of the allegorical significance of the Mosaic ark, and it aims to achieve a contemplative purification of the self and transcendence to the divine.[24] Meaning is largely derived from the interaction of visual arrangements of the elements of the ark with their symbolic subjects.[25] Thus, the multivalence inherent in the non-coincidence of image and text's superimposition imbued such diagrams with meditational value. While these meditative arks do seem closer to a geographic than an aesthetic visuality, they nevertheless indicate the medieval ability to interpret similitudes between disparate spheres of experience.

Furthermore, this strand of mystical theology also laid the basis for a devotion that emphasized meditation upon holy figures. The neoplatonic tradition taught that there was a resonance between "like" things, and posited that in the act of knowing the subject becomes like the object. This provided a dominant motif for mystical theology on the whole: knowing God involved becoming like God.[26] By meditating on holy figures, the devotee became like those who had become like God. This ladder of emulation offered a path for the devout Christian to move closer to the divine.

The emulation of holy figures could take a variety of forms. Most basic, perhaps, were the numerous devotional texts that presented the life of a holy figure, the *Meditationes de Vita Christi* of Pseudo-Bonaventure being a prime example. In addition to this textual meditation on key episodes from the life of Christ (including apocryphal material), the genre of the *Vita Christi* included illuminated manuscripts and sometimes exclusively visual presentations of the subject matter. In the fifteenth century, Thomas à Kempis's *On the Imitation of Christ* became an essential manual for devotion that emphasized the perennial Christian concern with the individual's responsibility to model oneself after Christ. Other scholarship has demonstrated how significantly the lives of holy figures came to provide normative models for religious devotion—a dialectical pairing of hagiographical veneration with individual moral responsibility.[27]

The mystical theology of Hugh and Richard of St. Victor can be connected to the vibrant devotional culture of the early Netherlands. The mystic Jan van Ruusbroec's *Espousals*, written in the fourteenth century

24. Richard of St. Victor, "The Mystical Ark," in *Richard of St. Victor* (New York: Paulist, 1979) 151–53.

25. Chase, *Contemplation and Compassion*, 80–82.

26. Denys Turner, *The Darkness of God: Negativity in Christian Mysticism*, 2nd ed. (Cambridge: Cambridge University Press, 1998) 46.

27. Gabor Klaniczay, "Legends as Life Strategies for Aspirant Saints in the Later Middle Ages," *Journal of Folklore Research* 26, no. 2 (1989) 151–71.

in **Middle Dutch** (not ecclesiastical Latin), are noteworthy for their usage of technical mystical language. Geert Warnar argues that this, coupled with a wave of mystical Brabantine poetry in the early fourteenth century, demonstrates that the literate audiences of the Low Countries shared a common idiom of mystical theology.[28] Jean Gerson, chancellor of the University of Paris from 1395–1429, despite fears about potential heresy, wrote an influential mystical devotional text "more to women than to men"[29]—a strong statement of his broad audience—and which he says is a following of Richard of St. Victor's own mystical teaching.[30] The ubiquity and importance of late medieval devotion evidences its ready availability to both Patinir and his audience.

To assess any resonance between this devotional program requires a close treatment of Patinir's *Saint Jerome in the Desert* itself. From the start, the image clearly functions within the genre of the pilgrimage of life. First, *Saint Jerome in the Desert* shows various scenes from the hagiographical narrative of Jerome's pilgrimage near Bethlehem, specifically the conversion of bandits who had originally stolen livestock from a nearby monastery. Second, there is a profusion of trails and roads throughout the artwork that all point to the concept of pilgrimage. Interestingly, Jerome also contemplates a crucifix, rather than what one presumes is the *Vulgate* nearby (Figure 19). This depiction of visual contemplation invites the viewer to join Jerome in the meditative pilgrimage depicted.

Writing about *Saint Jerome in the Desert*, Falkenberg has demonstrated the extent to which Patinir relies upon the iconography of virtue and vice. For instance, the goat and owl perched above Jerome inform the viewer of the presence of the Devil and temptation even in this remote space. The use of a rock in Jerome's devotion further signifies the reality of temptation, and the severity with which it must be dealt. This opposition of potential vice with Jerome's virtue is often interpreted as being mirrored in the binary composition of the piece as a whole. Falkenberg explains:

> We can conclude that St. Jerome's penitence and the legend of
> the ass appear to admonish the viewer to do as the robbers, and
> turn away from the sinful world of the "civitas terrena" and aban
> don the easy path, and instead mount the difficult path as a true

28. Geert Warnar, *Ruusbroec: Literature and Mysticism in the Fourteenth Century*, trans. Diane Webb (Boston: Brill, 2007) 89–93.

29. Jean Gerson, "The Mountain of Contemplation," in *Jean Gerson: Early Works*, trans. Brian Patrick McGuire (New York: Paulist, 1998) 75.

30. Ibid., 106.

"homo viator" imitating Christ, in the expectation of receiving forgiveness for sins and entering the heavenly homeland.[31]

By including a contemporary harbor city as an opposing device to the elevated monastery, Patinir dramatically pushes this question of virtue or vice into the everyday context of the viewer.

Patinir's iconography clearly places this specific work in the tradition of the pilgrimage of life. And if one follows Falkenberg, there is a dichotomy of choice offered to the saint, centering on virtue and vice. The domain of this choice draws in the viewer by including civic and rural scenes from the local context. On one level, it seems that Patinir is not offering a bridge to the mental contemplation of the divine, but a bridge between the lives of exemplary saints and the lives of his audience in Antwerp. Furthermore, the saint is afforded relatively little space in the composition as a whole.

The interpretation of the *Saint Jerome in the Desert* as a binary opposition is not so clear-cut, however. While there is a clear compositional contrast drawn between the elevated monastery and the low-lying port (the river even seems a counterpoint to the difficult path of the pilgrim before the monastery), there is a procession of successively more humble dwellings from the left background to central foreground. While scholars have emphasized the opposition between the worldly landscape of the "civitas terrena" and a holy destination, this piece of visual evidence serves to sacralize even the apparently profane portion of the image by establishing a series of clear stages of Jerome's devotion. The pilgrimage is not a binary decision, but a process that spans the entire painting. There is a dialectical awareness of both the hierarchical superiority of the spiritual and the necessity of the whole of the physical realm to reach the devotional goal. The painting is not just scattered amongst a landscape, but rather its elements suggest it may be an object of meditation within the devotional program of late medieval spirituality. A binary division of sacred and profane can be discarded in favor of interpreting the entire image as devotionally pertinent.

Of particular concern is the presence of a harbor and cityscape. Often singled out as evidence of Patinir's secularizing concern with non-religious material, such an understanding is at odds with the interpretation defended here. Nevertheless, the historical record of civic identity, in medieval Europe broadly and the Low Countries in particular, indicates a more complex relationship between city and religion. Historians and geographers have shown that cities were interpreted as large-scale iconographic

31. Falkenberg, *Joachim Patinir*, 92.

references to Christ's church, the New Jerusalem, or even a microcosmic reference to the whole universe.[32] Specifically in Flanders and the Netherlands, cities would undertake religious rituals that visited sites throughout the city as a form of pilgrimage. As an example, Bruges hosted an annual Feast of the Holy Blood, where a sacred relic was marched by guildsmen throughout the city to sites of importance in and along the boundaries of the city. While often cited in studies of civic identity,[33] it also establishes continuity between civic space and that of holy pilgrimages within the cultural context. This understanding of civic space in Patinir's *Saint Jerome in the Desert* is consistent with an interpretation that views the whole image as a devotional image.

Moreover, the harbor was metaphorically deployed in the late medieval world to represent a place of safety from the sensual sea of the world. Again looking to Gerson, he says that faith and love bring one into the "secure" and "deifying" harbor in God.[34] Gerson describes, in another text, that the sea represents various dangers and that safety is only found on the high rocks of the harbor.[35] This metaphor doesn't follow a simple duality of a choice, but instead sees elements of process in both the action of sailing on the dangerous sea and the need to climb to higher ground in the harbor. The painting's paradoxical juxtaposition of world landscape and saintly figure is consonant with the interplay of affirmation and negation within the devotion of the period.

While some of Patinir's innovation can be thus derived from mystical theological sources, other elements of the images have roots in Antwerp's more immediate context. One such aspect of Patinir's *Saint Jerome in the Desert* is the way virtue and vice provides a background that prompts decision in the viewer. As stated earlier, the goat and the owl's suggestion of vice is drawn in sharp contrast with Jerome's violent asceticism. As the viewer is invited to join Jerome on a spiritual pilgrimage, he or she is prompted to discern between virtue and vice in her own pilgrimage of life. Patinir presents this iconography to show the decision demanded of the devotee.

32. Keith D. Lilley, "Cities of God? Medieval Urban Forms and Their Christian Symbolism," *Transactions of the Institute of British Geographers*, New Series, 29, no. 3 (2004) 296–313.

33. Brown, "Civic Ritual," 280–81.

34. Jean Gerson, "On Mystical Theology: First Treatise," in *Jean Gerson: Early Works*, trans. Brian Patrick McGuire (New York: Paulist, 1998) 282.

35. Gerson, "The Mountain of Contemplation," 122.

The writings of Erasmus are important in considering this portrayal of decision in the context of cultivating virtue. His humanist awareness of virtue is coupled with a concern for piety amongst all Christians; if virtue is to be aspired to, all Christians should join in that endeavor. His use of proverbs, culled from both Latin and vernacular,[36] underscores this concern. Heavily indebted to the classical rhetoricians, especially Cicero, Erasmus also was a notable champion of dialogue and tolerance as tools for the pursuit of truth. Only by hearing a reasoned explanation of all possible positions can the individual hope to arrive at a truthful conclusion.[37] Individualism and reasoned consideration converge in the idea of decision.

This emphasis on agency in the process of ascending to the divine marks a shift in the devotional logic of Christianity. Late medieval mysticism often tended toward what ecclesiastical authorities termed the heresy of the "Free Spirit," a belief that proper devotion to God removed the possibility of sin, often associated with the Rhineland mysticism of figures such as Meister Eckhardt.[38] Similar sentiments emerge in the writings of the French beguine Marguerite Porete. In her *Mirror of Simple Souls*, the Soul declares during its journey, "Virtues, I take my leave of you forever,"[39] and later Love commends the Soul saying, "Such a Soul neither desires nor despises poverty nor tribulation, neither mass nor sermon, neither fast nor prayer."[40] Such writings illustrate a current within late medieval mysticism to diminish the importance of the institutional church and sacraments in the life of the Christian devout.

This otherworldly mysticism has a sense of the individualism apparent in the Netherlands' concern with virtue and vice as personal choices, but it clearly has less concern with navigating proper ethical action in everyday life. While in some ways this may be symptomatic of the eremitical or monastic settings of such mystical practice, it also speaks to the new confluence of religious suppositions in Patinir's Netherlands. John Bossy, in analyzing penance's transition from a communal sacrament to

36. Ari Wesseling, "Dutch Proverbs and Expressions in Erasmus' Adages, Colloquies, and Letters," *Renaissance Quarterly* 55, no. 1 (2002) 81–147.

37. Gary Remer, "Dialogues of Toleration: Erasmus and Bodin," *Review of Politics* 56, no. 2 (1994) 305–36.

38. Frank Tobin, "Introduction," in *Henry Suso: The Exemplar, with Two German Sermons*, trans. Frank Tobin (New York: Paulist, 1989) 17–18.

39. Marguerite Porete, *Mirror of Simple Souls*, trans. Ellen L. Babinsky (New York: Paulist, 1993) 85.

40. Ibid., 88.

an individual practice, singles out the *Devotio Moderna* and Christian humanism as key influences on a more personal, psychological concern with sin.[41] Of course, Antwerp was in proximity to both of these developments.

Saint Jerome in the Desert, therefore, depicts an interesting unity of older medieval concerns for the devotional life with more particularly contemporary concerns for individual agency and virtue. Consequently, Patinir's image becomes a profitable text to be examined within the broader theological discourse. The significance of the emerging market economy should not be understated, and it clearly resonates within the almost consumer sense of individual choice that virtue and vice imagery conveys. This does not, however, work itself out through a diminution of religious belief, but rather through a creative navigation of the devotional tradition.

The methodological shortcomings of prior approaches to Patinir center around the false division of religious and secular spheres, and the concomitant simplification of religious beliefs that does not create space for the full dynamics of devotional practice to be explored. Recognizing the complexity of the religious milieu of Patinir's Antwerp and placing his artwork into dialogue with the broader theological discourse, on the one hand, shows Patinir's real religious awareness of devotional belief. On the other, it also allows for a more precise way of seeing the points of innovation in Patinir's work: individual agency in the world is highlighted in a way distinct from its devotional forebears. These conclusions work to temper the tendency in previous scholarship to see landscape material as opposed to the religious matter, but it also raises questions about the interaction of new religious emphases on decision and the market economy of Antwerp.

In conclusion, Patinir's *Saint Jerome in the Desert* is elucidated when considered as a theological text functioning within a larger body of religious writings and devotional practices. This is, to some extent, a function of the image's unique historical moment; words, images, and practices were deliberately used as complements in devotional programs. Moreover, both Patinir and his audience were part of a religiously literate culture. These factors also render *Saint Jerome in the Desert* uniquely suited to reciprocally speak back into the theological discourse, indicating the need for a greater emphasis on activity in the world at large. A religious dimension of an artwork may be present even without overt indications, and thus the

41. John Bossy, "The Social History of Confession in the Age of Reformation," in *Transactions of the Royal Historical Society* 5th series, vol. 25 (1975) 27.

interpreter should not prejudge or dismiss religious elements until they have been explored within the broader theological environment of the art-work. Just as political, economic, and social concerns have been rightfully highlighted as necessary areas for analysis given an artwork, theological aspects of a piece should also be examined. As in Patinir's case, they may not only aid in interpretive work, but comparison against the backdrop of a religious discourse allows the unique elements of any text, written or visual, to come into sharper focus.

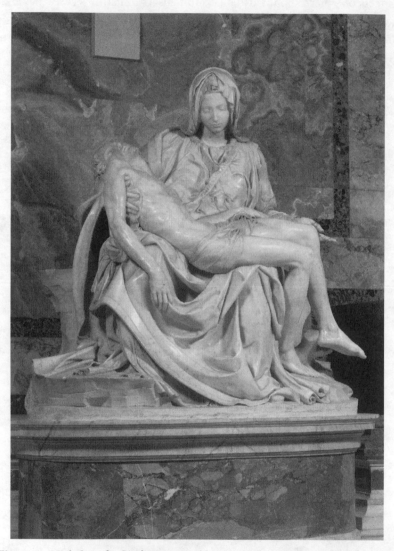

Figure 21. Michelangelo, *Pietà*, 1500, marble, 68.5 in. (174 cm), St. Peter's Basilica, Rome. Permission of Photo Scala Group.

Reading Theological Context

A Marian Interpretation of Michelangelo's Roman *Pietà*

ELIZABETH LEV

In the five hundred years since its unveiling in St. Peter's Basilica, the *Pietà* (c. 1500) by Michelangelo di Lodovico Buonarroti Simoni (1475–1564) has been the focus of critical acclaim and intense scrutiny. Scholars have provided descriptions and measurements of the sculpture (Figure 21) explored problems of its patronage and position, and recreated the technique and execution of the Florentine sculptor's youthful masterpiece. While many technical questions concerning the *Pietà* have been resolved—from the acquisition of the block of marble to the payments to the artist—other matters of debate endure. Of particular interest to this essay are questions of historical context, such as the sculpture's precise date of completion and final placement, and especially issues of theological content, such as Michelangelo's appropriation and innovation of a subject that was unusual in Italian sculpture.

Perhaps the most elusive aspect of Michelangelo's *Pietà* remains its meaning and function. Amid an extensive and diverse history of scholarship, two main schools of method have emerged to analyze the work.[1] The

1. These two schools of analysis have been formed most clearly in Frederick Hartt's writings on devotional practice and art in *Michelangelo's Three Pietàs* (New York: Abrams, 1975). Kathleen Weils-Garris Brandt has followed this line of thinking in "Michelangelo's Pietà for the Cappella del Re di Francia," in *Il se rendit en Italie': Etudes offertes a Andre Chastel* (Paris: Flammarion, 1987). Although Jacob Burckhardt identifies the *Pietà* as an altarpiece in his *The Altarpiece in Renaissance Italy* (London: Phaidon, 1988), he does not consider the liturgical implications of such works occupying a sacramental space. Marsha Hall spends little time on the Roman *Pietà*, but her approach to the Sistine frescoes, in *Michelangelo and the Frescos of the Sistine Chapel*

first, dating back to Jacob Burckhardt[2] in the nineteenth century, favors a secularist view of Italian devotional art in general.[3] Followers of this school have tended to regard the piece as primarily a chapel decoration.[4] In this case, the *Pietà* would combine the antique revival omnipresent in the Renaissance with the universal appeal of man and his form, sentiment and individual achievements.[5] This method primarily views the *Pietà* as

(New York: Abrams, 2002) looks at both the theological aspect and the question of preaching in the chapel; however, she spends little time on liturgical matters. In *After Raphael* (New York: Cambridge University Press, 2011), Hall takes more interest in the liturgical aspect of altarpieces, especially the discussion of Caravaggio's Entombment.

2. Jacob Burckhardt, *The Civilization of the Renaissance in Italy* (New York: Random House, 1995). Burckhardt describes a very secularized culture of Renaissance Italy with a humanism based on pagan or antique sentiment rather than any true religious feeling. Sacramental questions are dismissed as nostalgic or simply superstitious vestiges. In particular, the essay on "Religion and the Spirit of the Renaissance" in his *Civilization of the Renaissance in Italy* presents this view that thinking men of the age, great artists included, divorced theology and faith from art. Burckhardt also writes that Michelangelo had "severed himself from all that may be called ecclesiastical types and religious tone of feeling." *Cicerone Art Guide to Painting in Italy*, trans. A. H. Clough (London: Laurie, 1908) 126.

3. This school of secular-oriented method includes Robert S. Liebert, *Michelangelo: A Psychoanalytic Study of His Life and Images* (New Haven: Yale University Press, 1983). The tendency to see Michelangelo's work as self-referential pioneered by Liebert finds an echo in Beck who interprets the fiery intensity of figures as "characteristic of his own personality" *Italian Renaissance Painting* (New York: Harper & Row, 1981) 339. James Beck says little about the *Pietà* but treats Michelangelo's work as a formalistic exercise in variations on themes. John Addington Symonds led the charge of a Michelangelo subject to human instinct rather than higher. Symonds extolls aesthetic beauty with a vague religious sentiment, but leaves no place for organized devotion. He discusses the "refined" and "delicate" body of Christ of the *Pietà*, contrasting it a paragraph later with the "monstrous and deformed" corpse of Pope Alexander VI under whose pontificate the *Pietà* was made, *The Life of Michelangelo Buonarotti* (London: Nimmo, 1896) 1:72–73. Extending this issue beyond the Renaissance period, Michael Fried produced a profoundly secularist view of Caravaggio when he applied this methodology to the seventeenth century in *The Moment of Caravaggio* (Princeton: Princeton University Press, 2010).

4. Michael Hirst considers the *Pietà* to be chapel decoration, *The Young Michelangelo: The Artist in Rome 1496–1501* (New Haven: Yale University Press, 1994). William Wallace, in his biography of Michelangelo, states that the work stood on a low plinth with the cardinal's tomb at the foot of the work, so a funerary monument but not a liturgical object. William Wallace, *Michelangelo* (New York: Cambridge University Press, 2010) 23.

5. Charles DeTolnay, albeit less informed on the state and frequency of *Pietà* imagery at Michelangelo's time, considers the work a neo-Platonic exercise in inner and exterior beauty, *Michelangelo* (Princeton: Princeton University Press, 1947). The formalistic/aesthetic thinking also appears in the scholarship of Creighton Gilbert, who dismissed questions of placement and function in favor of the monumental effect.

ornament, to be seen as a resolution to formal problems arising in the art of the fifteenth century: the rendering of human anatomy,[6] the application of the classical ideal to sacred art and the imposition of compositional order in a figural group.[7] This approach developed from the nineteenth to the twentieth century to include psychoanalytical aspects of the work and the artist,[8] again always underscoring the *Pietà* as an example of individual achievement as opposed to work subordinate to its sacred tradition and function.

The second school, less cohesive, consists of scattered perspectives and meditations on the sacred nature of the subject matter and the sculpture's intended use.[9] While some scholars have meticulously researched its

He described Michelangelo as "formalist rather than expressionist," and suggests that his pathos "derives from previous associations with the subject." Creighton Gilbert, *Michelangelo: On and Off the Sistine Ceiling* (New York: Braziller, 1994) 27.

6. Creighton Gilbert favors a formalist view, for him pathos "derives from previous associations with the subject." Gilbert, *Michelangelo*, 27. Gilbert is interested mostly in whence a figure derives, less interest in function or placement. This is true also in his analysis of the Sistine sibyls and prophets.

7. Howard Hibbard best exemplifies the aesthetic/compositional approach to Michelangelo's art, *Michelangelo* (Boulder, CO: Westview, 1974). Also while James Beck recognizes the Sistine as papal chapel and its use during the conclave, he sees it as accruing glory for an individual family. In this light, Michelangelo's work is often treated as a series of studies drawing on formal precedents, *Italian Renaissance Painting* (New York: Harper & Row, 1981).

8. Liebert leads this school, but Hibbert, Beck and Symonds have also taken psychological aspects into consideration. John T. Spike leaves the *Pietà* as a "personal mystery" as opposed to a message. John T. Spike, *Young Michelangelo: The Path to the Sistine* (New York: Vendome, 2010) 118.

9. Frederick Hartt sees the *Pietà* as a mystical work, describing Mary as presenting the Body of Christ for adoration, thereby assuming that the group functions as an altarpiece. He also notes that the *Pietà* entered Italian devotional literature through the *Meditations of the Life of Christ* by an anonymous thirteenth-century Franciscan. For Hartt, the many representations of the dead Christ placed on altars illustrate the meaning and purpose of the Mass. For more examples of this school of sacred-oriented method, see Malcolm Bull, "The Iconography of the Sistine Chapel Ceiling," in *The Burlington Magazine* 130, no. 1025 (1988); Lynette M. F. Bosch, "Genesis, Holy Saturday, and the Sistine Ceiling," in *The Sixteenth Century Journal* 30, no. 3 (1999); John W. Dixon, *The Christ of Michelangelo* (Atlanta: Scholars, 1994); Esther Gordon Dotson, "An Augustinian Interpretation of *Michelangelo's* Sistine Ceiling," *Art Bulletin* Part I, 61, no. 2 (1979) and Part II 61, no. 3 (1979); William H. Forsyth, "Medieval Statues of the *Pietà* in the Museum," in *Metropolitan Museum of Art Bulletin* 11, no. 7 (1953); Frederick Hartt, *Michelangelo: The Complete Sculptures* (New York: Abrams, 1976); John W. O'Malley, "The Religious and Theological Culture of Michelangelo's Rome 1508–1512," in *The Religious Symbolism of Michelangelo: The Sistine Ceiling* (Oxford: Oxford University Press, 2001); John Pope-Hennessey, *Italian High Renaissance and Baroque Sculpture* (London: Phaidon, 2000); Kathleen Weil-Garris Brandt,

original placement to prove the work stood above an altar,[10] others have elaborated the study of liturgical practices for the dead.[11] Other scholars have investigated the historical use of *Pietà* groups in Northern funerary settings,[12] and the circumstances of the commission in the court of Pope Alexander VI.[13]

This diversity of scholarly approaches to the *Pietà* offers a microcosm of a larger and more complex problem: that of analyzing sacred aspects of Renaissance art—a divergence that is evidenced, for example, in the scholarly discussions of Michelangelo's entire body of work, especially in the Sistine Chapel, as well as the art of his contemporaries. This is particularly evident in the approaches taken toward understanding Michelangelo's painting in the Sistine Chapel, where much has been made of his groundbreaking formal triumph in using a sculptural technique in the organization of the narrative and the overt use of antique sculptures as models.[14] Others have focused on the ceiling fresco as an example of christological Humanism where the formal innovations are used to propel the narrative of salvation history.[15]

In addressing the *Pietà*'s religious context and character, there are, at least, four issues that shape our interpretation: the placement and dating

"Michelangelo's *Pietà* for the Cappella del Re di Francia," in *Il se rendit en Italie: Etudes offertes a Andre Chastel* (Paris: Flammarion, 1987); Edgard Wind, *The Religious Symbolism of Michelangelo: The Sistine Ceiling* (Oxford: Oxford University Press, 2001); and William Wallace, "Michelangelo's Rome Pietà Grave Memorial or Altarpiece?," in *Verrocchio and Late Quattrocento Italian Sculpture* (Florence: Le Lettere, 1992); and "Narrative and Religious Expression in Michelangelo's Pauline Chapel," *Artibus et Historiae* 10, no. 19 (1989). Wallace is open to a theological analysis but shies away from the sacramental.

10. Although Burckhardt assumed that the *Pietà* was an altarpiece, it was Weil-Garris Brandt who did the painstaking research to demonstrate this point.

11. See Hartt, *Michelangelo*; Forsyth, "Medieval Statues"; Pope-Hennessey, *Italian High Renaissance*; and O'Malley, "The Religious and Theological Culture."

12. See Forsyth, "Medieval Statues."

13. O'Malley "The Religious and Theological Culture." A. M. Voci, *Il Figlio Prediletto del Papa: Alessandro VI, Il Duca di Gandia e la Pietà di Michelangelo in Vaticano: Committenza e Destino di un Capolavoro* (Rome, Istituto Storico Italiano per l'Età Moderna e Contemporanea, 2001).

14. See Beck, *Italian Renaissance Painting*; Symonds, *The Life of Michelangelo Buonarotti*; and Charles DeTolnay, *Michelangelo*, 5 vols. (Princeton: Princeton University Press, 1943–1960).

15. See Bosch, "Genesis"; Bull, "The Iconography"; Dixon, *The Christ of Michelangelo*; Gilbert, *Michelangelo*; and O'Malley, "The Religious and Theological Culture." Marsha Hall and John Shearman have also made important contributions in the vein.

of the work as well as the precedents and innovations evident in Michelangelo's startling rendering of the Virgin Mary. When examined in light of these factors, the *Pietà* becomes more than a landmark in the history of art or a personal triumph in statuary; it is readable as a liturgical object that visually realizes a Renaissance theology of Mary.

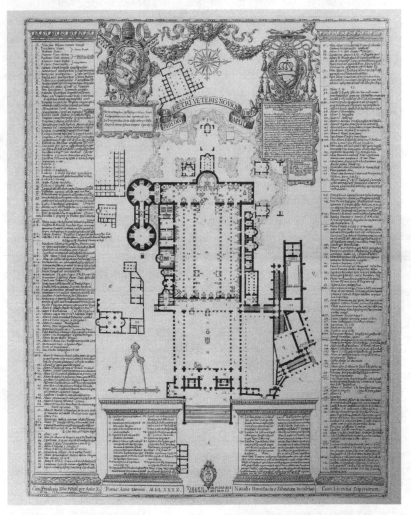

Figure 22. Tiberio Alfarano da Gerace, Plan of the Old Basilica of St. Peter, 1590, in Martino Ferrabosco, Architettura della basilica di San Pietro in Vaticano. Opera di Bramante Lazzari, Michel'Angelo Bonarota, Carlo Maderni, e altri famosi Architetti, Roma 1684. Permission of the Vatican.

The question of the original placement of the *Pietà* has been debated by scholars for over a century. While a letter from Michelangelo's patron Cardinal Jean de Bilhères-Lagaulas dated 1497[16] stipulated that the sculptural pair was to be placed in the chapel of St. Petronilla, the exact location in the chapel persists as the subject of contention. The Chapel of St. Petronilla, a small, round, former imperial mausoleum annexed to the old basilica, had been under French patronage since the reign of Louis XI. In a 1590 print, by Tiberio Alfarano (1525–1596), of the basilica's plan, the chapel is clearly marked as appending to the left transept and consisting of six radiating *sacella* or shrines with altars (Figure 22). This chapel was destroyed in 1520 to make way for the new basilica, leaving scholars of the *Pietà* without references to where the individual ornaments were placed in the chapel. The scholarly consensus that the marble work was to be placed in a niche is reinforced by the sculpture's shallow depth of 40.5 inches; Kathleen Weil-Garris Brandt has, furthermore, observed that the sculpture is unfinished on three sides.[17] The lingering question of the site of the niche was confronted head-on by William Wallace in "Michelangelo's Rome *Pietà*: Grave Memorial or Altarpiece?" Wallace argues that the work was intended for a side space, a religious monument belonging to a particular physical setting but independent of the chapel's liturgical function.[18] Michel Hirst's extensive analysis, while briefly considering the possibility that the work was an altarpiece, also endorses the position of the *Pietà* as a memorial.[19] Wallace's arguments, however, suffer from an

16. Gaetano Milanesi, *La Lettere Di Michelangelo Buonarroti* (Charleston, SC: Nabu, 2010) 613–14.

17. Kathleen Weil-Garris Brandt, "Michelangelo's Pietà for the Cappella del Re di Francia," in *"Il se Rendit en Italie": Etudes Offertes à Andre Chastel* (Paris: Flammarion, 1987) 84, for the measurements of the *Pietà*, taken with the large calipers, and the assistance of the Vatican curatorial staff.

18. William Wallace argues that work was destined as "monumental freestanding sculpture," William Wallace, "Michelangelo's Rome Pietà Grave Memorial or Altarpiece?," in *Verrocchio and Late Quattrocento Italian Sculpture* (Florence: Le Lettere, 1992) 252. It was to be placed on a low base above the tomb of the Cardinal directing attention to the "mortal remains buried in the floor," Wallace, "Michelangelo's Rome Pietà," 255. Wallace's attention to the work's iconography is noteworthy. Also, in his essay on the Pauline Chapel, Wallace is sensitive to the relationship between the iconography and its physical context (light in the chapel) but does not address its potential liturgical function. However, with both the *Pietà* and the Pauline frescos, he is aware of how the iconography communicates theology.

19. Hirst concludes that the work was in a side niche with the head of Christ oriented toward the altar. Michael Hirst, *The Young Michelangelo: The Artist in Rome 1496–1501* (London: National Gallery, 1994) 49.

incomplete understanding of chapel endowment. He claimed, "If Michelangelo's *Pietà* was commissioned to adorn the cardinal's tomb then it probably was not destined for an altar. Altars are erected for martyrs and saints, not for ordinary mortals."[20] Yet William Forsyth points out in his study of Northern medieval *Pietà* monuments, the subject was frequently used in Cardinal de Bilhères's native France as an altarpiece.[21] The use of the *Pietà* as an altarpiece was not to advertise the sanctity of the donor, but to give an orientation for the masses said on behalf of the soul of the deceased. In this respect, the discovery of a document dated 1504, is highly illuminating. The text, dated July 24, cites a "chapel to the memory of the Cardinal of St Denis," as Cardinal de Bilhères was often called, and the provisions in his will for Masses:

> for the suffrage of his soul in the basilica of the Prince of the Apostles in Rome constructed near the altar to St. Petronilla and in which a venerable and pious marble image of the Blessed Virgin Mary and her son Jesus Christ our Redeemer deposed from the cross and in the lap of the Blessed Virgin Mary was placed by his order.[22]

Establishing the use of the chapel for masses for the soul of the cardinal lends increased credibility to the theory that the *Pietà* had a liturgical function.

Several characteristics of the work itself also support this devotional interpretation. Mary's hands, for example, never come into contact with the flesh of her son. She cradles Christ under his arm through a cloth while extending her other hand toward the viewer. Frederick Hartt has observed that, in a liturgical context, the covered hand of Mary resembles the humeral veil used by the priest to hold the consecrated host.[23] Placed in a niche above the altar, the work would define the Eucharist as the body of Christ. Mary's open hand is frequently described by historians, such as John Pope-Hennessey, as a means to engage viewers by emphasizing

20. Wallace, "Michelangelo's Rome Pietà," 247.

21. See Forsyth, "Medieval Statues."

22. Weil-Garris Brandt discovered this document in the archive of San Luigi dei Francesi where Cardinal Lagraulas was a benefactor. Weil-Garris Brandt, "Michelangelo's Pietà," 106.

23. Hartt, *Michelangelo*, 83.

Jesus in her arms²⁴ or, in the case of Robert Liebert, interpreted as "the suppressed gesture of futility."²⁵

If, however, the *Pietà* functioned as an altarpiece, one could interpret the Virgin's hand as offering her son to the altar in the form of the Eucharist. From the earliest years, Christians have seen Mary as a figure of the church, which dispenses the sacraments. Furthermore, Christ's body, already rendered disproportionate to the body of the mother so as to fit within its structural pyramid, seems to be poised to tumble from Mary's knees despite their breadth. As an altarpiece, the destination of the body would be the altar, site of the transubstantiation of bread and wine into the flesh and blood of Christ.²⁶ Even the oft-remarked luminosity of the highly polished body of Christ becomes charged with deeper meaning. Couched against the shadows produced by the folds of Mary's robes, the shining body, recalling that Christ is light, would make an effective backdrop to the radiant disk of the host raised at consecration with the words "This is my body, which is given for you."²⁷ The host, always painted with great luminosity, whether in *Institution of the Eucharist* in San Marco by Fra Angelico (c. 1395–1455) or *The Disputation of the Sacrament* (1509–1510) by Raphael (1483–1520) finds its sculptural equivalent in Michelangelo's *Pietà*. In contemplating the liturgical dimension of Michelangelo's work, one can appreciate how the young Florentine sculptor produced a work that would accentuate the re-presentation of the sacrifice of Christ taking place upon the altar.

To understand the *Pietà*'s liturgical context, the dating of the work takes on greater significance. While the date of the contract is well known, the exact moment of completion is subject to debate. The statue appears, however, to have been in place by July 1500 at the latest.²⁸ This was a landmark year for all of Christendom, especially Rome, in that it was the

24. Pope-Hennessey, *Italian High Renaissance*, 8.

25. Liebert, *Michelangelo: A Psychoanalytic Study*, 67.

26. The connection between altar space and depicted scene was common in Florentine painting. Domenico Ghirlandaio (1449–1494), Michelangelo's painting master, painted a deposition for Santa Trinità with Christ tumbling onto the altar. Filippo Lippi's (c. 1406–1469) angel plucks a lily from a glass vase that is similar to, and placed in the same point as, the water vessel during the liturgy.

27. Luke 22:19 (NRSV).

28. While Hirst suggests that the group might have been ready by August 6, 1499 (coincidentally the date of the patron's death) on account of a payment made by Michelangelo to a *muratore*, the last payment made to Michelangelo for the *Pietà* was on July 3 of 1500, most likely for the completion of the work. Hirst, *The Young Michelangelo*, 55.

fifteen-hundredth anniversary of the birth of Christ and a Jubilee year. This special event, repeated every twenty-five years, had been instituted in 1300 as a once-in-a-lifetime opportunity to come to Rome and effect a reconciliation with God through prayer at the tombs of St. Peter and St. Paul. Repentant pilgrims who made the journey and fulfilled the conditions could expect to receive a plenary indulgence, a sort of spiritual clean-slate. Pope Alexander VI had many plans for this year, including the opening of Holy Doors in all four patriarchal basilicas with the door of St Peter's to be opened by the Pope in person. Already in 1497, the Pope was undergoing a personal conversion. Anna Maria Voci speculates that the murder of Alexander's son, Giovanni, the Duke of Gandia, had turned the Pope's mind to the rendering of spiritual accounts.[29] On June 19, 1497, Alexander convoked a consistory intended to curb abuses and promote church reform. The following month, he dismissed his children and other family members from papal court with the intention of leading a life better suited to the head of the Church.[30] While Alexander's conversion was short lived, during its height it involved all the court. Cardinal de Bilhères had been among the first cardinals appointed by Rodrigo Borgia upon his election and had formed part of the intimate papal circle since 1493. As part of this elite group, he was present at almost all papal ceremonies as well as during the planning stages for the elaborate Jubilee Masses and processions. Unlike practices of the modern age, this papal court rarely concerned itself with theological questions, which were rather the province of universities. Its principal public role, writes John W. O'Malley, was "to foster proper worship."[31] The majestic ceremonies, in fact, taught both Romans and pilgrims the art of devotion. Painting and sculpture, in this environment, would be expected to take on more than merely an aesthetic role; it emphasized the liturgical mystery much like the music or vestments. Cardinal de Bilhères approached Michelangelo about the *Pietà* commission during the first fervor of Alexander's conversion. On November 18 of 1497, Michelangelo was already in Lucca on behalf of Cardinal de Bilhères to purchase the marble block.[32] In this light it is not unreasonable to consider the *Pietà* a contribution on the part of a courtier to the reigning spirit of the court.

29. Voci, *Il Figlio Prediletto*, 14.
30. Ibid.
31. O'Malley, "The Religious and Theological Culture," xliv.
32. Hirst, *The Young Michelangelo*, 50.

On Good Friday of 1498, while Michelangelo was in Rome awaiting the arrival of his marble block from Carrara, Fra Mariano Gennezzano, a famous Florentine preacher, gave a powerful sermon on the passion of Christ in the Sistine Chapel. At the rhetorical climax, the friar invited the Pope to enter a state of "mystic rapture which would permit him to truly and completely comprehend the supreme sacrifice of the Son of God" and thus "be able to hope in divine mercy despite the weight of his sins."[33] In the context of Christ's redemptive sacrifice, Michelangelo's *Pietà* invites the viewer to emulate the rapt gaze of His mother, absorbed by her son who has taken the entire weight of human sin unto Himself.

Michelangelo's path had undoubtedly crossed that of the famous Augustinian friar both in Florence and then later in Rome. The eloquent and graceful preacher had given sermons at Santo Spirito to overflowing crowds and openly rivaled Savonarola, the fiery Dominican orator who had taken Florence by verbal storm. Lorenzo the Magnificent, Michelangelo's patron from 1489 until his death in 1492, particularly favored Fra Mariano, and eventually built a monastery outside Porta San Gallo for him, designed by none other than Giuliano Sangallo, Michelangelo's friend and advisor during his Roman sojourn.[34] O'Malley also notes evidence that Michelangelo was acquainted with both of these stirring preachers. A letter addressed to Michelangelo in 1498 mentions the artist's interest in the prophesies of Savonarola, and adds that "Fra Mariano speaks very badly of your prophet."[35] Both Savonarola's dire predictions of divine judgment and Fra Mariano's gracious certainty in God's mercy revolved around the upcoming Jubilee year as a significant christological anniversary. The spirit of renewal and repentance that was in the air seems to have permeated the *Pietà* commission. A century later, Caravaggio would receive his breakthrough commission for the two canvases for the Roman church of San Luigi dei Francesi in connection with the upcoming Jubilee year of 1600, specifically to instruct pilgrims of the great ransom paid by Christ to redeem man.[36] In this respect, painting and sculpture become "handmaidens of theology," joining the ranks of the great liberal arts of philosophy and music.[37]

33. Voci, *Il Figlio Prediletto*, 62.

34. O'Malley, "The Religious and Theological Culture," 55.

35. Ibid., 158.

36. Helen Langdon, *Caravaggio: A Life* (London: Pimlico, 1998) 170.

37. A Scholastic dictum said that philosophy is the "handmaiden of theology." The arts, considered lesser than philosophy, all the more so. Jorge J. E. Gracia and Timothy B. Noone, *A Companion to Philosophy in the Middle Ages* (Oxford: Blackwell, 2003).

rtured life, represented
early childhood as one
."⁴⁷ In a more religious
onarolian aesthetic" in
nding and the stupen-
an outward sign of to-
s also frequently cited,
adiso where St Bernard
on."⁴⁹ The most widely
nces of Michelangelo's
Marcello Ficino where

chelangelo revealed to
rs after the fact: "Don't
uch fresher than those
t Michelangelo's argu-
virgin who was never
might alter her body?
nd flowering of youth,
vay, may also conceiv-
prove to the world the

vith regularity in mod-
clared his explanation
e pioneers in theologi-
regarded the comment
Condivi understood to
though Michelangelo's
d over the intervening
t Michelangelo carved

uova *Interpretazione Teo-*
10) 79.

o XXXIII verse 1, Monda-

e Sedwick Wohl (Univer-

The greatest challenge of the *Pietà* commission was not the deadline or the obtaining of the block, but the subject matter itself. The *Pietà* has no biblical foundation. In fact, the first mention of the subject of the Virgin contemplating the lifeless body of her son dates back to the fifth century in the apocryphal Gospel of Nicodemus.³⁸ Although this devotional meditation had gathered momentum over the centuries particularly in the treatise of St. Bernard of Clairvaux, *Liber de Passione Christi et de doloribus et Planctibus Matris Eius*,³⁹ the *Pietà* did not arrive in art until the early fourteenth century in southern Germany under the name of *Vesperbilder*.⁴⁰ The Teutonic version was almost always sculpted out of wood, reminiscent of the cross. It was used for devotional exercises, particularly during vespers of Good Friday from whence comes the name.⁴¹ The subject migrated to France where it was called the *Pitié* and grew in popularity from the fourteenth and fifteenth centuries especially as funerary monuments.⁴² The *Pietà* subsequently spread to England, the Netherlands and through Northern Europe but encountered resistance in Italy. The subject appeared but rarely in Northern Italy and almost always in painted form, although the region of Friuli, bordering on Austria, seems to have produced several sculpted versions in the fifteenth century and provided a gateway for the subject into the rest of Italy. The earliest German *Pietàs* emphasized the suffering of Christ, such as the *Roettgen Pietà* (c. 1360) in the Rheinisches Landesmuseum in Bonn (Color Plate 13) where the exaggeration of the wounds and emaciation of the body of Christ underscore the physical suffering of His passion. Evoking both horror and pity at the tribulations of the son of God and his mother, the awkwardness of the corpse of Christ jutting across Mary's knees, elicits discomfort in the viewer. Gradually, particularly in Italy, attempts were made to attenuate the ungainliness of the composition and violence of the depiction. Cosmè Tura's 1469 panel of the *Pietà* in the Correr Museum in Venice bends the body of Christ to group the mother and son more closely, while downplaying the wounds.

Central Italian sculptors seemed determined to avoid the subject, not surprisingly, as the *Pietà* arrangement conflicted with their quest for harmony and proportion derived from the ancient Greco-Roman ideal.

38. Voci, *Il Figlio Prediletto*, 55.

39. Ibid.

40. *Mostra di Crocifissi e Pietà Medioevali del Friuli*. Exhibition Catalog. Soprintendenza ai Monumenti e Gallerie della Venezia Giulia e del Friuli (1958) 66.

41. Ibid, 66.

42. Voci, *Il Figlio Prediletto*, 57.

Lorenzo Ghiberti (1378–1455), **Donatello** (c.
(1396–1472), Mino da Fiesole (c. 1429–1484),
(1429/1433–1498), and Andrea del Verrocchio (c
led the subject, and certainly no ancient Roman s
of how to tame this unruly composition. Not wi
Maria Voci champion Michelangelo as the one w
ern resistance against this creation from the nortl

Michelangelo's own experience with the ima
ed. Jacopo del Sellaio had produced a version for S
around 1485–86, destroyed in Berlin's Kaiser Frie
while Perugino had produced another for San G
Florence in 1494, now in the Uffizi museum. The y
have seen a sculpted *Pietà* during his brief stay in
in the church of St. Dominic where he carved the
and St. Proculus for the monumental tomb of the s
century group, sculpted out of stone but painted
was most likely by a German artist. While the con
remains awkward, both the expression of Mary a
wounds show the restraint preferred in the Italian v
of Christ, however, is folded across his body, a po
artists as an alternative to the hand dangling downy

Another *Pietà* present in Bologna during the
stay was the painted panel by Ercole de' Roberti for
te around 1495, today in the Walker Art Gallery, Li
the body slightly to overcome the compositional di
subdued palette and elegant forms, the Ferrarese
peaceful meditation on this moment. A drawing in t
d'Arte Antica in Rome from 1494, commonly attrib
(though this has been contested by Federico Zeri), sl
to reconcile these different versions, with Christ slig
the knees of His mother, his hand extending dov
reaches forward to grasp the legs of her son.[44]

Michelangelo, who was formed in the circle o
and whose love of beauty in the human form was al
earliest work, *the Battle of the Centaurs*, must have b
aesthetic subject matter. But courage to challenge and
demonstrated in his 1496 *Bacchus*, was not lacking

43. Ibid.

44. *Mostra di Crocifissi*, 69n24, and n81.

and "the unconscious hope that at the end of a tc
by Jesus, one can return to the idealized mother or
remembers her, unchanged by the passage of tim
vein, Antonio Paolucci notes an "echo of the Sav
giving Mary eternal youth as a symbol of life un
dous features of the face of the young girl are mere:
tal spiritual purity."[48] Michelangelo's love of Dante
with reference to the passage in Canto 33 of the *Pai*
exalts Mary as "O virgin mother, daughter of thy :
accepted theory looks to the neoplatonic influe
youth in the Medici garden among Politian and
outward beauty reflects the beauty of the soul.

But in a rare moment of self-explanation, M
his friend Ascanio Condivi his motivation forty ye:
you know that women who are chaste remain m
who are not?" This may seem a crass remark, bt
ment grows more complex. "How much more so :
even touched by the slightest lascivious desire whic
Indeed I will go further and say that this freshness
apart from being preserved in her in this natural
ably have been given divine assistance in order to
virginity and perpetual purity of the mother."[50]

The words of the master have been dismissed
ern scholarship, although at the time Condivi de
"worthy of any theologian."[51] Edgar Wind, one of tl
cal analysis of the art of Michelangelo, nonetheless
a "grim joke at the expense of old spinsters, which
be a new contribution to morals and theology."[52] A
eloquence and ease of delivery were no doubt forg
decades, there is no reason to dismiss the idea tha

47. Liebert, *Michelangelo: A Psychoanalytic Study*, 70.

48. Stefano De Flores, *La Madonna in Michelangelo: I*
logico-Culturale (Vatican City: Librería Editrice Vaticana, 2

49. Dante Alighieri, *La Divina Commedia: Paradiso* can
dori edition, book 3 (Milan: Mondadori, 1985) 266.

50. Ascanio Condivi, *The Life of Michelangelo*, trans. Al
sity Park: Pennsylvania State University Press, 2006) 26–27

51. Ibid.

52. Liebert, *Michelangelo: A Psychoanalytic Study*, 69.

the face of the Blessed Virgin while meditating deeply on precisely the Mother of God and her role in the history of humankind's salvation.

Michelangelo grew up in Florence, a city second only, perhaps, to Siena in its devotion to Mary. The Tuscan calendar year began on March 25, the feast of the Annunciation and the shrine of the Santissima Annunziata, was one of the most visited Marian shrines in Europe with nobles, royals and prelates making regular pilgrimages. Michelangelo's parish was the Franciscan church of Santa Croce, and it was in this community he was raised and formed in his faith. After his death, Michelangelo's body was brought first to the basilica of the Santi Apostoli, the Franciscan generalate house in Rome, and then eventually buried in Santa Croce, which reinforces the long-standing tradition that Michelangelo was a member of the third order of that religious brotherhood.

The Franciscan order supported the teaching that Mary had been conceived without original sin. This presupposed that God had planned mankind's redemption from the beginning of time and had already determined Mary's role. As Mary agreed to the divine plan she became the vehicle through which mankind's salvation could take place. Michelangelo's recognition of Mary's special grace harkens back to the teachings regarding the Immaculate Conception of the Virgin, which were much discussed during the youthful years of the artist. Michelangelo was a child when Pope Sixtus IV established the feast of the Immaculate Conception on the universal calendar—a great triumph for Franciscan theology.

The theological implications of the momentous "yes" of Mary also offer a clue to understanding her facial expression. Far from the anguished, wailing Madonnas of the northern *Pietàs*, Mary's face is a study in smooth classical planes without a furrow or wrinkle to be seen—a visible representation of St. Paul's description of the church of which Mary is a figure, presented "in splendour, without a spot or wrinkle or anything of the kind."[53] This expression, described by some as "aloof" or "resigned," in reality represents the solemn acceptance of God's will. Her eyes humbly downcast as she gazes at her son, one can almost hear her words to the angel Gabriel, "Here am I, the servant of the Lord; let it be with me according to your word."[54] The faith of Mary as a young girl remains unaltered even to the death of her son.

Edgar Wind recognized that ignorance of Renaissance theology was one of art history's biggest impediments to understanding that period's

53. Ephesians 5:27 (NRSV).
54. Luke 1:38 (NRSV).

art. One should add, however, that the lack of recognition of the pervasive role of faith in Renaissance society also forms a barrier to fully comprehending the art of this period. In the case of Michelangelo's Roman *Pietà,* an analysis that includes the work's sacred motivation and meaning deepens the understanding of how Renaissance humanism, personal ambition and religious faith found material form in the capacity of a work of art to function as a sacramental object of devotion.

The greatest challenge of the *Pietà* commission was not the deadline or the obtaining of the block, but the subject matter itself. The *Pietà* has no biblical foundation. In fact, the first mention of the subject of the Virgin contemplating the lifeless body of her son dates back to the fifth century in the apocryphal Gospel of Nicodemus.[38] Although this devotional meditation had gathered momentum over the centuries particularly in the treatise of St. Bernard of Clairvaux, *Liber de Passione Christi et de doloribus et Planctibus Matris Eius,*[39] the *Pietà* did not arrive in art until the early fourteenth century in southern Germany under the name of *Vesperbilder.*[40] The Teutonic version was almost always sculpted out of wood, reminiscent of the cross. It was used for devotional exercises, particularly during vespers of Good Friday from whence comes the name.[41] The subject migrated to France where it was called the *Pitié* and grew in popularity from the fourteenth and fifteenth centuries especially as funerary monuments.[42] The *Pietà* subsequently spread to England, the Netherlands and through Northern Europe but encountered resistance in Italy. The subject appeared but rarely in Northern Italy and almost always in painted form, although the region of Friuli, bordering on Austria, seems to have produced several sculpted versions in the fifteenth century and provided a gateway for the subject into the rest of Italy. The earliest German *Pietàs* emphasized the suffering of Christ, such as the *Roettgen Pietà* (c. 1360) in the Rheinisches Landesmuseum in Bonn (Color Plate 13) where the exaggeration of the wounds and emaciation of the body of Christ underscore the physical suffering of His passion. Evoking both horror and pity at the tribulations of the son of God and his mother, the awkwardness of the corpse of Christ jutting across Mary's knees, elicits discomfort in the viewer. Gradually, particularly in Italy, attempts were made to attenuate the ungainliness of the composition and violence of the depiction. Cosmè Tura's 1469 panel of the *Pietà* in the Correr Museum in Venice bends the body of Christ to group the mother and son more closely, while downplaying the wounds.

Central Italian sculptors seemed determined to avoid the subject, not surprisingly, as the *Pietà* arrangement conflicted with their quest for harmony and proportion derived from the ancient Greco-Roman ideal.

38. Voci, *Il Figlio Prediletto,* 55.

39. Ibid.

40. *Mostra di Crocifissi e Pietà Medioevali del Friuli.* Exhibition Catalog. Soprintendenza ai Monumenti e Gallerie della Venezia Giulia e del Friuli (1958) 66.

41. Ibid, 66.

42. Voci, *Il Figlio Prediletto,* 57.

Lorenzo Ghiberti (1378–1455), Donatello (c. 1386–1466), Michelozzo (1396–1472), Mino da Fiesole (c. 1429–1484), Antonio del Pollaiuolo (1429/1433–1498), and Andrea del Verrocchio (c. 1435–1488) never tackled the subject, and certainly no ancient Roman sarcophagus offered hints of how to tame this unruly composition. Not without reason does Anna Maria Voci champion Michelangelo as the one who "overcame the southern resistance against this creation from the north."[43]

Michelangelo's own experience with the image was somewhat limited. Jacopo del Sellaio had produced a version for San Frediano in Florence around 1485–86, destroyed in Berlin's Kaiser Friedrich Museum in 1945, while Perugino had produced another for San Giusto degli Ingesuati in Florence in 1494, now in the Uffizi museum. The young Florentine would have seen a sculpted *Pietà* during his brief stay in Bologna from 1494–95 in the church of St. Dominic where he carved the figures of St. Petronius and St. Proculus for the monumental tomb of the saint. This late fifteenth-century group, sculpted out of stone but painted in the Northern style, was most likely by a German artist. While the composition of the figures remains awkward, both the expression of Mary and the carving of the wounds show the restraint preferred in the Italian versions. The right arm of Christ, however, is folded across his body, a pose favored by German artists as an alternative to the hand dangling downwards.

Another *Pietà* present in Bologna during the time of Michelangelo's stay was the painted panel by Ercole de' Roberti for San Giovanni in Monte around 1495, today in the Walker Art Gallery, Liverpool. Ercole angled the body slightly to overcome the compositional difficulties. Between the subdued palette and elegant forms, the Ferrarese painter offers a more peaceful meditation on this moment. A drawing in the Galleria Nazionale d'Arte Antica in Rome from 1494, commonly attributed to Michelangelo (though this has been contested by Federico Zeri), shows an early attempt to reconcile these different versions, with Christ slightly sunken between the knees of His mother, his hand extending downwards while Mary reaches forward to grasp the legs of her son.[44]

Michelangelo, who was formed in the circle of Lorenzo de' Medici and whose love of beauty in the human form was already apparent in his earliest work, *the Battle of the Centaurs*, must have balked at such an unaesthetic subject matter. But courage to challenge ancient formats, already demonstrated in his 1496 *Bacchus*, was not lacking in the twenty-three

43. Ibid.
44. *Mostra di Crocifissi*, 69n24, and n81.

year old sculptor. In his innovative treatment, he chose a compositional triangle, abandoning the traditional angular, almost cruciform arrangement, and enclosed Christ within the pyramid of Mary, surrounded by the folds of the Virgin's robe. While echoing the *Pietà* of Cosme Tura, the composition also harkens to the triangular Madonna and Child images that proliferated in Florence at the end of the fifteenth century. The body of Christ cradled closely at the head, as in the devotional images of the infant Jesus, drapes elegantly across Mary. Michelangelo overcame the traditional awkwardness of a taller figure in the arms of a smaller one, not only by decreasing the size of the adult man in relation to his mother, but also through the study of the articulation of the human body in Greek art. Giorgio Vasari (1511–1574) acknowledges a half century later that "it would be impossible to find a body showing greater mastery of art and possessing more beautiful members, or a nude with more detail of muscles, veins and nerves stretched over their framework of bones."[45] This extraordinary figure seems to derive from the classical antique models present in the gardens of Lorenzo de' Medici and Cardinal Raffaele Riario who introduced Michelangelo to his eventual patron Cardinal de Bilhères. The harmony of the physical parts and the ease of the articulation invite comparison to the finest of Greek statuary such as the Apollo Belvedere, then in the possession of Michelangelo's future benefactor Cardinal Giuliano della Rovere, who in three short years would become Pope Julius II and was cousin to Raffaele Riario. The anatomical detail admired by Vasari and evident in the work is, however, the result of empirical observation of the human body. The raised shoulder with its fold of flesh, the thigh muscles slumped within the skin and the veins swollen and distended in the lowered hand add a poignant human dimension to the beauty the Greeks reserved for the divine. The body presented by Michelangelo in the *Pietà* is a new hybrid, not fully classical nor yet completely of German realism, but God and man in one.

Perhaps the supreme enigma of the *Pietà* past and present among art historians or admirers remains the youthful mien of the Virgin. Explanations span a variegated spectrum. Anna Maria Vaco suggests that the adolescent face pays tribute to Lucrezia Borgia, Pope Alexander's daughter who had lost her brother, the Duke of Gandia, the same year of the *Pietà* commission.[46] Dr. Robert Liebert proposes the artist's longing for his mother and wet nurse, both of whom he lost while still very young,

45. Giorgio Vasari, *Lives of Artists* (Middlesex, UK: Penguin, 1987) 336.
46. Voci, *Il Figlio Prediletto*, 70.

and "the unconscious hope that at the end of a tortured life, represented by Jesus, one can return to the idealized mother of early childhood as one remembers her, unchanged by the passage of time."[47] In a more religious vein, Antonio Paolucci notes an "echo of the Savonarolian aesthetic" in giving Mary eternal youth as a symbol of life unending and the stupendous features of the face of the young girl are merely an outward sign of total spiritual purity."[48] Michelangelo's love of Dante is also frequently cited, with reference to the passage in Canto 33 of the *Paradiso* where St Bernard exalts Mary as "O virgin mother, daughter of thy son."[49] The most widely accepted theory looks to the neoplatonic influences of Michelangelo's youth in the Medici garden among Politian and Marcello Ficino where outward beauty reflects the beauty of the soul.

But in a rare moment of self-explanation, Michelangelo revealed to his friend Ascanio Condivi his motivation forty years after the fact: "Don't you know that women who are chaste remain much fresher than those who are not?" This may seem a crass remark, but Michelangelo's argument grows more complex. "How much more so a virgin who was never even touched by the slightest lascivious desire which might alter her body? Indeed I will go further and say that this freshness and flowering of youth, apart from being preserved in her in this natural way, may also conceivably have been given divine assistance in order to prove to the world the virginity and perpetual purity of the mother."[50]

The words of the master have been dismissed with regularity in modern scholarship, although at the time Condivi declared his explanation "worthy of any theologian."[51] Edgar Wind, one of the pioneers in theological analysis of the art of Michelangelo, nonetheless regarded the comment a "grim joke at the expense of old spinsters, which Condivi understood to be a new contribution to morals and theology."[52] Although Michelangelo's eloquence and ease of delivery were no doubt forged over the intervening decades, there is no reason to dismiss the idea that Michelangelo carved

47. Liebert, *Michelangelo: A Psychoanalytic Study*, 70.

48. Stefano De Flores, *La Madonna in Michelangelo: Nuova Interpretazione Teologico-Culturale* (Vatican City: Librería Editrice Vaticana, 2010) 79.

49. Dante Alighieri, *La Divina Commedia: Paradiso* canto XXXIII verse 1, Mondadori edition, book 3 (Milan: Mondadori, 1985) 266.

50. Ascanio Condivi, *The Life of Michelangelo*, trans. Alice Sedwick Wohl (University Park: Pennsylvania State University Press, 2006) 26–27.

51. Ibid.

52. Liebert, *Michelangelo: A Psychoanalytic Study*, 69.

the face of the Blessed Virgin while meditating deeply on precisely the Mother of God and her role in the history of humankind's salvation.

Michelangelo grew up in Florence, a city second only, perhaps, to Siena in its devotion to Mary. The Tuscan calendar year began on March 25, the feast of the Annunciation and the shrine of the Santissima Annunziata, was one of the most visited Marian shrines in Europe with nobles, royals and prelates making regular pilgrimages. Michelangelo's parish was the Franciscan church of Santa Croce, and it was in this community he was raised and formed in his faith. After his death, Michelangelo's body was brought first to the basilica of the Santi Apostoli, the Franciscan generalate house in Rome, and then eventually buried in Santa Croce, which reinforces the long-standing tradition that Michelangelo was a member of the third order of that religious brotherhood.

The Franciscan order supported the teaching that Mary had been conceived without original sin. This presupposed that God had planned mankind's redemption from the beginning of time and had already determined Mary's role. As Mary agreed to the divine plan she became the vehicle through which mankind's salvation could take place. Michelangelo's recognition of Mary's special grace harkens back to the teachings regarding the Immaculate Conception of the Virgin, which were much discussed during the youthful years of the artist. Michelangelo was a child when Pope Sixtus IV established the feast of the Immaculate Conception on the universal calendar—a great triumph for Franciscan theology.

The theological implications of the momentous "yes" of Mary also offer a clue to understanding her facial expression. Far from the anguished, wailing Madonnas of the northern *Pietàs*, Mary's face is a study in smooth classical planes without a furrow or wrinkle to be seen—a visible representation of St. Paul's description of the church of which Mary is a figure, presented "in splendour, without a spot or wrinkle or anything of the kind."[53] This expression, described by some as "aloof" or "resigned," in reality represents the solemn acceptance of God's will. Her eyes humbly downcast as she gazes at her son, one can almost hear her words to the angel Gabriel, "Here am I, the servant of the Lord; let it be with me according to your word."[54] The faith of Mary as a young girl remains unaltered even to the death of her son.

Edgar Wind recognized that ignorance of Renaissance theology was one of art history's biggest impediments to understanding that period's

53. Ephesians 5:27 (NRSV).
54. Luke 1:38 (NRSV).

art. One should add, however, that the lack of recognition of the pervasive role of faith in Renaissance society also forms a barrier to fully comprehending the art of this period. In the case of Michelangelo's Roman *Pietà*, an analysis that includes the work's sacred motivation and meaning deepens the understanding of how Renaissance humanism, personal ambition and religious faith found material form in the capacity of a work of art to function as a sacramental object of devotion.

Antichriſti.

Wir loſſen auff alle eyde die die geyſtlichen zu gefengknis gelo-
bet haben vnnd gebieten das mann nit allein mit geyſtlichem/
ſonder auch mit dem weltlichem ſchwerdt yre gütter beſchutzē
ſall/ ſo lang biß das ſie yr etwandt gutt widder haben 15. q. 6
c. Auctoritatem/vnd der yn dieſem krieck ſtirbt adir vordirbet
wirt erlangen das ewig leben 23. q. 5. c. Omret q. 8. c. Omni/
das heyſt ſeyns guts gewiß ſein/ das mans auch vor gut acht
ob ſchon chriſtenblüt daruber vorgoſſen wirdt. C

Figure 23. Lucas Cranach the Elder, *Pope Leading Armies*, 1521, woodcut, 3.73
x 4.63 in. (9.5 x 11.8 cm), in Lucas Cranach the Elder, *Passional Christi und
Antichristi*, Wittenberg: Johannes Grau. Permission of Pitts Theology Library, Emory
University.

Reading Visual Rhetoric

Strategies of Piety and Propaganda in Lucas Cranach the Elder's *Passional Christi und Antichristi*

BOBBI DYKEMA

Passional Christi und Antichristi (1521) is a Lutheran antipapist pamphlet with thirteen woodcuts each of Christ and the Pope by Lucas Cranach the Elder (1472–1553). Although its primary influences are to be found in the German devotional print tradition of the fifteenth century, *Passional Christi und Antichristi* functions simultaneously as prayer book and propaganda. For this reason, to analyze *Passional* only as a work of propaganda is to ignore half of its message and methodology. Cranach and the author-editors of *Passional's* text employed such strategies as binary opposition, sequencing, spatial treatment, and a complex interplay of text and image to persuade the reader-viewer of the rightness of the Lutheran cause, both positively in the sense of the true religion of Christ and negatively in the sense of the pamphlet's anticlerical message. These observations lead to an understanding of *Passional Christi und Antichristi* as a work of creative iconoclasm and double-directed prayer in which the image of the Pope is simultaneously displayed and effaced, and the reader-viewer is called into an attitude of prayer for true and against false faith.

Whether or not Martin Luther actually nailed his ninety-five theses to the door of the Wittenberg Schloßkirche in 1517, his theology of justification broke the mold of the medieval Catholic penitential system, in which cracks and fissures had been developing for some time.[1] For Luther,

1. Erwin Iserloh asserted that Luther disseminated the Ninety-Five Theses as an invitation to dispute with other scholars and theologians, but he did not actually post them on the Schlosskirche door as in popular imagination. Erwin Iserloh, *The Theses*

devotional praxis needed always to direct the worshipper toward the experience of Christ and an encounter with God;[2] thus, Luther's formulation vastly simplified the medieval religious complexities of the cult of the saints, monastic orders, rituals, and sacramentals.[3] For a church whose devotional practices, piety, and in some ways theology itself had been overwhelmingly image-based, this new devotion to the Word necessitated a sea change in visual culture.[4]

Fortunately for Luther, a powerful imagemaker devoted to his cause was able to bridge the gap between image and text with a solution that combined medieval conventions of devotional imagery with polemical images of the Pope to create a visual theology that complemented Luther's verbal theology. That artist was Lucas Cranach the Elder, and his pivotal work of Reformation visual media was a pamphlet entitled *Passional Christi und Antichristi*.

Passional Christi und Antichristi was published in May 1521 by Johann Rhau Grünenberg of Wittenberg, in at least five, and possibly as

Were Not Posted: Luther between Reform and Reformation, trans. Jared Wicks (Boston: Beacon, 1968). This has been (more or less) the accepted position amongst church historians for decades. More recently, a handwritten note by Luther's secretary, Georg Rörer, found in the university library at Jena, indicates that the Ninety-Five Theses may indeed have been posted on the door of the Schlosskirche. See Martin Treu, "Der Thesenanschlag fand wirklich statt: Ein neuer Beleg aus der Universitäts-bibliothek Jena," *Luther* 78, no. 3 (2007) 117–18; Volker Leppin, "Geburtswehen und Geburt einer Legende: Zu Rörers Notiz von Thesenanschlag," *Luther* 78, no. 3 (2007) 145–50; Joachim Ott and Martin Treu, eds., "Luthers Thesenanschlag: Faktum oder Fiktion, Schirftender Stiftung Luther-Gedenkstätten," in *Sachsen-Anhalt 9* (Leipzig: Evangelische Verlagsanstalt, 2008); and Berndt Hamm, "What Was the Reformation Doctrine of Justification?," in *The German Reformation: The Essential Readings*, ed. C. Scott Dixon (Oxford: Blackwell, 1999) 82.

2. Ursula Stock, *Die Bedeutung der Sakramente in Luthers Sermonen von 1519* (Leiden: Brill, 1982) 111ff.

3. Although the Word of God received new emphasis in evangelical reform of the liturgy, Luther and other evangelical preachers also urged more frequent reception of communion than the typical one to four times annually of most laypersons, as well as greater confidence in the receiver's preparation to receive the sacrament. Jürgen Diestelmann, *Usus und Actio: Das Heilige Abendmahl bei Luther und Melanchthon* (Berlin: Pro Business, 2007) 14–18.

4. The capitalized "Word" here is an intentional reference to Christ, who was the summation and content of scripture for Luther. Horst Wenzel makes an excellent argument for the metaphorical transmutation of the importance of the Word, over against the Catholic emphasis on sacraments, in both senses. Horst Wenzel, "The *Logos* in the Press: Christ in the Wine-Press and the Discovery of Printing," in *Visual Culture and the German Middle Ages*, eds. Kathryn Starkey and Horst Wenzel (Basingstoke, UK: Palgrave MacMillan, 2005) 223–50.

many as ten, German editions, followed by one in Latin.[5] It is a nineteen-centimeter quarto booklet of twenty-eight pages, with woodcuts by Lucas Cranach the Elder. *Passional Christi und Antichristi* consists of thirteen images of Christ paired with texts quoted from scripture; on each facing page is a contrasting image of the Pope paired with quotations mostly from canon law.[6] Each pair of facing pages of *Passional Christi und Antichristi* displays an image of Christ juxtaposed with an image of the Pope, whose actions are supported by quotations from canon law. Christ is first depicted refusing a crown, while the Pope demonstrates his authority over the emperor. Turning the page, we see Christ crowned with thorns (Figure 24), while the Pope receives the triple tiara (Figure 25). On the third set of facing pages, Jesus kneels to wash his disciples' feet (Color Plate 14) while the Pope extends his foot to be kissed (Color Plate 15). The fourth pairing depicts the miracle of the coin found in the fish to pay the temple tax, while the Pope exempts all clergy from taxation. Next, Jesus heals the sick and lame; the Pope enjoys a jousting tournament. In the German version of page eleven, Jesus is walking, barefoot, with two disciples; in the Latin version, he carries the cross, followed in both by the Pope carried in a litter. The next pairing shows Jesus preaching while the Pope feasts; this is followed by a woodcut of the Nativity (Figure 2), juxtaposed with a depiction of Leo X's predecessor, Julius II in full armor commanding an army (Figure 23). Next comes the Triumphal Entry into Jerusalem, juxtaposed with a depiction of the mounted Pope and his entourage riding unawares toward the mouth of hell. On page nineteen of the *Passional Christi und Antichristi*, Christ sends out his disciples in pairs without provisions, while the Pope refuses to establish a bishopric in any town lacking wealth and prestige. On the next page, Christ disputes with the Pharisees, while the Pope blesses monks and nuns, a station odious to Luther's theology. The penultimate pairing depicts Christ casting out the moneychangers, while the Pope signs indulgences. Finally, we see the ultimate ends of each figure: Christ ascends into heaven, while the Pope is cast into hell.

Cranach's strategic combination of text and image was designed to appeal to a wide spectrum of literacy; Luther called it "a good book for the laymen."[7] In many ways, it is a unique work of Lutheran art and propagan-

5. R. W. Scribner, *For the Sake of Simple Folk: Popular Propaganda for the German Reformation* (Oxford: Clarendon, 1994) 157.

6. Certain of the *Passional*'s pages also include brief editorial comments, which scholarship has mostly ascribed to Philipp Melanchthon.

7. Martin Luther, "Letter to George Spalatin: Wittenberg, March 7, 1521," in *D. Martin Luthers Werke, Briefwechsel*, eds. Gustav Bebermeyer and Otto Clemen

da. It contains both positive and negative messages, indicating not only the anticlerical agenda of the evangelical movement, but also its focus on the gospel of Christ. It was created by a known master artist, rather than anonymously; and its strategic use of images and text makes for a whole greater than the sum of its parts, with the two combined in a complex interplay that yields rich and provocative meaning. Most early Lutheran print propaganda (*Flugschriften*) falls into two broad categories: woodcut broadsheets whose message was conveyed by means of the image, and pamphlets that relied solely on text.[8] *Passional Christi und Antichristi* effects a brilliant marriage between the two.

The methodologies of current scholarship that has dealt seriously with *Passional Christi und Antichristi* often have failed to adequately explore its complex duality. Gerald Fleming's 1973 essay utilizes the methods of iconography and historical context to trace the Wycliffite, Hussite, early Lutheran, and other anti-papist influences on Melanchthon's text and Cranach's woodcuts.[9] While providing helpful background information, including a discussion of the impact of the pamphlet all the way up to the Diet of Augsburg of 1555, Fleming's analysis does not really address the question of how *Passional's* complex agenda functioned. In the context of a monograph on popular propaganda in the German Reformation, R. W. Scribner applies the methodology of semiotics to *Passional*.[10] While Scribner acknowledges the document's complexity, noting that it functions on a number of levels including, at its simplest, an "illustrated morality play,"[11] he does not explore the ramifications of this claim. What does it mean to base a work of propaganda on a genre of devotional art? How can a single object function as both? These are questions which Scribner's semiotic approach leaves unanswered.

Karin Groll's 1990 dissertation is primarily a work of historiography and book history.[12] While she traces some of the intellectual influences and central themes, her discussion is largely confined to the development

(Weimar: Bohlau, 1933) 2:298.

8. Mark U. Edwards Jr., *Printing, Propaganda, and Martin Luther* (Berkeley: University of California Press, 1994) 16.

9. Gerald Fleming, "On the Origin of the Passional Christi and Antichristi and Lucas Cranach the Elder's Contribution to Reformation Polemics in the Iconography of the Passional," *Gutenberg Jahrbuch* (1973) 351–68.

10. Scribner, *For the Sake*, 148–57.

11. Ibid., 155.

12. See Karin Groll, *Das "Passional Christi und Antichristi" von Lucas Cranach d. Ä* (Frankfurt am Main: Lang, 1990).

of the copy editions of Erfurt and Strassburg, and does not address the complex functions of *Passional* as a work simultaneously of devotion and propaganda.

Joseph Leo Koerner's 2004 *The Reformation of the Image* argues that *Passional Christi und Antichristi* is an early example of the "inherent negation" to be found in Lutheran pictures.[13] Koerner examines what he perceives as the iconoclastic gesture of Christian pictures generally, especially Lutheran images and most especially depictions of the crucifixion. The believer who views an image of the crucified Christ has been conditioned to see not a grotesque, abjectly suffering man but the Son of God. Thus he/she is trained to mentally "cross out" the abject and grotesque aspects of the image in favor of the glorious salvific reality revealed in it.

Koerner discusses how the iconoclasts were themselves creators of images in the cases where they disfigured images (often by scratching out eyes and hands) but left them in *situ*. These revised images, then, were in a sense jointly the creation of the original artist and the iconoclast. As Koerner says, "in order to vilify something it is necessary to exhibit it,"[14] and this is precisely what Cranach does in *Passional*, albeit in a creative rather than destructive mode, i.e., he creates new images of the Pope and places them in a context that is designed to efface the institution of the papacy in the viewer's mind.

Koerner's analysis of *Passional* is helpful in terms of its discussion of the art object's "latent iconoclasm."[15] Protestant Reformers not only engaged in iconoclasm by actively destroying images and objects considered objectionable, they did so in a creative sense as well, through such works as *Passional Christi und Antichristi*, in which the image of the Pope is displayed in order that it might be effaced. However, like Scribner, Koerner restricts his argument to those aspects of sixteenth-century theology and ecclesiology to which *Passional* says "no," largely ignoring those to which the pamphlet says "yes."

Other authors have included *Passional* as one of many examples in the service of wider aims: Ralph Shikes discusses Cranach as social critic;[16] John Dillenberger includes *Passional* in his treatment of sixteenth-century

13. Joseph Leo Koerner, *The Reformation of the Image* (Chicago: University of Chicago Press, 2004) 119–24.

14. Ibid., 113.

15. Ibid., 12.

16. See Ralph E. Shikes, *The Indignant Eye: The Artist as Social Critic in Prints and Drawings from the Fifteenth Century to Picasso* (Boston: Beacon, 1969).

theology and images;[17] religious historian Bernard McGinn describes *Passional* as a key example in the history of the idea of Antichrist.[18] While inclusion in such a quantity and range of scholarship underscores *Passional's* importance, it contributes little to an in-depth understanding of the work itself.

While methods of iconography, book history, semiotics, and hermeneutics inform the present study, Koerner's observation of *Passional* as a form of iconoclasm points the way toward a methodological approach with the potential to do justice to the complexities of religious art whose primary purpose is propaganda generally, and *Passional Christi und Antichristi* in particular. As a number of recent works in art history suggest, iconoclasm as a methodology is more than the study of the breaking of images. In Alain Besançon's *The Forbidden Image*,[19] Bruno Latour's *Iconoclash*,[20] W. J. van Asselt's *Iconoclasm and Iconoclash*,[21] and Mia Mochizuki's *The Netherlandish Image after Iconoclasm*,[22] the iconoclastic gesture is understood as a form of forced disenchantment, of communicating a rejection of the attachment to that which the image represents. As Koerner has argued, "To vilify something it is necessary to exhibit it,"[23] and in *Passional* Cranach exhibits the corrupt papacy to great effect, employing a number of artistic, visual-rhetorical strategies to make the case that the excesses of the office of the supreme pontiff are so extreme that it can justly be considered Antichrist.

To understand *Passional Christi und Antichristi* as an iconoclastic gesture aimed at the papacy in the form of a religious work of art, one that functions simultaneously as prayer book and propaganda, it is necessary to examine the artistic and visual-rhetorical strategies by which it achieves its complex, dual purpose. As a work of both text and image, Latin and vernacular, *Passional* was designed to engage both seeing and reading in

17. John Dillenberger, *Images and Relics: Theological Perceptions and Visual Images in Sixteenth-Century Europe* (New York: Oxford University Press, 1999) 83.

18. See Bernard McGinn, *Antichrist: Two Thousand Years of the Human Fascination with Evil* (New York: Columbia University Press, 2000).

19. See Alain Besançon, *The Forbidden Image: An Intellectual History of Iconoclasm*, trans. Jane Marie Todd (Chicago: University of Chicago Press, 2000).

20. See Bruno Latour, ed., *Iconoclash* (London: MIT Press, 2002).

21. See Willem J. van Asselt, ed., *Iconoclasm and Iconoclash: Struggle for Religious Identity* (Boston: Brill, 2007).

22. See Mia M. Mochizuki, *The Netherlandish Image after Iconoclasm, 1566–1672: Material Religion in the Dutch Golden Age* (Burlington, VT: Ashgate, 2008).

23. Koerner, *Reformation*, 113.

an audience with a wide spectrum of literacy. Its vivid pictures and simple language were simultaneously aimed at literate, semi-literate, and illiterate, young and old, theologically sophisticated and piously simple, with a memorable tale of the holiness of Christ contrasted with the greed and gaudiness of the papacy. Indeed, the *Passional* format would have been familiar to Cranach's audience as a devotional work, a small picture book aimed at the unlettered, whose subject matter was the life of Christ or of the saints.[24]

Such booklets had become commonplace in the fifteenth century. Pamphlets and single-sheet devotional images were created for sale at pilgrimage sites and other religious venues across Europe,[25] but it was in Germany that the printed image in both woodcut and engraving flourished. Thousands upon thousands of such images were created in works such as *Passions of Christ, Lives of the Virgin*, and so forth. Many common religious images developed a standard compositional arrangement and pictorial language, and most of Lucas Cranach's images of Christ in *Passional Christi und Antichristi* utilize these elements, entering into conversation with and continuing the German devotional print tradition.

Cranach had much more need of innovation with regard to polemical images of the Pope, which were uncommon prior to the Reformation. Here, Cranach needed to work in tandem with the author-editors of the text of *Passional*, drawing from the teachings and writings of Luther. *To the Christian Nobility of the German Nation* was published in August 1520, and *On the Babylonian Captivity of the Church* in October 1520; the first attacked the papacy's pretense to both spiritual and temporal power, especially its arrogation of authority over the emperor, and the assertion that only the Pope could convene councils. *On the Babylonian Captivity* attacks the seven sacraments, each of which is described by Luther as having no basis in scripture. Both of these writings, as well as the 95 *Theses*, castigate the papacy for leading Christendom astray in these matters, and it is here that Luther begins to refer to the papacy as Antichrist. *Passional* also appears to owe a debt to Nicholas of Dresden's 1412 *The Old Color and the New*, which shares with *Passional* both its antithetical structure and a significant amount of specific content, but the path of this influence is unclear.

24. Scribner, *For the Sake*, 149.

25. See A. Hyatt Mayor, *Prints & People: A Social History of Printed Pictures* (New York: Metropolitan Museum of Art, 1971).

Flugschriften and evangelical preaching were the engine that drove the Lutheran Reformation.[26] In cities across Germany, the diffusion of evangelical ideas was accomplished by preachers who considered themselves in solidarity with Luther proclaiming the Word of God to the people;[27] many of these additionally published their sermons in printed form. Hundreds of such sermons, treatises, pamphlets, and tracts, serving as a tangible record whose impact endured beyond that of oral forms of communication, were printed and sold. The state of the individual layperson's soul, literate or not, was of dire concern for evangelical preachers who believed the end of the world was at hand.

Luther believed that if presented with the truth, the papacy would change;[28] and by extension, that followers of the Church of Rome, whether nobles, clergy, or commoners, would revise their opinions of the Supreme Pontiff (and be moved to action) if only they had access to an accurate picture of the papacy's words and deeds. By placing these in direct opposition to the words and deeds of Christ, the Lutheran creators of *Passional Christi und Antichristi* hoped to establish an irrefutable case in the minds and hearts of Christians—especially German Christians—that the devil was at work in the highest office of Christendom.

Passional Christi und Antichristi as a single, discrete work of art was constructed for a particular purpose: to convince the reader-viewer of the corruption of the papacy. It was developed by men of faith for an audience of people of faith, whose reception of images of Christ was conditioned by the context of prayer and worship. Several artistic techniques in the structure of *Passional*, both literary and visual, allow the pamphlet to function as both polemic and prayer book, drawing the reader-viewer into two interconnected worlds: the timeless realm of the reign of Christ, and the immediate contemporary realm of the corrupt papacy of the first quarter of the sixteenth century. These techniques included binary opposition, sequencing, spatial treatment of images, and interplay of image and text.

26. Scribner, *For the Sake*, 1; and Edwards, *Printing, Propaganda*, 1–2.

27. Franz Lau and Ernst Bizer, "Reformationsgeschichte bis 1532," in *Reformationsgeschichte Deutschlands bis 1555* (Göttingen: Vandenhoeck & Ruprecht, 1964) 32–33. Scholars disagree as to how unified "Lutheran" teaching may have been in the early years of the movement. See Bernd Moeller and Karl Stackmann, *Städtische Predigt in der Frühzeit der Reformation: Eine Untersuchung deutscher Flugschriften der Jahre 1522 bis 1529* (Göttingen: Vandenhoeck & Ruprecht, 1996); and Edwards, *Printing, Propaganda*, 1–2.

28. Robert Rosin, "The Papacy in Perspective in Luther's Reform and Rome," *Concordia Journal* 29 (2003) 418–19.

While the purpose of *Passional Christi und Antichristi*, taken as a whole, is to persuade the reader-viewer of the utter corruption of the papacy, its strategy for doing so is to juxtapose images and texts from the life and ministry of Christ, as presented in the Christian canonical Gospels, with images of the Pope and texts from papal decretals that support the papacy's claims to absolute authority and luxurious living. The reader-viewer is led through a series of meditations on the life of Christ, interrupted at every turn by images and texts decrying the excesses of the papacy. As a prayer book, this structure invites the reader-viewer into a back-and-forth processes of iconoclastic devotion, or devotional iconoclasm, *with* the images and texts depicting Christ, and *against* the images and texts depicting the Pope, a sort of double-directed prayer like that found in the Lord's Prayer, in which the positive request of "Give us this day our daily bread" is followed by the negative "Lead us not into temptation, but deliver us from the evil one."[29] The reader-viewer using *Passional* as a sort of prayer book is invited to meditate on the life of Christ and be warned against the corruption of the papacy, moving between a meditative form of prayer and a negative form of petitionary prayer for delivery from the papal Antichrist. Similarly, the religious reformers of the sixteenth century saw themselves as responding to the demands of the gospel,[30] which involved both the positive effort of preaching the message of justification by faith, as well as the negative task of denouncing the errors of the current system.

Following the example of Nicholas of Dresden a century earlier, Cranach and his colleagues sought to achieve this result by delineating in word and image the sharp contrast between the papacy,[31] which had set itself up in spiritual authority over all of Christendom, and Christ the true founder and head of the Christian church. The presence of absolute goodness in Christ, as revealed in his humble and gracious suffering for and servanthood to humankind, is contrasted with its absence in the wickedness of the papacy, with its pretenses to wealth, luxury, power, and the usurpation of the God-given roles of temporal authority, as well as its dereliction of its rightful duty of preaching the Word of God.

29. Matt 6:9–13 (NIV).

30. Helga Robinson-Hammerstein, "Luther and the Laity," in *The Transmission of Ideas in the Lutheran Reformation*, ed. Helga Robinson-Hammerstein (Dublin: Irish Academic, 1989) 19.

31. Scribner, *For the Sake*, xxii.

Figure 24. Lucas Cranach the Elder, *Christ Crowned with Thorns*, 1521, woodcut, 3.73 x 4.63 in. (9.5 x 11.8 cm), in Lucas Cranach the Elder, *Passional Christi und Antichristi*, Wittenberg: Johannes Grau. Permission of Pitts Theology Library, Emory University.

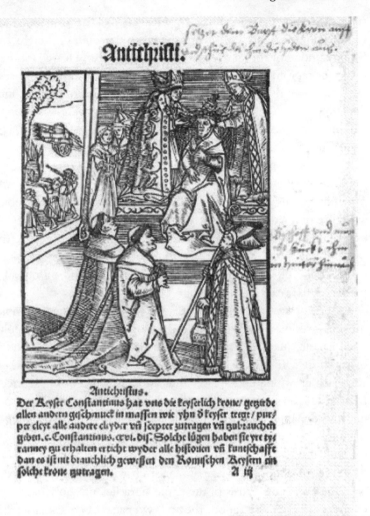

Figure 25. Lucas Cranach the Elder, *The Pope Crowned with the Triple Tiara*, 1521, woodcut, 3.73 x 4.63 in. (9.5 x 11.8 cm), in Lucas Cranach the Elder, *Passional Christi und Antichristi*, Wittenberg: Johannes Grau. Permission of Pitts Theology Library, Emory University.

The second pairing of woodcuts from *Passional* features a scene from Christ's passion, recalling the devotional nature of the passional genre. On the left-hand page, we see Christ crowned with thorns, which are being lowered onto his head with long sticks by a group of four men. He is simultaneously being mocked and beaten in this interior scene, his hands bound and his shoulders bearing a "royal" cape. As is often the case in

sixteenth-century passion imagery, at least two of the tormentors wear the tight leggings and slit trousers of the landsknechten of the Holy Roman Empire under Maximilian I, a population reviled and feared for their penchant for rape and pillage when not on the battlefield.[32] At Christ's feet is curled a small dog. References to Christ's tormentors as dogs, including depicting them in groupings that included dogs, were commonplace in late medieval passion narratives, such as that of the German "Das Passional" poem of the fourteenth century.[33]

The fourth page of *Passional* shows a much different ritual of crowning. The Pope is invested with his magnificent triple tiara by a pair of mitered bishops. All three wear richly embroidered capes. Looking on are more mitered bishops and several tonsured monks. The Pope sits on an ornamented dais, and one of the bishops bears an incense thurible, marking the "holy" state of the occasion. Through a doorway we glimpse three heralds blowing trumpets; a flaming bonfire; and a group of people preparing to fire off a cannon.

The contrast could not be clearer. Christ is tortured, humbled and mocked, while his vicar on earth, the Pope, enjoys all of the pomp and circumstance of a rich state occasion, crowned with jewels by the princes of the church. The reader-viewer may be tempted to ask at whose expense such rich crowning takes place, and whether it is a fitting service to the Man of Sorrows crowned with thorns. This presence/absence, positive/negative dynamic is played out with every page turn of *Passional*, throwing the evils of the papacy into sharp relief by shining on them the light of the truth of Christ.

The impact of the image of Christ crowned with thorns juxtaposed with the Pope crowned with the triple tiara lies not only in its dramatic contrast of binary opposition. The first two pages of *Passional* set the stage, showing Christ retreating into the wilderness as a group of his followers attempts to crown him king, while the Pope on the facing page is depicted receiving the emperor, with a text quoting a papal decretal from the Council of Vienne that proclaims that the papacy is not subject to the rule of secular authorities.

As the page is turned, the reader-viewer is confronted with an image of the one earthly crown that Jesus will accept: the crown of thorns that

32. Keith Moxey, *Peasants, Warriors, and Wives: Popular Imagery in the Reformation* (Chicago: University of Chicago Press, 1989) 72ff.

33. James Marrow, "Circumdederunt me canes multi: Christ's Tormentors in Northern European Art of the Late Middle Ages and Early Renaissance," *Art Bulletin* 59, no. 2 (1977) 174.

emblematized his humility and suffering during the events of his passion. The dramatic sequencing of the reception of crowns is calculated to bring about in the reader-viewer a state of prayerful wonder and awe at the sacrifice of Christ on his or her behalf, coupled with disgust at the arrogance of the papacy that has placed itself in the position of highest authority on earth.

The treatment of compositional and figural space across many of the pages of *Passional* is also designed toward maximum cognitive and emotional impact on the reader-viewer. In all but the last two pages of *Passional*, the figure of the Pope is placed visually above the figure of Christ. This spatial treatment is most dramatic in the third pair of images, where Christ is not only kneeling on the floor but bending at the waist to wash Peter's feet, while the Pope is seated on his throne on a stepped dais as princes kneel to kiss his foot. In this interior scene from the Gospel of John, Christ kneels on the floor, bending over the feet of a seated Peter as he washes them in a round basin. Christ's face is positioned so that the foot he holds in his right hand is near to his lips, as though he were about to kiss the foot. Two other disciples sit alongside the first, waiting their turn, while the rest stand in a cluster behind Christ. The disciples are depicted conventionally, mostly with beards and long robes, awaiting their turns for the foot-washing. The three foremost disciples are seated before Christ, with a line of additional disciples snaking off to the rear left. A single high arched window above the heads of the disciples suggests the interiority of the scene.

On the facing page, the Pope is enthroned beneath his baldachin, with an array of mitered bishops and tonsured monks, as well as nobles and princes, clustering around the throne. The Pope extends his shod foot for one of the princes to kiss, and raises his right hand in blessing. Cardinals, scholars, and other members of the three estates are included in the group waiting to pay homage to the Vicar of Christ, who is seated on a richly brocaded throne atop two steps. The Ionian column in the upper right underscores the rich ornamentation of the space.

Here, the roles of Christ and Pope are mirror images. Christ washes feet; the Pope's feet are kissed. Christ is humble servant; the Pope a proud ruler. The leader of the Christian church has succumbed to the attractions of the deference of all men, rather than being the servant of all, as Christ himself was.

The visual placement of the human Pope above the Son of God creates an escalating effect of cognitive dissonance at the heights of arrogance

the Pope has achieved, whether the reader-viewer is conscious of this strategy or not. Seeing the Pope in a high place that properly ought to be reserved for Christ provokes increasing alarm at how the conceit of the papacy has managed to turn the world upside down, an alarm that leads the believing Christian reader-viewer into prayer that God's will and not human will be done.

For the literate or even semi-literate reader-viewer, *Passional Christi und Antichristi* effected its dual function of propaganda and prayer through the complex interplay of text and image. In several instances, the text selected to accompany an image in the *Passional* series does not simply describe the action or event depicted, but serves rather as a theological commentary that interacts with the image to produce a complex interplay of meaning, such as the texts from Luke 9 and 2 Corinthians 8 on the poverty of Christ that accompany an image of the Nativity.

Appearing well past the halfway mark on page fifteen, the nativity scene in *Passional* establishes beyond doubt that the pamphlet's principle of organization is thematic rather than chronological. The woodcut scene depicts a young Virgin Mary and an older, bearded Joseph kneeling in adoration before the swaddled Christ child in a hay-filled manger box, as the ox and ass look on. The poverty of the Holy Family is underscored by the indoor/outdoor setting of the scene, and by the hole in the one sheltering wall, through which a house may be seen in the background. Also in the far background at the upper left is a group of shepherds responding to the heralding angel in the sky. The text refers the reader-viewer to Luke 9, where Jesus indicates to his disciples that "Foxes have holes and birds of the air have nests, but the Son of Man has nowhere to lay his head."[34] This text may be seen as a continuation of *Passional's* previous image and text regarding Christ, in which the Savior is determined to depart Capernaum, against the wishes of its inhabitants, because he was sent to preach the good news of the kingdom of God to many places (Luke 4:43–44). In Luke 9:58, other persons whom Jesus and his disciples meet along the way indicate that they would like to follow as well, but Jesus warns them that his peripatetic life and mission do not allow for comforts. From his birth in a stable because there was no room in the inn,[35] to his nomadic ministry throughout Judea relying on the hospitality of those to whom he ministered, Jesus' life on earth was characterized by radical poverty.

34. Luke 9:58 (NRSV).
35. Luke 2:7 (NRSV).

Jesus warns his potential followers in this text that choosing to follow him means choosing his humble lifestyle, as well.

The context of 2 Corinthians 8:9, the second scripture passage quoted by *Passional* in the text accompanying the image of Christ's nativity, is an appeal on the part of Paul to the church at Corinth for funds to support needy Christians in Jerusalem. Chapters 8 and 9 include a number of spurs to giving, including verse 9 of chapter 8, which is a christological argument, that Christ by grace, though he was rich—being the Son of God and dwelling in heaven with the Father—became poor for humanity's sake.

This concatenation of the nativity with Luke 9:58 and 2 Corinthians 8:9 is not an innovation on the part of *Passional's* author-editors. Augustine borrowed language from 2 Corinthians 8:9 in a discussion of Christ's nativity, which begins with a description of Jesus' human mother, Mary:

> Note this handmaid, chaste, and virgin, and mother: for there He received our poverty, when He assumed the form of servant, emptying Himself; that you might not shrink from His riches, and in your beggarly state not dare to approach Him. There, I say, He received the form of a servant, there He put on our poverty; there He impoverished Himself, there He enriched us. [36]

Juxtaposed with page after page of a lavishly adorned Pope, whose excesses are justified in canon law, the image of a Christ who voluntarily assumed poverty for humanity's sake inspires in *Passional's* reader-viewer a sense of gratitude and wonder, which contrasts vividly with the disgust engendered by the ostentatious Pope.

In this way creative works such as Cranach's *Passional* woodcuts become themselves a form of iconoclasm, where the subject of vilification, the Pope, is exhibited in an antithetical relationship to the very Christ of whose church he is purported to be the vicar. Where destructive iconoclasm, often confined to the eyes, mouth and hands of a painted or sculpted figure, serves to both reveal the image as an impotent object and remove its power,[37] creative iconoclasm accomplishes the same tasks, but bypasses the act of destruction and proceeds directly to an act of creation that reveals the emptiness of its subject matter. The goal is to critique and efface an existing practice, such as kissing the Pope's foot, which is likened in *Passional* to the worship of the beast prophesied in Revelation. *Passional Christi und Antichristi* as a whole thus serves as an iconoclastic gesture against such idolatrous behavior, causing in the reader-viewer a

36. Augustine, *On the Psalms*, trans. Bobbi Dykema (PL 37:1294).

37. Koerner, *Reformation*, 108.

mix of finely-tuned outrage with satisfaction at not being gulled by slick, deceptive appearances. Attuned to an attitude of prayer by the images of Christ, the reader-viewer of *Passional Christi und Antichristi* is brought to a place of agreement with Lutheran anticlericalism through repeated iconoclastic violations of reverence by the horror of a papacy at utter odds with the true religion of Christ.

Much of the power of early Lutheran propaganda derived from the power of the new medium of print itself, which had the effect of reconfiguring and narrowing the dimensions of reality in the mind of the reader-viewer.[38] The advent of print culture shifted the reception of information from a large-scale, communal experience to an individual, private one[39]—a shift that dovetailed neatly with the Lutheran emphasis on individual experience of and communication with God. *Passional Christi und Antichristi* made its appeal to the individual reader-viewer, effacing the image of the Pope as the spiritual leader of Christendom, and replacing it with that of Christ, who in Lutheran understanding is known primarily through and as the Word of God.

As Joseph Leo Koerner has documented, Lutheran pictures in the wake of *Passional* in various ways interpolate words with images to mediate their message. Retables for Lutheran altars featured images not of Christ crucified, as in Catholic churches, but of the Last Supper, in which the words of Christ institute the sacrament.[40] In Lutheran paintings that do depict the crucifixion, it is presented as itself a word. For example, Cranach's *Crucifixion with the Converted Centurion* (1538) includes both a visual representation of the crucifixion as well as the centurion's response, "Truly this man was the Son of God," articulated in text.[41] In this work, Cranach positions Christ's cross between "this" and "man" in the centurion's utterance; the words of which are painted directly on the panel;[42] or in his 1547 *Wittenberg Altarpiece*, which depicts the crucifixion as the content of Luther's preaching.[43] Thus, the reader-viewer experiencing the

38. Richard G. Cole, "The Dynamics of Printing in the Sixteenth Century," in *The Social History of the Reformation*, eds. Lawrence P. Buck and Jonathan W. Zophy (Columbus: Ohio State University Press, 1972) 95.

39. Marshall McLuhan, *Understanding Media: The Extensions of Man* (New York: McGraw-Hill, 1964) 157.

40. Koerner, *Reformation*, 340.

41. The text in German is written on the panel as follows: "Warlich Dieser Mensch Ist Gottes Svn Gewest."

42. Koerner, *Reformation*, 233.

43. Ibid., 194.

simultaneously prayerful and iconoclastic gesture of *Passional Christi und Antichristi* stands in a liminal zone between Catholic visual culture, in which even readers are primarily viewers, and Lutheran visual culture, in which even viewers are primarily readers.

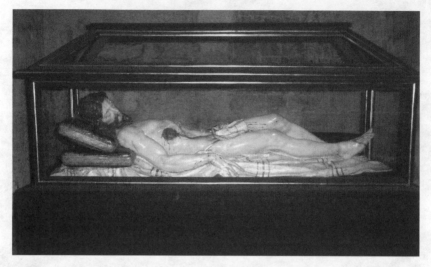

Figure 26. Gregorio Fernández, *Cristo yacente*, 1609, polychrome wood, lifesize, Convento de San Pablo, Valladolid, Spain. Author photo, permission of Convento of San Pablo.

Reading Devotion

Counter-Reformation Iconography and Meaning in Gregorio Fernández's *Cristo yacente* of El Pardo

ILENIA COLÓN MENDOZA

The *Cristo yacente,* the recumbent Christ, is a type of devotional sculpture, produced for centuries in Spain, that were made in increasingly greater numbers during the first half of the seventeenth century (Figure 26). Presenting a solitary figure of the supine Christ following the crucifixion, carved in wood and painted in lifelike colors, the *Cristo yacente* is one of the most moving forms of Spanish seventeenth-century Catholic art.

The most famous example of this type is preserved in the Capuchin Convent of El Pardo in Madrid. Commissioned by Philip III, King of Spain, the work is firmly attributed to Gregorio Fernández (1576–1636), who produced it in 1615 (Color Plate 16).[1] This work was created in accordance with Counter-Reformation mandates that required religious images to inspire both piety and empathy as recorded in the twenty-fifth session of the Council of Trent, and was entitled "On the Invocation, Veneration, and Relics, of Saints, and on Sacred Images." This session declared: "And the bishops shall carefully teach this, that, by means of the histories of the mysteries of our Redemption, portrayed by paintings or other representations, the people are instructed, and confirmed in (the habit of) remembering, and continually revolving in mind the articles of faith."[2] Fernández's sculpture shows Christ's dead body lying on a shroud,

1. Juan José Martín González, *El Escultor Gregorio Fernández* (Madrid: Ministerio de Cultura, 1980) 194.

2. James Waterworth, *The Canons and Decrees of the Sacred and Ecumenical Council of Trent* (London: Dolman, 1848) 235.

243

as narrated in the Bible by St. Luke: "Then [Joseph of Arimathea] took [the body of Christ] down, wrapped it in linen cloth, and laid it in a rock-hewn tomb where no one had ever been laid."[3]

Representations of the *Cristo yacente* relate iconographically to scenes of the pietà, the lamentation, and the entombment, and can also be associated with medieval catafalques and other devotional images of the dead Christ throughout history.[4] These sculptures of Christ are also closely related to depictions of the anointment, and most directly to images of the Holy Sepulchre. The *Cristo yacente* is the main component of re-creations of the Holy Sepulchre that took place in Spain during Holy Week, and the figure is meant to be understood not only as a surrogate for divine sacrifice as represented by the sacrament of the Eucharist, but also as a symbol of the promise of resurrection.

Many extant sculptures of the *Cristo yacente* are kept hidden from view for most of the year, until the Thursday of Holy Week, when they are presented for public veneration.[5] What spectators see at this time is an image of the dead Christ characterized by several key features. The body of Christ lies flat on its back, though it and the head are slightly tilted to the right, toward the viewer. The left leg is also usually bent toward the right, to allow full view of the figure. One or two pillows, often decorated with elaborate lacework and brocades, support the head. The entire body lies on a shroud. The figure's right hand rests on the shroud, while the left hand remains on the folded loincloth, or *subligaculum*. The body's turn toward the right allows the viewer to see the wounds and, particularly, the chest wound produced by Longinus's lance, from which blood and water poured, as described in John 19:34.[6] The blood and water are usually replicated by polychrome paint and resin. An elongated nose, high cheekbones, and sunken eyes distinguish the facial features. In Fernández's version, like many others that follow, the mouth is shown half-open, as are the eyes, through which the dead figure of Christ subtly engages the viewer. Painstaking details are rendered in the musculature, hair, teeth, and skin. Sculptures of this type were often carved from several blocks

3. Luke 23:53 (NRSV).

4. Enrique Cordero de Ciria, "Cristos yacentes Madrileños," *Villa de Madrid* 24 (1986) 44.

5. A. Igual Ureda, *Cristos Yacentes en las Iglesias Valencianas* (Valencia: Servicio de Estudios Artísticos, Institución Alfonso El Magnánimo, 1964) 11. Holy Week celebrates the passion of Christ and the events preceding Easter Sunday.

6. "One of the soldiers pierced his side with a spear, and at once blood and water came out" (John 19:34 NRSV).

of pine, which were then joined, varnished and painted. The image of the *Cristo yacente* is meant to communicate with the viewer and to encourage religious fervor; its pathos appeals to basic human compassion, and explains the image's popularity in seventeenth-century Spanish society.

Although imagery related to the *Cristo yacente* type—such as the lamentation, the pietà, and the entombment—has been studied over the years, little, if anything, has been written about the particular iconography of this type. Distinct from its counterparts in passion imagery, the *Cristo yacente* is restricted to a single figure. The Virgin Mary and the other mourners—Mary Magdalene, St. John the Evangelist, Nicodemus, and Joseph of Arimathea—are absent in the *Cristo yacente*. The lamentation over the body of Christ is traditionally placed after the deposition in the narrative sequence; in representations of the lamentation, the figures mentioned above crowd around his body, which is usually placed on the floor or on an altar-like stone slab.[7] In Niccolò dell'Arca's *Lamentation* (1463–85) for Santa Maria della Vita in Bologna, for example, the body of Christ is placed low on the floor and rests on a stone slab, complete with pillow and shroud.

The pietà, like the entombment, also represents mourning over the body of Christ, but in this case by the Virgin Mary alone. The overall arrangement of the scene varies; some show the Virgin holding Christ's head while his body rests on the floor, while other examples show Christ's body resting entirely on her lap, as if he were a child. The pietà imagery first emerges during the later Middle Ages in Germany and is associated with the vespers for Good Friday, which centered around images of the dead Christ on his mother's lap.[8] An excellent example of this sculptural type is the *Roettgen Pietà* (c. 1360), today in the Rheinisches Landemuseum, Bonn, Germany (Color Plate 13). The pietà is most often described as a devotional image to aid in contemplation in which the narrative is implied; it is understood as an *andachtsbild*.[9] This term is used to refer to a devotional image that is both narrative and iconic; the image is presented

7. James Hall, *Dictionary of Subjects and Symbols in Art* (Boulder, CO: Westview, 1979) 246.

8. Gertrud Schiller, *Iconography of Christian Art*, 1st American ed., (Greenwich, CT: New York Graphic Society, 1971) 2:179.

9. Joanna Ziegler, *The Word Becomes Flesh* (Worcester, MA: Cantor Art Gallery, 1985) 14. For more on *andachtsbild*, see Georg Dehio, *Geschichte der deutschen Kunst*, (Leipzig: de Gruyter, 1923) 2:117–23; and Erwin Panofsky, "'Imago Pietatis: Ein Beitrag zur Typengeschichte des 'Schmerzensmanns' und der 'Maria Mediatrix,'" in *Festschrift für Max J. Friedländer zum, 60. Geburtstage*, ed. Max J. Friedländer (Leipzig: Seeman, 1927) 294.

as a "semi-narrative," allowing personal contemplation and reflection.[10] According to the late Erwin Panofsky, the purpose of these images is to place the viewer in a state of "contemplative immersion."[11] This contemplation is directly linked to the fact that scenes of the lamentation and the pietà are not described in the Gospels and do not represent specific historical moments; therefore, they encourage viewers to meditate on overall themes of the life and the passion of Christ.[12]

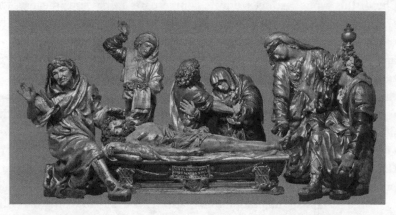

Figure 27. Juan de Juni, *Entombment*, 1544, Polychrome wood and gilding, lifesize, Museo Nacional de Escultura, Valladolid, Spain. Permission of Erich Lessing/Art Resource, New York.

The entombment includes many of the same characters that are represented in the lamentation—figures that, again, are not represented alongside the *Cristo yacente*. Juan de Juni's (c. 1507–1577) *Entombment of Christ* (1544) for the funerary chapel of the Franciscan monk Antonio de Guevara (originally placed in the now destroyed monastery of San Francisco in Valladolid) is often claimed as a precursor to the *Cristo yacente* because, in this case, the sculpture of Christ can be considered separately from the rest of the figural group (Figure 27).[13] In this entombment, like many others, Joseph of Arimathea and Nicodemus take precedent over some of the other figures, and the scene usually takes place either before a

10. James Clifton, *The Body of Christ in the Art of Europe and New Spain* (New York: Prestel, 1997) 14.

11. Panofsky, "'Imago Pietatis,'" 264.

12. Schiller, *Iconography*, 15.

13. Juan José Martín González, "En torno a Gregorio Fernández: Obras inéditas o poco conocidas," *Goya* 84 (1968) 349.

hollow rock of varied forms or near a sarcophagus.[14] The biblical verses in Matthew 27:57–61 describe how Joseph "had taken the body, wrapped it in a clean linen cloth, and laid it in his own new tomb, which he had hewn out in the rock: and he rolled a great stone to the door of the sepulchre, and departed. And there was Mary Magdalene, and the other Mary, sitting over against the sepulchre." John 19:38–42 recalls that Joseph was helped by Nicodemus, who brought myrrh and aloes to preserve the body.[15] John also adds that the tomb was in a garden near the place of the crucifixion. When artists or sculptors deal with the subject less as a narrative and more as a devotional work, angels take the place of the human figures.[16] Schiller has argued that the entombment's devotional aspect is directly tied to its emotional content, which allows the image to move away from straight-forward narration and more to empathetic and generalized representation.[17] This notion is significant to our own understanding of the *Cristo yacente*. The complete absence of figures in the *Cristo yacente* also allows the narrative to be implied and the work, therefore, serves as an aid to meditation and functions as an *andachtsbild*. As such, it is a devotional image that encourages contemplation not only on the death of Christ but, more specifically, on his sacrifice for humankind and the forgiveness of sin. By extension, such an image allows the faithful to reflect on their own eventual death and resurrection.

Another important episode in Christ's passion, one that is often overlooked by scholars, is the anointment. This scene takes place after the deposition and the bearing of the body; in the latter, Christ's body (which can be depicted either naked or covered by a shroud) lies on a bier or on the ground, but is always shown in front of a rock.[18] It is significant to note that, from the fourteenth century onward, the Christ of the entombment is no longer wrapped in a shroud but instead is represented with his

14. Hall, *Subjects and Symbols*, 113.

15. "After these things, Joseph of Arimathea, who was a disciple of Jesus, though a secret one because of his fear of the Jews, asked Pilate to let him take away the body of Jesus. Pilate gave him permission; so he came and removed his body. Nicodemus, who had at first come to Jesus by night, also came, bringing a mixture of myrrh and aloes, weighing about a hundred pounds. They took the body of Jesus and wrapped it with the spices in linen cloths, according to the burial custom of the Jews. Now there was a garden in the place where he was crucified, and in the garden there was a new tomb in which no one had ever been laid. And so, because it was the Jewish day of Preparation, and the tomb was nearby, they laid Jesus there" (John 19:38–42 NRSV).

16. Hall, *Subjects and Symbols*, 114.

17. Schiller, *Iconography*, 174.

18. Ibid., 169.

genital area covered by a cloth.[19] **Although the Gospels state that the body was wrapped in cloth, the tendency to represent the body exposed is of utmost importance to the Spanish tradition in particular, where to witness the body of Christ is to believe in his humanity and his incarnation.** The anointment, during which Christ's body was prepared for burial, is mentioned in John 19:39.[20] The biblical author recounts how Christ's body was embalmed with herbs brought by Nicodemus in a scene that is prefigured by the gifts of frankincense and myrrh, which the Magi presented to the Christ child.[21] A scene showing the actual process of anointment is represented in fol. 28v of the *Ingeborg Psalter* (c. 1210), today in the Musée Condé, Chantilly. The theme of the anointment begins to appear in Western art from the twelfth century onward. According to Schiller, this scene is distinct in that "the dead Christ lies not on a flat stone but on either a high chest resembling a sarcophagus or a bier."[22] This high chest appears in some arrangements for *Cristos yacentes*.

Scenes of the Holy Sepulchre, which relate to the liturgies of Good Friday and Easter, are also linked to the *Cristo yacente*. From the first half of the tenth century onward, some monasteries enacted a liturgical entombment, during which the eucharistic host was symbolically "buried" and then "raised" on Easter Sunday. On these occasions the host was placed "under a stone, in a chalice on a secondary altar or in a container of a burial niche" and was later resurrected.[23] This liturgical reenactment was paralleled by the building of structures intended to imitate the Holy Sepulchre in Jerusalem. These chapels, which likewise date to the tenth century, often had tombs in which a crucifix or a host was buried on Good Friday. In the Externsteine chapel in Germany, in addition to the burial of the host, a wooden figure of Christ was also buried. An example of such a wooden sculpture, from 1290, is preserved in the monastery of Luneburg in Wienhausen near Celle, Germany.[24] Here, on Maundy Thursday

19. Ibid., 171.

20. John 19:39 (NRSV): "Nicodemus, who had at first come to Jesus by night, also came, bringing a mixture of myrrh and aloes, weighing about a hundred pounds."

21. Schiller, *Iconography*, 172. See Erika Langmuir, "The Dual Nature," in *The Image of Christ*, ed. Gabriele Fina (London: National Gallery, 2000) 46. The anointing of Christ's feet by the anonymous sinner also prefigures the anointing of his dead body, a scene that takes place at the house of the Pharisee. See Luke 7:36–50.

22. Schiller, *Iconography*, 172.

23. Ibid., 182.

24. See Babette Hartwieg, "Drei gefasste Holzskulpturen vom Ende des 13. Jahrhunderts in Kloster Wienhausen," in *Zeitschrift für Kunsttechnologie und Konservierung*

or Good Friday, the figure itself was placed in the replica tomb while the host was hidden in a small box built into the side of the Christ figure.[25] On the eve of Easter, this figure was removed and replaced by a figure of the risen Christ.[26] It is worth noting in connection with this tradition that two of the Spanish *Cristos yacentes* also have receptacles for placement of the host. Gregorio Fernández's first *Cristo yacente* at the church of San Pablo in Valladolid has a receptacle that has now been sealed for conservation purposes (Figure 26). Likewise, Gaspar Becerra's (c. 1520–c. 1570) *Cristo yacente* (c. 1563) in the Monastery of Descalzas Reales in Madrid has a glass reliquary that allowed for placement and viewing of the host (Color Plate 17).

Formal devotion to the Holy Sepulchre began around the early thirteenth century with the founding in 1214 of the Order of the Augustine Canons of the Holy Sepulchre, who established the traditions surrounding its veneration.[27] The site itself had been venerated since the early Christian period, but with the establishment of the Crusades and the tomb's destruction in 1009, there was renewed interest in reestablishing a Christian presence in Jerusalem.[28] It was not until the thirteenth century that a more systematic approach, which included re-creations, was put into place outside the Holy Land since the area had fallen under Muslim control and was inaccessible to Christians.

Many of the original backdrops for these *Cristos* have been lost, including, presumably, scenes of the Holy Sepulchre. Two main formats were available for the presentation of *yacentes*. Some were placed in vitrines within a chapel or side altar, while others formed part of *retablos*.[29] Both

(Worms am Rhein: Wernersche Verlagsgesellschaft, 1988) 2:207. Hartwieg discusses the original location and context of the figure and its use during Black Friday. Furthermore, she suggests that the sculpture was ritually anointed with some sort of coating to preserve the wood. *Effigy of Christ* and *Sarcophagus*, c. 1290 and 1449. Oak, 247 x 58 x 30 (fn. 36 cont.) cm (effigy); 252 x 80.5 x 172 cm (sarcophagus). Wienhausen, Germany.

25. Schiller, *Iconography*, 182.

26. *Arisen Christ with Sarcophagus*, c. 1280 –90. Oak, 95.5 x 36 x 34.5 cm (Christ); 37 x 70.5 x 25.5 cm (sarcophagus). Wienhausen, Germany.

27. Schiller, *Iconography*, 183. For a complete history of the Holy Sepulchre, see Colin Morris, *The Sepulchre of Christ and the Medieval West: From the Beginning to the 1600* (Oxford: Oxford University Press, 2005). Morris traces its beginnings to the year 325.

28. See Martin Biddle, *The Tomb of Christ* (Phoenix Mill, GB: Sutton, 2000) 21. See also p. 76 in the text for a discussion regarding the seemingly uninterrupted pilgrimages to the site.

29. For all sepulchre types and formats, see Neil C. Brooks, *The Sepulchre of Christ*

presentational types formed part of theatrical re-creations of the Holy Sepulchre.[30] For example, documentary evidence exists that the *Cristo yacente* produced by Gaspar Becerra for the convent of Descalzas Reales, Madrid, was complemented by a backdrop that included tapestries and paintings, which re-created scenes of Calvary and Jerusalem. The backdrop produced a similar effect to the altar scene in a drawing (c. 1660) by Francisco Rizi (1614–1685) and located today in the Santarelli Collection of the Uffizi.[31]

Another Spanish work that postdates the *Cristo yacente* illustrates this transition from tomb to altar quite clearly. Pedro Roldán's *Entombment* (1670–72) in the *retablo* of the Hospital de la Caridad, Seville, shows the body of Christ being lowered into the tomb.[32] The relationship of the Holy Sepulchre to the altar derives from the traditional belief that the tomb *is* the altar.[33] By consequence, the body becomes the Eucharist and Christ becomes the sacrificial lamb. He sheds his blood for the faithful—blood that is coincidentally abundant in the sculptures of the *Cristo yacente*—and his body becomes the bread of the Eucharist, both of which redeem sins and lead to everlasting life. By sacrificing His mortality, Christ promises believers eternal life at his side. The incarnation of Christ was the key event that allowed for his ultimate suffering, death upon the cross. Therefore, his body is at once the eucharistic host and the bread of life.[34] The holy sacrament is referenced in contemporary seventeenth-century documents

in *Art and Liturgy with Special Reference to the Liturgical Drama* (Chicago: University of Illinois, 1921) 13–25, 59–66. He makes a distinction between "true" sepulchres and the *reposoir* or Place of Repose where the host is placed on Maundy Thursday for use in Friday Mass. The *yacentes* of San Pablo and Descalzas Reales are "true" sepulchres in that they are used to place the host on Holy Friday, which is later removed on Easter.

30. Jesús Urrea, "Los Cristos yacentes de Castilla y León," in *Tercer Encuentro para el Estudio Cofradiero: En Torno al Santo Sepulcro. Zamora, 10–13 de Noviembre, 1993* the Instituto de Estudios Zamoranos, ed. (Zamora: Jambrina, 1995) 17–29.

31. See María Ruiz Gómez, "Dos nuevos lienzos de la escuela madrileña en las Descalzas Reales de Madrid, y una hipótesis sobre la devoción al Santo Sepulcro," *Reales Sitios* 35, no. 138 (1998) 58; and Alfonso Pérez Sánchez, *El Dibujo Español de los Siglos de Oro* (Madrid: Ministerio de Cultura, 1980) 103. Francisco Rizi, *Drawing of Altar*, c. 1660. Pencil, pen, and sepia, 470 x 485 mm, inventory 10558. Santarelli Collection, Uffizi, Florence.

32. See Neil MacGregor, *Seeing Salvation: Images of Christ in Art* (New Haven: Yale University Press, 2000) 211. Pedro Roldán, *Entombment*, 1670–72. Polychrome wood, 3,10 meters wide. Hospital de la Caridad, Seville, Spain.

33. MacGregor, *Seeing Salvation*, 185.

34. David Freedberg, *The Power of Images: Studies in the History and Theory of Response* (Chicago: University of Chicago Press, 1991) 164.

as the "Sacramentum Amoris Austriaci" (The Beloved Sacrament of the Austrians), which linked the devotion to the Eucharist to Conde Rudolfo, founder of the House of Austria, and by extension to the House of the Hapsburgs making a clear link between the patronage of Philip III and the image of the *Cristo* of El Pardo.[35] Because images of the supine Christ played a key role in liturgical reenactments they established a relationship between the Eucharist and the physical body of Christ. This was in accord with the Council of Trent's thirteenth session, which concluded that the real presence of the body of Christ (*corpus*) is the Eucharist.

The sculptural representations of Christ produced by Fernández follow Counter-Reformation mandates that dictated that the viewer should react with empathy and even sorrow upon viewing religious images, particularly those of the passion of Christ. As noted by the Blessed Juan de Ávila in his treatise *Audia Filia* (*Listen, Daughter*), a treatise on Christian perfection published in 1556, these sculptures then function as an aid to visionary experience. In chapter 75 of *Audia Filia*, Juan de Ávila recommends how to meditate on the passion of the Lord: "For this it is very useful to have some well proportioned images of the stages of the Passion, which you would look upon many times, so that later without much sorrow you can imagine them on your own."[36] This treatise—like the texts produced in the sixteenth century by Fray Juan de la Cruz and St. Teresa of Ávila—further acknowledges that adequate sculptural images of the passion of Christ, including the *Cristo yacente*, served to foster deeper spiritual reflection.[37] This spiritual function was enriched by the association

35. Alfonso Rodríguez G. de Ceballos, "Arte y mentalidad religiosa en el Museo de la Descalzas Reales," *Reales Sitios* 35, no. 138 (1998) 14.

36. Original text: "Y para esto sirve mucho tener algunas imágenes de los pasos de la pasión, bien proporcionadas, en las cuales miréis muchas veces, para que después, sin mucha pena las podáis vos sola imaginar." Beato Juan de Ávila, "No forzar la imaginación," in *Avisos y reglas cristianas sobre aquel verso de David: Audia Filia*, 1556, ed. J. I. Tellechea (Barcelona: Flors, 1963) 169.

37. In book 3, chapter 35, section 3 of his *Subida al Monte Carmelo* (*Ascent to Mount Carmel*), Juan de la Cruz notes how "The use of images has been ordained by the Church for two principal ends—namely, that we may reverence the Saints in them, and that the will may be moved and devotion to the Saints awakened by them. When they serve this purpose they are beneficial and the use of them is necessary." San Juan de la Cruz, "Ascent to Mount Carmel," *The Complete Works of Saint John of the Cross, Doctor of the Church*, ed. and trans. by E. Allison Peers (London: Burns Oates & Washbourne, 1934) 1:310. St. Teresa explains how images aided her visually: "I had so little ability to represent things in my mind that if I did not actually see a thing I could not use my imagination . . . It was for this reason that I was so fond of images." St. Teresa of Avila, *Saint Teresa of Jesus: The Complete Works*, ed. and trans. by E. Allison Peers

of these images with the devotion to the Holy Sepulchre, a practice that gained popularity in Spain through ceremonial reenactments held during Holy Week. It was through imagery that both the Holy Sepulchre and the resurrection of Christ were re-created as part of a sacred drama, in which sculptures of the *Cristo yacente* operated as a surrogate to the physical body of Christ.

According to Palomino, Gregorio Fernández "did not undertake to make an effigy of Christ Our Lord or of His Holy Mother without preparing himself first by prayer, fast, penitence, and communion, so that God would confer his grace upon him and make him succeed."[38] His religious devotion and iconography characterize him as a Counter-Reformation artist. Aside from preparing himself in this way, Fernández was also aided in artistic expression by textual descriptions of visual and visionary experiences by some of the most revered and highly committed figures of Counter-Reformation Spain. Writings by the Carthusian Fray Antonio de Molina and the Dominican Fray Luis de Granada, for instance, gave clear form to the type of imagery considered appropriate for pictorial and sculptural representations intended to direct the viewer's devotions advantageously.[39] In his 1613 *Ejercicios Espirituales*, Spiritual Exercises, Fray Antonio describes the body of Christ as bruised and tattered, as Mary would ostensibly have seen it:

> when she sees the Sacred Body denigrated by blows and bruises, flayed and all covered in wounds. When she sees the hands and feet so torn with such big holes; when she touches the bones and finds them disjointed and out of place, especially the left

ed. (London: Sheed and Ward, 1963) 1:55–56. I have changed the word "pictures" in Peers's translation to "images." *La Vida de la Santa Madre Santa Teresa de Jesús y algunas de las Mercedes que Dios le hizo escritas por ella misma por mando de su confessor* (Madrid: Tello, 1882), chap. 9, p. 89. Original text: "Tenia tan poco habilidad para con el entendimiento representar cosas, que si no era lo que via no me aprovechaba nada de mi imaginación . . . A esta causa era tan amiga de imágenes."

38. Antonio Palomino, *Lives of the Eminent Spanish Painters and Sculptors*, trans. Nina Ayala Mallory (Cambridge: Cambridge University Press, 1987) 70. Original text: "No hazia Efigie de Christo Señor Nuestro, y de su madre Santísima, que no se preparasse con la Oracion, Ayunos, Penitencias, y Comuniones, porque Dios le dispensasse su gracia para el acierto." Acisclo Antonio Palomino de Castro y Velasco, "Juan de Juni y Gregorio Hernandez, Escultores," in *El Museo Pictorico y Escala Optica* (Madrid: L.A. de Bedmar, Impressor del Reyno, 1715–1724) 3:278.

39. These texts were included in sermons but also would have been available to the artist because they were widely published. Diego Valentín Díaz, Fernández's polychromer and neighbor, also had an extensive library whose inventory included all the titles discussed here, which may have been available to the sculptor.

shoulder; when she sees it all worn with the great weight of the Cross; the head perforated and full of thorns and she takes some out that have broken; the face full of spit and dried and coagulated blood, the neck bruised by the rope; and lastly all of Him mistreated.[40]

The *Cristo yacente* is the visual counterpart to the textual description of the body of Christ after the Crucifixion. Granada thought that such sculptures could keep the populace from sinning: "there is no other more powerful way to turn [people] away from sin than to place in front such a [lamentable] figure."[41] In turn, an empathetic response ostensibly would reaffirm in the beholder's mind the importance of the sacrament of the Eucharist as represented through the wounds and blood, prominent features in the *Cristo yacente*.

Fernández's *Cristo yacente* was commissioned by Philip III to celebrate the birth of his son, Philip IV, who was born on Holy Friday in 1605. It was placed in the convent in 1615.[42] The convent of El Pardo was founded on November 12, 1609, by Philip III and was inaugurated in 1613.[43] Jerónimo de Cabrera (Calabria) is recorded as having "painted all the ornament of the Sepulchre of Christ that His Majesty gave to the Capuchins in the imitation of marble (or jasper)."[44] Based on documentary evidence, it seems that the sculpture was placed in the oratory of the

40. Antonio de Molina, *Ejercicios Espirituales, De las excelencias, provecho y necesidad de la Oración mental reducidos a Doctrinas y Meditaciones . . .* (Madrid: Marin, 1777) 573. Quoted in Emilio Orozco, *Mística, plástica y barroco* (Madrid: Cupsa, 1977) 33–34. Original text: "Cuando viese el Sagrado Cuerpo denegrido de golpes y cardenales, desollado y todo cubierto de llagas. Cuando viese la manos y pies tan desgarrados, con tan grandes agujeros; tentase los huesos, y los hallase todos descoyuntados y fuera de sus lugares, especialmente el hombro izquierdo; cuando le viese todo molido con el gran peso de la Cruz; la cabeza taladrada, y llena de llagas de la espinas, y sacase algunas, que se habian quedado quebradas; el rostro lleno de salivas, y sangre seca y cuajada, la garganta desollada de la soga; y finalmente todo El maltratado."

41. Fray Luis de Granada, *La Pasión de Nuestro Señor Jesucristo*, ed. José Ramos Domingo (Salamanca: Ediciones Sígueme, 2003) 96. Original text: "no hay otro medio más poderoso para apartarlos del pecado, que ponerles delantes tal [lastimera] figura."

42. Philip IV was born on April 8.

43. González, *Gregorio Fernández*, 193.

44. Original text: "pintó de jaspe todo el ornamento del Sepulcro de Cristo que Su Majestad dió a los Capuchinos." Jerónimo de Cabrera (Calabria), n.d., leg. 38, fols. 65–66, CSR, 38, 65–66, Archivo General Simancas, Casa y Sitios Reales, published in Martín González, *Gregorio Fernández*, 194n116; and Gregorio Blanco García, *Historia de "El Cristo de el Pardo"* (Madrid: Convento de PP. Capuchinos, 1987) 17.

Palacio Real of El Pardo before it was moved to the Capuchin church.[45] According to Father Mateo Anguiano, who wrote a history of the convent in 1713, once Gregorio Fernández finished the work, he:

> placed it in the vitrine and took it to his Majesty who was impressed by its sight and notably happy [that the artist] had executed exactly what he had wished for. The pious Monarch remunerated him for his work and ordered that the sacred image be put in his Oratory. From then on he venerated it and frequented it many times and with much tenderness. Later (when his Majesty returned to the court in Madrid) he had the Sacred Image brought and ordered that it be placed in his Oratory where it remained until 1615 when his Majesty donated it to the Royal Convent of El Pardo and ordered that it be brought and placed in a vitrine within the chapel, as was done . . .[46]

This document informs us that the work was moved from Valladolid to Madrid, placed in the Oratory, and then transferred to the convent. Martín González argues that the *Cristo yacente* was in the convent by June of 1615, while the 1713 documents claims that it was installed on a Friday in March of the same year.[47] Although the patronage of the work is secure, the date of the sculpture is still debated. The date of the commission is also problematic. Enrique Serrano Fatigati argues that the work was ordered in 1603 and venerated by 1606 in the Royal Palace of Valladolid.[48] More commonly, it is believed to have been commissioned in 1605, but Martín González presents documentary evidence that suggests it was commissioned in 1614. A letter from Tomás de Angulo to the duke of Lerma dated

45. Urrea, "Los Cristos," 21.

46. Fray Mateo Anguiano, *Parayso en el desierto donde se gozan espirituales delicias y se alivian las penas de los afligidos* (Madrid: Fernandez, 1713) 109. Original text: "la colocó en una urna y se la llevó a Su Magestad quien quedó admirado de verla y notablemente gustoso de que hubiese tenido el acierto de executar lo mismo que había deseado. Remuneróle el piadoso Monarca su trabajo, y mandó poner la sagrada imagen en su Oratorio. Desde entonces la veneró y frecuentó mucho y con gran ternura. Después (cuando Su Magestad volvió a Madrid a la Corte), mandó traer la Sagrada Imagen, e hizo que se colocase en su Oratorio donde estuvo hasta 1615, en que Su Magestad gustó donarla a su Convento Real del Pardo, y mandó se traxese a él y que se colocase en una urna de la capilla como se hizo" (punctuation added to translation).

47. Martín González, *Gregorio Fernández*, 194; Anguiano, *Parayso*, 112; and Blanco García, *Historia*, 17.

48. Enrique Serrano Fatigati, *Escultura en Madrid desde mediados del siglo XVI hasta nuestros dias* (Madrid: Fototipia de Hauser y Menet, 1912) 102.

March 30 (Archivo General de Simancas, Casa y Sitios Reales, Leg. 325, fol. 311) reads:

> Last Tuesday I was at the Pardo in order to take a walk in the vegetable gardens of the Capuchin fathers and to complete some works [pending,] rushing to make sure everything is to the Majesty's liking upon his arrival. The chief Father told me how his Majesty ordered that in the small room that was under the major altar a sepulchre be made and he gave me the paper enclosed here with the measurements of the canvas to be painted by brush which is to be of Our Lady of Piety at the foot of the cross, with her child in her arms, St. John and Magdalene at the sides, and also of a Christ to be done in the round, that can be made by Rodríguez [Fernández] from Valladolid, who is the one that made your Excellency's and that of my lady the Duchess of Uceda, may there by Glory, and the painting on canvas can be done here.[49]

The *Cristo yacente* of El Pardo is the best known of Fernández's *Cristos yacentes*. It is recorded in such widely read primary sources as Palomino, Ceán Bermúdez, and Ponz.[50] Palomino mentions "the image of the Most Holy Christ in his Tomb in El Pardo."[51] Ceán Bermúdez cites "Another [Christ] our Lord also at the sepulchre in his chapel."[52] Ponz writes that

49. Urrea "Los Cristos," 21, believes the historical mistake on dating the work to 1605 stems from Anguiano, *Parayso*, 106. The reliance on this source explains the 1605 date in the label at the Capuchin Convent and Blanco Garcia's insistence for the earlier date. Cordero de Ciria, "Cristos yacentes Madrileños," 50, notes: a document dated to January 7, 1613, manuscript 3.661, Biblioteca Nacional, Madrid, holds all the secrets to the date of the work. Unfortunately, I was unable to locate this document as cited. Text: "El Martes pasado estuve en El Pardo a veer cómo se caminava en la guerta de los Padres capuchinos y rematar algunas obras que allí y en trofa faltaban y dar prisa a todo, para quando su Magestad fuere allá esté como se desea. El Padre comisario me dixo cómo su Magestad mandaba que en un aposentillo que está debaxo del altar major se hiziese un sepulcro y me dió el papel que va aquí para las medidas del lienzo que se ha de pintar de pinzel que ha de ser de Nuestra Señora de la Piedad al pie de la Cruz con su hijo en los brazos, y San Joan y la Magdalena a los lados, y también del Christo que se ha de hazer de bulto, que éste lo podría hazer Rodríguez el de Valladolid que es el que hizo el de V.E. y el de mi señora la Duquesa de Uceda, que haya Gloria, y a la pintura de lienço se podrá hacer aquí." Tomás de Angulo, January 30, 1614, Leg. 325, fol. 311 CSR, 325, 311. Archivo General de Simancas, Casa y Sitios Reales, Spain. Text is published in Blanco García, 14. Also published as Leg. 15, fol. 311 in Martín González, *La Escultura Barroca Castellana*. 2 vols. (Madrid: Galdiano, 1959 and 1971) 152.

50. Palomino, *Spanish Painters and Sculptors*, 70.

51. Ibid., 70.

52. Juan Augustín Ceán Bermúdez, *Diccionario histórico de los más ilustres*

"one goes up to the convent of the Capuchin fathers that was founded in the time of Philip III. They have in their church some works worthy of esteem, particularly the image of Jesus Christ in the sepulchre placed in the altar of his chapel, one of the best made by the celebrated Gregorio [F] Hernández."[53] The titles that Palomino and Ponz give to the piece, "Most Holy Christ in his Tomb" and "Christ at the Sepulchre," respectively, are important to the understanding of the function of the type, as they make explicit connection to the Holy Sepulchre. Since Philip III was the patron of the convent, it is likely that this *Cristo yacente* was venerated by the royal family. Martín González observes that in 1692 a Mass was held in front of the *Cristo yacente* that granted the participant indulgences for time to be spent in purgatory.[54] This clearly illustrates what McKim-Smith calls the "potency" of the image.[55] In Christian tradition, certain images are thought to have the power to intercede of behalf of the viewer and provide a truer meditative experience. Even today, many pilgrims venerate this statue and kneel in prayer at its feet.[56] The intercessory character of the work is further confirmed by the anecdote in the anonymous *Compendio de la Historia del Santísimo Cristo de El Pardo* (1807) that recounts what Fernández said of the *Cristo yacente*: "I have made the body but only God has been able to make the head."[57] Fernández establishes a connection

profesores de la Bellas Artes en España (Madrid: La Real Academia de San Fernando Imprenta Viuda de Ibarra, 1800) 2:270. Original text: "Otro señor también en el sepulcro en su capilla."

53. Antonio Ponz, *Viaje a España, Seguido de los dos Tomos del Viaje Fuera de España*, ed. Casto María del Rivero (Madrid: Aguilar Editor, 1947) 564. Original text: "se sube al convento de padres Capuchinos, que se fundó en tiempo de Felipe III. Tienen en su iglesia algunas obras dignas de estimación, y lo es en particular la imagen de jesucristo en el sepulcro colocado en altar de su capilla, de las mejores que hizo el celebre Gregorio Hernández."

54. Martín González, *Gregorio Fernández*, 193.

55. Gridley McKim-Smith, "Spanish Polychrome Sculpture and Its Critical Misfortunes," in *Spanish Polychrome Sculpture 1500–1800 in United States Collections*, ed. Suzanne Stratton (New York: Spanish Institute, 1993) 23.

56. For additional sources, see Esteban García Chico, *Gregorio Fernández* (Valladolid: Gerper, 1952) 17; María Elena Gómez Moreno, "Escultura del Siglo XVII," in *Ars Hispaniae* 16 (Madrid: Plus-Ultra, 1963) 81; Jesús Urrea, "A propósito de los yacentes de Gregorio Fernández," *Boletín del Seminario de Estudios de Arte y Arqueología* 38 (1972) 543; Ciria, "Cristos yacentes Madrileños," 49–50; Teresa Fernández Pereya, "Cristos de Madrid," *Anales del Instituto de Estudios Madrileños* 33 (1993) 171; and Alain Saint Saëns, *Art and Faith in Tridentine Spain (1545–1690)* (New York: Lang, 1995) 66.

57. Martín González, *Gregorio Fernández*, 194. Original text: "El cuerpo lo he hecho yo; pero la cabeza sólo la ha podido hacer Dios." This is a variant on the legend of the Volto Santo.

between himself and God as the ultimate creator of Christ and all images of him—in particular the *Cristo yacente* of Catholic Spain.

Methodological Issues of Historical-Religious Context in Nineteenth-, Twentieth-, and Twenty-first Century Art

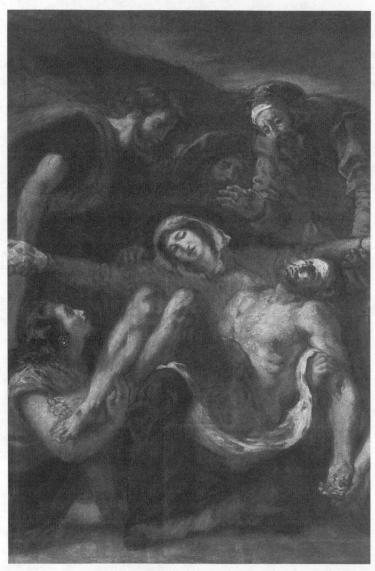

Figure 28. Eugène Delacroix, *Pietà*, detail, 1844, oil and wax on canvas 11.6 x 15.5 ft. (3.56 x 4.75 m), Church of Saint Denis du Saint-Sacrement, Paris. Photo permission of Christian Murtin.

Historicism and Scenes of "The Passion" in Nineteenth-Century French Romantic Painting[1]

JOYCE C. POLISTENA

In the first quarter of the nineteenth century, France experienced political and economic upheaval as the impact of growing democratization and industrialization shook the cultural foundations of post-Napoleonic society. One surprising effect was a pronounced and public revival of religion to address with this desultory state of affairs. In 1830, a sequence of Mariophanic events occurred only days before the riots that led to the collapse of the reign of Charles X. The reports of the appearances of the holy personage in a Parisian chapel of an order of nuns contributed the religious revival and deepened *les sentiments religieuses*. In that same year, a member of the Chamber of Deputies declared, "Gentlemen, whether you like it or not, the feeling for religion has in the last six years regained a power which no one could have foreseen."[2] As the famed art critic and literary figure, Théophile Gautier, is reputed to have said, "Bit-by-bit skepticism had gone out of fashion."[3] As the philosopher/theologian Bernard Lonergan understood it, theology emerges from religion but it also emerges from the

1. This essay is developed from a paper, "The Romantic Impulse for Scenes of The Passion and the Collective Ambition of the Bourgeoisie" (Association of Scholars of Christianity in the History of Art symposium, "History, Continuity, and Rupture: A Symposium on Christianity and Art," May 25–31, 2010). Some points of this essay are based on my book, *The Religious Paintings of Eugène Delacroix* (Lewiston, NY: Mellen, 2008).

2. Paul Thureau-Dangin, *L'Église et L'état sous la monachie de juillet* (Paris: Plon, 1880) 14. Also see Philip Spencer, *Politics of Belief in Nineteenth-Century France.* (London: Faber & Faber, 1954) 72.

3. George Boas, *French Philosophies of the Romantic Period* (Madison, WI: Johns Hopkins Press, 1925; repr., New York: Russell and Russell, 1964) 100.

cultural forces that propel its questions.[4] Several forces, including new Romantic approaches to theology, in combination with the social disorder, make it scarcely surprising that by the 1830s a transformation occurred in the questions about the person of Jesus. French theologians, taking the lead from studies that originated in the German universities some decades earlier, abetted the inquiry into the essential unity between religious art and the transcendent character of its subject. Claims for picturing Christ's doubt and suffering were held as an orthodox way to explain the theology. Jesus, the God-man, was understood to have experienced progressive growth in his human knowledge and to have experienced doubt as well as suffering.[5] Examination of the historical development of Christ's human consciousness led to methodologies that, in turn, proved fruitful for artists and spawned a new repertoire of themes and symbols. Among the most dramatic portrayals of the humanity of Jesus can be seen in works by Théodore Chassériau (1819–1856) such as, *Christ in the Garden of Olives* (1840).

Although formalist methodologies claim that subject matter and iconography are irrelevant to interpretation, this essay considers subject matter critical to analysis because, for much of the nineteenth century, artists and art critics understood subject matter as key to their Romantic identity.[6] In France, the mutable relationship between religion and modernity propped up religious subject matter as a salient transmitter of cultural values. Political and religious engagement shifted so dramatically in the Romantic era that artists appropriated and reinterpreted the theme of suffering hero, Jesus. To visualize scenes of "The Passion," many Romantic painters relied on biblical historicism but rather quickly eroded its sacred and metaphysical meaning. Patronage among members of the *haute bourgeoisie* was always a factor. Often, religious works appreciated by the cultural elite were based their general knowledge of the Christ as a heroic figure and not on theology but oriented toward their faith in

4. Bernard J. F. Lonergan, SJ, "Theology in Its New Context," in *A Second Collection of Papers by Bernard J. F. Lonergan, S. J.,* eds. William Ryan, SJ, and Bernard Tyrrell, SJ (London: Darton, Longman and Todd, 1974) 14. Lonergan includes cultural nationalism and economic nationalism as forces that may impact theology and religion.

5. "Neither the perfection of Christ's human nature nor his possession of the Beatific Vision . . . excludes the possibility of ignorance nor of progressive growth in his human knowledge . . . and it was in no way incompatible with doubt or with suffering." Gerald McCool, *A Rahner Reader* (New York: Crossroads, 1981) 160.

6. Anne Larue refers to this premise in her essay, "Delacroix and His Critics: Stakes and Strategies," in *Art Criticism and Its Institutions in Nineteenth-Century France*, ed. Michael R. Orwicz (Manchester: Manchester University Press, 1994) 76.

science and on a religion of humanity.[7] More significantly is the fact that irrespective of an artist's individual skepticism or orthodoxy, a great number of paintings and prints dedicated to scenes of "The Passion" were commissioned, created, and admired amid a defiantly anti-clerical and secular society. The present essay takes account of the contemporary perceptions of religious ideas as well as the historiography of "The Passion" scenes by artists in order to disentangle skewed meanings that have developed into art historical accounts.

An example of a widened perspective on religious subject matter and its stress on the humanity of the holy was uttered by the art critic Henri Delaborde, who described Paul Delaroche's (1797–1856) paintings of *The Agony in the Garden* (1840, 1844) as the voice of grief and anxiety, attributing the deep pathos in the painting not to its transcendent meaning but to the artist's psychological distress.[8] In these works, Delaborde posited that religious faith and religious themes were a pretext for intense personal feelings. In the rapidly changing culture of post-Napoleonic France, writers and art reviewers did not try to explain the basis for the spate of new Romantic symbols and motifs in religious art. The focus was now on the human nature of Christ and not on dogma or abstract systems of theology.

In the 1830s and 1840s, when humanitarian and progressive Catholic principles were most influential, religious art that represented these philosophies flourished. Catholic liberalism more readily influenced subjects and motifs for religious images than at any time since the Baroque period—some two-and-a-half centuries earlier. As in the Baroque, new spiritualities emphasized the subjective human experience of God in the events of ordinary life. By accepting the potentiality of contemporary everyday events as a source for experiencing the sacred, many were inspired to correct the causes of poverty and injustice. Republican secularists and religious figures rallied equally to the call for universal brotherhood. On the one hand, secularists believed they could harness social reform to principles of Christian liberalism with motifs such as "Jesus Liberator" or "Jesus, the Worker." Among the many good examples of depicting Jesus as a "man of the people" are works by Honoré Daumier (1808–1879) such as, *Jesus Carrying the Cross* (c. 1848) or *Ecce Homo* (1849–52) in which the facial features of his figures and the urban setting typify this contemporary

7. Bernard Reardon, *Religion in the Age of Romanticism* (Cambridge: Cambridge University Press, 1985) 237–66.

8. Henri Delaborde, "Paul Delaroche," Revue de Deux-Mondes (1857) in *Etude sur les Beaux-Arts en France et en Italie* (Paris: Jules Renouard, Libraire, 1864) 2:307.

flavor. Such motifs became popular with the working classes in an effort to emphasize the fraternal aspects of Christianity and proclaim this religion as the defender of liberté, egalité, fraternité. The symbolism was effective, in part, because it joined reformist principles with Romantic feelings for religious mystery and the Christian virtues. On the other hand, for members of the haute bourgeoisie, images of Jesus' passion—the agony, betrayal, scourging, crucifixion, lamentation, and entombment—evoked an empathetic response that was strongly tethered to a social class distinctly different from the workers or peasants.

The cultural elite of France not only identified with but also critically supported images of "The Passion" based on a rather narrow understanding of Christian beliefs. Informed by misshapen tropes of deification, the men and women of the literate bourgeoisie including patrons, artists, and critics favored scenes of "The Passion" of Jesus to the near exclusion of other gospel narratives. Prone to imagine the heroic aspects of the man/God, the elite audience identified with the concept of the suffering solitary figure as a suitable and even salutary symbol for the general malaise and feeling of vulnerability. In this period, there was an attraction to the theme of suffering and not to salvation. An attraction that was conditioned by human presumption and power and, instead of underscoring that God became man, the emphasis appears that men and women can become gods.

In order to properly contextualize the distinction by social class, this essay proposes what will undoubtedly seem like a controversial claim given received critical opinion. Scenes of "The Passion" by Romantic or academic stylists, by devout or skeptical artists, share a common visual language in their chosen motifs, scenarios, and details. This is significant because previous studies have posited a stark opposition among contemporary artists in terms of the difference in style, orthodoxy or ideology, whereas, it appears that artists of different stylistic schools shared a pictorial language that emphasizes the humanity of the sacred persona to a marked degree. Among the most prominent are Théodore Chassériau, Eugène Delacroix (1798–1863), Paul Delaroche, Hippólyte Flandrin (1809–1864), and Ary Scheffer (1795–1858); but also lesser-known figures such as, Hippôlte Lazgeres (1817–1887), J.-F. Boissard de Boisdenier (1813–1866), or A.-H.-J. Cambon (1819–1885).

At the time of this pivotal reframing of the figure of Jesus, leading art critics and reviewers explained that the suffering hero Jesus was emblematic of the widespread anxieties in contemporary society without

attributing any theological meaning to the innovation. The writers them-selves are members of the elite, literate and literary class, thus their char-acterizations helped to shape skewed perceptions of Christology for an audience of their own social class. For example, art critic Charles Blanc believed the suffering, tragic figure of Jesus was a pervasive one. Writer and art critic, Théophile Gautier believed that Jesus was always a tragic character and in his review of Chasseriau's 1844 painting *Agony in the Garden*, he asserted iconic meaning to Jesus' passion. "It represents the tears of our times which flow from his eyes . . . our melancholy pours its heart out in this veil of tears . . . this figure intelligent and tired . . . it is the suffering concern of our age."[9] An anonymous reviewer of the 1844 Salon declared: "A modern sadness pounds under the tunic of Christ; they are the tears of our times . . . our melancholy . . . the uneasy suffering anxiety of our age."[10] Blanc believed Delacroix's painting of the *Pietà* (Color Plate 18) aroused more intense feeling than any other because it emphasized the sorrows of a mother.

Blanc declared:

> Although there are a thousand others [paintings of the *Pietà*] . . .
> this time it is so profoundly sensitive, so human, and so heart-rending that all men, Christian or Pagan, must be moved to
> their innermost selves . . . the secondary figures are more grave
> but not less moving. The sad mountains of Judea which are
> enveloped in dark light, the dusky sky and the desolate nature
> in mourning; all this carries the soul to only one emotion, an
> immense sadness.[11]

Comte Louis Clément de Ris praised yet another of Delacroix's paintings, *The Lamentation* (1848) and he recommended the image for its sensitive rendering of human feeling: "The mournful sadness of the passage, the Virgin's flood of tears . . . the piety of the disciples . . . all combined to agitate your soul; [it] thrilled to things divine."[12] In another example, Delacroix's painting *The Mount to Calvary* was praised for its

9. Théophile Gautier, "Le Salon de 1844," in *Critique d'art: Extraits des Salons (1832–1872)*, ed. Marie-Helene Girard (Paris: Seguier, 1994) 41–60.

10. An anonymous reviewer of the Salon of 1844. Recorded in Gautier, "Le Salon," 97.

11. Charles Blanc, *Les Artistes de mon temps* (Paris: Librairie de Firmin-Didot et Cie., 1876) 54.

12. L. Clément de Ris, *L'Artiste* (April 1848) 2.

depiction of human frailty. "The expression of Jesus, who is convulsed in pain is panting, livid, nearly crushed. Christ sinks under the cross."[13]

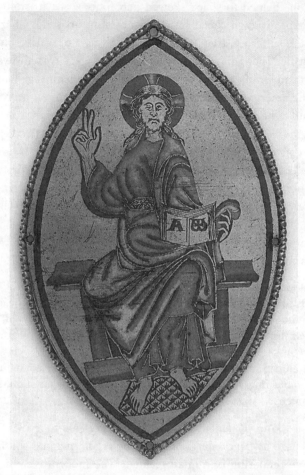

Figure 29. *Christ in Majesty* plaque, c. 1160–70, Champlevé enamel, 5 x ¹³/₁₆ x 3 ⁹/₁₆ in. (14.7 x 9.03 cm), the Metropolitan Museum of Art. Permission of the Metropolitan Museum of Art.

Art critic Alfred Nettement described Paul Delaroche's painting of *Christ on the Mount of Olives* (1855) with similar emphasis on its contemporary feeling: "The spectacle of sad humanity, then something more, the feeling of true sadness, have conducted Delaroche to the only true religion, to the religion of pain, to Christianity."[14] At times artists and critics who

13. Théophile Gautier, "Salon de 1844" *La Presse*, 29 March 1844.

14. Alfred Nettement, "Une visite à Paul Delaroche, Mai 1857," in *Poètes et artistes contemporains* (Paris: Lecoffre, 1862) 22. Also see Foucart, *Le Renouveau*, 275n80.

were less familiar with dogma or creedal practices and who identified with the resigned sufferer were challenged by more authoritative voices. Monsignor Barbier de Montault, the nineteenth-century historian of religious art, judged varied compositions of the scene of Jesus' *Climb to Calvary* as unorthodox because the temporal gradation was upset. In a series of articles on *The Way of the Cross*, de Montault explained that traditional iconography for this theme had recently been called into question, and he documented the iconographic history of each of the fourteen *Stations of the Cross*, noting that certain motifs or scenes had Rome's approval while others did not.[15] The greater part of the cultural elite were aligned with very general ideas about Christ in Christian doctrine. A prime example of this type of distorted notion of Christology can be identified in the works by the novelist and playwright George Sand. A writer who is representative of an avant-garde literary class, Sand believed that Jesus exemplified the suffering of all the people and insisted that the redemptive value of Christ's sacrifice must be situated in the life of contemporary Frenchmen and women. In her way of thinking, the common people too, by their suffering, become *figura Christi*.[16] Sand's Romantic interpretation violated orthodox teaching, which holds that human suffering can be joined to the sufferings of Jesus *already taken place* to affect redemptive merit but does not equal or substitute for God's sacrifice. Sand's truncated interpretation of the meaning of the Gospels is also representative of progressive principles and Romantic feeling that entwined political liberty with the cause of Christ.

Prior to 1830, during the reign of Napoleon I, an apparently dormant religious feeling was bestirred by a sensational text appearing at an opportune moment of history. François-Auguste-René de Chateaubriand's 1801 book, *The Genius of Christianity* was a vigorous defense of the Catholic faith in which the author provided an elaborate explanation

15. Barbier de Montault, *Traité d'iconographie chrétienne*, new ed. (Paris: Vivès, 1900) 1:135–38. Barbier de Montault contributed a series of articles on the iconography of the "Chemin de la Croix" for *Annals Achéologiques*. See *Annals Archéologiques*, 25 vols. (Paris: Didron, 1848–1864); and, specifically, Barbier de Montault, "Chemin de la Croix," in *Annals Archéologiques*, vols. 21–25 (Paris: Didron, 1862–1864). Vol. 26 is the Index for the series.

16. Sand did not see redemption as having been brought about by the unique sacrifice of Jesus. Compare Heb 10:12–14 (NRSV). "For Sand Jesus has less to do with a mystical messianism than a theory of history." Frank P. Bowman, *Le Christ des Barricades* (Paris: Cerf, 1987) 265–67. See Paul Christophe, *George Sand et Jesus* (Paris: Cerf, 2003).

of the aesthetics and the morality of Christianity.[17] Relatively soon after the success of Chateaubriand's book, which had inculcated a religious revival among the educated classes, Felicité de Lamennais published his enormously influential text, *Reflections on the State of the Church in France During the 18th-century and its Actual Situation* in 1809. The book followed anti-traditional theologies and sold by the thousands and was translated into several languages.[18] Lamennais aimed to forge a society based on Christian socialism and demanded the separation of church and state.[19] The priest's fiery personality and mesmerizing speeches fueled the imagination of artists, many of whom became aware of the kind of radical Christian idealism after the intense polemic surrounding the revolution of 1830. Perhaps overstating the case somewhat, the twentieth-century historian Claude Carcopino asserts, "It would be difficult to find a man of letters or a thinker in the nineteenth century who did not at some point in his life submit to the intellectual domination of Lamennais."[20]

If the previous generation of bourgeoisie skeptics was inspired by Chateaubriand's thinking, something similar occurred among the Romantics in the 1830s. In this historical moment, lapsed Catholics, skeptics, and agnostics alike were invigorated by the preaching of the Dominican friar Abbé J.-B.-H. Dominique Lacordaire, who captivated the minds and hearts of bourgeoisie with the same magnetism and ardor that Père Lamennais evoked among the working classes.[21] Around the same time, Abbé Lacordaire's lectures, which were held in the cathedral of Notre Dame, Paris, were great public events at which, according to witnesses, Lacordaire "aroused an admiration verging on stupor."[22] Romantic figures such as the novelist Victor Hugo and the poet Alphonse Lamartine attend-

17. François-Auguste-René de Chateaubriand, *Génie du christianisme ou beautés de la religion chrétienne* (Paris: Hachette, 1805). Chateaubriand lived from 1768 to 1848.

18. For a full discussion of Lamennais's philosophy, see Louis Le Guillou, *Lamennais* (Paris: Brouwer, 1969). Also see, by the same author, *L'Évolution de la pensée religieuse de Félicité Lamennais* (Paris: Colin, 1966) chap. 5.

19. Reardon, *Religion*, 190.

20. Claude Carcopino, *Les Doctrines sociales de Lamennais* (Paris: Presses universitaires de France, 1942) 199. Alec Vidler, *Prophecy and Papacy: A Study of Lamennais, the Church and the Revolution*, Birkbeck Lectures (London: SCM, 1954) 271.

21. Philip Spencer argued that Lamennais never got more than toleration from the upper classes. He characterized Lacordaire's audience as "a group that, although they believed in the need for religion as a moral code and as structure for civil order, did not think its dogmas worthy of belief." *Politics of Belief in Nineteenth-Century France* (London: Faber & Faber, 1954).

22. Spencer, *Politics of Belief*, 56.

ed. As a priest Lacordaire loosely guided the "Confrerie de Saint-Jean-l'Évangelist" dedicated to the propagation of the faith through the visual arts. The group, which was located near the city of Lyon and spawned the "Lyonese style," avoided scenes of "The Passion," preferring a traditional repertoire of pious Marian images and imaginative compositions of the heavenly realm.

It is quite true that images of the life and passion of Jesus were growing in popularity among all the classes and in a variety of painting styles. Salon records from 1831 to 1848 reveal that artists exhibited thirty-nine paintings of *Christ in the Garden of Olives*, thirty pictures of *Christ on the Cross*, thirty-three of *The Head of Christ*, twenty-nine images of *Christ in the Tomb*, twenty-four paintings of *The Descent from the Cross*, and fifteen of *Christ Dying on the Cross*.[23] This represented approximately a 73 percent increase over the early post-Napoleonic period, although at no time were religious subjects more than 14 percent of the total number shown at the Salon. On the other hand, the percentage of State commissions for religious subjects is much higher. Auguste Barbier testified to the surprising state of affairs in his Salon review of 1837, in which he said that there were now more religious subjects than those of battle pictures.[24] Similarly, in the 1838 review published in *Revue des deux-mondes*, Frederic de Mercy claimed, "there is scarcely an artist this year who has not made a religious picture."[25] It is noteworthy that the Marxist art historian Leon Rosenthal was the first to observe the insertion of contemporary religious values into Romantic art and he credited the rise in the number of religious subjects shown in the Salon to be directly related to their zeal for universal brotherhood.[26] Published in 1914, Rosenthal's analysis was pretty much a singular view until the ground-breaking effort by Bruno Foucart in 1987, in which he documented the revival of religious painting in nineteenth-century France.

23. The statistics were compiled by Foucart based on his analysis of those subjects described by Père C-F Chevè in *Dictionnaire theologique* (Paris: L' Abbé Migne, 1856) 9:101. In 1914 Rosenthal published figures for religious subjects compiled from nineteenth-century sources that vary only slightly from the data by Chevé. Leon Rosenthal, *Peinture romantique* (Paris: Librarie Thorin et Fils, 1930) 137. Similar data for later years was published by Pierre Angrand, "L'État mécène: Période authoritaire du second empire (1850–1860)" *Gazette des beaux-arts* 71 (1968) 303–48.

24. Auguste Barbier, "Salon de 1837," *Revue des deux-mondes* 10 (1837) 146. Also see Leon Rosenthal, *Du Romantisme au realisme, essai sur l'evolution de la peinture en France de 1830–1848* (Paris: Renouard, 1914; repr., Paris: Macula, 1987) 87.

25. Ibid., 389.

26. Ibid., 375–76.

As a class, the Parisian writers, critics, and art patrons appeared to propagandize Romantic images of Jesus as the solitary hero who experiences not only the physical but the excruciating psychological pain of his ordeal. They favored a haunting vision of suffering Jesus, who is nearly crushed under the weight of his temptation to forgo obedience and death. It represented a new, modern type of Jesus figure. Such a portrayal connotes a Jesus whose prescient vision includes the impending desertion by his disciples, of Peter's denial, his arrest and trial, torture, mocking, and death. Biblical scholars remind us that the narrative features represented by Romantic artists—"the emotional pathos, the concentration of pain and suffering—have no place in the Gospel accounts."[27] The greatest of the Romantic painters convey scenes from "The Passion" with its suggestion of Jesus' temptation not to obey; whereas, lesser artists fix their imagination on the representation of the physical and the sentimental.

The ambition of the bourgeois elite with regard to Christian beliefs was predicated on associating self-identity with that of the suffering Son of the Godhead. Delacroix is a prime example of this caste: a Parisian sophisticate, a member of the *haute-bourgeoise*, a successful and famous painter. Somewhat surprisingly, Delacroix created many of the religious subjects for his own pleasure and not for patrons. Much like his contemporary Romantics, whether impassioned artists, bourgeois patrons, or nondogmatic skeptics, Delacroix lived with a sense of personal uncertainty in this epoch. Debates about theology and religion were far from purely the concern of seminarians; questions about belief or unbelief circulated with passion among poets and politicians. It is certainly true that Delacroix's art was a product of Romantic imagination and the larger part of his oeuvre was based on literary sources and a taste for exoticism and medieval historiography. Nevertheless, his religious paintings were informed in general terms by the Romantic penchant for introspection that defined the aesthetic and experiential as *spiritual* in meaning and, more particularly, he was influenced by principles of liberal theology as disseminated by Lamennais and others. (For a time, Delacroix's intimate friend George Sand worked with Lamennais on the journal *The Future* [*L'Avenir*].)

It was Pierre-Paul Prud'hon's (1758–1823) *Christ on the Cross* (1823) that ushered in a truly modern style for religious subjects because it expressed an individual's psychological pain and doubt—a concept of Jesus

27. Raymond Brown, SS, *A Crucified Christ in Holy Week: Essays on the Four Gospel Passion Narratives* (Collegeville, MN: Liturgical, 1986) 18.

that evolved from Romantic subjectivism.[28] Some renditions of scenes of "The Passion" by artists such as Prud'hon, Chasseriau, Delacroix, or Delaroche, followed the Spanish Baroque model of a still-suffering Jesus, his head turned upward toward the Father and his lips parted as if reciting the last prayer: "Why have you forsaken me?" Baudelaire described Delacroix's 1846 painting of *Christ on the Cross* as pathetic, violently evocative of deep melancholy; the terrestrial Jesus revealed his humanity in his divinity. Although the poet did not respond with equal enthusiasm to works by Scheffer and Delaroche, we may notice in their renditions similar symbols of Jesus' human pathos *in* his divinity. Artists of dissimilar styles took up these themes portraying expressions of desolation and resignation in the figure of Jesus; he is viewed amid the shadows, bereft of human consolation, physically broken, and on the ground. Baudelaire commented about the 1848 painting of *The Entombment* (alternatively titled *The Lamentation*) and situated Delacroix's achievement within Romantic and aesthetic reveries that sought to harness universal truths.

> Have you ever seen the essential solemnity of the *Entombment* better expressed? Do you honestly believe that Titian could have invented this? . . . Eugène Delacroix always bestows upon [The Holy Mother] a tragic breadth of gesture which is perfectly appropriate to the Queen of Mothers. It is impossible for an amateur who is anything of a poet not to feel his imagination struck, not by an historical impression, but by an impression of poetry, religion and universality.[29]

Scenes from "The Passion" synergize form and dogma in which Romantic artists plumb a certain kind of tension between the idea of Jesus' love and the possibility of the believer's empathic response. Christology defines divine love as it is manifested in the body; thus, the christological interpretation is that the body is Jesus' *love* for others and simultaneously, the body is the *beloved*. In her authoritative analysis, historian Caroline Walker-Bynum explains that Jesus' perfectly pitched sensibility is a metaphor for God's incarnate love for humanity, a concept that stressed the Creator's respect for his creatures.[30] For example, she cites passages from

28. The idea was asserted decades earlier by German theologians such as J.-A. Möhler and J.-J. von Döllinger in Germany and later in France by L'Abbé Louis Bautain.

29. Charles Baudelaire, "The Salon of 1859," in *The Painter of Modern Life and Other Essays*, ed. and trans. Jonathan Mayne (London: Phaidon, 1964) 169.

30. Caroline Walker-Bynum, *Theology of the Body* (New York: Columbia University Press, 1995) 333.

St. Bonaventure: "the soul and the body are but one person . . . Bound to-gether by tenderness, even passion."[31] The poetic language of the medieval scholastics is one of the best possible means to explain the compelling role theology plays in Romantic religious paintings because regard for medieval scholastic theology was still active in the nineteenth century.

As painters depict scenes of *The Crucifixion, The Lamentation,* or *The Entombment* they show the sacred body torn, lanced and probed, carried, anointed, wrapped, and mourned over. The images presented Jesus as a body for adoration. Color is used to signify the transcendent and to draw the viewer to the painterly flesh of Jesus, which is rendered as coequal with his divine spirit. For many Romantic painters, emphasis on the sensation of color and of motion across the terrain of the body imaginatively expressed the mystical and the mysterious. The concept evolved in the Baroque period, in which the sacramental and mystical express human pathos and grief with form and contrast. Again, it was Delacroix who said as much in his essay on Michelangelo (July 1830): "The forms, contrasts, shadows, and lights on the fleshy and shifting terrain of the body—*It is God himself.*"[32]

As a theological argument, the Jesus type preferred by the elite class relied increasingly on a tradition developed from a misshapen theology of deification.[33] Beginning with the Book of Genesis that states, "Man is created in the image and likeness of God;" the concept is reiterated in St. Paul's epistle to the Philippians (2: 6–8): "Christ Jesus . . . emptied himself, taking the form of a slave being born in human likeness . . ." The church

31. Ibid., 332.

32. "*C'est Dieu lui-même* . . . " Eugène Delacroix, "Sur le jugement dernier," in *Ecrits sur l'art,* eds. François-Marie Deyrolle and Christophe Denissel (Paris: Librarie Séguier, 1988) 281.

33. Giles Constable observed that, especially in Greek theology, deification did not entail belief in mystical union; rather, the doctrine was fundamentally about salvation. "Known in Greek as *thosis,* deification did not refer primarily to the divinization of individuals who, through grace, achieved and then surpassed the summit of human experience; rather, it provided the underpinning for all Christian cosmology." *Three Studies in Medieval Religious and Social Thought* (Cambridge: Cambridge University Press, 1995) 145–55.

Karl Morrison observed that in the Medieval period belief in divinization also formed an essential chapter in the history of empathy: "The believer's inward likeness to the divine 'you' was God's presence—persona, or name—in his heart." *I Am You: The Hermeneutics of Empathy in Western Literature, Theology, and Art* (Princeton: Princeton University Press, 1988) 36–37, 66–67. Morrison's ideas are also cited in Jeffrey F. Hamburger, *St. John the Divine: The Deified Evangelist in Medieval Art and Theology* (Berkeley: University of California Press, 2003) 235n27.

in the early centuries after Jesus' death preached the goal of deification of humankind as a heavenly reward. The doctrine of the incarnation restated the fundamental dignity of mankind, but for centuries the debate swirled between the belief of a man becoming god-like after death or becoming like the divine in his lifetime.[34] Art historian Jeffrey Hamburger outlined the historiography of this serious controversy among several brilliant theologians, and its impact on the visual representation of human idealization. (The story of that debate makes fascinating reading today.) In manuscript illumination, panel painting, or sculpture, we may view the process of the debate by which self-identification with God was carried out. Imperial leaders disguised and defined themselves as a holy personage.

The theological debate reached its apogee among medieval theologians, a period, Hamburger reminds us, when most of the scenes associated with "The Passion" were formulated.[35] Of particular importance was St. Thomas Aquinas, who determined that the relation of the image to the model represented the totality of both the substance and nature of the thing itself and not only by appearance. Thomists believed that the object of the adoration of the body of Christ (as it might exist in the monstrance) was to adore God.[36] At the early centuries Christomimesis was restricted to exalted individuals and continued through millennia, to representations of the enthroned Holy Roman Emperor Otto III in the Gospel Book of Otto III (c. 1000). It was in the Renaissance when the artist's self-portraits emerged as an image of self-exaltation. Hamburger cites Albrecht Dürer's (1471–1528) *Self Portrait* (1500) as the first to mark this profound change of status. The artist as creator signaled a tempting approbation of power.

From the historiography of idealization of humanity or human divinization, it is not difficult to understand the ambitions of later generations that aimed toward this same identification. Members of the educated bourgeoisie understood *imitatio Christi* not only as emulation of Christ's humanity and passion but also imitation of Christ's divinity, as manifested

34. I am relying on Hamburger's description of the evolution of the doctrine of Christomemeis. *St. John the Divine*, 2–20.

35. Hamburger, *St. John the Divine*, 3–4.

36. St. Thomas Aquinas, using his scholastic system, declared that images are identified so particularly with the model that they incur the adoration of Jesus. See Jean Wirth, "La critique scholastique de la theorie thomiste de l'image," in *Crises de l'image religieuse: de Nicee II a Vatican II/sous la direction de Olivier Christin et Dario Gamboni eds.* (Paris: Maison des sciences de l'homme, 1999) 92–109; "Divinization," in *Dictionnaire de spiritualite, ascetique et mysticque*, 1370–1445 (Paris: Bueauchesne, 1957); and Ben Drewery, "Deification," in *Christian Spirituality: Essays in Honour of Gordon Rupp*, ed. Peter Brooks (London: SCM, 1975) 35–62.

in a Champlevé enamel plaque (Figure 29) of *Christ in Majesty* plaque (c. 1160–70) and the divinity of individual genius. From this basis, we can trace a rather uncomplicated development of the image of self-aggrandizement and the cult of the individual into the nineteenth century. As Hambuger succinctly describes the phenomenon, "The elite were no longer burdened by a sense of sacrilege."[37] It appeared an uncomplicated and unchallenged process to simply project himself or herself as a deified ruler. J.-A.-D. Ingres' (1780–1867) *Napoleon on His Imperial Throne* (1806) is a good example of this type of image making (Color Plate 19). It projects human authority as equal to that of a divine eminence. The Romantic epoch spearheaded the concept of the artist-genius, thus men and women of talent were emboldened by a tradition that signaled a divinization of the artist's status. One illustration of self-defined exceptionalism is embedded in Josef Danhauser's 1840 painting, *Franz Liszt Performing at the Piano*, in which key figures among the Romantic literary and musical coterie, are cosseted around Liszt in rapturous reverie typical of their Romantic fervor.

Paintings and literature that focused exclusively on themes of Jesus' passion were symbols of self-projection for an entire class. Attraction to the theme of suffering and not to salvation was an expression of their ambition and prestige. The elite were attracted to actions of the sacred persona as a hero for the many, but they refused to accept their need to be saved. Instead of underscoring that God became man, the emphasis appears that men and women can become gods. In terms of popular appeal, the working classes and members of *le petit bourgeoisie* preferred the sympathetic disposition of the suffering man/God who faced his agony in the garden of Gethsemane sustained by his faith in the Father. By 1863 Ernest Renan published his controversial and enormously popular portrayal of the historical Jesus. The premise of his book pushes the dialectic of Christomimesis to the breaking point as a portrait of a man sustained by his *own* strength of character and not by God. First published in 1863 by the 1880s Renan's narration mirrored the agnostic perceptions of the *haute bourgeoisie*: the man-god in a religion of humanity and a religion of science.[38]

The intellectual effervescence of the Romantic epoch included questions of faith, doubt, truth, and beauty, but also eruptions of cultural, political, and philosophical growth. The religious revival begun in earnest by

37. Hamburger, *St. John the Divine*, 8–9.
38. Reardon, *Religion*, 237–66.

1830 emerged from the philosophical and theological critiques by German idealists whose writings formulated a crucial contribution to the epoch. To this creative effort we include the effect of progressive theologies that helped shape change in the visual arts. In France, the evident religiosity of the first decades of the nineteenth century and the ample artistic output that resulted from this surge of curiosity about the person of God, about biblical history, and historiography brought to light a new repertoire of themes and symbols. The particular pairing of social class and an imaginative "type" for the figure of Jesus casts doubt on the dismissive epithet that has been given to nineteenth-century religious art as "a moribund genre." In fact, the renewed interest in theology invigorated Romantic painting however secondarily. As a regenerative genre, religious art encapsulated rival cultural values that would express ideological, psychological, and philosophical differences. The once prevalent interpretation of nineteenth-century religious painting as merely about narrative rendered with pious sentiment is challenged by evidence of contrary intentions.[39]

39. Richard R. Brettell and Caroline B. Brettell discussed popular subjects of religious paintings with some disdain: "Paintings seem more than faintly ridiculous to us today." *Painters and Peasants in the Nineteenth Century* (New York: Skira/Rizzoli, 1983) 96. Linda Nochlin concluded that among artists, critics, and supporters of Realism, "the question of successful religious painting is dismissed as irrelevant." *Realism* (New York: Penguin, 1971) 81–84, 88–92. Sally Promey and David Morgan are chiefly responsible for reintroducing religion as visual culture into the academic discourse of American art. See Sally Promey, "The 'Return' of Religion in the Scholarship of American Art," *Art Bulletin* 85, no. 3 (2003) 581–603; David Morgan and Sally Promey, *Exhibiting the Visual Culture of American Religions*, exhibition catalog (Valparaiso, IN: Brauer Museum of Art, Valparaiso University, 2000); and David Morgan, *Visual Piety: A History and Theory of Popular Religious Images* (Berkeley: University of California Press, 1998). For a discussion of religion as visual culture in nineteenth-century France, see Michael Paul Driskel, *Representing Belief: Religion, Art, and Society in Nineteenth-Century France* (University Park: Pennsylvania State University Press, 1992); Cordula Grewe, *Painting Religion in the Age of Romanticism* (Burlington, VT: Ashgate, 2010); and Debora L. Silverman, *Van Gogh and Gauguin: The Search for the Sacred Art* (New York: Farrah, Strauss and Giroux, 2000).

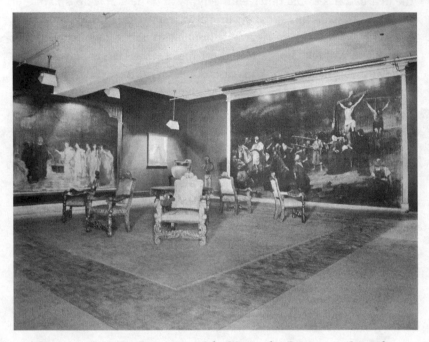

Figure 30. Furniture Department, John Wanamaker Department Store, the Historical Society of Pennsylvania, John Wanamaker Papers. Permission of the Historical Society of Pennsylvania.

Consuming Christ

Henry Ossawa Tanner's Biblical Paintings and Nineteenth-Century American Commerce[1]

KRISTIN A. SCHWAIN

In 1910, the Furniture Gallery at John Wanamaker's Philadelphia department store featured contemporary facsimiles of seventeenth-century English thrones chairs, *objects d'art*, and three prominent works of academic art: the massive painting *Behold! The Bridegroom Cometh (The Wise and Foolish Virgins)* (1907–8) by the African-American artist Henry Ossawa Tanner (1859–1937) as well as his more intimate (although still large) piece, *Christ and His Mother Studying the Scriptures (Christ Learning to Read)* (1910); and *Christ on Calvary* (1888), perhaps, at the time, the most well-known work in the American northeast, by the Hungarian artist Mihaly Munkácsy (1844–1900). The commercial photograph documenting this gallery (Figure 30) is exceptional only in the quality and popularity of the artworks' display. The intermingling of art, commerce, and Christianity animated nearly all aspects of late-nineteenth and early-twentieth-century American life. This gallery presents a series of challenges to twenty-first century scholars well-versed in modern art criticism's emphasis on an "art for art's sake" viewing posture and the sociologist Max

1. This essay is developed from a paper, "Civilizing Vision: The Protestant Patrons of Henry Ossawa Tanner's Biblical Paintings" (Association of Scholars of Christianity in the History of Art symposium, "Faith, Identity, and History: Representations of Christianity in Modern and Contemporary African American Art," March 23–24, 2012). Preliminary research was completed in June 2009 with the kind support of an Andrew W. Mellon Foundation Fellowship at the Library Company of Philadelphia and the Historical Society of Pennsylvania.

Weber's secularization thesis of modernity, as fine art appears alongside mass-produced commodities and Christianity holds sway in a secular institution.[2]

This essay's examination of the relationships between and among Tanner's religious paintings, the visual practices they authorized, and the commercial tactics of Wanamaker's department store is shaped by two overlapping methodological approaches: visual culture and consumption studies. The interdisciplinary study of visual culture promotes the examination of the cultural frameworks and circumstances in which people encounter works of art.[3] Art historian and religious studies' scholar David Morgan describes seeing as "an operation that relies on an apparatus of assumptions and inclinations, habits and routines, historical associations, and cultural practices."[4] It is an action that encompasses the object, the beholder, the process of viewing, and the setting in which it takes place. The photograph of Wanamaker's furniture gallery provides the opportunity to analyze a historically specific union of academic art, salable goods, and presumed (although not pictured) shoppers, showcasing the kinship of fine art and commercial culture, beholders and consumers, in the early twentieth century.

2. For a discussion on how Weber's secularization thesis of modernity has influenced the study of religion in American art scholarship, see Sally Promey, "The 'Return' of Religion in the Scholarship of American Art," *The Art Bulletin* 85, no. 3 (September 2003) 581–603. For historiographies on the study of art and religion, see David Morgan, "Toward a Modern Historiography of Art and Religion," in *Reluctant Partners: Art and Religion in Dialogue*, ed. Ena Giurescu Heller (New York: Gallery at the American Bible Society, 2004) 16–47; and S. Brent Plate, "The State of the Arts and Religion: Some Thoughts on the Future of a Field," in *Reluctant Partners: Art and Religion in Dialogue*, ed. Heller, *Reluctant Partners*, 48–65.

3. Although visual culture is commonly considered an interdisciplinary area of inquiry, scholars in a variety of disciplines continue to debate its appropriate subject matter and institutional position. Art historian John Davis briefly describes three primary models of visual culture study: one that examines the history of images, another that centers on contemporary media consumption, and a third that focuses primarily on visual practice. I subscribe to the third model for its emphasis on how cultural forces shape ways of seeing in historically specific ways. See John Davis, "The End of the American Century: Current Scholarship on the Art of the United States," *Art Bulletin* 85, no. 3 (2003) 560–61. For expanded discussions of the relationship between visual culture and American religions in particular, see David Morgan, *The Sacred Gaze: Religious Visual Culture in Theory and Practice* (Berkeley: University of California Press, 2005); David Morgan and Sally Promey, *The Visual Culture of American Religions* (Berkeley: University of California Press, 2001); and Kristin Schwain, "Visual Culture and American Religions," *Religion Compass* 4, no. 3 (2010) 190–201.

4. Morgan, *Sacred Gaze*, 3.

Visual culture's focus on the imbrication of viewers, social practices, and objects shares much in common with the study of consumption. Material culture scholar Ann Smith Martin writes that issues of consumerism and materialism "cluster around one key theme: the interaction of people, ideas, and material objects."[5] Understanding objects as embedded in exchanges between and among producers, sellers, and buyers within specific historical contexts maps onto the model of visual culture established above. It also makes sense of the interweaving of American Christianity and consumer culture that marks Wanamaker's department store enterprise. Religious studies scholar R. Lawrence Moore asserts that what scholars often refer to as the process of secularization is more aptly described as a process of commodification, since "religious influences established themselves in the forms of commercial culture that emerged in the nineteenth century."[6] The marriage of the methodological frameworks of visual culture and consumption studies enables scholars to consider objects that exist within multiple, and often conflicting, disciplinary categories and to stress the messiness that characterized modern American life.

This essay looks at how Tanner's religious paintings participated in the wider culture of art appreciation and consumption at the beginning

5. Ann Smart Martin, "Makers, Buyers, and Users: Consumerism as a Material Culture Framework," *Winterthur Portfolio* 28, no. 2/3 (1993) 143. Many scholars have discussed and debated the growth of modern consumer culture in the early twentieth century as well as its implications for socioeconomic relations of all kinds. In addition to Martin's essay, the following three review essays represent the vibrant scholarly landscape of consumption studies from different disciplinary perspectives: Mary Louise Roberts, "Gender, Consumption, and Commodity Culture," *American Historical Review* 103, no. 3 (1998) 817–44; Peter Jackson, "Commodity Cultures: The Traffic in Things," *Transactions of the Institute of British Geographers* 24, no. 1 (1999) 95–108; and Juliet B. Schor, "In Defense of Consumer Critique: Revisiting the Consumption Debates of the Twentieth Century," *Annals of the American Academy of Political and Social Science* 611, no. 1 (2007) 16–30.

6. R. Laurence Moore, *Selling God: American Religion in the Marketplace of Culture* (New York: Oxford University Press, 1994) 5. See, in particular, chap. 8: "Religious Advertising and Progressive Protestant Approaches to Mass Media." For additional studies on the relationship between religion and consumption, see R. Laurence Moore, *Touchdown Jesus: The Mixing of Sacred and Secular in American History* (Louisville: Westminster John Knox, 2003); Paul C. Gutjahr, *An American Bible: A History of the Good Book in the United States, 1777–1880* (Stanford: Stanford University Press, 1999); Colleen McDannell, *Material Christianity: Religion and Popular Culture in America* (New Haven: Yale University Press, 1995); Leigh Eric Smith, *Consumer Rights: The Buying and Selling of American Holidays* (Princeton: Princeton University Press, 1995); and Saul Zalesch, "The Religious Art of Benziger Brothers," *American Art* 13, no. 2 (1999) 56–79.

of the twentieth century to understand what functions they served for middle- and upper-class viewers, European- and African-American alike. By examining how Tanner's works coincided with trends in art criticism, religious and art education, progressive era reform efforts, and the display strategies of consumer culture, this essay underscores historian Harry Stout's assertion that Christianity has always been part of American commercial life. As early as the eighteenth century, he writes, religious leaders knew they had "to compete in a morally neutral and voluntaristic marketplace environment alongside all the goods and services of this world."[7] More specifically, this essay shows how Tanner's academic art participated in America's modernization and how cultural conservatives—more than avant-garde figures—advanced an "art for art's sake" viewing posture that proceeded to dominate the American art scene well into the twentieth century.

Henry Ossawa Tanner, one of America's most preeminent and successful academic artists at the turn of the century, promoted an empathetic mode of viewing popular among culture brokers, art critics, educators, and middle-class viewers alike.[8] He trained with Thomas Eakins (1844–1916) and Thomas Hovenden (1840–1895) at the Pennsylvania Academy of the Fine Arts (PAFA) before moving to Paris and enrolling in the Académie Julian in 1891. Thereafter, his art was in constant circulation within the United States and across Europe. His first major solo exhibition in the United States in 1908 cemented his reputation as an internationally renowned painter of religious imagery.

The large painting that hung in Wanamaker's furniture gallery, *Behold, The Bridegroom Cometh*, also known as *The Wise and Foolish Virgins*, was perceived to be Tanner's masterpiece when it was exhibited in France and the United States in 1908. Contemporary critics stressed that Tanner's representation of the parable of the second coming depicts the moment at which "the master of ceremonies is in the act of giving his summons." The virgins, who are "made to typify the expectancy of the peoples awaiting a

7. Harry S. Stout, *The Divine Dramatist: George Whitefield and the Rise of Modern Evangelicalism* (Grand Rapids: Eerdmans, 1991) xvii.

8. For an introduction to Tanner's art and life, consult two exhibition catalogs published in the early 1990s that established the foundation for current scholarship on the artist: Dewey F. Mosby, Darrell Sewell, and Rae Alexander-Minter, *Henry Ossawa Tanner* (Philadelphia: Philadelphia Museum of Art, 1991); and Dewey F. Mosby, *Across Continents and Cultures: The Art and Life of Henry Ossawa Tanner* (Kansas City, MO: Nelson-Atkins Museum of Art, 1995). For a more recent catalog, see *Henry Ossawa Tanner: Modern Spirit,* ed. Anna O. Marley (Berkeley: University of California Press, 2012).

heavenly bridegroom," go to meet him, "whose presence is made known by the light in the distance." Importantly, Tanner's wise virgins do not turn their backs on their sisters, but rather, assist them: "One in the group on the right is holding out her lamp, so that it might help the flickering light of her companion in distress. On the left is another on her knees; her well-trimmed lamp is beside her, while she is trying to help her distracted sister who is seated, even at the risk of missing the festivity herself." [9] Tanner confirmed that he wanted to soften the story and add a moral lesson: "I hoped to take off the hard edge too often given to that parable . . . interpreting the whole parable in keeping with our knowledge of the goodness of God and what he considers goodness in us." [10]

Tanner's desire to encourage the viewer's personal engagement was consistent with the interpretive practices of the African Methodist Episcopal (A.M.E.) Church in particular and Protestantism in general. Tanner's father, Benjamin Tucker (B. T.) Tanner, was a minister, and later a bishop, in the A.M.E. Church, a highly organized and formal institution established in the North that promoted middle-class virtues of discipline, restraint, and self-reliance. [11] B. T. Tanner's position as editor of *The Christian Recorder* and later the *A.M.E. Church Review* acquainted the aspiring artist with the theological and social debates that occupied the church leadership. It also enabled him to visualize how its members interpreted the biblical text, as manifested in sermons and scholarship alike. Scholars began with a biblical passage, placed it in its scriptural and historical contexts, and related it to current realities. [12] For example, in the sermon Bishop

9. "Mr. Tanner's Bible Paintings on View" [1908?], newspaper clipping, Henry Ossawa Tanner Papers, Archives of American Art, Smithsonian Institution, Washington D.C. (hereafter Tanner Papers).

10. Henry Ossawa Tanner, "The Story of an Artist's Life: II—Recognition," *World's Work* 18 (1909) 117–44.

11. On the A.M.E. Church and its elite status, see William E. Montgomery, *Under Their Own Vine and Fig Tree: The African-American Church in the South, 1865–1900* (Baton Rouge: Louisiana State University Press, 1993); Lawrence S. Little, *Disciples of Liberty: The African Methodist Episcopal Church in the Age of Imperialism, 1884–1916* (Knoxville: University of Tennessee Press, 2000); and Stephen W. Angell and Anthony B. Pinn, eds., *Social Protest Thought in the African Methodist Episcopal Church, 1862–1939* (Knoxville: University of Tennessee Press, 2000). For an extended discussion of the black elite at the turn of the century, see Willard B. Gatewood, *Aristocrats of Color: The Black Elite, 1880–1920* (Fayetteville: University of Arkansas, 2000).

12. Albert J. Raboteau describes the general structure of the sermon in "The Chanted Sermon," in his book *A Fire in the Bones: Reflections on African-American Religious History* (Boston: Beacon, 1995) 141–51. For examples of A.M.E. sermons that deployed this formula, see Daniel A. Payne, *Sermons and Addresses, 1853–1891:*

Daniel Payne delivered at B. T. Tanner's ordination to the bishopric, he equated the prophesy of Isaiah to the second coming:

> And the cow and the bear shall feed; the young ones should lie down together; and the lion shall eat straw like the ox. The lion shall not become an ox, nor the ox a lion, but they shall live in peace and harmony, in perfect harmony with the other . . . And what is meant? Why this . . . The time is coming, it is fast approaching, when all the nations of the earth shall harmonize and live in peace to make way for the second coming of the Son of man.[13]

Just as Bishop Payne interpreted a passage from Isaiah to exemplify the divine injunction for peace among races and nations, Tanner analyzed the parable to demonstrate the presence of the divine in human life; to avow the coming of God's Kingdom; and to underline the need for individual preparation for God's arrival.[14]

Payne's model of biblical interpretation was common among Protestant leaders. Bishop John H. Vincent, the founder of the Chautauqua Institution—a national organization that combined Protestantism and reform for a predominantly Euro-American, middle-class audience—reflected on Luke 1:48, "All generations shall call me blessed," in the "Sunday Lessons" section of *The Chautauquan: A Weekly Newsmagazine.*[15] After situating the "Nazarene girl" in her scriptural, historical, and geographical contexts, Vincent concluded that women should pattern themselves on the Virgin Mother, just as men modeled themselves on Christ. Bishop Vincent set the scene for readers to imagine Mary and identify with her. In doing so, he textually enacted what Protestant leaders worked to accomplish visually throughout the nineteenth century. Morgan's extensive study of nineteenth-century Protestant visual culture establishes that didactic imagery, which instructed and taught and was employed to facilitate conversion was gradually replaced by devotional imagery, which was contemplated by the viewer and intended to nurture and aid in the formation of personality. "By promoting the appreciation of fine art and by

Bishop Daniel A. Payne, ed. Charles Killian (New York: Arno, 1972).

13. Payne, *Sermons*, 60–61.

14. I expand on Tanner's visual exegesis in *Signs of Grace: Religion and American Art in the Gilded Age* (Ithaca, NY: Cornell University Press, 2008).

15. John H. Vincent, "Sunday Readings," *The Chautauquan: A Weekly Newsmagazine* 18, no. 1 (April 2, 1893) 24–25. On Chautauqua, see Alan Trachtenberg, "'We Study the Word and Works of God': Chautauqua and the Sacralization of Culture in America," *Henry Ford Museum and Greenfield Village Herald* 13, no. 2 (1984) 3–11.

investing artists with the power to interpret scripture rather than merely illustrate it," Morgan writes, "liberal Protestant clergy [and] pedagogues . . . joined with the new wealth of Protestant commerce to imbue art with a devotional and liturgical purpose."[16] Listening to sermons, reading scriptural lessons, studying devotional imagery; all these activities encouraged middle-class Protestants to personally engage with the biblical protagonists and identify themselves with them.[17]

The model of biblical exegesis visualized by Tanner and promulgated in church pews, popular literature, and religious imagery mirrored a narrative mode of art interpretation popular at the turn-of-the-century. Art historian Michael Leja demonstrates that beholders at the 1893 Columbian Exposition in Chicago gravitated to works like Thomas Hovendon's *Breaking Home Times* (1890), which "presented sentimental psychological dramas with which a majority of viewers—largely white and middle-to-upper class—could identify." According to Leja, "they treated the paintings as theatrical vignettes providing occasions for discerning the emotional and psychological conditions of the characters and for sympathizing or identifying with them."[18] Tanner's representations of biblical scenes were far more similar to Hovendon's genre paintings than traditional religious art in the United States. Early American gravestones and portraits, for example, relied heavily on the emblematic tradition to communicate with viewers, while religious history and apocalyptic landscape paintings demanded knowledge of allegorical, scriptural, and typological interpretation to purvey moral lessons and cultural instruction.[19] Tanner, like his

16. David Morgan, *Protestants and Pictures: Religion, Visual Culture, and the Age of American Mass Production* (New York: Oxford University Press, 1999) 318. On art education and "object lessons" in the Unites States more generally, see JoAnne Mancini, *Pre-Modernism: Art-World Change and American Culture from the Civil War to the Armory Show* (Princeton: Princeton University Press, 2005); Eileen Boris, *Art and Labor: Ruskin, Morris, and the Craftsman Ideal in America* (Philadelphia: Temple University Press, 1986); Simon J. Bronner, "Object Lessons: The Work of Ethno- logical Museums and Collections," in *Consuming Visions: Accumulation and Display of Goods in America 1880–1920*, ed. Simon J. Bronner (New York: Norton, 1989) 217–54.

17. Like so many of their Protestant counterparts, the A.M.E. Church Sunday School Union also relied on illustrations for religious education in their publications *The Juvenile Lesson Paper*, *The Gem Lesson Planner* (intended for primary school students), *The Leaf Cluster* (directed to Sunday School teachers), and *The Lesson Pictures*. The latter was a quarterly that contained "a picture for every Sunday of the Year." See "The Lesson Pictures," *The A.M.E. Church Review* 19, no. 1 (1902) 392.

18. Michael Leja, "Modernism's Subjects in the United States," *Art Journal* 55 (1996) 66.

19. See Diane Apostolos-Cappadona, *The Spirit and the Vision: The Influence of*

contemporaries, employed some of these representational tools, but at the same time, impelled viewers to become part of the biblical story and enact it in the present.

Tanner's presumption that viewers would individually engage works of art conformed to new trends in art education. From 1895 through the 1920s, "picture study" dominated Progressive era debates on education for students of all ages and classes. Historian of art education Mary Ann Stankiewicz illustrates that American tastemakers, reformers, and educators, influenced by John Ruskin's moral aesthetics and William Morris's craftsman ideal, shared four fundamental beliefs: "the value of art for the education of morals; close ties between art, nature, and spiritual experience; the importance of art as a cultural study; and the role of imagination and genius in art."[20] Picture study posited a direct link between artworks and their appreciation to the cultivation of Christian values, the socialization of immigrants and former slaves into middle-class standards of deportment, and cultural stability. Cultural entrepreneurs and tastemakers, convinced of art's civilizing function, ensured that middle-class Americans had access to original works of art and reproductions of them. They established three of the most important institutions for art's display—museums, department stores, and world's fair[21]—and promoted the surge in art publishing that followed the Civil War, taking advantage of improved reproductive technologies and transportation systems to produce "new mass visual media like magazines, chromolithography, and art education materials for the public schools" that put art in the hands and homes of middle-class Americans.[22]

Christian Romanticism on the Development of 19th-Century American Art (Atlanta: Scholars, 1995); John Davis, *The Landscape of Belief: Encountering the Holy Land in Nineteenth-Century American Art and Culture* (Princeton: Princeton University Press, 1996); Wendy Greenhouse, "Daniel Huntington and the Ideal of Christian Art," *Winterthur Portfolio* 31, no. 2/3 (1996) 103–40; Gail E. Husch, *Something Coming: Apocalyptic Expectation and Mid-Nineteenth-Century American Painting* (Hanover, NH: University Press of New England, 2000); Roger Stein, "Thomas Smith's Self-Portrait: Image/Text as Artifact," *Art Journal* 44, no. 4 (1984) 316–27; and Dickran Tashjian and Ann Tashjian, *Memorials for Children of Change: The Art of New England Stonecarving* (Middletown, CT: Wesleyan University Press, 1974).

20. Mary Ann Stankiewicz, "'The Eye is a Nobler Organ': Ruskin and American Art Education," *Journal of Aesthetic Education* 18, no. 2 (1984) 51. See Mary Ann Stankiewicz, "A Picture Age: Reproductions in Picture Study," *Studies in Art Education* 26, no. 2 (1985) 86–92; and Boris, *Art and Labor*, chaps. 4 and 5.

21. See Neil Harris, *Cultural Excursions: Marketing Appetites and Cultural Tastes in Modern America* (Chicago: University of Chicago Press, 1990).

22. Mancini, *Pre-Modernism*, 9. Perry Pictures was one of the most important

Journals and home decorating manuals catering to European- and African-American audiences instructed teachers and homemakers on what pictures to examine, where to hang them, how to look at them, and why it mattered.[23] In a particularly dramatic, though not uncommon, account of fine art's civilizing function, Jerome Down, a professor of Sociology at Trinity College in Durham, North Carolina, presented the results of his study of African-American interiors 1901.[24] After noting that twenty-four of the twenty-five homes he examined contained pictures, and that most of the images contained religious subject matter, Down concluded:

> The art which the Negroes now have in their homes is one of the best civilizing influences that could possibly be provided for the race. Their love for pictures, ornamental furniture, music and romance, is a great factor in giving stability for the family, in building up reverence for the home, in restraining population and promiscuous intercourse, in softening their tempers and subduing their passions. If they had more opportunities to gratify their love for art they would drink less liquor, commit less crime, and in many ways become better citizens. It should be the aim of Negro educators and ministers of the gospel everywhere, to afford a larger art life for the members of their race, and to direct the taste of the Negro into paths that uplift and strengthen character.[25]

Echoing his contemporaries, Down advanced the correlation between art appreciation and the cultivation of middle-class values. This correlation was enabled, at least in part, through the beholder's identification with

distributors of art reproductions for classrooms and promoted itself in a host of publications, including *The Southern Workman* and *The School Arts Book*, the primary professional journal for drawing and art teachers after Henry Turner Bailey—one of the most important figures in art education in the opening decades of the twentieth century—assumed the editorship in 1903. For sample advertisements, see "The Perry Pictures" in *The Southern Workman and Hampton School Record* 28, no. 3 (1899) 117; and *School Arts Book* 7, no. 10 (1908) xi. For a discussion of educators' preference for Perry Pictures, see "The Educational Value of Pictures," *The Southern Workman and Hampton School Record* 28, no. 4 (1899) 138. See Stankiewicz, "A Picture Age," 86–92.

23. There are a myriad of examples of such essays and publications. For a representative sample, see Estelle M. Hurll, "Selecting Pictures for the Home," *The Decorator and Furnisher* 23, no. 4 (1894) 133–34; Lucy Monroe, "A Circulating Picture Gallery," *Current Literature* 19, no. 1 (January 1, 1896) 46–47; and Mrs. A. N. Johnson, "The Greatest Pictures in the World," *A.M.E. Church Review* 26 (1910) 326–34. For an extended discussion of the impetus behind these books and essays, see Boris, *Art and Labor*, chaps. 4 and 5.

24. Jerome Down, "Art in Negro Homes," *Southern Workman* 30, no. 2 (1901) 95.

25. Ibid.

a picture's protagonists. The author of another typical essay asserted that older students have the ability to examine complex pictures and should be encouraged to articulate "all they see in the picture." This provides them with two valuable opportunities: to produce a "connected description" or to tell a story suggested by picture.[26] The writer's emphasis on picture study as story telling endorsed the same visual practices promoted by religious leaders, art critics, and educators alike.

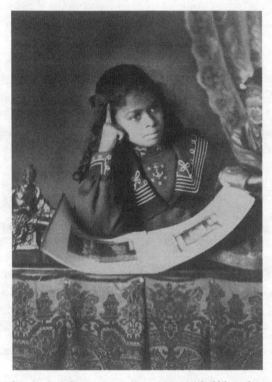

Figure 31. Thomas E. Askew, *African American girl*, half-length portrait, with right hand to cheek, with illustrated book on table, c. 1899–1900. The Library of Congress, Prints & Photographs Division, LC-USZ62–63574. Permission of the Library of Congress Prints and Photographs Division.

Studio photographs of European- and African-Americans showcase the role of fine art and its reproductions in the performance of middle-class domesticity. Mining the conventions of fine art and photographic portraiture, for example, the African-American photographer Thomas Askew pictures a young woman sitting behind a table covered with a damask

26. "The Educational Value of Pictures," 137.

tablecloth with a portfolio of images open before her (Figure 31).[27] She rests her head on her hand and looks away from the viewer, posed in a moment of reflection on the pictures that dominate the foreground and the sculptures that frame her on each side. Like the pictorialist photographs of F. Holland Day and Gertrude Käsebier and paintings of Thomas Eakins, Mary Cassatt, and William Merritt Chase, Askew's portrait exhibits the centrality of art appreciation—as well as the practices of attention and engagement it cultivated—to the processes of civilization and socialization.

Tanner's patrons, particularly John and Rodman Wanamaker and Robert Ogden, and the African-American elite shared the artist's faith in Christianity as the primary means to a civilized society and the vital role of fine art in facilitating that process. John Wanamaker was one of the most influential merchants of the late nineteenth and early twentieth-century who helped formulate the practices that produced a culture of consumer capitalism in cooperation with educators, social reformers, politicians, publishers, artists, and religious leaders.[28] Before transforming the abandoned Pennsylvania Freight Station into one of the first modern department stores in 1876, Wanamaker invited the famed evangelist, Dwight L. Moody, to conduct a revival on the property. Properly anointed, his department stores grew alongside philanthropic efforts that centered on the practice and progress of Christianity around the world. By 1898, Wanamaker taught almost two thousand people every week at his Sunday Bible classes. He served as president of the Philadelphia Sabbath Association for forty years, expanded the Salvation Army and the YMCA (the latter into Madras, Calcutta, Seoul, and Peking), and was president of the World Sunday School Association in 1919.[29] Three phrases commonly attributed to John Wanamaker invoke the holy trinity of Christianity, Commerce, and Culture that molded his business philosophy and extensive

27. This photograph was part of the award-winning exhibit W. E. B. Du Bois created for the American Negro Exhibit at the 1900 Paris Exposition. He selected 363 photographs and organized them into albums—*Types of American Negroes*; *Georgia, U.S.A.*; and *Negro Life in Georgia, U.S.A*—to counter prevailing racist stereotypes and showcase the diversity of African-American life in the United States. For an extended discussion of Du Bois's exhibit, please see Shawn Michelle Smith, "'Looking at One's Self through the Eyes of Others': W. E. B. Du Bois's Photographs for the 1900 Paris Exposition," *African American Review* 34, no. 4 (2000) 595; and Shawn Michelle Smith, *Photography on the Color Line: W. E. B. Du Bois* (Durham, NC: Duke University Press, 2004).

28. William R. Leach, *Land of Desire: Merchants, Power, and the Rise of a New American Culture* (New York: Pantheon, 1993) xiv.

29. Ibid., 191–224.

philanthropic activity: "Commerce is the great civilizer."[30] "The Golden Rule of the New Testament has become the Golden Rule of Business."[31] "Art goes hand-in-hand with commerce."[32]

John Wanamaker's marketing and display strategies were shaped by his son, Rodman Wanamaker, and his business associate, Robert Ogden, both of whom believed in the educational power of objects and the affinity of art and advertising. An early biographer credited Rodman Wanamaker with bringing "art to merchandise."[33] A firm believer in the civilizing potential of home decoration and the refining power of the old masters, Rodman contended that people were more apt to attain personal happiness if they lived in harmonious surroundings and appreciated art and beauty.[34] Consequently, he paid careful attention to store display, imported art and artifacts from around the world, and guided his father's art collecting. Wanamaker was influenced, too, by Ogden, who belonged to a new category of merchant who knew the selling power of images and advocated the use of illustrations.[35] In an 1898 speech, Ogden traced the relationship between art and advertising to the ancient world and cited Giotto as the first modern to "decorate modern scenery in the interests of business."[36]

30. John Wanamaker (firm), *Golden Book of the Wanamaker Stores: Jubilee Year, 1861–1911* (John Wanamaker, 1911) 132.

31. Quoted in Joseph H. Appel, *The Business Biography of John Wanamaker, Founder and Builder: America's Merchant Pioneer from 1861 to 1922* (New York: Macmillan, 1930) xv.

32. Wanamaker (firm), *Golden Book of the Wanamaker Stores*, 245.

33. Appel, *Business Biography*, 446.

34. Ibid., 450.

35. Leach, *Land of Desire*, 51. Ogden was heavily invested in African-American education in the South and donated a number of Tanner's paintings to the Hampton Institute. A recent history of the Hampton University Museum compiled by former and present staff members highlights Ogden's intimate relationship to the Institute. See "Hampton's Collections and Connections: A Unity of Art and Life," *International Review of African American Art* 20.1 (2005) 5–31. For Ogden's view on black education, see Ogden, "The Conference for Education in the South," *Annals of the American Academy of Political and Social Science* 22, no. 2 (1903) 271–79. For an account of the tensions between Northern white philanthropists, including Ogden, and Southern black educational institutions, see William Watkins, *The White Architects of Black Education: Ideology and Power in America, 1865–1954* (New York: Teachers College Press, 2001). On black teachers in the segregated South, see Hilton Kelly, *Race, Remembering, and Jim Crow's Teachers* (New York: Routledge, 2010).

36. "The Sphinx Club Dinner: Robert C. Ogden Delivers an Address, Taking 'Art in Advertising' as His Subject," *New York Times*, April 14, 1898, 7. Ogden continued: Giotto "began his career in the sheep business, chalked the rocks with portraits of his

He argued against an "art for art's sake" viewing posture, asserting that "art in advertising is art for humanity's sake."[37]

The paintings that graced the walls of Wanamaker's furniture gallery manifested Wanamaker's faith in art's evangelical function. American viewers of Tanner and Munkácsy's art were prepared to experience religious art devotionally thanks to at least three travelling shows of religious imagery that received Wanamaker's blessing as well as extensive critical attention. Munkácsy's large religious paintings *Christ Before Pilate* (1881) and *Christ on Calvary* (1884) became known to millions of Americans through multi-city tours, catalogs, and inexpensive reproductions.[38] In a scrapbook of testimonials that accompanied the 1888 tour (by which time Wanamaker had acquired both pictures), critics and beholders universally described Munkácsy's *Christ on Calvary* as "the most eloquent and practical sermon of our day" that brought "the truth of the gospel home to the heart" and "made a marked mental picture for all time."[39] Similar responses framed reactions to the travelling exhibition of the French artist James Joseph Jacques Tissot (1836–1902), who produced over three hundred and fifty watercolors of the New Testament that toured the United States in 1898 and were published in two folio volumes accompanied by the Latin text of the Vulgate, its English translation, and the artist's archaeological notes on Oriental life and customs.[40] One critic summarized the feelings

sheep, doubtless for the three-fold purpose of cultivating his taste for art, defacing natural scenery, and promoting the business of his employer."

37. Robert Ogden, "Advertising Art," *Dry Goods Economist* (May 15, 1898), quoted in Leach, *Land of Desire*, 52.

38. Wanamaker purchased the two paintings in 1887 and 1888, respectively, for between $100,000 and $175,000 each. Munkácsy's importance to Wanamaker and his immense popularity is well documented in Laura Morowitz, "A Passion for Business: Wanamaker's Munkácsy, and the Depiction of Christ," *Art Bulletin* 91, no. 2 (2009) 184–206. For archival information, including correspondence with the artist and tickets, advertisements, pamphlets, reviews, and guest books that accompanied the travelling exhibitions, see John Wanamaker Collection, the Historical Society of Pennsylvania (hereafter Wanamaker Collection).

39. *Testimonial to M. De Munkácsy The Painter of Christ on Calvary* (scrapbook). Wanamaker Collection, Box 240. Quotations are from: Rev. F. Robert, Louisville, KY; W. W. Jorday, pastor of Congregational Church, NJ (November 30, 1889); and F. S. Goodman, Cleveland, OH (January 25, 1888).

40. For contemporary accounts on Tissot, see Edith Coues, "Tissot's 'Life of Christ,'" *Century Magazine* 51, no. 2 (1895) 289–302; Jean Jacques, "An Artist's Conception of the Life of Christ," *Bookman* 8 (1898) 282, 352–59; Clifton Harby Levy, "James Tissot and His Work," *Outlook* 60, no. 16 (December 17, 1898) 954–64; and Cleveland Moffett, "J. J. Tissot and His Paintings of the Life of Christ," *McClure's Magazine* 12, no. 5

of many when he noted: "it is not merely a life of Jesus, but a living Jesus who passes from birth to death in the eyes of the spectator."[41] Following the Tissot campaign, Wanamaker anointed a "Tissot Gallery" on the fifth floor of his New York store to display art and sold all four volumes of Tissot's work in installments for those participating in the "Wanamaker Tissot Club."[42]

Two years after Tissot's successful tour, Tanner corresponded with Ogden and expressed his interest in organizing a large traveling exhibition of his religious pictures modeled on Tissot's successful show.[43] When it came together eight years later, the criticism generated by Tanner's exhibition echoed that received by Munkácsy and Tissot in 1888 and 1898, respectfully. Commentators noted that Tanner brought "the stories of the Bible down to earth" and "sensed events removed from the lapse of nineteen centuries and has depicted them with such sincerity that the personages seem to live and breathe."[44] Another directly compared Tanner's exhibition to Tissot's display:

> He seems to have been able to project himself back into the past and to paint religious subjects realistically without a trace of that archaeological point of view which you note, for example, in the remarkable reconstructions of Tissot. He does not adapt a scriptural theme to latter-day conditions. He simply makes his appeal on broad human grounds, painting his sacred figures simply as men and women moving against their natural background.[45]

Although Tanner's work certainly participated in popular interest in the historical Christ—he purchased the "Oriental" costumes from Munkácsy's estate and, like Tissot, visited the Holy Land to view its inhabitants and

(1899) 386–96.

41. Levy, "James Tissot," 959. Tissot described his intention in a similar way: "To make alive again before the eyes of the spectator the divine personality of Jesus, in his spirit, in his deeds, in all the sublimity of his surroundings." Jacques, "An Artist's Conception of the Life of Christ," 353.

42. Wanamaker distributed Tissot's four volume *Life of Christ* in 1899. Consumers could join the Wanamaker Tissot Club to purchase the $30.00 to $50.00 book for $1.00 down and $3.00 a month. For sample advertisements, see "Wanamaker Daily Store News: Tissot's Life of Christ," *North American* (Philadelphia), October 26, 1899, 8; and "John Wanamaker: Great Book Offer," *The Southern Workman* 29.1 (January 1900) 57.

43. Robert C. Ogden to Henry Ossawa Tanner, July 12, 1900, Tanner Papers.

44. Quoted in "Pictures of Bible History," *Globe* (c. 1908) and "Mr. Tanner's Bible Paintings on View" (c. 1908), exhibition reviews and clippings, Tanner Papers.

45. "Art Exhibition" (c. 1908), press clipping, Tanner Papers.

built environment firsthand—critics stressed that his broad Christian vision allowed them to psychologically engage the gospel story and clothe it in modern dress.[46] They imprinted the gospel message in the hearts and minds of viewers.

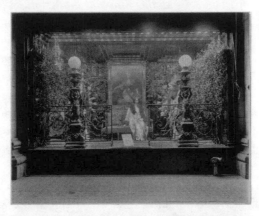

Figure 32. Window Display, John Wanamaker Department Store, c. 1893–1904, the Historical Society of Pennsylvania, John Wanamaker Papers. Permission of the Historical Society of Pennsylvania.

Wanamaker's presentation strategies showcased his belief that academic art civilized viewers by acting as visual sermons that encouraged their empathy and by presenting standards of genteel behavior. For example, his personal collection of Old Master and French Salon paintings often appeared in interior vignettes and window displays. One early-twentieth century window centers on a painting of a seated young woman with a fur-collar that edges her luxurious clothing and sets off her smooth skin (Figure 32). The mannequin, set inside a fenced-off garden, is posed in almost the same position. The display presents a standard that the consumer understood to embody taste and appropriate behavior. At the same time, it invited her to walk inside the department store to purchase the

46. On Tanner's belief that Christian faith, more than race, determined a person's place in the world and proffered hope for social equality, see Schwain, "Figuring Belief: American Art and Modern Religious Experience," PhD diss., Stanford University, 2001; and Schwain, *Signs of Grace*. See also Alan Braddock, "'Painting the World's Christ': Tanner, Hybridity, and the Blood of the Holy Land," *Nineteenth-Century Art Worldwide* 3, no. 2 (2004), http://www.19thc-artworldwide.org/index.php/autumn04/298-painting-the-worlds-christ-tanner-hybridity-and-the-blood-of-the-holy-land; and Alan Braddock, "Christian Cosmopolitanism: Henry Ossawa Tanner and the Beginning of the End of Race," in *Henry Ossawa Tanner: Modern Spirit*, ed. Anna O. Marley (Berkeley: University of California Press, 2012) 135–43.

clothing and assume that model herself. To put it differently, the painting established both the form and content of the window; it presented the ideal as well as the material means to attain it. The emphasis on edification through emulation is stressed in the third painting in the furniture gallery, Tanner's 1910 *Christ and His Mother Studying the Scriptures (Christ Learning to Read)* (Color Plate 20). Predicated on a photograph of Tanner's wife and son, the painting models familial intimacy; underscores the American woman's role as the Madonna of the home; and stresses the significance of education. The painting relies on the visual practices encouraged by religious leaders, art critics, educators, and tastemakers like Wanamaker; viewers identified themselves with a picture's protagonists and, in doing so, learned the values and behaviors of middle- and upper-class Americans.

Wanamaker's art collection, window displays, and store publications reproduce what the *Golden Book of the Wanamaker Stores*, published in 1911 to celebrate Wanamaker's fifty years in business, proclaimed: "Eyes must be educated. We do not know what we see, but we see what we know. And so, people must be taught the methods of manufacture . . . They must be educated in Merchandise." A few sentences earlier, the author listed what actions constituted critical seeing: weighing, analyzing, sifting, deciding, and individualizing material goods.[47] Wanamaker's instructions to consumers closely paralleled the work and writing of the connoisseur and historian of Renaissance art Bernard Berenson, who also advocated close, disciplined, and informed looking in beholding works of art.[48] Wanamaker's "Museum of Merchandise" worked to teach visitors to look—and consume—critically, at least within the boundaries of his pre-selected goods.[49]

The intersection of Tanner's art, the ways of seeing it impelled, and its circulation in Wanamaker's department stores indicate that the artist's stress on an interior religious life, and art's role in cultivating it, coalesced with the broader Protestant emphasis on consumption and modernization. In doing so, it supports the claim of scholars Mancini, Leja, Michelle Bogart, and Sarah Burns, who assert that the construction of aesthetic modernism was forged less by the movement's self-proclaimed "revolutionaries" than the work of art patrons, enthusiasts, and critics whose goals were culturally conservative.[50] While European- and African-American

47. Wanamaker, *Golden Book*, 238.

48. Bernard Berenson, *The Florentine Painters of the Renaissance* (New York: Putnam's Sons, 1904) 5.

49. "November: A Commanding Occasion," *New York Times*, November 1, 1901, 4.

50. Mancini, *Pre-Modernism*; Leja, "Modernism's Subjects in the United States";

tastemakers turned to works by the old masters and academic painters like Tanner to promote their social agendas, the visual practices they prompted encouraged beholders to *experience* art and to identify with its subjects. In doing so, they paved the way for modernist art critics like Clive Bell and Roger Fry to frame the beholder's engagement with modern art as a form of absorption that takes place in a higher realm of emotion, detached from the material realities of everyday life.

Michelle Bogart, *Artists, Advertising, and the Borders of Art* (Chicago: University of Chicago Press, 1995); and Sarah Burns, *Inventing the Modern Artist: Art and Culture in Gilded Age America* (New Haven: Yale University Press, 1996).

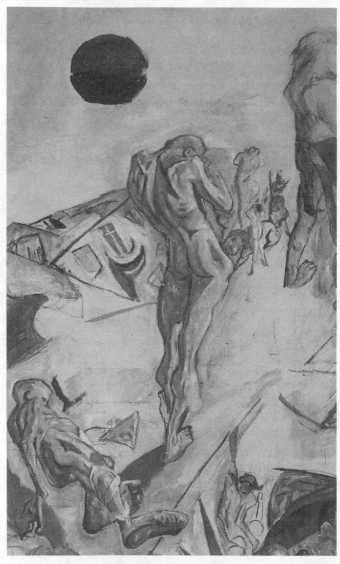

Figure 33. Max Beckmann, *Resurrection*, detail, 1916–1918 (unfinished), oil on canvas, 135 ³/₄ x 195 ²/₃ in. (345 x 197 cm), Staatsgalerie Stuttgart. Permission of Staatsgalerie Stuttgart. Artists Rights Society (ARS), New York.

Figuring Redemption

Christianity and Modernity in Max Beckmann's *Resurrections*[1]

AMY K. HAMLIN

In recent histories of modern art, the German painter Max Beckmann (1884–1950) occupies a divided position. To some social art historians, his figurative style renders him ideologically suspect because it violates the critical values of abstraction that define the modernist idiom in early twentieth-century painting.[2] To art historians who apply biographical, formalist, or iconographic methods, Beckmann's early paintings of biblical themes illustrate his assimilation of Northern Renaissance art, and merely anticipate the triptych format of his mature work. Purged of overt religious references and their historically liturgical function, Beckmann's modern triptychs, such as *Departure* (1932, 1933–35), make mythic allegorical pronouncements about the human condition (Figure 34).[3]

1. This essay is developed from a paper, "Figuring Redemption: Max Beckmann's Resurrections" (Association of Scholars of Christianity in the History of Art symposium, "Why Have There Been No Great Modern Religious Artists?" February 8, 2011). Unless otherwise indicated, translations are the author's.

2. Hal Foster et al. *Art since 1900: Modernism, Antimodernism, Postmodernism*, 2nd ed. (New York: Thames & Hudson, 2011) 1:210–11. See Benjamin H. D. Buchloh, "Figures of Authority, Ciphers of Regression: Notes on the Return of Representation in European Painting," *October* 16 (1981) 39–68.

3. H. H. Arnason and Elizabeth C. Mansfield, *History of Modern Art*, 6th ed. (Upper Saddle River, NJ: Prentice-Hall, 2010) 260–63; and Sam Hunter, John Jacobus, and Daniel Wheeler, *Modern Art: Painting, Sculpture, Architecture, Photography*, 3rd ed. (Upper Saddle River, NJ: Prentice Hall, 2004) 128–29. See also Reinhard Spieler, *Max Beckmann 1884–1950: The Path to Myth*, trans. Charity Scott Stokes (Cologne:

Despite their authoritative tone, these histories afford a tendentious and superficial reading that cannot sufficiently unfold the relationship between Beckmann's idiosyncratic figurative forms and his early obsession with Christian subjects. Consideration must be afforded to Beckmann's "patterns of intention"[4] by examining his fascination with Arthur Schopenhauer's aesthetics and by placing his early religious paintings in the context of the art critical discourse of the time in which they were created. This essay aims to provide a historical understanding of the curious rapport between form and subject in Beckmann's two *Resurrection* paintings, which are both owned by the Staatsgalerie in Stuttgart.[5]

Beckmann's first *Resurrection* (1908–1909), completed in Berlin (Color Plate 21), is a neo-Baroque vision of salvation rendered on the vertical axis. It is a congested picture, whose impressive dimensions—nearly thirteen by eight feet—accommodate the earthbound group of figures clad in contemporary dress that appear rather out of place amidst and beneath the throng of fleshy naked bodies. Seven years later, Beckmann began his second *Resurrection* (1916–18) in his new home in Frankfurt (Figure 35). At eleven by sixteen feet, this *Resurrection* is larger than the first and rendered instead on the horizontal axis to accommodate a more macabre vision of salvation in which a blackened sun presides over a clutch of spectral figures that do not so much inhabit the denuded landscape as haunt it.

Although rarely mentioned, much less illustrated, in modern art histories, these paintings have been the subjects of monographic studies by three Beckmann scholars. Veronika Schroeder and Wolf-Dieter Dube, in their respective essays on the first and second *Resurrections*, claim a place for Beckmann's paintings in the pictorial genealogy of resurrection. Both address to varying degrees the rapport between Beckmann's autobiographical desires and his formal and iconographic innovations in each picture *vis-à-vis* Hans Memling, Michelangelo, El Greco, and Peter Paul Rubens.[6]

Taschen, 2002). Originally published as *Max Beckmann 1884–1950: Der Weg zum Mythos* (Cologne: Taschen, 1994).

4. Michael Baxandall, *Patterns of Intention: On the Historical Explanation of Pictures* (New Haven: Yale University, 1985). Baxandall's method of inferential criticism seems appropriate here because it is able to approach what he called the artist's "cognitive style" as a means of evaluating a historical explanation of a given artwork.

5. Erhard Göpel and Barbara Göpel, *Max Beckmann: Katalog der Gemälde* (Bern: Kornfeld und Cie, 1976) 1:88n104, 131–32n190.

6. Veronika Schroeder, "Max Beckmann—Die Auferstehung von 1908," in *Festschrift für Christian Lenz: Von Duccio bis Beckmann*, eds. Felix Billeter, Helga Gutbrod, and Andrea Pophanken (Frankfurt am Main: Blick in die Welt, 1998) 155–68; and Wolf-Dieter Dube, "On the 'Resurrection,'" in *Max Beckmann: Retrospective*, eds.

Dietrich Schubert, in his concise but ambitious book that explores both paintings, offers a less conventional approach by evaluating the influence of Friedrich Nietzsche's philosophy on Beckmann's engagement with the question of redemption (*Erlösungs-Frage*).[7] Schubert's analysis is unique because it acknowledges Beckmann's religious imagination as a profound source of inspiration and innovation in his art. But Schubert's emphasis on Nietzsche is ultimately misplaced because it fails to reckon also with Beckmann's aesthetic imagination, which cannot be separated from his engagement with the idea of redemption as freedom from suffering. Indeed, this essay argues that Beckmann's familiarity with Schopenhauer's aesthetic philosophy sharpens our understanding of the relationship between expressive form and religious subject matter in the first and second *Resurrection*s.

When Beckmann's library was finally catalogued in 1984, scholars found an annotated copy of the 1902 edition of Schopenhauer's seminal text *The World as Will and Representation*.[8] The annotations are only sporadically dated, which makes it difficult to define a precise connection between Schopenhauer's ideas and Beckmann's art at a given time. But when viewed as circumstantial evidence, the importance of this discovery is undeniable given the Schopenhauerian sensibility of many of Beckmann's statements throughout his career as well as his repeated references to "Schoppi" (as he affectionately referred to him) in his early diaries.[9]

Begun in 1814 and published in December 1818, *The World as Will and Representation* is Schopenhauer's most well known and influential treatise.[10] In it he elucidated his solution to what he believed to be the central question of philosophy, that is, the riddle of existence. His funda-

Carla Schulz-Hoffmann and Judith C. Weiss (St. Louis: Saint Louis Art Museum, 1984) 81–89.

7. Dietrich Schubert, *Max Beckmann: Auferstehung und Erscheinung der Toten* (Worms am Rhein: Wernersche Verlagsgesellschaft, 1985) 1. Nietzsche's *Thus Spoke Zarathustra* figures prominently in Schubert's analysis, especially of the first *Resurrection*; he specifically identifies Beckmann's use of light as a metaphor for salvation and brings the concept of the *Übermensch* to bear on his analysis.

8. Peter Beckmann and Joachim Schaffer, eds., *Die Bibliothek Max Beckmanns* (Worms am Rhein: Wernersche Verlagsgesellschaft, 1992).

9. Max Beckmann, *Self-Portrait in Words: Collected Writings and Statements, 1903–1950*, ed. Barbara Copeland Buenger, trans. Barbara Copeland Buenger and Reinhold Heller (Chicago: University of Chicago Press, 1997).

10. For a lucid introduction to and historical evaluation of Schopenhauer's philosophy, see Patrick Gardiner, *Schopenhauer* (Bristol: Thoemmes, 1963); and Bryan Magee, *The Philosophy of Schopenhauer* (Oxford: Oxford University Press, 1983).

mental wonder about the world was, somewhat paradoxically, based on an understanding of it as a miserable and evil place. To explain how this was so, he neatly identified the principal idea of his book in its title. The world we perceive is a façade, a representation that is supported by an irreducible, universal will that is the source of all suffering.

Beckmann was sympathetic to Schopenhauer's central belief that the individual experiences the world through the many unfulfilled and futile expectations of the will that lead—inexorably—to a life of suffering. According to Schopenhauer, the monastic practice of self-denial known as asceticism offers permanent release from this painful cycle. For less pious folk, however, temporary release can be found in the aesthetic contemplation of the world as representation.

The visual arts, and painting in particular, assume a privileged, if burdened status in Schopenhauer's treatise. In a section devoted to history painting (*Historienmalerei*), examples of which he provides from the Old and New Testaments, he writes:

> For to fix the fleeting world, which is forever <u>transforming itself, in the enduring picture of particular events</u> that nevertheless represent the whole, is an achievement of the art of painting by which it appears to bring time itself to a standstill, since it raises the individual to the Idea of its species.[11]

The paradox of the history painter's craft, according to Schopenhauer and underlined here by Beckmann, requires him to represent the dynamism of specific events in an inherently static medium. What's more, he has an obligation to the individual—whom Schopenhauer refers to elsewhere as the beholder—to elevate the individual out of the world of the will (the world of suffering) and into the world of representation (the transcendent realm of the Platonic Idea). This is where the opportunity for redemption occurs that nonetheless requires still more of the painter. Schopenhauer continues:

> ... only the really artistic view of such [historical] subjects, both in the painter and in the beholder, concerns never the individual

11. Arthur Schopenhauer, *The World as Will and Representation*, trans. E. F. J. Payne (New York: Dover, 1969 [1819]) 1:48, 231. Original text: "Denn die flüchtige Welt, welche sich unaufhörlich <u>umgestaltet, in einzelnen Vorgängen, die doch</u> das Ganze vertreten, <u>festzuhalten im dauernden Bilde</u>, ist eine Leistung der Malerkunst, durch welche sie die Zeit selbst zum Stillstande zu bringen scheint, indem sie das Einzelne zur Idee seiner Gattung erhebt." Beckmann and Schaffer, eds., *Die Bibliothek*, 83 (Beckmann's annotation).

particulars in them, which properly constitute the historical, but
the universal that is expressed in them, namely the Idea.[12]

The vague imperative here to create a "really artistic view" of the subject
and to emphasize the universal over the particular further defines Scho-
penhauer's requirements for redemptive painting. Several binaries that
Schopenhauer establishes in *The World as Will and Representation* help
bring Beckmann's religious and aesthetic imagination into focus.

will (thing in itself)	→	representation (Idea)
suffering	→	salvation
particular	→	universal
nominal meaning	→	*real meaning*
cognition	→	*perception*
sublime (grotesque)	→	*beautiful*

In particular, this essay addresses the italicized binaries with respect to the
Resurrection paintings, starting with the distinction Schopenhauer makes
between the nominal meaning of the picture (*nominale Bedeutung des Bil-
des*) and the real meaning as well as cognition and perception.[13]

Begun in the fall of 1908 and completed in January 1909, Beckmann's
first attempt at the *Resurrection* represents a milestone in his desire to
visualize redemption by means of biblical subjects, not just in terms of
scale but also pictorial ambition. In 1906, 1907, and 1908 he painted, re-
spectively the *Crucifixion* (which he called simply *Drama*), *Adam and Eve*,
and the *Flood*.[14] Even the titles signal Beckmann's ambivalence regarding

12. Schopenhauer, *World as Will*, 232. Original text: "Nur geht die eigentlich
künstlerische Ansicht derselben, sowohl im Maler als im Betrachter, nie auf das indi-
viduell Einzelne in ihnen, was eigentlich das Historische ausmacht, sondern auf das
Allgemeine, das sich darin ausspricht, auf die Idee." Beckmann and Schaffer, eds., *Die
Bibliothek*, 83.

13. Schopenhauer explored these concepts in his discussion of aesthetics in the
third book of *The World as Will and Representation*, which is entitled "The World
as Representation, Second Aspect." These concepts are discussed on the same pages
that Beckmann marked. Schopenhauer writes: "Finally, the historical and outwardly
significant subjects of painting often have the disadvantage that the very thing that is
significant in them cannot be presented in perception, but must be added in thought.
In this respect the nominal significance of the picture must generally be distinguished
from the real." Schopenhauer, *World as Will*, sec. 48, 231. For the original German,
see Arthur Schopenhauer, *Die Welt als Wille und Vorstellung*, 3rd ed. (Leipzig: F. A.
Brockhaus, 1859) 1:273.

14. Göpel and Göpel, *Max Beckmann*, 67n57, 72n67, 84–85n97.

the specific, nominal requirements of his biblical subjects and his interest
in translating a particular biblical passage into an archetype of redemp-
tion. In the *Resurrection*, he eschews specific references to Judgment Day
in the absence of Christ as divine judge. This is a conspicuous deletion
in the history of art that would have been unthinkable to painters such
as Rubens, whose well-known 1617 depiction of the Last Judgment in
Munich's Alte Pinakothek was likely a point of reference for Beckmann.
Rather than create a "tasteless Rubens imitation," as one unsympathetic
critic accused Beckmann of doing,[15] he appears to have been interested in
distilling from Rubens' hierarchical vision the transcendent meaning of
the subject. To borrow Schopenhauer's terms, Beckmann sought to depict
the real meaning, or the *Idea* of redemption, apart from its conventional,
nominal representation.

 Beckmann was an artist not an illustrator; form, not the subject mat-
ter, provided his content. Male and female figures, of comparable size, age
and physique, are subordinated to an evenly applied chiaroscuro.[16] They
congeal and disperse in a flurry of agitated brushstrokes and luminous
pigments in the upper reaches of the canvas. In much of the painting,
the viewer's perception of pure form—as an aesthetic embodiment of the
Idea—works to trump his/her cognitive apprehension of the subject mat-
ter. This was essential for Schopenhauer, who believed that the nominal
subjects of history painting distracted from their real meaning that could
only be comprehended through will-less perception, which is why the
clothed contemporary figures in the bottom third of the composition are
so distracting. Although these figures occupy the same pictorial space as
the others, the specificity of their faces and their clothed bodies detracts
from the anonymous forms of the naked bodies.

 When the painting was exhibited in the 1909 Berlin Secession exhi-
bition, the art critic Ewald Bender saw this as evidence of Beckmann's in-
ability "to narratively master his subject matter."[17] Another critic remarked
how the *Resurrection* displayed an "ingenious flood of color and confident
modeling" of form, but that it ultimately suffered from incongruity.[18] This

15. "Und die 'Auferstehung' dokumentiert sich als eine geschmacklose Rubensimi-
tation." Robert Schmidt, "Die Achtzehnte Ausstellung der Berliner Secession 1909,"
Die Kunst für Alle 24 (1909) 445.

16. Amy K. Hamlin, "Between Form and Subject: Max Beckmann's Critical Recep-
tion and Development, ca.1906–1924," PhD diss., New York University, 2007, 81.

17. "Und vor allem; unsere jungen Maler müßten erst wieder einmal lernen, einen
Stoff erzählerisch zu meistern." Ewald Bender, "Berliner Sezession," *Der Kunstwart* 22
(1909) 301.

18. "Die Vision seliger Reigen über zivilen Menschen, die die Auferstehung

was undoubtedly by design, but to what end? From left to right, Beckmann painted himself, his mother-in-law, his wife Minna in a white dress, his sister-in-law kneeling in the central foreground, and three family friends milling about on the right.[19] These characters figure prominently in Beckmann's diary from the time he worked on the *Resurrection*; his entries tell of dinner parties dominated by conversations about art. They also suggest a sense of boredom and even alienation from bourgeois life. On January 14, 1909, he wrote: "People are lonely in each other's company."[20] This remark is echoed in another critic's observation on the *Resurrection* that "no clear relationships exist between the various people."[21] Bereft of the familiarity that attends genuine social interaction, these contemporary figures awkwardly perform roles in an untitled resurrection play. They are, I would argue, like the intercessors in a renaissance devotional painting. Beckmann was well aware of these figures in the history of art, saintly figures that act as mediators between God and the faithful. In 1904, he visited Colmar (at the time in Germany, not far from the border with France), where he allegedly saw the famous *Isenheim Altarpiece* (c. 1510–1515) by Matthias Grünewald (c. 1470–1528).[22] The central crucifixion scene must have made an impression on Beckmann; the intercessory gestures of the Virgin Mary, Mary Magdalene, and St. John the Baptist seem to anticipate those of Beckmann, his wife, and sister-in-law in the *Resurrection*.

Does this aesthetically paradoxical interpretation of a conventional religious subject suggest an attempt on Beckmann's part to secularize redemption? Or might it constitute a modern spin on a religious idea? Both are potentially valid if we understand modern secularism, as Mark C. Taylor does, as "a *religious* phenomenon, which grows directly out of the Judeo-Christian tradition as it develops in Protestantism."[23] In his book *After God*, Taylor asserts that "to appreciate religion's abiding significance, it is necessary to consider not only its explicit manifestations but also its latent influence on philosophy, literature, [and] art," among

empfinden, leidet an einer Inkongruenz zu voller Akkorde, . . . aber sie enthält eine Körpermalerei von so genialer Flutung der Farben und Sicherheit der Modellierung, daß man an diese nah betrachteten Details alle Hoffnung für den Aufstrebenden zu knüpfen hat." Oscar Bie, "Berliner Sezession," *Die neue Rundschau* 20, no. 2 (1909) 909.

19. Göpel and Göpel, *Max Beckmann*, 88n104.

20. Beckmann, *Self-Portrait in Words*, 101.

21. "Bestehen keine deutlichen Beziehungen zwischen den verschiedenen Menschen." Anna Plehn, "Berliner Sezession," *Sozialistische Monatshefte* 12 (1908) 771.

22. Beckmann, *Self-Portrait in Words*, 72, 341n3.

23. Mark Taylor, *After God* (Chicago: University of Chicago Press, 2007) 2–3.

others.[24] Beckmann was not a believer per se, but he was raised Protestant and in 1906 married into a devoutly Lutheran family; his mother-in-law, in particular, often engaged him in theological conversation.[25] In addition, Beckmann's annotated book collection suggests a keen interest in Schopenhauer's redemptive aesthetics as well as, more generally, Christianity, Gnosticism, Buddhism, and Theosophy.[26] But it is the primary evidence of his paintings that best evince his engagement—both explicit and latent— with religion and modernity.

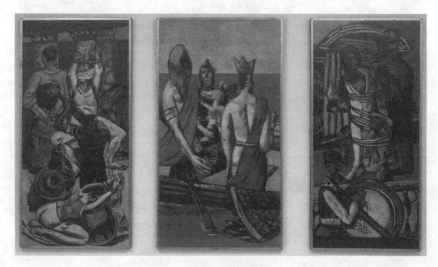

Figure 34. Max Beckmann, *Departure*, Frankfurt 1932, Berlin 1933–35, oil on canvas, side panels 7 ft. ³/₄ in. x 39 ¹/₄ in. (215.3 x 99.7 cm), center panel 7 ft. ³/₄ in. x 45 ³/₈ in. (215.3 x 115.2 cm), the Museum of Modern Art, New York. Permission of the Museum of Modern Art/Licensed by SCALA/Art Resource New York. Artist Rights Society (ARS), New York.

Beckmann embarked on his second *Resurrection* in 1916. At eleven by sixteen feet, it was the largest canvas he ever worked on. It was also the product of an artist changed by war. In August 1914, Beckmann volunteered as a medical orderly in World War One; he served on both Fronts between the fall of 1914 and the early summer of 1915, when he was given

24. Ibid., xiii.

25. Göpel and Göpel, *Max Beckmann*, 143n201; and Friedhelm Wilhelm Fischer, *Der Maler Max Beckmann* (Cologne: DuMont Schauberg, 1972) 9.

26. See Beckmann and Schaffer, eds., *Die Bibliothek*, passim. Also, for an extensive analysis of Beckmann's work through the lens of his metaphysical and spiritual interests, see Margot Orthwein Clark, "Max Beckmann: Sources of Imagery in the Hermetic Tradition," PhD diss., Washington University, 1975.

leave following a nervous collapse.[27] From the Western Front in the spring of 1915, he famously expressed the following in a letter to his wife Minna: "For me the war is a miracle [*ein Wunder*], even if a rather uncomfortable one. My art can gorge itself here."[28] Beckmann closely correlated his war experience with his creative development; as this ambivalent statement suggests, his attitude toward the war, and by extension his art, was both spiritual and conflicted. In another letter, he articulated these impulses and connections more explicitly: "Everywhere I discover deep lines of beauty in the suffering and endurance of this terrible fate. (. . .) The second day of Pentecost is at an end, and the Holy Spirit once again has been poured out over peaceable lands."[29] Three preparatory sketches from 1914 imply that the idea to revisit the theme of resurrection gestated for about two years.[30] And although these were arguably inspired by his time in the trenches, neither the sketches nor the painting can be described as pure reportage.

Compared to Beckmann's first *Resurrection*, a lot has changed, most notably the orientation, but also the style. The high horizon line in this broad, but claustrophobic landscape subordinates the many naked and only partially realized figures that trouble the terrain. The Lazarus figure in the center assumes the titular role of resurrection, but the way in which Beckmann rendered his bodies precludes the promise of everlasting life (Figure 33). This *Resurrection*, as Charles Haxthausen has argued, becomes an anti-resurrection.[31] Dessicated, gaunt and bloodless bodies replace the volumptuous, richly colored figures of the first *Resurrection*.

More grotesque than beautiful, the figures of Beckmann's second *Resurection* invoke another major binary in Schopenhauer's redemptive aesthetics. Beckmann openly disagreed with Schopenhauer's belief that beauty, especially in "the expression of the face and countenance, is pre-eminently the province of painting."[32] In the margins of his copy of *The*

27. For more on Beckmann's experiences in the war, see Barbara Buenger, "Max Beckmann and the First World War," in *The Ideological Crisis of Expressionism*, eds. Rainer Rumold and Otto Karl Werckmeister (Columbia, SC: Camden House, 1990) 236–69; and Charles Haxthausen, "Beckmann and the First World War," in *Max Beckmann: Retrospective*, eds. Carla Schulz-Hoffmann and Judith C. Weiss (St. Louis: Saint Louis Art Museum, 1984) 69–80.

28. Beckmann, *Self-Portrait in Words*, 159.

29. Ibid., 173.

30. Christian Lenz identified the central gesticulating figure in the second sketch as a self-portrait of "the artist as a seer, as a prophet." Christian Lenz and Thomas Döring, *Max Beckmann: Selbstbildnisse* (Heidelberg: Braus, 2000) 121–23.

31. Haxthausen, "Beckmann," 78.

32. Schopenhauer, *World as Will*, sec. 52, 226.

World as Will and Representation, Beckmann countered: "Poor Schoppi
. . . there are in fact two Ideas: one that tends toward absolute beauty and
the other toward the grotesque."[33] In the second *Resurrection*, and in a
way that anticipates a trend in postmodern aesthetics, Beckmann seems
to suggest that the grotesque offers another path to redemption that para-
doxically recognizes chaos and suffering as its chief condition.[34] In a diary
he kept on the Western Front, Beckmann described the aftermath of a
trench battle on June 8, 1915: "Everything in disorder. Staggering shad-
ows. Majestically rose and ash-colored limbs with the dirty white of the
bandages and the somber, heavy expression of suffering."[35] Ultimately,
however, it is upon the evidence of the painting that a more persuasive
case can be built. There is in Beckmann's new style a "formal asceticism"
that is quite consistent with Schopenhauer's redemptive aesthetics. In the
austerity and almost elegant simplicity of Beckmann's new linear style, es-
pecially when compared to the formal sensuality of his pre-war canvases,
he visualizes Schopenhauer's argument that a lasting redemption can be
found in a complete retreat from painful desires generated by the will.

An apposite characterization of Beckmann's new style, the phrase
"formal asceticism" (*formale Askese*) was invented by none other than
Gustav Hartlaub, who is well known for coining the term New Objectiv-
ity (*Neue Sachlichkeit*) in 1923. During the war, Hartlaub was the Deputy
Director of the Kunsthalle Mannheim and in that capacity visited Beck-
mann's Frankfurt studio in September 1918.[36] Several paintings made a
deep and lasting impression on Hartlaub, namely the incomplete *Resur-
rection* as well as a triumvirate of easel paintings—*Descent from the Cross*,
Adam and Eve, and *Christ and the Adulteress*—that were all three com-
pleted in 1917.[37]

Hartlaub discussed them in his 1919 book entitled *Art and Religion:
An Essay on the Possibility of a New Religious Art* (*Kunst und Religion: Ein
Versuch über die Möglichkeit neuer religiöser Kunst*), which grew out of his

33. "Armer Schoppi . . . Es giebt eben 2 Ideen eine die zur absoluten Schönheit
neigt und die Groteske andere." Beckmann and Schaffer, eds., *Die Bibliothek*, 82.

34. See Leo Bersani, *Culture of Redemption* (Cambridge, MA: Harvard University
Press, 1990).

35. Beckmann, *Self-Portrait in Words*, 175–76.

36. For an intelligent discussion of Hartlaub's visit to Beckmann's studio, see Karo-
line Hille, *Spuren der Moderne: Die Mannheimer Kunsthalle von 1918 bis 1933* (Berlin:
Akademie, 1994) 240–43.

37. Göpel and Göpel, *Max Beckmann*, 133–34n192, 137–38n196, 138–39n197.

1918 exhibition on "New Religious Art," [38] Hartlaub described his impression of Beckmann's Christian pictures in this way:

> It is apparent here how this austere formal asceticism, this discipline to which the artist may have subjected himself in response to his wartime impressions and which taught him to condense a powerfully abundant fantasy into a few, terse figurative formulas, has now already borne fruit. [39]

Hartlaub goes on to applaud Beckmann for abandoning his formal allegiances to the Impressionist "international language" in favor of the Germanic sensibility found in the Medieval art of Hans Baldung and Veit Stoß. Beckmann's new style here assumes the status of an agent, a sort of disciplinarian that imposes a clarifying order on its subjects. Hartlaub suggests that in Beckmann's ostensibly Christian paintings, the literary motifs are powerfully subordinated to "the form of an immense eschatological symbol" [*die Gestaltung des ungeheuren eschatologischen Symbols*]. [40] In Schopenhauer's terms, the nominal meanings of the canvases are subordinated to the real through Beckmann's new formal language. Hartlaub articulates this aesthetic relationship generally in *Art and Religion* at the beginning of the second chapter entitled "Foundations of Religious Art," wherein he writes:

38. Hartlaub not only discussed Beckmann's paintings in the book, he also illustrated *Descent from the Cross*, *Christ and the Adulteress* as well as the second *Resurrection*. Other artists he discussed and whose works were illustrated in the book include Erich Heckel, Oskar Kokoschka, Paula Modersohn, Emil Nolde, Max Pechstein, and Karl Schmidt-Rottluff. These same artists were also represented in his 1918 exhibition, "Neue Religiöse Kunst," that took place at the Kunsthalle Mannheim between January and February 1918. In this well-attended show, Hartlaub demonstrated what he believed to be the fundamentally spiritual impulse of expressionism, amplified by the war and practiced by a younger generation of artists. He placed more emphasis, however, on the "primitive" style of these artists than on their religious, frequently biblical, subject matter. For an extensive and insightful account of this exhibition, from its genesis to its critical reception, as well as the 1919 book *Kunst und Religion*, see Hille, *Spuren die Moderne*, 22–81.

39. "Es zeigt sich hier, welche Früchte diese opfervolle formale Askese, diese Disziplinierung, der sich der Künstler wohl unter den Eindrücken des Krieges unterworfen haben mag und die ihn einen gewaltigen Phantasiereichtum auf wenige knappe figürliche Formeln zusammendrängen lehrte, bereits heute gezeitigt hat." Gustav Hartlaub, *Kunst und Religion: Ein Versuch über die Möglichkeit neuer religiöser Kunst* (Leipzig: Wolff, 1919) 84. I would like to thank Charles Haxthausen for his assistance with this translation.

40. Ibid.

> A "religious work of art," which underlies our analysis as a pre-
> supposition, must possess both religious and aesthetic value. All
> that the true artist wants to express must have become form, a
> clearly designed symbol, not merely an emblem of meaning–the
> "literary"–that evokes, in this case, religious associations. There-
> fore the religious feeling as such must be able to enter into the
> "form" . . . in the forms and colors of sculpture and painting.[41]

In other words, religious content emerges organically through the sensual, formal properties of the artwork creating meaning that is autochthonous to form.

This decidedly modern and indeed formalist aesthetic theory infused the art critical discourse in Germany at the time and was one that Beckmann was sympathetic to, as his engagement with Schopenhauer suggests.[42] And although Beckmann declined to participate in Hartlaub's "New Religious Art" exhibition in 1918,[43] he expressed enthusiasm for the project, observing that it was "not only excellent but also in many ways contiguous with the most essential and urgent questions of our time."[44]

Perhaps not surprisingly then, given the way in which this formalist aesthetic mandate shaped Hartlaub's discussion of modern art and religion, Beckmann left the second *Resurrection* unfinished in 1918 and thereafter abandoned in his art Christian subject matter on this scale and of this ambition. It would seem that he was at last able to master—by formal means—his subject matter as Ewald Bender had exhorted him to in 1909.

41. "Ein 'religiöses Kunstwerk,' wie wir es als ein Postulat unseren Untersuchungen zugrunde legen, muß beides, religiösen und ästhetischen Wert besitzen. Alles, was der echte Künstler zum Ausdruck bringen will, muß Form, sinnfällig gestaltetes Symbol geworden sein, nicht bloßes Bedeutungszeichen, das 'literarische,' in diesem Falle religiöse Assoziationen hervorruft. Somit müßte also auch das religiöse Gefühl als solches in die 'Form' eingehen können . . . in die Formen und Farben der Plastik und Malerei." Ibid., 26.

42. With respect to how this shaped Beckmann's early work, I refer the reader to my dissertation: Hamlin, "Between Form and Subject," 31–76.

43. Citing his desire to reach a particular goal in his art, Beckmann declined Hartlaub's repeated and impassioned invitations to participate in the exhibition. See especially Beckmann to Hartlaub, received on September 3, 1917. This handwritten letter is reproduced, partially transcribed, and discussed in Hille, *Spuren der Moderne*, 234–35, 374n53.

44. "Nicht nur ausgezeichnet sondern in vielen Punkten die wesentlichsten und dringensten Fragen unserer Zeit berührend." Beckmann to Hartlaub, August 31, 1917, quoted in Hille, *Spuren der Moderne*, 234.

A traditional approach to Beckmann's oeuvre might well treat the second *Resurrection* as a failure owing to its incomplete state and iconographic idiosyncrasies. But it is worth noting that he kept the ambitious picture—with the painted side facing out—in his Frankfurt studio for some time, as a kind of talisman not despite but rather because of its fragmented state.[45] Its most immediate and successful progeny affords an instructive coda to the methodological object lesson that this analysis of the two *Resurrections* offers.

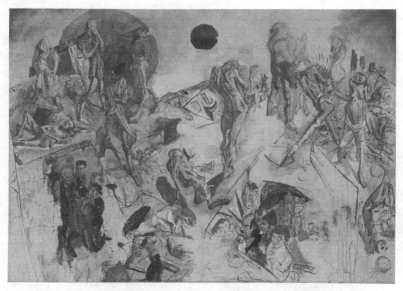

Figure 35. Max Beckmann, *Resurrection*, 1916–1918 (unfinished), oil on canvas, 135 ³/₄ x 195 ²/₃ in. (345 x 197cm), Staatsgalerie Stuttgart. Permission of Staatsgalerie Stuttgart. Artists Rights Society (ARS), New York.

Night, begun in mid-1918 and completed in early 1919, is in many respects a fully realized eschatological symbol (Figure 36).[46] It nonetheless relies on a powerfully ambiguous narrative arc, however novel and prosaic compared to the borrowed rhetoric of the *Book of Revelation* in the second *Resurrection*. In this painting, the lean forms and ashen palette

45. In 1933, when Nazi officials dismissed him from his teaching post at the Städel art school in Frankfurt, he rolled up the painting and took it, along with his other belongings, to Berlin. Adolf Hitler's public diatribe against modern art on July 18, 1937, and the opening the next day of the "Degenerate Art" exhibition that featured nearly a dozen of Beckmann's paintings prompted the artist to leave Germany for good. The second *Resurrection* accompanied him into exile in Amsterdam and then, after World War II, on to St. Louis, Missouri. Göpel and Göpel, *Max Beckmann*, 131–32.

46. Ibid., 140–42n200.

of Beckmann's new style embodies what Hartlaub might have referred to as a religious feeling inasmuch as it attempts to elevate suffering as a human condition. Paul Ferdinand Schmidt, an art critic for the journal *Der Cicerone*, would have agreed. He wrote a favorable review of Beckmann's first postwar exhibition in Frankfurt in June 1919, asserting that "a seamless network of things living and dead pervades the surface [of *Night*], and the chaos is crystallized into a perfect symbol. [. . .] We look through the atrocity of this event as through the Veil of Maya and into the tragedy of life itself."[47] Eduard von Bendemann, however, was not so unequivocal about the painting's religious and aesthetic status as Schmidt's Schopenhauerian interpretation suggests. The art critic for the *Frankfurter Zeitung* at the time, Bendemann was the first to pen a review of the exhibition and had this to say of *Night*:

> Also the subject matter of *Night*, for example, speaks so strongly [of] the gruesome attack on a family by a deadly mob as a symbol of the horror of our time. But it is never given to mere literary illustration that requires commentary. Rather it has assumed a readily intelligible figurative form.[48]

Bendemann's apparent uncertainty over the powerful role of the painting's subject underscores the aesthetic intractability of Beckmann's continued reliance on vaguely discernable subject matter even as his figurative style grew more robust and confident.

In conclusion, Beckmann's second *Resurrection*, even more than its predecessor and progeny, may be read as a deeply ambivalent painting, not because of its austere figurative style, but rather its putative subject. As a historical explanation, this claim elicits an alternative approach to the ideological understanding of modern figurative art in general and Beckmann's *Resurrection*s in particular. It posits a rejoinder to Benjamin

47. "Die Fläche wird von einen lückenlosen Netz lebender und toter Dinge erfüllt, und das Chaos kristallisiert sich zu einem vollkommenen Symbol . . . Wir blicken durch das Grauenhafte des Vorgangs wie durch den Schleier der Maja in die Tragik des Lebens selber." Paul Ferdinand Schmidt, "Max Beckmann," *Der Cicerone* 11, no. 21 (1919) 683.

48. "Aber so stark auch das Gegenständliche zum Beispiel in der 'Nacht' spricht— der grausige Überfall einer Familie durch ein Mordbande als Symbol des Entsetzens unserer Zeit—niemals wird es als bloß literarische Illustration, die eines Kommentars bedarf, gegeben, sondern stets hat es unmittelbar fassliche bildliche Gestalt angenommen." Eduard von Bendemann, "Die neue Kunst," (Ausstellung der "Vereinigung für neue Kunst" in *den Räumen des Frankfurter Kunstvereins) Frankfurter Zeitung*, June 1, 1917.

Buchloh's characterization of Beckmann's representational paintings as "ciphers of regression."[49] It might be more historically accurate, if needlessly pejorative, to describe Beckmann's religious subjects—as opposed to his style—in this way. A more conciliatory turn of phrase could in this respect account for the artist's obsession with these subjects as ciphers of *redemption* insofar as they plied him with a rhetorically inconsequential means of developing a thoroughly modern figurative language that could symbolize the sort of freedom from the will that Schopenhauer advocated. Ultimately, the unfinished *Resurrection* harbored for Beckmann the promise of creation amidst the profound suffering in the artist's life and in the world at large. It claimed a place in his life that is echoed in a statement he made in his diary on May 2, 1941, shortly after completing his fourth triptych entitled *Perseus*. He wrote simply: "Creation is redemption."[50]

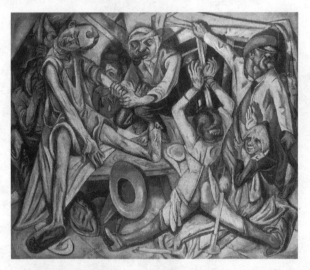

Figure 36. Max Beckmann, *Night*, 1918–1919, oil on canvas, 52 $^3/_4$ x 50 $^5/_8$ in. (133 x 154 cm), Kunstsammlung Nordrhein-Westfalen, Düsseldorf. Permission of Kunstsammlung Nordrhein-Westfalen, Düsseldorf © 2012. Artists Rights Society (ARS), New York.

49. Buchloh, "Figures of Authority," 53.
50. Quoted in Spieler, *Max Beckmann*, 115.

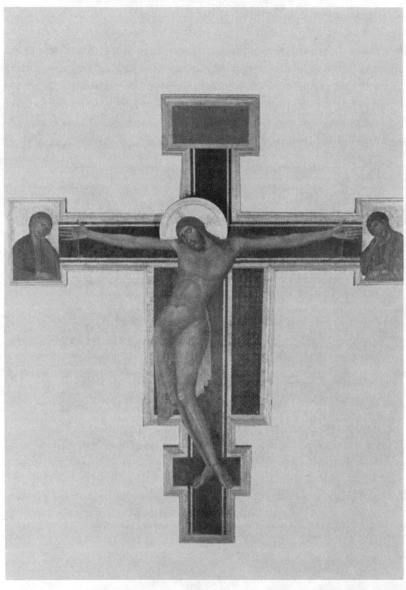

Figure 37. Giovanni Cimabue, *Crucifix*, c. 1287–8, tempera on panel,
1763/8 x 1531/2 in (448 x 390 cm), Santa Croce, Florence. Permission of
Bridgeman Art Library.

Embodiment as Sacrament

Francis Bacon's Postwar Horror[1]

RINA ARYA

The power of Francis Bacon's (1909–1992) art lies, in part, in the contradictory range of responses that it evokes. Some viewers experience his paintings as energetic and uplifting; others react to the despondent and annihilating qualities of Bacon's oeuvre. This polarization of expression is encapsulated in an oxymoron that Bacon coined: "exhilarated sense of despair."[2] Unpacking this phrase further we see that the extremes need not only be viewed as contradictory but also as part of his sensibility. The despair may characterize Bacon's observation of his historical environment. He lived through violent times, including the two World Wars and the unrest in Ireland during the early part of the twentieth century. The exhilaration refers to Bacon's own personal attitude of transcending the despair, of overcoming the violence in life to embrace the sentience of the human body. One of Bacon's common refrains was "we are meat, we are potential carcasses."[3] He rejected belief in God and was vehemently atheistic. In the absence of God humanity cannot be conceived of as being created in

1. This essay is developed from a paper, "The A-theology of Francis Bacon" (Association of Scholars of Christianity in the History of Art symposium, "Why Have There Been No Great Modern Religious Artists?" February 8, 2011). For an extended study of the topic see the author's book *Francis Bacon: Painting in a Godless World* (Farnham: Lund Humphries, 2012).

2. David Sylvester, *The Brutality of Fact: Interviews with Francis Bacon* (London: Thames and Hudson, 1993) 83.

3. Ibid., 64.

imago dei or as creatures bound to an eschatology. The only truth is that of the biological reality of the human—we are born and we die.

Bacon's art boldly addresses the consequences that the eclipse of God has on the human condition. One reading of Bacon's art is to view it as an embrace of nihilism. Matthew Gale and Chris Stephens note, "In a world without God, humans are no different to any other animal, subject to the same innate urges; transient and alone, they are victims and perpetrators of meaningless acts."[4] A polar sentiment is conveyed by the possible consequences of nihilism. In the absence of purpose in life, uncertainty emerges about what happens after death, and the feelings of futility that this might generate, Bacon speaks of the importance of making life special. He says, "I think of life as meaningless; but we give it meaning during our own existence. We create certain attitudes which give it a meaning while we exist, though they in themselves are meaningless really."[5] And elsewhere makes a similar comment, "we are born and we die, but in between we give this purposeless existence a meaning by our drives."[6] It is precisely the meaninglessness of life that is the spur to making life meaningful or extraordinary. This essay argues that Bacon revealed the extraordinary in the ordinary and the sacred in the profane. In his art, Bacon confronted the ordinariness of life, the alienation of human relationships, and the existential despair in the face of nothingness. In doing so, he reinforces the sacredness of human life though the living body.

Friedrich Nietzsche's proposal of the death of God in his 1882 *The Gay Science* is celebrated as an extended expression of the significance and ramification of this notion. This passage tells the story of the madman who runs into the marketplace announcing the death of God—"God is dead, and we have killed him."[7] Through the guise of the madman, Nietzsche alerts people to the realization that "belief in the Christian God has become untenable in modern Western society."[8] Nietzsche argued that the bases on which Western culture was laid, namely the belief in the Christian God and morality, were discredited and needed to be eliminated. Bacon paints a visual analogue to Nietzsche's death of God. In Nietzsche's

4. Matthew Gale and Chris Stephens, *Francis Bacon* (London: Tate, 2008) 27.

5. Sylvester, *Brutality*, 133.

6. Ibid., 134.

7. Friedrich Nietzsche, *The Gay Science*, trans. Walter Kaufmann (New York: Random House, 1974 [1882]) 182.

8. Alister McGrath, *The Twilight of Atheism: The Rise and Fall of Disbelief in the Modern World* (London: Doubleday, 2004) 149.

description of the passage of the madman, God's death is conveyed as a physical death. We hear the sound of the gravediggers and smell the rotting flesh. In Bacon's art, God's absence was not a mere disappearance; he showed the effects of the absence in a conceit that can be described as an absent presence. The Godless world is evidenced in the bleak and fragile figures who populate Bacon's canvases, from the three monsters that sit and gnarl at the foot of the Cross in *Three Studies for Figures at the Base of a Crucifixion* and the popes who scream in the face of the death of their office.

In spite of his professed atheism, Francis Bacon's oeuvre is marked by a continued, even obsessive, preoccupation with the sacred. His art represents both a continuity with and opposition to the history of Christianity and the visual arts. The cardinal purpose of Christian art was to operate symbolically, devotionally, and narratively in order to communicate the truths of the Bible. However, the history of Western art has been premised on a Judeo-Christian legacy, hence the centrality of sacred subject matter for centuries. Given the presence of Christianity in the past two-thousand years of European art, it is not surprising that many of the key influences on Bacon's imagination were drawn from that reservoir. Furthermore, it was not only in the visual arts that Christian themes and motifs predominated. Indeed in other fields, such as literature and poetry, the Bible presented a wealth of images and ideas. In being drawn to certain literary texts, such as T. S. Eliot's 1922 *The Wasteland*, which Bacon was known to have read, he was engaging with Christian notions in the text.

Bacon often described his use of sacred symbols in terms of their non-religious significance, such as their formal qualities or by the evocations or resonances of their symbols. However, Bacon's dismissal of the significance of these sacred motifs is belied by the frequency with which they appear in his oeuvre. Bacon was specifically propelled toward two archetypal symbols of Christianity: the crucifixion and the pope. Bacon became fixated on these two symbols and repeatedly returned to them. Bacon's attraction to these symbols was multifaceted. He was drawn to the formal qualities offered by the symbols as well as to the symbolic associations. He would employ the suggestive power of these symbols but then distort them to his own ends.

Bacon's engagement with the crucifixion of Jesus Christ as a visual motif of human suffering was aroused by two works of art in particular. The first of these was *Crucifix* (1287–8) by Cimabue (Figure 37), which Bacon saw in Florence before it was destroyed, and described as "one of

the most marvelous Crucifixions that I have ever seen."[9] However, the *Isenheim Altarpiece* (c. 1510–1515) by Matthias Grünewald (c. 1470–1528) was arguably one of the most influential works on Bacon's imagination. For Bacon, the *Isenheim Altarpiece* epitomized the height of suffering and intensity and was deeply cathartic. He told Peter Beard how, through the process of viewing, "people came out as though purged into happiness into a fuller reality of existence."[10] This corresponded to Bacon's own formulation of great tragic art, which was meant to communicate to the masses and be able to lift people up into a fuller reality of life.

In responding to Cimabue's crucifix and Grünewald's altarpiece, Bacon claimed to be less influenced by the hallowed aspects of the paintings than he was by the formalistic attributes or the more general ideas about humanity that were generated by the paintings. In Cimabue's *Crucifix*, for example, he was drawn to the undulating shape of the figure on the cross and likened it to a "worm crawling down the Cross," which he would attempt to replicate in *Three Studies for a Crucifixion* (1962).[11] The influence of Grünewald's *Isenheim Altarpiece* was more long-standing, and throughout his oeuvre Bacon aimed to capture the grand horror depicted in the Gothic masterpiece.

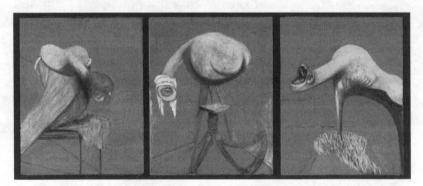

Figure 38. Francis Bacon, *Three Studies for Figures at the Base of a Crucifixion*, c. 1944, oil on board, 37 x 29 in (94 x 73.7 cm) each, Tate, London.
Permission of TATE Images.

9. Michel Archimbaud, *Francis Bacon: In Conversation with Michel Archimbaud* (London: Phaidon, 1993) 36.

10. Henry Geldzahler, *Francis Bacon, Recent Paintings 1968–1974: March 20– June 29, 1975* (New York: Metropolitan Museum of Art, 1975) 16.

11. Sylvester, *Brutality*, 14.

Bacon's artistic engagement with the motif of the crucifixion spanned his entire oeuvre. In fact, three of his first paintings, all painted in 1933, were of crucifixions. When Bacon returned to painting in 1944 he also returned to this motif, creating his seminal work on this subject, the triptych *Three Studies for Figures at the Base of a Crucifixion* (Figure 38). In 1950, Bacon painted *Fragment of the Crucifixion* and in the 1960s Bacon painted two other crucifixion triptychs. In 1988, Bacon painted a second version of his 1944 triptych. Therefore, it cannot be said that the crucifixion was a motif of momentary or passing interest for Bacon. The crucifixion motif visually and conceptually framed Bacon's art. Even when the crucifixion was not explicitly depicted in Bacon's paintings, its implicit presence was often suggested in a work's title or in the ensuing minatory mood of a painting.

In many of his works, Bacon disassociated the crucifixion from the historical narrative of the passion of Christ. Bacon used the crucifixion as an armature or vehicle to explore anthropological and sociological issues about human behavior such as the prevalence of animal instincts in the human and the relationship between predator and prey. Bacon told David Sylvester how he felt that the crucifixion is "a magnificent armature on which you can hang all types of feeling and sensation," adding that he had not "found another subject so far that has been as helpful for covering certain areas of human feeling and behavior."[12] In his unique interpretation Bacon conflated the crucifixion with the abattoir, particularly in the crucifixion triptychs of 1962 and 1965 respectively, where we see an animal being hung upside down in the guise of a crucified victim. What makes Bacon's representations more radical is that he treated human flesh like animal carcasses and in so doing he humanizes the body by exposing its naturalism. The art historical references, such as Cimabue's *Crucifix* become distorted in his studies. Bacon did not enhance the original by acceding to the aims and intentions that the original artists had. He transformed Cimabue's representation that emphasized Christ's nobility in suffering through the natural sinuous curves of Christ's body to a representation where the Christ figure undecorously slides down a waste chute in the right-hand panel of *Three Studies for a Crucifixion*.

At the same time, Bacon reinvested the crucifixion with contemporary meaning. Many of Bacon's crucifixions have more in common with the paintings of animal carcasses by Rembrandt van Rijn and Chaïm Soutine than they do with conventional, often sentimental, depictions of

12. Ibid., 44.

Christ on the cross. Bacon took the symbol of the crucifixion, which had become sanitized and made banal in its overuse in the history of Western art and restored it to its original effect in the context of an instrument of torture. In that respect he evoked a pre-Christian, Roman, use of the crucifixion as a symbol unbridled violence. The violence and brutality of the crucifixion can be traced back to the Christian context, where we witness the enormity of the sacrifice that Christ made to save mankind.

Bacon's representations of the pope, screaming and disintegrating, continue to be among his most celebrated works. These works took as their point of origin Diego Velázquez's *Portrait of Pope Innocent X* (1650), which he never saw in the original but which he nonetheless singled out as one of the greatest portraits in Western art.[13] As with his engagement with the motif of the crucifixion, Bacon's representations of the pope were a recurring subject in his art. Bacon painted papal series in 1951, 1953, and 1961. These works, such as his seminal *Study after Velázquez's Portrait of Innocent X* (1953), featured the pope in various states of psychological disintegration (Color Plate 22).

In his explorations of the pope, who is one of the most venerated figures in the history of art, Bacon examined the significance of a reverential figure in the context of the death of God. Instead of celebrating the pope's ecclesiastical and governmental power, Bacon ravaged the image of the pope, exposing his vulnerability in the face of such power. He was drawn to papal portraits in the history of Western art (Color Plate 23), such as Titian's *Portrait of Pope III* (1543) and Velázquez's *Portrait of Innocent X* (1953), examples which conveyed the pope as an authority in a way that had not previously been done by artists such as Raphael, who depicted the Pope Leo X as a scholar. Interestingly, Bacon specifically, either consciously or unconsciously, drew on representations of the pope developed by artists such as Titian and Velázquez during a period of the Catholic Church history in which the authority of the papacy had been challenged by Protestantism, including the secession of the Church of England from Rome in 1534. From this history of Christianity and the visual arts, Bacon adopted some of the pictorial conventions of the Grand Manner in his papal depictions, such as the papal robes and throne but subverts the most important feature—the authority of the position of the pope.

Bacon's representations of the popes resemble the pontiff insofar as they are clad in papal attire and are seated on the papal throne. But they are very unlike the pope because of the screams or cries that they emit.

13. Ibid., 38.

This is a radical aesthetic and symbolic distortion of how we would expect the pope to look, behave and signify. The pope was conventionally painted in regalia and was presented in terms of his symbolic power. Bacon took the unusual step of bifurcating the identity of pope, exposing the complexity of his identity as both the head of the Roman Catholic Church and a human being. Thus Bacon succeeds in rehabilitating the uniqueness of the pope by exposing his elevated status.

In his recovery of the sacred, Bacon appealed to the repositories of significance that these two motifs signified and then distorted them to convey the contemporaneous significance of Christian symbols in a post-Christian culture. The crucifixion becomes less about the specific theological event of Christ dying on the cross to save the sins of humankind and more about violence and death. Similarly, the papal images are not about the pope *per se* but about the downfall of an iconic figure, or the scream that deforms the mouth or, combining the two readings, the scream that conveys the demise of the pope's authority *ex cathedra*. In the wake of the death of God, the pope screams into the abyss.

The recovery of Christian themes and motifs in Bacon's art presents complex methodological problems for viewers and scholars alike. Many scholarly discussions of Bacon's life and art have explored certain themes including his eclectic use of source material, his working practices, the level of violence in his work, and his unrelenting obsession with the human form. However, the sacramental aspects or dimensions of his art has been an area of continued neglect in Bacon studies. Bacon himself was, in part, responsible for this. He was questioned about his religious beliefs in interviews because of the preponderance of Christian symbols in his work. He also drew attention to religion by referencing it explicitly in many of his titles. However, Bacon espoused atheism and denied that his employment of these Christian symbols was motivated by any spiritual intentions. This halted further discussions on the subject of religion in interviews and his definitive statements and dogmatic views on religion closed conversations rather than encouraging dialogue. Bacon's own unequivocally atheistic stance was one of the reasons that many critics do not pursue the subject of religion in his art. These critics willingly acknowledge the plethora of Christian motifs in Bacon's work, but downplay the sacramental aspects by acknowledging that Bacon was a very visually and culturally attuned artist who responded to the post-war times that he lived in by employing myths and symbols that resonated with him.

Francis Bacon explored the pertinence of Christian motifs in a postwar cultural context where belief in God was not universally shared.

Bacon's contribution to the history of Christianity and the visual arts includes a paradoxical use of Christian motifs that raises interesting questions and challenges to the field of art history. Before the twentieth century, religious motifs were most often employed as means through which theological claims could be visually and materially articulated. In the history of Christian art, the aesthetic was not necessarily regarded as ancillary to the symbolism but it was, to a greater or lesser extent, bound to the theological message. By separating distinctly religious motifs from their historically held symbolism and making it possible to interpret their significance with recourse to disciplines beyond theology, such as anthropology and sociology, Bacon problematised a basic assumption that shaped the art historical discourse, namely the connection between religious motif and sacred meaning. Rather than allowing the scholar to assume a fixed relationship between motif and meaning, Bacon's art demonstrates that this connection is always contextualized.

Scholarship on the sacred aspects of Bacon's work has been sparse and has generally limited in focus to particular areas of interest, such as his use of a specific symbol. Hugh Davies has written about Bacon's popes and curated the exhibition *Francis Bacon: The Papal Portraits of 1953* for the Museum of Contemporary Art, San Diego.[14] Wilson Yates concentrated on the imagery of the crucifixion and the violence of humanity in his papers, "The Real Presence of Evil: Francis Bacon's Three Studies for Figures at the Base of a Crucifixion" and "Francis Bacon: The Iconography of Crucifixion."[15]

Michael Peppiatt has been the most discursive about the pertinence of sacred themes in Bacon's art. Peppiatt discussed the Christian subjects of the crucifixions and the popes in his 1997 biography of Bacon, cryptically titled *Francis Bacon: Anatomy of an Enigma*, and in 2004 curated an exhibition entitled *Francis Bacon: The Sacred and the Profane* for the Institut *Valencia* d'Art Modern, which then continued at the Musée Maillol in Paris. In *Francis Bacon: Anatomy of an Enigma*, Peppiatt describes how Bacon is propelled to the structures of belief as if drawn by "a fetishistic force" that pulled him back as "if he had to make a belief out of his

14. Hugh Davies, *Francis Bacon: The Papal Portraits of 1953* (San Diego: Museum of Contemporary Art, 2001).

15. Wilson Yates, "The Real Presence of Evil: Francis Bacon's Three Studies for Figures at the Base of a Crucifixion," *ARTS* 8, no. 3 (1996) 20–26; and Wilson Yates, "Francis Bacon: The Iconography of Crucifixion," in *The Grotesque in Art and Literature: Theological Reflections*, eds. James Luther Adams and Wilson Yates (Grand Rapids: Eerdmans, 1997) 143–91.

non-belief."[16] Bacon is not content with delineating the death of God but takes it a step further to demonstrate why belief is not possible. The three monsters in *Three Studies for Figures at the Base of a Crucifixion* bear testimony to the impossibility of belief. Bacon was showing the effects of the "religious hangover" that Nietzsche referred to, not in the sense of missing the comfort that faith provided but more in the employment of the symbols that enabled him to convey his lack of belief.[17]

Acknowledging the forthrightness of Bacon's atheist claims does not mean that his personal beliefs, or disbeliefs, should overshadow readings of his art. Bacon was not a religious person but his art is engaged with religion in multiple respects. He was influenced by a number of Christian paintings from art history that he used recurrently as triggers in the formulation of his images. The most explicit sense of sacramental dialogue is through his employment of Christian symbols. Bacon's persistent reflections on the human condition—the suffering body, the presence of evil, and death—are perennial themes of the history of Christianity and the visual arts that take us to the core of being.

Bacon's figures are doomed; they are alone, many are in the grip of despair or are left contemplating the abyss. It is easy to see how many would conclude that Bacon's art was nihilistic. His view of the human condition is dark and bleak, and has been compared to the worldviews of writers such as Franz Kafka and Samuel Beckett. However, the lack of ultimate significance in life does not mean that life has no value but only that meaning is contingent. The lack of ultimate meaning is precisely the reason to make life extraordinary, which Bacon argued that we do in the creation of experiences and activities that are significant to us: "I think of life as meaningless; but we give it meaning during our own existence. We create certain attitudes which give it a meaning while we exist, though they in themselves are meaninglessness really."[18]

On one level of his practice his work is profane and ordinary. His paintings are of figures (some anonymous, others known to him) that are located in impersonal and stark interiors that resemble hotel rooms. In spite of this ordinariness the figures exude an incandescence that is anything but profane. Bacon began with the profane, or rather uses the

16. Michael Peppiatt, *Francis Bacon: Anatomy of an Enigma* (London: Phoenix, 1997) 141.

17. Michael Peppiatt, "Three Interviews with Francis Bacon," in *Francis Bacon: A Retrospective,* ed. Dennis Farr, 38–50 (New York: Abrams, 1999) 41.

18. Sylvester, *Brutality,* 133.

profane in order to articulate a sense of the sacred, which is seen in his transformation from a static representation to a distorted representation of the lived presence. Starting with the photographic image, Bacon embarked on a process of deconstruction that involved distorting the likeness of the image until he attained something that conveys the reality of the person as they are in their living form. Bacon described what he aims to achieve:

> There is the appearance and there is the energy within the appearance. And that is an extremely difficult thing to trap. Of course, a person's appearance is closely linked with their energy. So that, when you are in the street and in the distance you see somebody you know, you can tell who they are just by the way they walk and by the way they move. But I don't know whether it would be possible to do a portrait of somebody just by making a gesture of them. So far it seems that if you are doing a portrait you have to record the face. But with their face you have to try and trap the energy that emanates from them.[19]

What Bacon strove to convey were the non-tangible forces that people exude in the mannerisms, gaits, and other characteristics that are unique to each individual and that capture their physical presence. Bacon's incorporation of this "anima" quality separates the artificial representation of persons from their physical reality. The emanations and energy that Bacon sought to capture cannot be configured in positive terms but can be conveyed by a comparison between a photograph of an individual and the experience of a face-to-face encounter with that person. We experience this not as physical manifestations but as a lived reality. So we are aware of the appearances but are unable to separate them from the person. Bacon conveyed this vitality in his distortion, where the painting gives a sense of the sentient being, the embodied presence or "living quality."[20] Leiris describes this level of intimacy as "the real presence."[21] By real presence Leiris is suggesting that the figure exerts itself forcefully and has a "heightened sense of presence" through which we gain direct access to flesh and blood reality. The real presence is a phrase that is used in eucharistic theology as "an expression used to cover several doctrines emphasizing the actual presence of the body and blood of Christ in the Holy

19. Ibid., 175.

20. Ibid., 173.

21. Michel Leiris, *Francis Bacon: Full Face and in Profile*, trans. John Weightman (Barcelona: Polígrafa, S. A., 1987) 2.

Sacrament, as contrasted with others that maintain that they are present only figuratively."[22] Although Leiris denied that his application of the term had any connection with theology, I think that the crossover between the two ideas is too important to overlook.[23] The theological understanding is that we encounter the actual and not simply the symbolic in the ritual. In Bacon's art, we come face to face with an image that expresses the presence of the person as opposed to their mere representation. It is inaccurate to say that we actually experience the reality of the person because we are still confronting a painting. However, we come as close to the flesh-and-blood reality as we can. In the real presence the theological symbols become realized in their actuality in the ritual and in the real presence meant here we experience the sensation of the body.

In his focus on the material (the body and its drives) and his negation of any metaphysical realities (such as the soul), Bacon pinpointed the body as the locus of vitality (pleasure and pain). One sparingly used motif is that of two bodies entwined, such as in *Two Figures* (1953) and *Two Figures in the Grass* (1954). These entwined figures convey the coming together of eros and thanatos in the most exhilarated moment of vitality, which is the wonder-struck cry of life. The condition of death in the lived body is not unique to these representations but is articulated in all of Bacon's figures. Bacon was very insistent about the proximity between life and death, which he described as being "like the turn of a coin."[24]

Many accounts of Bacon's art focus on the depravity of a world where God, and the accompanying Christian moral framework, has been eradicated and the only certainty is that of the human body. Whilst the bleakness of this position is central to his outlook, it can be couched in wider terms of existential possibility. The constant reminder of our mortal condition in Bacon's art can serve as a reminder of the precariousness of human life and hence the importance of savoring the experience of being alive. In his deconstruction of the representation of the static body and the consequent evocation of the living body, Bacon moved from the profane to the sacred. Bacon reconsecrated the sacramental content of these motifs.

In the post-war era, Bacon employed Christian symbols and ideas to convey ideas about the human condition, such as the place of suffering in life. The study of the sacred aspects of Bacon's art enhances interpretations

22. Elizabeth A. Livingstone, *The Concise Oxford Dictionary of the Christian Church* (New York: Oxford University Press, 2000) 483.

23. Leiris, *Francis Bacon*, 14.

24. Sylvester, *Brutality*, 159.

of his work and should not be viewed as antithetical to his intentions. He did not use the symbols to support Christian narratives but extends these themes to convey the experience of desertion by the death of God. In his adaption of the motifs of the crucifixion and the pope, Bacon dissected the relationship between symbol and faith. Paradoxically, Bacon was dependent on the history of Christianity and the visual arts in order to react against and define his own theological, atheist, artistic imagination.

Bacon questioned the tenability of Christianity, and Christian art, in a world that had experienced the Holocaust—belief in God required one to face the problem of evil. If God is so powerful and benevolent than why does He not stop suffering? If the response given is that suffering occurs because of human free will and, humans are responsible for much of the evil in the world, then even so God seems morally obliged to intervene. In the seventeenth century, when belief in God was central to the cultural life of Europe, Velázquez's *Innocent X* was a picture of spiritual authority. In his *Study after Velázquez* Bacon was not desecrating the original; on the contrary, he declared that he thought that it was one of the best paintings in the history of Western art. While *Innocent X* has resonance in the seventeenth century, it lacked pertinence for a twentieth-century audience. Bacon's *Study after Velázquez* was both a revision and an update that was relevant for contemporary culture the modern viewer.

Figure 39. Paul Pfeiffer, *Fragment of a Crucifixion (After Francis Bacon)*, projected images 3 x 4 in. (7.6 x 10.2 cm), digital video loop, projector, metal armature, DVD player, 5-second video loop. Permission of Paula Cooper Gallery, New York.

Media, Mimesis, and Sacrifice

Paul Pfeiffer's Contemporary Christological Lens[1]

ISABELLE LORING WALLACE

Paul Pfeiffer (1966–) is an artist whose works in photography and video installation align contemporary and seemingly secular subjects, such as professional athletes and entertainers, with religious themes whose significance is further underscored by titles that evoke Christian themes (Figure 39). Provocatively, and in spite of titles such as *Four Horsemen of the Apocalypse* (2000), *John 3:16* (2000), *Morning After the Deluge* (2003), and *The Saints* (2007), the religious dimensions of Pfeiffer's work have been consistently minimized within the critical literature, which instead concentrates on the artist's assessment of humanity's fate at the hands of mass and new media.[2] This essay, in an effort to make sense of Pfeiffer's

1. This essay is developed from a paper, "On Rivalry and Retribution: Sacrifice and Ritual in the Art of Paul Pfeiffer" (Association of Scholars of Christianity in the History of Art symposium, "Why Have There Been No Great Modern Religious Artists?" February 8, 2011). For this essay, I am indebted to several individuals whose insights (and patience) I continue to value: Jennie Hirsh, Christopher Michalek, Nathanael Roesch, Lisa Saltzman, Linda Wallace, Judith McWillie, Nora Wendl, and, last but not least, Paul Pfeiffer. In addition, a sincere thanks is owed to the Paula Cooper Gallery and Paul Pfeiffer's studio—in particular, Lia Lowenthal and Rachel Rampleman, respectively.

2. Many of the ideas in this essay were first broached in a slim volume designed to commemorate Paul Pfeiffer's visit in 2007 to the University of Georgia in Athens as part of the Visiting Artist and Scholar Lecture Series. My previous essay says far less about *Fragment of a Crucifixion (After Francis Bacon)* but a good deal more about the role of rivalry and retribution within Pfeiffer's work as a whole. Thus, for an essay that casts a wide (if inevitably less deep) net, see "On Rivalry and Retribution: Paul Pfeiffer and a New Interpretation of New Media," in *Paul Pfeiffer: Contemporary Art at the*

religious references and their relationship to the artist's secular imagery, focuses on a single work that is emblematic of the artist's oeuvre *and* its myopic reception: *Fragment of a Crucifixion (After Francis Bacon)* (1999).[3]

Sharing its title with a painting of 1950 by Francis Bacon, Pfeiffer's *Fragment* is among his most celebrated works. Best described as a small-scale video installation, *Fragment* features soundless, edited footage of a black man, seemingly in extremis, pacing in isolation on a basketball court while surrounded by thousands of camera-wielding spectators (Color Plate 24). As some spectators will immediately know, the work makes use

Dodd, eds. Isabelle Loring Wallace and Nora Wendl (Athens: Lamar Dodd School of Art, 2008) 6–27. For a substantially revised and expanded version of this same text, see "On Rivalry, Retribution, and Religion: Paul Pfeiffer and a New Interpretation of New Media," *Religion and the Arts* 16 (2012) 231–62. The following quotation is a representative sample of the literature's dominant trends: "Pfeiffer's works address how the image of the human being has been transformed by new digital technologies, which can be used both to store limitless amounts of visual information and to manipulate pre-existing images." Hilarie M. Sheets, "Making DeMille Dance," *ArtNews* 99, no. 10 (2000) 200–204. Notably, the artist is often the most eloquent commentator on subjects of subjectivity and digital media. See his interview with Jennifer González, "Paul Pfeiffer," *Bomb* 83 (2003), http://bombsite.com/issues/83/articles/2543.

3. Notable exceptions are Stefan Basilico's interview with the artist: "A Conversation with Paul Pfeiffer," *Documents* 21 (2001) 30–43; and the artist's own text: "*Quod Noman Mihi Est*? Excerpts from a Conversation with Satan," in *Vestiges of War: The Philippine–American War and the Aftermath of an Imperial Dream 1899–1999*, eds. Angel Velasco Shaw and Luis H. Francia (New York: New York University Press, 2002) 279–89. Basilico begins his interview with an observation he does not pursue: "I wanted to do this interview because I see certain things in your work that aren't addressed in most of what's written about it. For instance, it seems to me that there is a consistent ecclesiastical framing; Catholic symbolism, imagery and references run through your work." Perhaps because of the following reply from Pfeiffer, this line of thought is not pursued further in the interview: "What you're talking about is more like a subtext. I don't have an interest in commenting on religion per se. But I am very interested in the relationship between religion and the history of art and the history of human consciousness." Also, it's worth noting upfront that Pfeiffer's title, specifically, its reference to Francis Bacon, may encourage a secular reading of Pfeiffer's work, as Bacon is generally understood to have painted religious motifs from a secular point of view with the aim of addressing humanity's barbarism. However, as Rina Arya's essay in this volume makes clear, the subject of Bacon and religion is perhaps more complicated and, for that, the association of Pfeiffer and Bacon perhaps more fitting. For essays that cursorily engage *Fragment*'s relationship to Bacon's precedent, see Carly Berwick, "Paul Pfeiffer," *Hommes Vogue International* 10 (2001–2002) 134–35; Dominic Molon, "Corporealities," in *Paul Pfeiffer* (Chicago: Museum of Contemporary Art, 2003) 16; and Cedar Lewisohn, "A Perfect Match," *Art Review* 10 (2006) 60. To my knowledge, no essay has worried over the potentially productive ambiguity of the name Francis Bacon, which could also refer to Sir Francis Bacon, the famous scientist who made use of religious symbols and metaphors in his writing.

of appropriated footage of professional basketball player Larry Johnson celebrating the success of making a difficult shot. In the process of making *Fragment*, what did Pfeiffer do and *not do* to this footage? *Fragment* was conceived using a technique, which dominates Pfeiffer's early work in video and photography, and which has now become something of a signature. The process is typically called "erasure" by Peiffer's critics, but "camouflage" by Pfeiffer himself, who has observed that digital software allows him to remove information from the original through what is, in fact, an additive process in which pixels from one moment in a video (or place within a still image) are replicated and placed atop pixels located within another moment in the video (or portion of the digitized photograph).[4]

In the case of *Fragment*, a variety of information was extracted from the original footage using this process: the athlete's name and number, the lines of the court, the ball, and, perhaps most pointedly, the other players. In addition, some aspects of the footage have been exaggerated—for example, the flashes caused by cameras in the crowd, which add to the effect of Johnson as a persecuted figure.[5] That said, it is important to note that, although looped, Johnson's movements and expressions have not been altered. In fact, the dramatic change in his affect reflects no change at all; instead, it is an effect of the frame in which the Johnson is placed. Seen in the original context of the game and its dramatic narrative, Johnson reads one way; seen in the context created by Pfeiffer, he reads another: inherently, his image is neither triumphant nor anguished, but rather a complex amalgam of these two states, for he is at once a hero and, in Pfeiffer's hands, a human sacrifice. It is precisely this ambiguity that *Fragment* manifests, since what one sees in its video is not the pure expression of torment (as some critics contend), but rather its complex—and thanks to Pfeiffer's technique, its literal—entanglement with joy. By the same token, *Fragment* also manifests—and through its title calls attention to—the conjunction of sacred and secular, since what one finds in the video is not Christ, but Johnson *as* Christ in an image that functions to foreground the irreducibility of sacred and secular for which Christ was already a symbol.

4. Pfeiffer describes this process in an interview for the PBS series, *Art 21*. See Paul Pfeiffer "Paul Pfeiffer: Erasure, Camouflage, and 'Four Horsemen of the Apocalypse,'" *Art 21: Art in the Twenty-First Century*, Season 2, http://www.art21.org/texts/paul-pfeiffer/interview-paul-pfeiffer-erasure-camouflage-and-four-horsemen-of-the-apocalypse.

5. In the *Four Horsemen of the Apocalypse* series—a suite of photographs that also feature lone basketball players on the court in extreme circumstances—Pfeiffer manipulated the lights of the arena to amplify their significance. The same may have been done in *Fragment* with respect to the camera flashes.

In addition, *Fragment* conjoins distinct temporalities: on the one hand, the fleeting specificity of Johnson's profane, media-saturated present, and on the other, the transcendent timelessness of the sacred as evidenced in the looped image of Christ at the moment of his sacrifice.

This essay also proceeds by modifying the frame. In a departure from extant literature, *Fragment* is considered through a christological lens, transforming the information *around* Pfeiffer's work in the hopes that a methodological shift will add depth and productive ambiguity to our understanding of a work that is too often viewed through an exclusively secular lens. This reading does not aim to replace any interpretation dedicated to celebrity and media culture with one that isolates the religious from the contemporary. For, just as Pfeiffer entangles exaltation and anguish by modifying the context in which we see the image of Johnson, this essay brings sacred and secular together by adopting a novel approach to the interpretation of Pfeiffer's installation. Doing so will allow me to approach two questions Pfeiffer seems determined to ponder and prompt: first, what *is* the relevance of Judeo-Christian thematics to contemporary imaging technologies; second, and still more fundamentally in the words of the artist, "Does it even make sense to think of technology in religious terms?"[6]

Before turning to these questions, it is necessary to describe *Fragment* and its reception in a bit more detail. As noted, *Fragment* is rightly, if rarely, classified as a video installation. This is because in contrast to conventional video art the spectator's attention is directed both to the video as such and the equipment required to project the video onto the gallery or museum wall.[7] Moreover, because the projector reads anthropomorphically—its rounded dome as if a head atop an elongated neck or torso—*Fragment* can be said not only to thematize *within* the projected video, but also to stage through the installation *as a whole* a complex relationship between man and contemporary imaging technologies. Comments to the latter effect, as well any formal analysis of the work's technical components, are curiously absent from the scant literature on *Fragment*—a work that is, for all its impact and fame, rarely the object of sustained analysis.[8]

6. Pfeiffer, "*Quod Noman*," 286.

7. Although the projector is visible, the DVD player is, as per the work's installation instructions, always hidden behind the sheetrock wall on which the work is mounted.

8. Essays on Pfeiffer rarely omit *Fragment of a Crucifixion*, as this work was one of two videos included in the 2000 Whitney Biennial for which Pfeiffer received significant notoriety and the museum's first Bucksbaum award. Interestingly, though, the discussion of this work remains somewhat stunted and rarely transcends description

Instead, scholars and critics tend merely to describe the installation (often incompletely) and situate it within the broader context of an oeuvre that includes several religiously titled works said to be about celebrity-athletes and the technologies that sustain and promote them. In sum, *Fragment* is often superficially addressed in the literature and typically only to the extent that it is part of larger body of work engaged with athletes and the entwined phenomena of mass and new media.[9]

Needless to say, such an approach does *Fragment* and the whole of Pfeiffer's work a disservice, both because it inadequately interprets the specifics of *Fragment*—most notably, its complex spectatorial dynamics and foregrounded christological aspect—and because it overly stresses the links between this and other sports-identified works, thereby isolating Pfeiffer's religious references and reducing them to casual metaphor. Indeed, at least two commentators have observed of these works, as if in exhaustive summation, that they evidence the "nearly religious spectacle of professional sports."[10] In reality, religious references are unevenly spread through Pfeiffer's sports-themed works, even as they also appear alongside other recurring, core concepts such as one-point perspective throughout the whole of Pfeiffer's multi-faceted oeuvre.[11] Neither exclusive to, nor

or casual analogy.

9. The approach of Deborah Solomon is typical: "Paul Pfeiffer harbors an odd twin obsession with basketball and the Bible. While plenty of American men treat hoops as if it were a major world religion, Mr. Pfeiffer is in no danger of being confused with your average jock . . . His *John 3:16* (1999), at P.S. 1, is a never-ending video-loop assembled from more than 5,000 digitized images of a basketball as it floats through the air. What should we make of this blurry ball? It suggests a throbbing orange migraine (especially if you don't love sports), as well as an eternal light, centered, radiant and harking back to the New Testament passage of the work's title." See "A Roll Call of Fresh Names and Faces," *New York Times*, April 16, 2000, Sunday, Arts and Leisure, 35.

10. See the press release for the Paul Pfeiffer exhibition at MUSAC (The Museo de Arte Contemporáneo Castilla y León): "MUSAC Presents *Paul Pfeiffer. Monologue.* The Acclaimed American Artist's First Solo Show in Spain," September 28, 2008–January 11, 2009, http://www.musac.es/index_en.php?ref=23300; and Jennifer González's interview in which the interviewer uses this same phrase in her discussion of *John 3:16*: "As an unending loop, the work anchors the title's biblical connotations of eternal life, while the cropped and spliced NBA footage makes reference to the almost religious spectacle of professional sports." González, "Paul Pfeiffer."

11. Sports-related works that do not invoke religion directly include *Caryatid*, 2000, and *Corner Piece*, 2002. The direct invocation of religion in non–sports-themed works can be found in *Desiderata*, 2004, which consists of edited footage from *The Price Is Right* and borrows its title from a well-known religious poem; *Study for Jerusalem*, 2006, a video installation featuring edited footage of singer Freddy Mercury in concert, and, as critics have acknowledged, *Morning After the Deluge*, 2004, whose

dominant within Pfeiffer's sports-themed work, biblical narratives are thus a primary, but not exclusive frame of reference for the artist, no matter what subject is nominally at issue. So while it is interesting to consider the connections between professional sports and religion, and while Pfeiffer has encouraged critics in this line of thinking noting that "stadiums are referred to as domes, a direct relation to religious architecture,"[12] it is misleading to suggest that Pfeiffer is only interested in religion (and perhaps Christianity in particular) to the extent that it provides a language for thinking about the kind of adoration, rapture and demonization that attends modern day sports.[13] Indeed, Pfeiffer has said on numerous occasions that he is interested in the athlete and, more specifically, "the condition of the person in the stadium," because, for him, the "perceptual overload" endured by the individual in this circumstance is ultimately "archetypal of the world we live in today."[14] Just what that condition is, and

title makes obvious reference to both the history of art, as well as the Old Testament, despite being little more than a large-scale, real-time video of the sun rising and setting simultaneously. Perhaps because of the nature of *Deluge*'s imagery, critics have discussed this particular work in ways that acknowledge the religious reference implicit in its title. See Jane Farver, "Morning After the Deluge," in *Paul Pfeiffer* (Chicago: Museum of Contemporary Art, 2003) 43–47; Pfeiffer's own commentary, "Private View: The Sun is God," *Tate Etc* 2 (2004) 90–94; and my own, "Technology and the Landscape: Turner, Pfeiffer, and Eliasson after the Deluge," *Visual Culture in Britain* 12, no. 1 (2011) 57–75. In this essay, I examine the relationship between Pfeiffer's work and Turner's and discuss the entanglement of technology, religion, and apocalypse in the work of each.

12. Solomon, "A Roll Call," 35.

13. For an example of this approach, see Cedar Lewisohn, "A Perfect Match," 60. "His *Fragment of a Crucifixion (After Francis Bacon)* freeze-frames an instant of demented rapture on the basketball court. The star of the scene seems to be completely alone in the universe, his adoring audience willing to bring him on in total adoration—the type of climactic moment athletes live for. There's something demonic about the image, something gladiatorial, as if Larry Johnson has just slain an innocent Christian." Similar rhetoric underwrites Cate McQuaid's commentary on the *Four Horsemen of the Apocalypse* series. "In one, a player who stretches his arms up exultantly literally loses his head: Pfeiffer has erased it and exaggerated the glow of the stadium light square on the player's shoulders. It looks like the biblical Judgment Day, with the crowd cheering and the man forsaking his human bonds for rapture." "His Photographic Truth is the (Un)Real Thing," *Boston Globe*, February 23, 2003, N7.

14. I draw on two separate but similar quotations here. The first, "As an artist I am interested in the condition of the person in the stadium. In some ways it's archetypal of the world we live in today." Louise Kennedy, "'Visionary' Video Artist Is in the Loop," *Boston Globe*, February 7, 2003, C19. The second appears in Pfeiffer's interview with Jennifer González: "To me, being there, living inside the spectacle or inside the arena, in this moment of perceptual overload, is the archetypal seed of current times." See

what relation it bears both to Christianity and new media, are precisely the questions this essay aims to address.

By way of transition to those questions, a few final thoughts on the reception of *Fragment* and the works with which it's aligned: as it turns out, the most sophisticated literature on Pfeiffer's "sports-themed work" eschews religion, instead concerning itself with the racial and, to a lesser extent, erotic implications of the artist's work in this area.[15] Noting that Pfeiffer's work often features black male bodies that suffer the extreme pressure of being seen, numerous writers have acknowledged the artist's interest in the topics of colonialism and African-American identity, often in concert with Pfeiffer's eloquent commentary.[16] Bearing out the idea that Pfeiffer is interested in both the universal and particular connotations of these images are these remarks, made by the artist in his excellent, wide-ranging conversation with Jennifer González:

> A special relationship exists between black bodies and spectacle. It's almost as though the spectacle could not exist without them. Think of the colonial condition. Frantz Fanon writes about the former child of the colony who goes to the metropolis and finds himself on the subway and has the distinct feeling that he is out-side himself, that he is watching himself . . . colonial subjects are alienated not just from their labor, but from their sense of who they are, as something more than a spectacle for other people.[17]

"Paul Pfeiffer."

15. Debra Singer mentions that Pfeiffer unveils the "latent eroticism of the sports spectacle," cited in Linda Yablonsky, "Making Microart that Can Suggest Macrotruths," *New York Times*, December 9, 2001, Arts and Leisure Section AR39. Also, Holland Cotter associates *Race Riot* with a "group grope." See "Art in Review: Paul Pfeiffer at the Whitney Museum of American Art," *New York Times*, January 18, 2002, E44.

16. Pfeiffer has spoken of such issues often, but his most sustained engagement with the topics of race and colonialism can be found in "*Quod Noman.*" In turn, his commentators have also attended to the racial dimension of his work. For example, Niklas Maak has said of *The Long Count*, 2001, that therein "racism appears as a beast: the white viewers stare with a hunger for fear at the black boxer, who, like an animal, can no longer speak, just gasp for breath and fight." "On Paul Pfeiffer," in *Paul Pfeiffer: Monologue*, ed. Octavio Zaya (Barcelona: Museo de Arte Contemporáneo Castilla y León, 2009) 53. For additional analyses of race in Pfeiffer's work, see Carly Berwick, "Maybe Race has Nothing to Do With It," *Feed* (2000), http://www.feedmag.com; González, "Paul Pfeiffer"; Joan Kee, "Processes of Erasure: Paul Pfeiffer's Narratives of the Global," *Art and AsiaPacific* 32 (2001) 64–69; and Pfeiffer's *Art 21* interview, "Erasure, Camouflage & 'Four Horsemen of the Apocalypse.'"

17. González, "Paul Pfeiffer."

Pfeiffer's remarks, as well as some of his titles—*Race Riot* (2001) and *Goethe's Message to the New Negroes #2* (2002), for example—suffice to establish that the artist is engaged with issues of race and identity, and more recent works suggest such interests have been extended to Pfeiffer's own identity as a Philippine-American. Video installations like *Live from Neverland* (2006) and *The Saints* call direct attention to the Philippines and its complex intersection with Western culture (both make use of a chorus of Filipino men and women to "narrate" Western dramas: Michael Jackson's televised rebuttal of child molestation charges and a famous soccer match between England and West Germany in 1966, respectively), but at least one scholar is certain that other, earlier works also reflect—and inevitably abstract—Pfeiffer's interest in the conjoined subjects of colonialism and imperialism.

In *The Decolonized Eye: Filipino American Art and Performance*, Sarita Echavez See writes with authority and great erudition about a number of Pfeiffer's works, but it is her stated goal to come to terms with one video in particular: *Morning After the Deluge*.[18] Although the religious dimension of *Deluge* is obvious and substantial, See's essay says comparatively little about religion and engages not at all with the title's textual and art historical referents.[19] Instead, See reads this video of a static sun and moving horizon as evidence of Pfeiffer's engagement with Philippine-American history and further argues that "universalist formalist interpretations" of the sort egged on by Pfeiffer's "classical and canonical references" are but a symptom of Eurocentrist critical discourse and the invisibility of imperialism to itself. Taking her cue from Pfeiffer's insistence that the depopulated landscape of *Deluge* is, in fact, a figure study, See argues that Pfeiffer's oeuvre tracks the dissolution of the human subject, which eventually gives

18. Sarita Echavez See, *The Decolonized Eye: Filipino American Art and Performance* (Minneapolis: University of Minnesota Press, 2009) 39–67. Of equal note in this context are the essays of Lawrence Chua and Joan Kee, respectively: "Jerusalem: Violence, Space and Mimesis in the Work of Paul Pfeiffer," in *Paul Pfeiffer: Monologue* Octavio Zaya, ed. (Barcelona: Museo de Arte Contemporáneo Castilla y León, 2009) 171–84; and "Processes of Erasure" 64–69.

19. While discussing Pfeiffer's *24 Landscapes*, See does raise the question of whether Pfeiffer's work "proposes the kind of devotional praxis particular to queer Filipino America." However, this line of inquiry is soon returned to a postcolonialist framework in which Pfeiffer's irreverent devotion to the absented Marilyn Monroe articulates something of American imperialism. Also, I should note that while discussing Pfeiffer's *Vitruvian Man*, See references Leo Steinberg's famous argument about the sexuality of Christ, noting that this work likewise functions as an occasion for a sexually shameless reverence. See, *Decolonized Eye*, 52 and 59, respectively.

way to the space and ideology that surrounds it. Indeed, what we are to see in Pfeiffer's empty landscape is neither the nineteenth-century American sublime, nor technology's ability to endlessly negotiate time and space. Rather, for See, it is the "imperialist politics of abstraction" that are on display in a work whose depopulation repeats, but thereby makes visible the genocidal act of nation-building, which in turn makes possible the enduring fantasy of a shameless, virginal land.[20]

Although it features neither a landscape, nor a depopulated space, *Fragment* does feature in See's essay, and she writes about the work in sustained and sophisticated ways, relating its imagery and temporality to the African-American experience of slavery. Describing the video as an "endless animated convulsion," See rightly insists that Pfeiffer's looped, five-second video is at once short and perpetual—an aspect of the work that makes the athlete's voluntary movements seem compulsive, an oddly ecstatic repetition. Intimately linked to trauma within psychoanalytic discourse, repetition is associated by See with not only the historical phenomenon of slavery, but also a modern conception of celebrity, both of which reduce the subject to a capitalized object. Thus, for See, the mute suffering of Johnson is best understood as a late twentieth-century embodiment of what Paul Gilroy has called the "slave sublime," in which the ineffable terrors of slavery are conjoined with the redemptive capacity of suffering.[21]

20. See also reads Pfeiffer's *24 Landscapes*, 2000/2008, in this light, noting the absenting of Marilyn Monroe from the Californian forest is a similar kind of (consciousness-raising) razing. See, *Decolonized Eye*, 53–55, 63–67.

21. Paul Gilroy, *Black Atlantic: Modernity and Double Consciousness* (Cambridge, MA: Harvard University Press, 1993). See concludes her discussion of *Fragment* with a lament that echoes my own, providing one substitutes religion, and Christianity in particular, for the concept of racialized politics: "The vague, tentative remarks of a few reviewers notwithstanding, no critics have referred explicitly to the history of white supremacy and racial torture like lynching that these images evoke. Typically verbose and occasionally eloquent when it comes to topics such as sport as cult, the gradual dissolution of the body in contemporary art, the impact of new technologies, and the temporal distortions particular to video loop art, Pfeiffer's critics fall silent when it comes to the *politics* of these same topics." See, *Decolonized Eye*, 62. As a point of fact, I have written at some length about slavery and *Fragment*, arguing that *Fragment* inverts African-American history, which moved from the slave sold at public auction as chattel to the athlete-as-entertainer drafted on live television as indentured property of the NBA. (Though by no means exhaustive, this text draws on Hegel's master–slave dynamic and its apt critique by Frantz Fanon.) Here, I will not speculate as to whether my remarks were vague, verbose, or merely overlooked; rather, I will simply reiterate that, for me, and I think for Pfeiffer, all these concepts are enriched through their intersection with two consistently comingled aspects of Pfeiffer's oeuvre:

Concepts like redemption and ecstasy bring us close to religious discourse (just as the entwined histories of slavery and colonialism abut the history of organized religion), but See's reading, for all its depth, does not engage the religious connotations of these words, nor does it place Pfeiffer's religious background on equal footing with the artist's mixed race and multi-national upbringing.[22] Of course, here it might be prudent to note that this essay is also indifferent to Pfeiffer's background and convictions, especially as they intersect with the personal, but culturally informed issue of faith. In essays, interviews and conversation, Pfeiffer tends to speak of religion in metaphorical terms, but, at times, one senses something more, an involuntary slippage between metaphor and faith, the boundaries of which are not always clear. Needless to say, Pfeiffer's art assumes meaning apart from (and in excess of) his intentions, and while Pfeiffer's convictions necessarily *inform* his work, they may be an insufficiently reliable framework for interpretations that mean to interpolate his oeuvre within a broader and ever-shifting nexus of ideas.[23]

This essay aligns Pfeiffer's acknowledged subjects—celebrity culture and the mediating technologies that sustain it—with the topic that his commentators are least likely to address: the Judeo-Christian tradition, and therein, the entangled concepts of mimetic desire and sacrifice, as theorized by the French literary scholar, René Girard.[24]

(1) the religious narratives so often referenced by Pfeiffer's titles, and (2) the mediating technologies that are central to both the making and meaning of Pfeiffer's art. For my own account, see "On Rivalry and Retribution," 6–27.

22. Pfeiffer was born in Hawaii and grew up in the Philippines where his parents first met; his mother is Philippina and his father is American.

23. These comments are not meant to dissuade or dismiss attempts to connect Pfeiffer's work and life. For example, there are undoubtedly interesting things to say about ritual and Roman Catholicism, the primary religion of the Philippines. It is only to suggest that my reading is concerned less with the work's origins and more with its implications for an audience that may or may not know the "facts" of Pfeiffer's life.

24. Pfeiffer's conversation is peppered with references to Frantz Fanon and Walter Benjamin; however, he never mentions Girard or any other theorist who forges a link between the concepts of sacrifice and mimesis. Even so, Pfeiffer's work may be productively understood as a visual analogue for the type of analysis undertaken by Girard in his well-known readings of both literature and scripture. In the service of this claim, I note Pfeiffer does not invent images but is instead engaged with their appropriation and re-presentation. Thus, like a scholar who revisits an extant text for the purpose of assessing its fundamental meaning and import, Pfeiffer focuses his attention on images that exist in the world already, reframing them in ways that redefine and reveal their ultimate significance. That this significance is often filtered through religious narratives mined for their reliance on the themes of mimesis and sacrifice is a

Girard, who developed the concept of mimetic desire over the course of several decades, maintains that *when* one desires, one mimics the behavior of someone else, who already desires one's chosen object. Thus, on his account, the identity, and even the existence of a beloved is a byproduct of a more fundamental ambition to copy a third party—the model or mediator in Girard's terminology—whom the lover ironically disavows as his unworthy imitator. Of equal concern to Girard, and to Pfeiffer as we have seen, is the concept of sacrifice. As Girard famously argues, sacrifice resides at the heart of all religions and is the ritualistic mechanism by which communities routinely solve escalated mimetic crises. On his account, when mimetic competition escalates in its dimensions, bringing a crowd to the verge of radical fracturing, the rivalrous mob is faced with the following choice: continue in the "all against all" mentality engendered by such rivalries, or find a scapegoat, the accusation of whom will unite the crowd and transform its outlook into the more efficient "all against one."[25] As described by Girard, the scapegoat, singled out for his marginal status relative to the group, is accused by the crowd of an injustice believed to have precipitated the current crisis. Innocent of both the crime and crisis,

fact that aligns Pfeiffer with Girard in particular, making the former, in some respects, a visual equivalent for the latter. On mimetic desire and sacrifice, see the following three books by René Girard: *Deceit, Desire and the Novel: Self and Other in Literary Structure*, trans. Yvonne Freccero (Baltimore: Johns Hopkins University Press, 1966); *Violence and the Sacred*, trans. Patrick Gregory (Baltimore: Johns Hopkins University Press, 1979); and *Things Hidden Since the Foundation of the World*, trans. Stephen Bann and Michael Metteer (Stanford: Stanford University Press, 1987). For a useful analysis of Girard's legacy and broader intellectual context, see Chris Fleming, *René Girard: Violence and Mimesis* (Malden, MA: Polity, 2004) 152–64. For a sophisticated meditation on the link between sacrifice and mimesis in the work of René Girard, Giorgio Agamben, Luce Irigaray, and Homi Bhabha, see Rey Chow, "Sacrifice, Mimesis and the Theorizing of Victimhood (A Speculative Essay)," *Representations* 94 (2006) 131–49. For a reflection on Girard's conception of Christ, see Frederiek Depoortere, *Christ in Postmodern Philosophy: Gianni Vattimo, René Girard, and Slavoj Zizek* (New York: T. & T. Clark, 2008) 34–91. Also, note that Girard's theory of mimetic desire plays a role in Lawrence Chua's analysis of *The Saints* and *Live from Neverland* (see Chua, "Jerusalem"), but to my knowledge, this is the only other place, save my earlier essay, "On Rivalry and Retribution," where Girard appears in the literature on Pfeiffer. Notably, Chua's engagement with Girard is largely political: "Pfeiffer's work exposes the violent mimesis that underscores unequal power relations and suggests some of the ways this mimicking can also be a strategy for liberation." "Jerusalem," 172.

25. Throughout his career, Girard differentiates between internal and external mediation, claiming that the latter does not lead to antagonistic rivalries because the mediator is too distant (geographically, psychologically, socially) from the desiring subject. In the case of internal mediation, as defined by the proximity of subject and model, rivalry is inevitable.

the scapegoat is nevertheless found guilty by the mob, which demands his capital punishment or exile. In this way averting mimetic catastrophe, the crowd then raises the scapegoat to the status of a god or king, attributing to him both the original crime and the miraculous restoration of peace.

As several critics have remarked, verification of Girard's theory is difficult, especially since he claims that the accusing crowd is typically ignorant of two things: the mimetic nature of its desire and the innocence of the victim or scapegoat. As a consequence, any record of violence inevitably sides with the persecutors and records as righteous their distorted version of events. In fact, for Girard, this is the very definition of myth, as opposed to both great literature and Judeo-Christian scripture, both of which he characterizes as heroic attempts to tell the truth about desire and its relation to violence. Indeed, on Girard's account, the process of demythologizing sacral violence begins with the Old Testament retelling of ancient myths and is brought to fruition with the story of Christ as relayed in context of the Christian gospel.[26] With this, and other aspects of Girard's framework in mind, let us return to *Fragment*.

That a relationship exists between Christ's crucifixion and the anguish depicted in *Fragment* is obvious and expressly noted by Pfeiffer in his title. Tormented and soon to be sacrificed before a crowd of onlookers, Johnson, like Jesus, is a scapegoat who is akin to and different from his peers. Made of flesh, but endowed with capacities that seem supernatural, he stands apart from the crowd without being utterly removed from its concerns and therefore is ripe for the kind of victimization and divination the story of Christ bears out. But, if a famous athlete can be made to play the part of tormented scapegoat, he is also, by definition, an object of desire—or more precisely mimetic desire—the one to whom fans flock, imitating both the camera and each other in rivalrous adulation of the athlete's rare gifts. In ways both literal and conceptual, Pfeiffer's video thus conflates desired object and vilified scapegoat, and in this respect, seems to depart from Girard's theory, in which the scapegoat repairs, and, in fact, *distracts from* mimetic rivalries associated with the beloved. And yet, when seen from another point of view, this compression of beloved and vilified object—a compression that results from Pfeiffer's technique and unfolds, importantly, in time—only deepens the connection between Pfeiffer's work and Girard's. For just as Girard's theory has competing suitors shift their focus from beloved object to vilified scapegoat, so Pfeiffer's

26. For an analysis of myth and its relation to the Bible, see Girard, *Things Hidden*, 141–223.

video effects a change in the spectator's focus: where once we saw only the revered athlete known as Larry Johnson, we now see an anonymous sacrificial victim analogized to Christ instead. Thus, the question isn't whether Pfeiffer's video is compatible with the related concepts of mimetic desire and sacral violence—Pfeiffer's transformation of Johnson and the surrounding crowd is easily read as an analogue for these phenomena and their relation. Rather, the real question—for Girard and for us in turn—is how violence and the scapegoat are framed. As noted, Girard maintains that myths are disingenuous about certain, key mimetic facts, whereas the story of Christ, to which Pfeiffer's title plainly alludes, exposes both the scapegoat's innocence and the role played by mimetic desire in affecting his undeserved persecution. With that in mind, let us consider what light the installation *as a whole* can shed on these questions.

As observed previously, *Fragment* foregrounds the equipment required to project the diminutive footage of its protagonist's agonized movements. Held in place by a metal armature mounted to the wall just below the projected image, the projector, though itself quite small, exceeds the size of the three by four inch image it produces and is, by conventional standards, intrusive, distanced no more than twelve inches from the digital projection it sustains and to some extent obscures. Looming over the video it facilitates, the projector appears to bully the washed-out image, backing it against the wall and pinning there by the implied threat of force.[27] Again, there is an analogy to consider, not to mention the role played within this analogy by media: for just as the projected video is contingent on technology from which it seems to suffer, so within that video a man appears wounded by camera flashes, and trapped, on a conceptual level, by the knowledge that he is a byproduct of numerous cameras, which sustain and disseminate his image. In turn, the spectator is marginalized by *Fragment's* electronic, but anthropomorphic equipment, since he sees,

27. On numerous occasions Pfeiffer has written about the horror film *The Exorcist* and the idea of an encounter with and even one's possession by an inhuman Other. As he suggests in "*Quod Noman*," this experience is structurally analogous to our encounter with the racial Other *and* modern technologies, both of which threaten to possess and overcome us in ways that are both exhilarating and terrible. On the concept of possession in Pfeiffer's work, also see Pfeiffer, "Paul Pfeiffer and Thomas Ruff in Conversation," in *Paul Pfeiffer* (Düsseldorf: Hatje Cantz, 2004) 67; Pfeiffer, "Scenes of Horror: 'Poltergeist,' 'The Exorcist,' and 'Amityville Horror,'" *Art 21: Art in the Twenty-First Century*, Season 2, http://www.art21.org/texts/paul-pfeiffer/interview-paul-pfeiffer-scenes-of-horror%E2%80%94poltergeist-the-exorcist-and-the-amityv; Sheets, "Making DeMille Dance," 200–202; and Katy Siegel, "Paul Pfeiffer," *Artforum* 38, no. 10 (2000) 174–75.

but with Pfeiffer's equipment always in view. In fact, given the placement and size of the work's projector, one might say that the projection and projector function as a closed loop from which the beholder is excluded and with which he feels required to compete. Looking at *Fragment* therefore means looking obliquely—both because Johnson's performance is for the camera (rather than for fans in the arena) and because, in a more literal sense, the space traditionally reserved for the beholder has been usurped by the equipment required for the video's projection. Tellingly aligned by Pfeiffer with media, as such—Girard's (media)tor or model thus comes between the subject and his beloved, thereby disrupting the fantasy of a dyadic rapport between the spectator and the installation's projected spectacle. Bested in this way, *Fragment's* marginalized beholder encounters the projector as an obstacle and rivalrous personage, perhaps, for a moment, forgetting that without Pfeiffer's anthropomorphic equipment there would be neither an impulse to look nor a video projection to desire.

As a consequence, the beholder is likely to think more critically—and ultimately more analogously—about the dynamics depicted within the video he reviews, for while common sense dictates that the fans in the arena are oriented (without mediation) toward Johnson, and while everything about the concentric structure of the arena confirms Johnson's centrality and desirability, the beholder's experience of Pfeiffer's installation as a whole—one this essay has described as competitive, mediated and mimetic—raises a different, if repressed possibility: that Johnson's fans are actually drawn to the camera as well as other, camera wielding fans, the activities and impulses of which they slavishly mimic, even as they try to maintain that they were here first, and that it is the camera that has followed them, interrupting and impeding a live and otherwise unmediated experience of their idol. In sum, there is a provocative relationship here between Pfeiffer's installation and the content of the video therein: one of which illustrates, the other of which, with the spectator, enacts and *brings to consciousness* the triangular structure of mimetic desire in which spectators compete with cameras and each other for their shared object of interest. In turn, it is this consciousness that recommends *Fragment* to the rank of scripture and great literature as defined by Girard; for, like them, Pfeiffer's installation deploys and makes visible two things the scapegoat mechanism must ultimately repress: the mimetic nature of desire and the innocence of the would-be-scapegoat, who is here compared with the paradigmatically innocent figure of Christ. Burdened by this knowledge, *Fragment's* spectator thus finds himself in a situation

that requires but cannot compel the scapegoat mechanism, and it is while stalled at this ethical impasse, with image of torture before him, that the spectator comes to know the true and, from a Girardian point a view, truly Christian subject of Pfeiffer's video: the scapegoat mechanism as such, in all its ugliness, unjustifiability, and commonplaceness.

Anguish may receive top billing in *Fragment*, but, as with so many of Pfeiffer's works, a second subject seeps through and informs the surface. Taken at face value, that subject is success and jubilation, a professional athlete relishing his accomplishments on the court. Yet, if one were to dig deeper and ask after the source of such pride, what would one find if not a rivalry, a secular competition that might nevertheless be understood in religious terms? As Girard has observed, rivalry is everywhere in the Bible, as is the palliative, compensatory concept of sacrifice. Arguably, the Bible begins with rivalry and makes it the foundation for all that will follow. Thus, as a way of deepening the discussion of *Fragment* and bringing this meditation to a close, let us revisit the entangled concepts of sacrifice and mimetic desire and consider them in conjunction with the book of Genesis, synonymous in the Judeo-Christian tradition with notion of the beginning.

In the third chapter of the Bible's first book, the serpent tempts Eve with two points of particular interest here: the fruit's capacity to level certain distinctions between God and humanity, and God's jealousy relative to this prospect.[28] In what could be interpreted as a mimetic rivalry, the relation described in *Genesis* between Adam and Eve and their creator is both imitative and competitive. Desirous of the fruit and the mimetic promise it embodies, they aspire to inhuman heights and thus escalate to the point of crisis the rivalry between them and the divine image in which they are modeled. Adam and Eve's rivalrous challenge of God ends in their exile and the promise of death, punishments that in turn anticipate various acts of compensation and vengeance in the Old Testament, which likewise anticipate the sacrifice of Christ referenced by Pfeiffer in *Fragment*. It may already be clear how such ideas relate to Pfeiffer's work and

28. This is not the place to review the long and conflicted history of Genesis commentary (a tradition that now includes many scholars from outside the field of theology); nor is it the place to summarize the interpretive shifts that mark this history, since the primary concern of this text is the appeal of Genesis for a culture defined by new media's seemingly omniscient and all-seeing eye. For a useful overview of recent historical and psychoanalytic readings of Genesis, as well as an attempt at their reconciliation, see Roland Bober, "The Fantasy of Genesis 1–3," *Biblical Interpretation* 4, no. 4 (2006) 309–31.

the image of an ambitious man suffering before the cameras' all-seeing eye.[29] But before concluding this essay and returning to *Fragment* a final time, allow one further observation on the subject of the Fall. In the aftermath of the fruit's consumption it is not death that Adam and Eve initially suffer; rather, it is knowledge of themselves as seen and seeable entities, that which is from another (divine-like) point of view visible as mortified image. Provocatively, this realization may be inseparable from a sense of rivalrous acknowledgment, as it is in the fateful moment of the Fall that humanity is engaged for the first time by an omniscient and all-seeing eye. Prior to this, God speaks to Adam, but does not require Adam's response, rather only his ear and obedience. It is only after Adam and Eve eat from the Tree of Knowledge that God looks for Adam, asks after Adam, and engages Adam, in short, that he addresses Adam as rival. As such, one might say that within the tradition repeatedly referenced by Pfeiffer, shame and an awareness of being seen, like their counterparts, agony and jubilation, are born together and are never disentangled, either from each other or from the ideas of vision and rivalry.[30]

Returning to *Fragment*, Pfeiffer's entanglement of jubilation and torment takes on new meaning,[31] as does its double invocation of a punitive, all-seeing eye—first within the video in the form of the relentless flashbulbs, and second, in the installation as a whole, in the form of its bearish equipment. These aspects of the work, when added to the fact that the layers of *Fragment* imply a causal narrative—the hubristic triumph of Johnson in the original effectively "leading to" his anguished sighting and the implied threat of compensatory sacrifice in Pfeiffer's edited video—allow

29. For a discussion of the relationship between the surveying camera and the idea of a divine, all-seeing eye, see Astrit Schmidt-Burkhardt, "The All-Seer: God's Eye as Proto-Surveillance," in *CTRL [Space]: Rhetorics of Surveillance from Bentham to Big Brother*, eds. Thomas Levin, Ursula Frohne, and Peter Weibel (Cambridge, MA: MIT Press, 2002) 17–31. Also note that the phrase "god's eye view" sometimes appears in reviews of Pfeiffer's work but without substantive commentary. See, for example, Christopher Miles, "Paul Pfeiffer: UCLA Hammer Museum, Los Angeles," *Tema Celeste* 88 (2001) 77.

30. For a more philosophical meditation on this same nexus, see my article: "From the Garden of Eden and Back Again: Pictures, People and the Problem of the Perfect Copy," *Angelaki: Journal of the Theoretical Humanities* 9, no. 3 (2004) 137–54.

31. If there were space, I would argue that Pfeiffer's *Four Horsemen of the Apocalypse* series—a series which is in many ways a photographic counterpart to *Fragment*, and one whose title implies yet another reckoning between man and the eye that surveys him—conjoins but disentangles these emotions, laying them bare in discrete photographs that are by turn jubilant and despondent.

us to align all the elements of Pfeiffer's work with the religious framework invoked in his title, just as the work's imagery in turn insists on the relevance of such matters in the present.

In summation, *Fragment*, which takes as its subject the sighting of an individual by an omniscient, rivalrous eye, not only stages the threat of sacrificial violence and its mimetic origin, but also calls to our attention the fraught nature of being in the world, when existence means being a site of vision for another. In contemporary culture, that other is more often than not the formidable eye of the all-seeing camera, which looms over mankind and judges its hubristic offenses, many of which play out daily in a culture obsessed with celebrities who are by turns idolized and defamed. For, as *Fragment* economically insists, the story of mankind's ambition is, for all its resonance in the present, foundational and eerily familiar: first the conjoined experience of acknowledgement and objectification, followed by punishment and exile, both of which are exacted with cruel indifference by an all-seeing eye that establishes worth even as it takes it away. Of course, what *Fragment* also documents is the complex predicament of wanting and resenting this omnipotent attention, precisely because of the confirmation and negation it provides.[32] Anguished and jubilant, mortified and exhilarated, seeing but for the first time seen, *Fragment* foregrounds an ambivalent psychology that is at once ancient and contemporary, perhaps suggesting that media culture is, among other things, the traumatic repetition of a primal trauma in which the distinction between individuals and images was both born and immediately collapsed.[33] Indeed, with

32. Provocatively, it is ambivalence wrought by seen-ness that underwrites another foundational myth: Lacan's theory of the mirror stage, which also functions as an origination story, albeit at the level of the individual subject. On the correlation between the Fall and the Lacanian mirror stage, see Jane Gallop, *Reading Lacan* (Ithaca, NY: Cornell University Press, 1985) 85; and Malcolm Bowie, *Lacan* (Cambridge, MA: Harvard University Press, 1991) 21. Carly Berwick seems to gesture in this direction when she says of *Fragment* and its debt to Bacon, "This basic inspiration is transformed to oscillate between astute, specific observations on mass media—such as its creation of a spectacle society where each individual is staring in his own movie, or conversely, his own personal nightmare—and universal themes such as the ego's constant negotiation between pride and abjection." Berwick, "Paul Pfeiffer," 134.

33. As Boris Groys has said, "The modern age has not been the age in which the sacred has been abolished but rather the age of its dissemination in profane space, its democratization, its globalization. Ritual, repetition, and reproduction were hitherto matters of religion; they were practiced in isolated, sacred spaces. In the modern age, ritual, repetition, and reproduction have become the fate of the entire world, of the entire culture." See "Religion in the Age of Digital Reproduction," *e-flux* 4 (2009), http://www.e-flux.com/journal/view/49.

Pfeiffer's encouragement, one can say that mass media reprises and ab-
stracts the Fall, while at the same noting the relevance of this narrative to
other secular and political structures—slavery, colonialism, imperialism,
advanced capitalism—that also objectify the subject at the very moment
of its acknowledgment by a recognized or dominant authority.[34] Thus,
although Pfeiffer encourages us to think of these dynamics in terms of
foundational Christian texts, throughout his oeuvre he is equally invested
in establishing the relevance of rivalry, retribution, and surveillance to
modernity, aspects of which reinstate ideas that are neither reducible to,
nor ultimately separable from the Judeo-Christian tradition they uncan-
nily reprise. What may make Pfeiffer's work specifically Christian, at least
in a Girardian sense, are his efforts to identify and *see through*—indeed to
see past—the phenomenon of mimetic violence, the diverse instantiations
of which overlap and align in the complex work under discussion in this
essay. In turn, and however ironically, it is this fundamentally Christian
ambition that has ultimately obscured the religious dimension of his
practice.

34. Pfeiffer has established this nexus explicitly in "*Quod Noman*," placing medita-
tions on colonialism, African-American identity, perspective, and possession in dia-
logue with each other for the purpose of calling attention to their structural affinities.

Contributors

James Romaine, Associate Professor of Art History and chair of the Department of Art History at Nyack College. He is the President of the Association of Scholars of Christianity in the History of Art (ASCHA). His recent scholarship includes *Art as Spiritual Perception: A Festschrift for Dr. E. John Walford* (Crossway, 2012), and contributing to the exhibition catalog *Tim Rollins and K.O.S.: A History* (MIT Press, 2009).

Linda Stratford, Associate Professor at Asbury University. She is on the board of the Association of Scholars of Christianity in the History of Art and has produced a number of publications and presentations that draw upon cross-disciplinary training in art history, and aesthetics, including a manuscript in progress, *Artists into Frenchmen*, a study of art and identity in modern France.

Linda Møskeland Fuchs, independent scholar. She is Chair of the Governing Board of Chesterton House, a Christian Study Center serving the students of Cornell University. Her recent work includes "Adopting Identity: Afterlife Personae in 2nd–3rd Century Rome," a presentation at the Getty Museum for the 2009 College Art Association conference.

Matthew Milliner, Assistant Professor of Art History at Wheaton College. His recent work includes "Man or Metaphor? Manuel Panselinos and the Protaton Frescos," in *Approaches to Byzantine Architecture and Its Decoration: Studies in Honor of Slobodan Ćurčić* (Ashgate, 2012).

Rachel Hostetter Smith, Gilkison Professor of Art History, Taylor University. Dr. Smith is on the board of the Association of Scholars of Christianity and the History of Art. She was curator of *Charis: Boundary Crossings*, a traveling exhibition of Asian and North American artists and is directing a similar project originating in South Africa. She writes on a wide range of topics related to Christianity and the Arts.

Heather Madar, Associate Professor of Art, Humboldt University. Her recent work includes "Dürer's Depictions of the Ottoman Turks: A Case of Early Modern Orientalism?" in *The Turk and Islam in the Western Eye (1453-1750), Visual Imagery Before Orientalism* (Ashgate, 2011).

Elena FitzPatrick Sifford, PhD candidate in Art History at The City University of New York. She is completing her dissertation on the Black Christ in colonial Mexico and Central America.

Chloë Reddaway, Researcher and Lecturer in Christianity and Art, Cambridge Faculty of Divinity. She is a visiting lecturer in the King's College London MA program in Christianity and the Arts and a module author and external examiner for the Southern Theological Education and Training Scheme.

Matthew Sweet Vanderpoel, PhD student in the History of Christianity at The University of Chicago Divinity School. He has served as Visiting Instructor in Church History and Systematic Theology at the Université Chrétienne Bilingue du Congo.

Elizabeth Lev, Adjunct Professor of Art History, Duquesne University. She is the author of *The Tigress of Forlì: The Remarkable Story of Catherine Riario Sforza de'Medici* (Harcourt Mifflin Houghton, 2011).

Bobbi Dykema, Instructor, Humanities and World Religions at Strayer University. She is the author of "Woman, Why Weepest Thou? Rembrandt's 1638 *Noli me tangere* as a Dutch Calvinist Visual Typology," in Erhardt and Morris, eds., *Mary Magdalene: Iconographic Studies from the Middle Ages through the Baroque* (Brill, 2012).

Ilenia Colón Mendoza, Assistant Professor in Art History, University of Central Florida. She is the author of the forthcoming book *The Cristos yacentes of Gregorio Fernández: Polychrome Sculptures of the Supine Christ in Seventeenth-Century Spain* (Ashgate).

Joyce Carol Polistena, Professor of Art History, Pratt Institute. Among her recent publications is the essay, "The Image of Mary of the Miraculous Medal: A Valiant Woman" in *Nineteenth-Century Art World Wide* (May 2012).

Kristin Schwain, Associate Professor of American Art at University of Missouri-Columbia. She is the author of *Signs of Grace: Religion and American Art in the Gilded Age* (Cornell University Press, 2007).

Amy K. Hamlin, Assistant Professor of Art History, St. Catherine University. She is currently preparing a book manuscript on Max Beckmann provisionally titled *Max Beckmann: Allegory and Art History*.

Rina Arya, Associate Professor, School of Art and Design, University of Wolverhampton. Her recent work includes *Painting in a Godless World: The Religious Dimensions of Francis Bacon* (Lund Humphries, 2012), and *Abjection and Representation* (Palgrave Macmillan, 2014).

Isabelle Loring Wallace, Associate Professor of Contemporary Art, Lamar Dodd School of Art at the University of Georgia. She is the author of numerous essays in the field of contemporary art and is the editor, along with Jennie Hirsh, of *Contemporary Art and Classical Myth* (Ashgate, 2011); and the editor, along with Nora Wendl, of *Architectural Strategies in Contemporary Art: A Strange Utility* (Ashgate, 2013). She is also the author of *Jasper Johns* (Phaidon 2014).

Subject Index